Down
THE
Rabbit
Hole

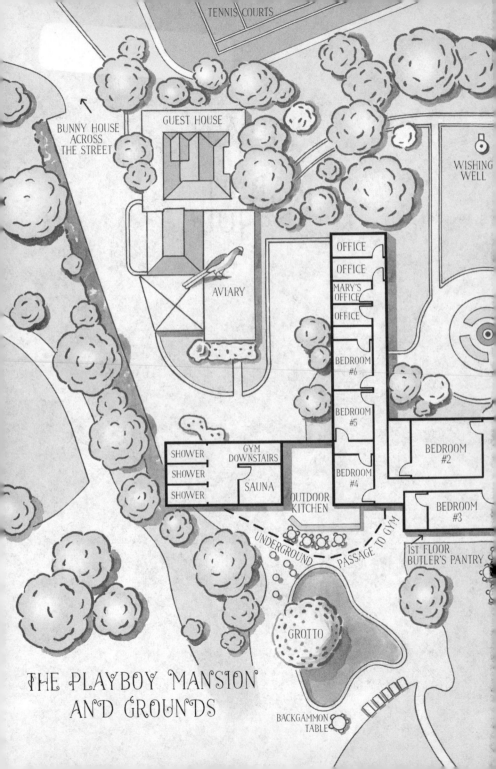

TENNIS COURTS

BUNNY HOUSE
ACROSS
THE STREET

GUEST HOUSE

WISHING
WELL

AVIARY

OFFICE

OFFICE

MARY'S
OFFICE

OFFICE

BEDROOM
#6

BEDROOM
#5

BEDROOM
#2

SHOWER

SHOWER

SHOWER

GYM
DOWNSTAIRS

SAUNA

BEDROOM
#4

OUTDOOR
KITCHEN

BEDROOM
#3

UNDERGROUND PASSAGE TO GYM

1ST FLOOR
BUTLER'S PANTRY

GROTTO

BACKGAMMON
TABLE

THE PLAYBOY MANSION
AND GROUNDS

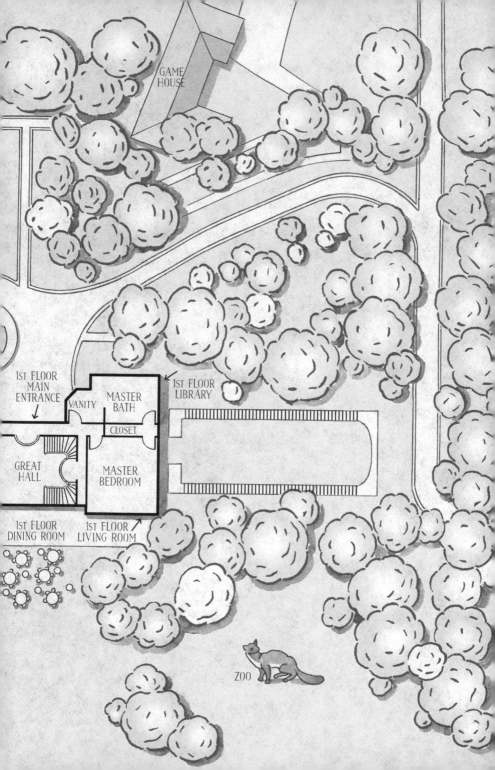

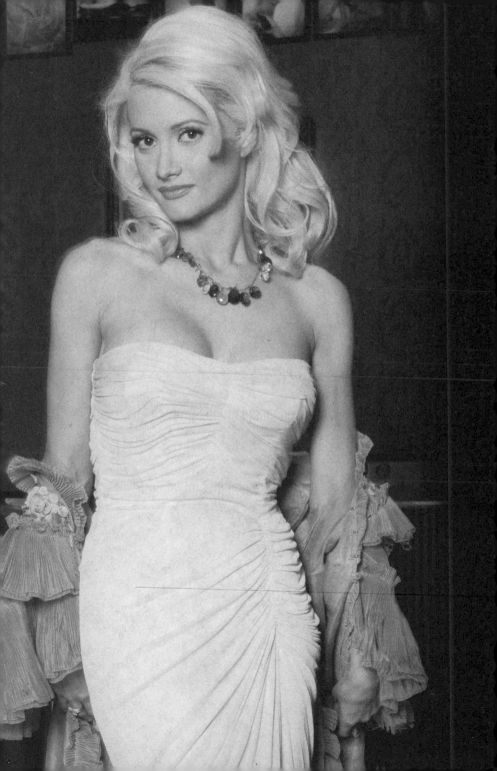

Down
The
Rabbit
Hole

CURIOUS ADVENTURES AND CAUTIONARY
TALES OF A FORMER PLAYBOY BUNNY

HOLLY MADISON

DEY ST.
AN IMPRINT OF
WILLIAM MORROW *PUBLISHERS*

DEY ST.

Map illustration by Rodica Prato.

HarperCollins books may be purchased for educational, business, or sales promotional use. For information please e-mail the Special Markets Department at SPsales@harper collins.com.

A hardcover edition of this book was published in 2015 by Dey Street Books, an imprint of William Morrow Publishers.

FIRST DEY STREET BOOKS PAPERBACK EDITION PUBLISHED 2016.

Designed by Lorie Pagnozzi

Library of Congress Cataloging-in-Publication Data has been applied for.

ISBN 978-0-06-237211-6

21 22 23 DIX/LSC 20 19 18 17 16 15 14 13 12

To my family,
who inspire me to be a better person

Thus grew the tale of Wonderland.

—Lewis Carroll, *Alice's Adventures in Wonderland*

AUTHOR'S NOTE

D on't you miss the mansion?" squealed a round-faced, wholesome-looking 20-something girl in a high-pitched voice.

"Um," I started, unsure of how to answer her politely. "No . . . ?" I said, offering her a halfhearted smile.

Here I was, an independent, successful woman, making millions of dollars a year (all on my own), headlining a hit show on the Las Vegas Strip, coproducing and starring in my own television show, and this woman was asking me if I missed the mansion?

Clearly the public perception of the life I shared with Hugh Hefner at the Playboy Mansion was a far, far cry from the actual reality I experienced.

This question wasn't really that uncommon. Fans would regularly ask me about my time living what they assumed was this lavish, decadent life in Holmby Hills and whether I regretted my decision to leave.

"Hef really fucked up when he let you go," a young fan said, shaking her head, at a Las Vegas meet-and-greet. That was another one I was regularly on the receiving end of.

"It's okay," I would always say. "I'm much better off now."

I couldn't—and still can't—believe that these adult women were actually serious. While filming the E! reality series *The Girls Next Door*, I

never thought of myself (or my two costars) as role models or anyone to be taken seriously.

I thought people were just laughing at us. I thought of us as walking advertisements: "Don't try this at home, kids."

I'm not stupid. I know how unsavory that whole situation was. You could read it all over my unsmiling face. Cameras often caught me rolling my eyes or looking totally uninterested. As if I didn't feel trapped enough, I built up a wall around me. I'd gotten myself into a bad situation, but I became distinctly aware that was *not* the impression fans walked away with.

The show was the epitome of mindless reality television, which was fine. We all have our guilty pleasures that we like to unwind with at the end of the day. There is something underneath the surface that isn't okay about it, though. Around the turn of the millennium, it became fashionable for women to appear stupid—to get by solely on their looks and to be concerned only with fame and materialism. Some of the effects of that moment in the zeitgeist still linger today.

And somewhere along the way, I too bought into the ludicrous fantasy . . . perhaps even more so than others.

While there was a part of me that acknowledged the idiocy and superficiality that surrounded me, I fell for the glamour: hook, line, and sinker. It took years for me to realize just how manipulated and used I had been. I could never admit that to myself at the time, because to do so would have been to acknowledge how dark and scary a situation I was in . . . and how very little in control I was.

"I'm an adult. I'm here because I choose to be. I'm here for adventure, a once-in-a-lifetime experience. I'm here as a stepping-stone to something else," I routinely told myself. And perhaps the biggest disillusion: "I'm here for love."

Deeper and deeper I fell down the rabbit hole.

Many people may think that I'm biting the hand that fed me and that I should be grateful for the opportunity *Girls Next Door* and *Playboy* af-

forded me. And while I *am* grateful, it's also clear to me that most people fail to realize that there are two sides to every coin and that even the most fantastic fairy tale has a dark underbelly. Being attached to *Playboy* can make people not want to have anything to do with you, even in quirky, crazy Hollywood. There were many times the hateful backlash made me wish I stayed the broke, awkward 21-year-old waitress I'd been before Hef came into my life.

When I finally did find the strength to leave the mansion, I began receiving lucrative offers to reveal my version of events, but I never pursued them. I wasn't interested in writing a sensational tell-all for the sole purpose of exposing someone else's strange habits and dirty secrets (don't worry, you'll find those things here, but in the context of something bigger). I wanted to have my own story to tell, too.

To this day, it astounds me the number of misconceptions that abound about my life and my experiences while at the mansion. Usually, the version of the story most flattering to Hef is the one that prevails.

I've seen both sugarcoated and sensationalized accounts of life at the mansion, but nothing I've ever read remotely resembles what I actually experienced. I always thought it would be classy to not kiss and tell . . . but after a while you just get sick of having other people trying to tell your story for you.

Hopefully, once you read my story, you will be able to understand why I made some of the choices I made . . . and why I also felt trapped by those choices. I hope that sharing my mistakes can prevent someone else from making similar ones, or give someone the courage to leave a bad situation.

This starts off as your typical "Small-Town Girl Goes to Hollywood" story that we've all heard a hundred times before. But it's also much more than that: it's the unauthorized, never-before-told story of the Playboy Mansion and the man that holds the key; it's a behind-the-scenes account of reality television at its most decadent and absurd; it's a cautionary tale; it's the story of betrayal and abuse but ultimately of survival, success, and

redemption; and finally it's a real-life fairy tale with heroines, villains, odd characters, strange happenings, and, of course, a "Happily Ever After."

Some of the names in this book have been changed to protect the innocent . . . as well as some of the not so innocent. When you've journeyed into a dark world where publicity and fame are commodities so deeply desired and unable to be bought, you're hesitant to give some of those people who have hurt you the attention they so desperately crave. But I am here to set the record straight: the good, the bad, and the ugly. The naked truth. I was born a girl with an insatiable appetite for the extraordinary: the strange, the unusual, the glamorous, and the morbid. And I experienced all of it.

So follow me down the rabbit hole . . . the truth may be stranger than you imagine.

Down the Rabbit Hole

PROLOGUE

—

*"I know who I was when I got up this morning, but I think
I must have been changed several times since then."*
—Lewis Carroll, *Alice's Adventures in Wonderland*

1988

It wasn't the most lavish-looking present under the tree. The flat, square package was wrapped in simple green and white paper with a glossy red drugstore-bought bow and addressed to me from my aunt.

When I was nine, Christmas wasn't necessarily the spectacular event it had been in years past. I wasn't particularly interested in toys anymore, but I wasn't yet mature enough to appreciate the more practical presents.

Holding the soft object in my hand, I didn't expect much.

Carefully, I peeled away a corner of the paper to reveal what appeared to be the bright blue cover of a book. With a bit more eagerness, I tore away the remaining wrap and read aloud the words: *Marilyn Monroe Paper Dolls*.

Of course I had heard of Marilyn Monroe before. Madonna had spent most of the '80s replicating the movie star—most memorably in her 1985

Material Girl music video—and like most fourth-grade girls, I idolized the pop singer. But I don't recall ever *seeing* Marilyn before this moment.

Smiling up at me from the cover of this gorgeous book were two illustrations of the starlet: one dressed in a black-sequined showgirl costume and top hat from her 1953 movie *Gentlemen Prefer Blondes* and one in a casual pink sweater and capris with flowing blond curls from 1952's *Clash by Night*.

Flipping through the thick, glossy pages I saw a variety of costumes from her most famous roles: a pageant swimsuit with sash and tiara from *We're Not Married* (1952); a cream gown with a pink and purple, frilly kimono wrap from *The Prince and the Showgirl* (1957); a green and yellow Bo Peep–inspired ensemble from one of her earliest roles; and so many more.

More than 30 different costumes (including one of the starlet in nothing but a bathrobe draped over her otherwise naked body) filled the pages to dress the bikini-clad Marilyn Monroe cutout figure. On the back of the book was a biography, detailing how the orphan Norma Jeane became one of the world's greatest movie stars.

With extra special care, I methodically cut out the figure and each of her glittering outfits. I spent hours dressing and re-dressing my Marilyn doll, imagining how she must have felt in each moment: the weight of those gilded gowns, the sounds of an active movie set, the wondrous eyes of the countless admirers, and the decadent Hollywood parties I could only dream about.

My little world felt so limiting. As my family bounced from Oregon to Alaska, then eventually back to Oregon again, no place ever felt like home. I grew up hunting, fishing, reading, and playing in the woods in Alaska; when I arrived in Oregon I was a fish out of water. The kids in my new school loved two things and two things only: sports (which I had never played) and video games (which I couldn't afford). Not to mention, my social skills were lacking. I frequently tried to reinvent my image, my

group of friends, and my hobbies, but nothing ever felt like *me*. The other kids treated me like an outsider because they thought I was different.

They were right—I was different. I dreamt of a world outside my little rain-soaked suburban bubble. I'd fantasize about a glamorous career and all the amazing costumes I would wear one day. I thought that if I wished hard enough, perhaps I would fall down the rabbit hole and find myself in a decadent world beyond my wildest dreams.

And Norma Jeane Mortenson did that—didn't she? She escaped her boring existence and became Marilyn Monroe.

Quickly, my fascination with the star escalated. Every Sunday morning, I would grab the newspaper and pull out the TV guide. My eyes would scan over the programming list searching for the titles of any of her movies listed in the book.

The first one I finally came across was *Bus Stop* (1956). I set up our family VHS player to record it when my parents weren't looking. They let me keep the paper dolls, but they didn't really care for Madonna or Marilyn or such frivolous fascinations. I found that first film a little dull—some of the nuances in *Bus Stop* went right over my nine-year-old head. After all, they couldn't always spell everything out in the 1950s.

As weeks became months, my VHS collection grew and I became acquainted with most of Monroe's better-known pictures. *How to Marry a Millionaire* quickly became my favorite, mainly for the campy 1950s fashions on screen.

Yes, I know what you're thinking. I'm almost embarrassed to admit that because of the film's title, but the title and plot had nothing to do with why I liked it. I loved the three main characters. They were just too irresistible: model roommates played by Lauren Bacall (the smart one), Marilyn (the romantic one), and Betty Grable (the athletic one who always said what was on her mind).

As for Marilyn herself, I was absolutely enchanted with the glamorous creature whose beauty transcended the small television set in my

family's living room. On screen, she appeared to have everything she ever dreamed of: fame, beauty, fortune, and, of course, love.

Someday I'll know what it's like, I thought. *Someday I'll know what it's like to have it all.*

2002

If I just put my head under the water and take a deep breath in, it would all be over, I thought. The bathroom was empty as I swam alone in the giant marble tub. The air was chilly inside the mansion walls, with a draft that always seemed to rustle through the rooms. I pulled my shoulders under the warm water and rested my stoned eyes on the wall opposite me. *But could I really do it?* I dipped my toes in and out of the water and listened for the quiet echo the splash made as it bounced off the tile walls, feeling like an exotic fish trapped in some enormous aquarium. Outside the bathroom, the mansion was eerily quiet.

It was *unusually* calm at this hour of the night. We spent yet another evening out at one of Hollywood's hottest nightclubs (like clockwork, we went clubbing every Wednesday and Friday), before coming home and retiring to Hef's room, where we all smoked weed and went through the weird bi-weekly "bedroom routine" (which was nothing like most people imagined it to be). To an outsider, our evenings looked incredibly glamorous: seven beautiful women dancing the night away behind velvet ropes and bulging security guards, private table service to cater to our every desire, and exclusive access to the club—all at the expense of the world's most notorious boyfriend: Hugh Hefner. But if you looked close enough, each girl appeared to be just a little bit vacant and merely going through the motions of what life *ought* to be. Life inside the mansion wasn't at all what I expected to be—not even close.

Everyone thinks that infamous metal gate was meant to keep people out. But I grew to feel it was meant to lock me in. I wasn't quite sure how I ended up in this curious, often dark world, but I was petrified by

my own fear of what it would mean to ever leave. Tucked away inside Hugh Hefner's rolling Los Angeles estate, I was controlled by a spur-of-the-moment decision I made at 22 years old that I had grown to deeply regret despite the extravagant world it afforded me. It was a decision that changed the course of my life.

I *had* to believe that there was a greater purpose for the choices I had made: whether it was to help advance my career or whether it was truly for love. And depending on the month, the week, and sometimes even the hour of the day, I would waffle back and forth between precisely why I was living a life as nothing more than "Girlfriend Number One" to a man who was old enough to be my grandfather. I didn't want to admit that I had sold a bit of my soul for the chance at fame.

Would anyone even miss me? It's amazing the dark places your mind can wander when you're depressed. The depths of my own depression had led me down this very dark path, and there was no gleaming light, however distant, at the end of this tunnel. Maybe it was the pot and the alcohol, but drowning myself seemed like a logical way to escape the ridiculous life I was leading. I just couldn't take my misery anymore. Of course my family would be devastated, but I rarely saw them enough for my absence to make a difference.

From a distance, it appeared as though the girlfriends' days consisted of bopping around Beverly Hills shops, driving flashy cars, and toting designer handbags. I played the part of the perfect girlfriend well: a bubbly, fun-loving, carefree girl who loved her dogs, her lifestyle, and, most important, her boyfriend. Playing that role quickly became second nature, and the blurred lines of reality made it so that some days I struggled to even remember what I was like before moving into the mansion. It was like a high-stakes version of teenage politics: sometimes you try so hard to fit in that you almost forget it's all an act. I was afforded many things while I lived in the Playboy Mansion . . . but never the opportunity for the sort of self-discovery most 20-somethings enjoy.

Public criticism and speculation have always trailed Hef and his

harem of young, blond girlfriends: "Do they all sleep with him?" the more conservative folks would wonder. "It's all an act. They're just paid to be arm candy," the younger crowd would usually surmise. "How does he keep up with them all?" the older men marveled. But life inside the Playboy Mansion wasn't exactly the sexy fairy tale my ex-boyfriend would have you believe. In fact, it was like a bedazzled, twisted prison where the inmates developed their own hazing and hierarchy and where the release back into society was the equivalent of being excommunicated.

How would the other girlfriends react to my death? Among the seven girlfriends, I had only one friend: Bridget Marquardt. Surely she would be distraught over my death, but I couldn't imagine the others girls would shed even a single tear. The climate inside the mansion was toxic. I didn't participate in the cocaine benders, the side boyfriends, or all their hare-brained moneymaking schemes that were all in direct violation of Hef's house rules. I rarely left the mansion, so making it home in time for curfew was never an issue either. Needless to say, my goody-two-shoes reputation wasn't the most welcome among this group of girls. In fact, they'd probably view my unexpected demise as an opportunity to get away with more shit as Hef busied himself with the public relations roll-out regarding a death at the mansion. Not to mention, it would mean less competition. Yep, they would be glad I was gone.

Would Hef even feel bad when he heard the news? He'd probably be completely shocked. In his eyes, as long as each girlfriend had a substantial allowance to buy nice things—and the ability to bask in the reflection of his fame—that's all she needed to be happy. He would surely never concede that my misery had anything to do with him or the life he provided. *Would he even miss me?* No, I was certain I was just another warm body—as we all were. "Just another blonde," I could hear him say. Internally, I decided he would label it a devastating accident. His main concern would be navigating *Playboy* out of any sort of PR crisis. A small memorial might even be held at the mansion, but it would glorify my

days at *Playboy* and with Hef, once again promoting the idea that life inside those walls was nothing short of paradise.

And just like that, I would be swept under the rug with every other scandal and ghost that once plagued Hugh Hefner . . . and my memory would involuntarily serve as yet another public reminder of the beauty that is *Playboy*.

I think that knowing my death would be in vain convinced me not to go through with it. In truth, I didn't really *want* to die, but I saw no other way out. Thankfully the only thing greater than my need to escape was my desire to share my experience. If I sunk my head below the water and went to sleep, no one would ever know the truth.

Eventually I'll tell my story, I thought. I wasn't sure when and I wasn't sure how, but someday I would fight my way out. Someday I would be whole again.

"Begin at the beginning," the King said, very gravely,
"and go on till you come to the end."
—Lewis Carroll, *Alice's Adventures in Wonderland*

Slowly, the large iron gates surrounding the infamous compound creaked open and our shuttle began its ascent up the steep driveway. My nose was pressed so tightly against the window—anxious to spot any sign of the luxurious Holmby Hills estate expertly hidden by the lush foliage—that my makeup smudged on the glass. Over my shoulder, I heard a fellow partygoer point out the first glimpse of the 20,000-square-foot Gothic Tudor that was steadily coming into view.

"There it is!" a man in silk pajamas shouted. I craned my neck to spot the roof and fixed my eyes on the horizon as the mansion began to surface. Like an early morning sunrise, it was magic. The estate—situated on five rolling acres in one of L.A.'s most prestigious neighborhoods—looked like a castle from a fairy tale. My large eyes widened, trying to fully absorb this moment.

As the shuttle reached the top of the driveway, my girlfriend Heather spotted the infamous "Playmates at Play" sign and nudged me in the ribs.

"Look!" she said, her smile so large I thought it was about to snap off her cheeks. We both burst into laughter. We were positively giddy. *We are actually here*, I thought. *I made it to the mansion.* It had become a goal of mine to see the inside of these walls, and I told myself that I could now happily check that one off the bucket list. I even wondered if I would meet Gatsby himself . . . Mr. Hugh Hefner.

My story wasn't atypical: a small-town girl—farmer's daughter, so to speak—who dreamt of becoming someone extraordinary.

There were less than 10,000 residents in my hometown, and my high school graduating class was smaller than the guest list to most Hollywood parties (since then, it has seen a boost in tourism thanks in part to the *Twilight* movies, but let me assure you, there was no Edward Cullen sauntering through my lunchroom).

After graduation, I moved 30 miles away to attend Portland State University. Which didn't feel far enough, but it was the best I could do.

It was early 1999 and I was in my second year in college when I heard on the news that *Playboy*'s "Millennium Playmate" search was coming to Portland. Immediately, my mind started to wander. I found Oregon's weather depressing and didn't feel like opportunity exactly lurked around every corner there. I had been thinking a lot about moving to Los Angeles to try my luck, but I didn't know anyone in L.A. or have the financial means to make such a big move.

Apparently, according to the report, the magazine had been conducting a nationwide "on the road" search for the "Millennium Playmate." A gigantic tour bus traveled the United States (and Canada), stopping in 45 cities testing candidates. The girl chosen would receive $200,000, would appear inside the January 2000 issue of *Playboy,* and would be flown around the world to represent the men's magazine for the entire year. It sounded like just the opportunity I was looking for!

This wasn't the first time *Playboy* popped up on my radar. As was

true with many children of the '80s, it wasn't abnormal for us to have a *Playboy* magazine arrive at the house. I even remember my mom and dad studying the front cover of a *Playboy* once to find the hidden rabbit head. As a kid, you think that sounds like a pretty fun game, but we were quickly told that it was "for adults only." One day my sister and I were scouring the house for any Christmas presents my mom may have hidden when we came across a few *Playboy*s that had been hidden away. We flipped through in absolute hysterics, pointing out all the bare butts. I was a kid, so I thought it was hilarious!

While *Playboy* wasn't completely foreign to my home, it still felt rebellious. I knew that if I auditioned for the "Millennium Playmate" and happened to be chosen, my parents wouldn't be thrilled at the prospect of me posing naked, but possibly would have respected my decision. It was a reputable magazine with a storied history, so it felt edgy but also somehow safe.

Plus, at the time many of Hollywood's biggest stars were appearing in the magazine: Cindy Crawford, Jenny McCarthy, Drew Barrymore, etc. Not to mention, my icon Marilyn Monroe was *Playboy*'s first ever cover girl. Naturally, I too had pipe dreams about one day being in the magazine.

This is perfect, I thought. *I'm going to audition!*

According to the news report, the process was quite simple: call the provided number, make an appointment, and show up with your favorite bikini.

That's when my genius idea to fast-track my stardom hit its first speed bump: I didn't actually own a bikini. In my defense, I lived in Oregon. Why would I need a bikini? And when I say things were tight financially, I mean they were *tight*. But I decided it was about time to make an investment in my future. After calling the number, getting the address where the bus would be stationed, and securing an audition time the following week, I went shopping.

Needless to say, Portland wasn't brimming with retail shops specializing in swimwear, but I remembered seeing one downtown near my col-

lege campus, so I popped in to see what I could find. I didn't really know where to begin. Obviously, I had never taken photos in a bikini before (this was about 15 years before "selfies" became popular), so I didn't know what I should be looking for. After scouring the racks for the best deal, I decided on a silver metallic bikini that was both sexy but also one that I felt reasonably comfortable in.

Before the audition, I figured I should probably get some kind of tan. There weren't too many sunny days in the Pacific Northwest, so my complexion was incredibly light (particularly when coupled with blond hair and a silver swimsuit). I went to the nearby tanning salon and had my first experience with a tanning bed. I was terrified of going to my audition bright red, so I asked for the lowest possible voltage. It wasn't a drastic difference, but it did the job.

As I pulled into the address I had been given, I spotted the tour bus immediately. It was so large that it stood out like a sore thumb in the hotel parking lot it was stationed in. When I arrived, I was ushered inside the hotel lobby with the other "potential playmates" to fill out some paperwork before stepping onto the bus for the audition. Over my new metallic bikini, I wore a barely above-the-knee black "miniskirt" and a white button-down blouse in hopes of capturing that "girl next door" image photographers were apparently looking for. And, to be honest, it was also the sexiest outfit I owned.

To tell the truth, I was a bundle of nerves; I had never modeled before, so the idea that I'd be posing practically nude was terrifying. But I figured that since editors were hoping to discover new talent, they were expecting girls to be relatively inexperienced. On the bus, I envisioned a few stylists helping candidates with hair and makeup touch-ups and a distinguished photographer guiding the amateur models into the most flattering poses. Don't get me wrong, I knew it wasn't a full-blown shoot, but I expected at least a little help. It was *Playboy*, after all.

After a few minutes of waiting, I was escorted to the gigantic 45-foot-long tour bus with two other girls. We were made to wait in the ultra-lux

"living room" area, which was wrapped in leather with a seven-foot movie screen in the back. I remember thinking that it was nicer than any home I'd ever been in. Framed portraits of *Playboy*'s most iconic covers hung on the walls that reached up to a mirrored glass ceiling. A man with a clipboard walked into the room and greeted us. He gave us a brief history of the magazine and then asked that we go around the room and introduce ourselves and say why we were there.

One girl looked like a Pamela Anderson–inspired stripper with white poufy hair, a clingy silvery dress, and clear-plastic platform heels (and appeared to have brought her pimp with her). For a moment, I remember wondering if she was actually a female impersonator. There weren't too many women like her running around Portland at the time and I was so distracted by her appearance that, for the life of me, I can't recall a single thing she said.

The other girl was pretty, but not too remarkable, and I'd guess about 10 years older than me.

"I came to try out because I've always wanted to be a Playmate," she gushed. The man with the clipboard smiled and nodded, pretending not to have heard this response more than 20,000 times already. "And me and my best friend have a bet on who would become one first. I want to be Miss April."

Then it was my turn.

"I've always dreamed of moving to Los Angeles and becoming an actress," I explained, the other two candidates glaring at me. "I love Marilyn Monroe and she was the first Playmate, so that's why I want to be in *Playboy*."

For some reason, each of us believed we were total shoo-ins. I mean, I really thought I had a shot. Knowing what I know now, though, none of us ever stood a chance.

After the meet-and-greet, each girl was called one by one into the onboard "photo studio." When my name was called, I stood up and pressed the creases out of my skirt before making my way into the room.

It all felt very rushed. Besides the photographer, the room was empty—no stylists or coaches to speak of.

"Hi, Holly, how are you?" the photographer said, staring down at my application in his hand and guiding me towards a white backdrop. "This will be great. Just relax. Have fun."

I was instructed to strip down to my bikini for the first photograph. Brimming with nerves, I did what I was told.

"Awesome, great," the photographer said hurriedly. "Now, can you take off your top?"

Oh shit! He wants me to do what? I thought. *He's not going to take pictures of my boobs. Is he?*

It was incredibly naïve; I know that now. I had figured that the first round of photos were just to see if you were cute enough to be called back and then perhaps we'd discuss the possibility of more revealing photos. I wasn't expecting to get naked at that very moment.

Begrudgingly, I shed my top for a photo. Given how incredibly awkward I felt, I can't imagine it was the most flattering photograph. Immediately, I felt the urge to do some kind of damage control. I had signed my life away on the photo release, so could they use these photos even if I wasn't selected?

"Um," I said, clearing my throat. "Could you make a note or something that you don't have my permission to use these pictures unless I'm selected?"

The photographer gave me a weird look, clearly not expecting that kind of reaction from a girl auditioning for *Playboy*.

"Okay, I'll make that note," he said before scribbling something down on my application. That was it, ten minutes and I was done.

Now looking back, I don't think I could have done anything more damaging to my chances. "Hi, I'm Holly. I want to be in *Playboy* but don't use my topless photo." But at the time, I wasn't prepared for it. Of course I had hopes of becoming the "Millennium Playmate," but I sure as hell didn't want a topless photo of myself snapped in the back of a bus to be

printed in the magazine (worrying about it appearing online wasn't even a consideration back then). What if they did a spread of all the girls that auditioned?

Not too surprisingly, I never heard a word from them.

When the Millennial *Playboy* issue eventually came out, a set of Peruvian twins graced the centerfold (the girls were models from Miami who never even stepped foot on the *Playboy* bus; the "tour" was mostly a publicity stunt for the January issue).

Wow, twins! I thought. I never stood a chance.

In the previous issue was a four-page spread called "Girls of the Millennium Search" showcasing collages of nude photos from the girls who auditioned on the bus. It was exactly the type of story I wanted to avoid. Frantically, I scanned the pages but didn't see my photo anywhere.

Thank God I said something. Although after signing the paperwork, I'm pretty sure the editors could have done whatever they wanted with my photo. Yet, while I didn't want to end up in some throwaway section of the magazine, I had to admit I felt a bit defeated. I thought I'd blown my opportunity to appear in *Playboy*.

It wound up being six years—and a very strange twist of fate—before my next chance at a pictorial.

In the meantime, I'd decided to transfer schools so I could make my way to Los Angeles.

Before I left, however, there was one thing I needed to do.

I TOOK A DEEP breath as I plunked three brand-new credit cards down on the receptionist's desk. Like every college student, I had received a slew of credit card offers in the mail and applied for as many as I could get. Since the limits were so low, it took three cards to cover the $7,000-plus my new set of breast implants would cost me.

As each card swiped through the machine—maxing out one after the other—I carefully filled out the paperwork with nervous excitement. You

might think my failed *Playboy* casting was the reason I was now sitting in the doctor's office preparing for an expensive cosmetic procedure, but that was really just the straw that broke the camel's back. For the past several years I had struggled with insecurities about my chest—or lack thereof. I'd always been naturally curvy from the waist down, but from the waist up, I was as skinny as a stick figure.

This had plagued me through high school and I spent those years perpetually armed with a heavily stuffed Wonderbra. I wasn't trying to appear stacked per se—I was just trying to balance the proportions of my body while I waited for the bombshell chest I was certain I would one day develop. I remember gaping at Anna Nicole Smith's *GUESS* ads when I was in junior high, hopeful that I would be just as voluptuous one day, but it never happened. (I even sent away for herbal supplements "guaranteed" to increase your chest by two cup sizes! Surprise! They didn't work. I actually called and got my money back.)

The nurse led me into the preop room and instructed me to change into the scratchy hospital gown. I had never had even the most minor surgery before, but I was young, fearless, and determined to look my best. After all, you only live once, right? I was sure I would pay the credit cards off in a timely manner. It was no big deal.

After the procedure, I woke up feeling like I had been run over by a garbage truck. The doctor had made the surgery sound so simple during my consultation that I actually thought I would be up on my feet that same day. Foolishly, I planned on keeping the entire ordeal a secret from my parents. I wasn't in the habit of discussing my private anatomy with my mom and dad, and since I'd been stuffing my bras religiously for years, I figured they wouldn't even notice. There was *no way* they would have allowed me to pile on all this massive credit card debt in one swoop, but I didn't want to hear anyone's advice (I was always one of those stubborn kids who insisted on learning things the hard way).

The nurse rolled me out of the facility in a wheelchair to meet my friend who was scheduled to pick me up. Slumped over in the passenger

seat, I realized there was no way I could keep this from my parents. After she pulled into the driveway and walked me to the front door, I not so gracefully stumbled through the entryway and flopped on my parents couch, clutching a barf bag full of bile to my chest. In this state, I had to explain the whole ordeal to them as they shook their heads with a mixture of amusement and amazement. Luckily for me, I had long been rebellious and they were used to my crazy antics.

After a few days of recovery where I felt like an elephant was sitting on my chest, I finally made it to the mall to buy my first post-surgery bra. As I tried on a handful, I finally found a perfect fit. I looked at the tag on the lacey white Victoria's Secret Dream Angels bra: a 34D! The surgeon had told me he couldn't guarantee what size my breasts would end up being—I had asked for a C cup using a topless photo of a Playmate as inspiration. I couldn't believe I was a D cup—I was huge!

While I don't regret the surgery (I couldn't have been happier with my body), the credit card debt would end up becoming too much for me to pay off in a timely manner—contributing to money troubles that would end up haunting me in the years to come.

Shortly after the surgery, with roughly $100 in my bank account, I packed up my battered red Toyota Celica and made my way, like countless girls before me, down the Pacific Coast for a chance at "making it." After two years at Portland State University, I transferred my credits to Loyola Marymount, a private university about five miles south of Santa Monica. I was earning a double major in psychology and theater arts and figured there was no better place to study acting than in L.A.

Student housing was already at capacity when I arrived, so transfer students were put up at a hotel across from campus (two students to a room) until we could make other arrangements. I thought it was so cool getting to live in a hotel and I didn't want to have to move out after my first semester. Not to mention, apartments in Los Angeles were really pricey and I was anxious about having to eventually factor that into my already tight budget.

I hadn't been in Southern California more than 24 hours before I realized I needed a relatively well paying job—and quickly!

At a friend's suggestion, I headed to the Hooters in Santa Monica to apply for a waitressing gig. Much to my surprise, I was hired on the spot.

Thank God for my new boobs, I thought.

My first day on the job, the manager handed me the signature "Hooters Girl" outfit and motioned for me to go change. When I emerged from the stall in the women's restroom, I paused to take a long look at myself in the mirror.

How can I go out on the floor in this outfit? I thought. I had never felt so naked in an outfit before. The breeze of the air-conditioning went right through the thin tank top and tiny spandex shorts as if I wore nothing at all. And the shorts were so tiny, the girls' butt cheeks always hung out of the bottoms. I often thought the restaurant should have been called Cheekers. The only blessing was the nylons. Hooters Girls were required to wear tan pantyhose to make their legs look flawless, but to me they also added a measure of decency.

Suck it up, Holly, I thought. My dream was always to make something of myself, and by allowing me to afford to stay in L.A., this job was a means to that end. I had read an article about Hooters Girls in *Jane* magazine that highlighted how much cash they earned in tips. There was no way I was giving up this opportunity.

I fixed my hair, put a smile on my face, and walked out the door. And you know what? It really wasn't that bad. I soon learned to love my job.

After a short time in the city, I settled into a tiny Westwood apartment with my friend Nora. Besides a mattress, a lamp, and a pile of schoolbooks, my room was all but empty. My Hooters salary was barely covering my daily expenses, so I relied heavily on scholarships in order to pay for a portion of the hefty tuition at the private university. What was left over for me to pay? . . . Well, let's just say it went unpaid for quite some time.

I was 20 years old and almost delusionally confident and optimistic.

I was convinced I could do anything I could put my mind to . . . even become a famous actress *and* get my college degree within a few years. I knew I wasn't always the hottest girl in the room, but I also knew I wanted success so badly that I would work harder than anyone else for it. For a while, I *did* manage to juggle it all: the school, the job, and the auditions. There was only so much longer I could keep it up, though. I was burning the candle at both ends and something was bound to give.

As it happens with transfers, many of my credits from Portland State didn't apply towards my program at Loyola Marymount. In order to graduate on time, I'd have to load up on credits, which included long theater hours that would require working backstage on different productions during the evenings when I typically waitressed. I knew that with a packed school schedule and a full-time job, I wouldn't have any time to study. And if I couldn't study, I wouldn't be able to meet the minimum grade requirements of my scholarships. So after a year at LMU, I decided to take a break from school to focus on pursuing my career. I would never be as young or as eager as I was in that moment, and I figured that I might as well take the plunge. School would always be there, so if it didn't work out for me, I could easily go back and finish my degree. It's not unusual to graduate from college at 30; but it's a lot less likely to break into acting at that age. In my heart, I thought it was the best decision for me at the time.

With school on hold, I picked up more shifts at Hooters and eventually started working part time as a Hawaiian Tropic model. The gig basically required me to show up at events in company apparel or appear in movie bit roles in swimwear and a "Miss Hawaiian Tropic" pageant sash. I thought it would be a great way to make extra money and also to meet people. In Hollywood, you never knew where opportunities would arise. I would end up being right, of course. The gig would lead to something, though maybe not what I had expected.

Not long after, at a Hawaiian Tropic Bikini Contest in Beverly Hills, one of the event organizers pointed out an older man.

"You see that guy over there?" he asked. "That's Hugh Hefner's personal physician." Naturally, it was exciting that someone associated with *Playboy* was at the event, but I didn't give it too much consideration until an hour later when the man approached me.

"Would you be interested in attending a party at the Playboy Mansion?" he said, barely taking the time to meet my eyes. My mouth fell to the floor. He posed the remark as a question, but it was clear he already knew there was only one answer.

He'd apparently been at the party offering invitations to the girls he deemed *Playboy*-party worthy. It wasn't abnormal for a representative from the magazine or one of Hef's friends to invite attractive women to the parties. Many of my coworkers had become regulars at the mansion. I guess I just wasn't expecting an invitation of my own, and especially not from his doctor of all people.

Was he really asking me if I want to go to the Playboy Mansion? I thought. For a starstruck girl from Oregon, this felt like the chance of a lifetime.

"Are you kidding?" I squealed. "Of course!"

In Los Angeles in 2000, there was only *one* invitation that mattered: a *Playboy* party. Nowadays, invitations to the Playboy Mansion are sold to the highest bidders and to any media outlet offering any morsel of publicity. It's no longer considered exclusive or coveted. But back then? It was *the* place to be. Hef threw only a handful of parties each year with a maximum capacity of about 800—and the guest list was strictly invitation only.

When I received my glossy black invitation in the mail a few days later, I could feel my heart swell with excitement. "Hef's Midsummer Night's Dream Party," it read. On the front was a beautiful pinup illustration by famed artist Olivia De Berardinis and inside was a small piece of paper with directions. It was like Cinderella *finally* scoring an invitation to the ball—except instead of arriving by horse-drawn carriage, we would board a shuttle at a UCLA parking garage.

The dress code was strict: "Sleepwear Required." My coworker

Heather had also landed an invitation—a huge coup for me considering invitees weren't allowed a "plus one"—so we immediately starting obsessing over what we would wear.

Despite having very little flexible income, I decided I *needed* a new lingerie set from Frederick's of Hollywood: a black satin corset with matching garter belts, thigh-high stockings, and a short yet conservative silk robe to wear on top of the ensemble. Bikinis and Hooters shorts aside, it would be a little while before I would be comfortable parading around in "lingerie or less," the staple look at a *Playboy* party.

ONE BY ONE, GUESTS stepped off the shuttle. Every inch of the estate seemed to sparkle. Bright white twinkle lights lit the walkway towards the decadent soiree; gorgeous colored spotlights draped the cascading waterfalls framing the pool. Both Heather and I were so overwhelmed we barely spoke a word to each other as we took in the magnificent grounds. Before we entered the party, a staffer asked to take our photograph. We didn't even question why as one by one each woman stood for a Polaroid. When we finally made our way around to the backyard, we spotted the most lavish buffet of food I had ever seen.

For two broke waitresses who existed mainly on Top Ramen and chicken wings, it was a feast fit for royalty: seafood bars, carving stations, sushi buffets, dessert carts, and gorgeous-looking drinks flowing from the flagstone bar next to the pool.

Suddenly Heather jerked my arm and pointed across the lawn.

"Oh my god, there's Cameron Diaz," she said, pointing to the tall beautiful blonde sitting at a table nearby. And next to her was Jim Carrey. Across the pool, Heather spotted Leonardo DiCaprio! It was a virtual who's who of Hollywood!

"Holly! Heather!" We heard our names through the crowd. Who could we possibly know here?

It was a welcome relief to see our friend Kira, another Hooters server,

waving to us from across the party. She navigated her way through the sea of people with the expertise of someone accustomed to these types of events. Working together, I knew that Kira had seen her fair share of *Playboy* parties.

"You guys want a tour?" She posed the question as if we had just happened into her very own living room, and we immediately took her up on the offer. She walked us through the infamous candlelit grotto (which was still empty at this early hour), through the zoo where we fed grapes to the tiny monkeys, and inside the '70s-themed game house before making our way into the main event. Gorgeous colorful fabrics clung to every corner of the grand tent rooftop, while faux grass lined the bottom, creating the illusion of some fantastical forest (although I'm quite certain that many of the people in attendance didn't make a habit of reading Shakespeare, and, in some cases, quite possibly had never even heard of the play the party was named for). Everything looked so sensuous and inviting.

It wasn't until we were tucked away in a corner of the tent that I finally spotted our infamous host looking quite gloomy—especially for a man flanked by two of the most breathtaking beauties I had ever seen. The Bentley twins were tall, tan, and reed thin with slow, languorous walks. They conducted themselves like royalty—as if they were on the arm of a king or a president—but were dressed like sex kittens in custom-tailored Baracci costumes. Shimmering with beads, sequins, and Swarovski crystals on French lace skirts and tops, their outfits were unlike anything any other partygoer was wearing. They were sexy but oh so elegant, with perfectly painted faces and blond cascading curls decorated with glittery butterflies. They were picture perfect and, needless to say, made a lasting impression.

"He never stays for that long," Kira said, when she saw me looking over at Hef and his fabulous girlfriends. I watched as Hef sat in a crowded corner of the tent, shaking hands with one partygoer after another. My first thought was that he appeared really out of it. *Was he senile?*

I thought. More likely, he was just bored. After 50 years of glad-handing, I'd imagine you'd get sick of it, too.

I knew I didn't have long before he made his escape, so Heather and I headed towards his table to introduce ourselves. Maybe Mr. Playboy would see me, think I was pretty, and suggest I audition for a pictorial. It was a long shot, but I figured it couldn't hurt. *Stranger things could happen.*

"Hi, I'm Holly," I said, sticking out my hands to meet his.

"What's that?" he asked, clearly having trouble hearing over the crowd.

"I'm Holly," I repeated, a little louder.

"Oh, hi. Nice to meet you, darling," Hef said before turning his attention to the next person. There were no fireworks, no "Rhapsody in Blue," and there certainly wasn't any audition.

Oh well, I thought, *I gave it a shot.*

CHAPTER 2

In another moment down went Alice after it, never once
considering how in the world she was to get out again.
—Lewis Carroll, *Alice's Adventures in Wonderland*

A year after my first Playboy Mansion invite, I had become some-thing of a fixture at the infamous Sunday "Fun in the Sun" pool parties. After that fateful Midsummer Night's Dream party, Heather and I started getting invited back to the mansion regularly. What wasn't to love? Bikinis, drinks, food, music, and friends. And without fail, the sun was always shining on Hef's little corner of heaven. He wouldn't have had it any other way.

Without the massive tents and fake grass that the staff sprawled out for the Midsummer Night's Dream soirees, you could really appreciate the true beauty of the property: lush landscaping, rolling green hills, and exotic birds that roamed freely throughout the grounds. It was unlike anything I had ever seen before—it was truly an oasis in the middle of Los Angeles and a life so unlike my own that I almost envied the women that were able to call this magical place home.

Of those women, the glamorous Bentley twins had already exited the

mansion by this time, leaving an opening for a new crop of blondes to emerge—most of whom also wound up being published in the magazine as Playmates in rapid succession. In the *Playboy* culture, it's considered an honor to be chosen as the magazine's Playmate of the Month (the large pictorial includes a poster folded in the center of the issue, hence the name "centerfold"). An even bigger honor was to be chosen as the magazine's Playmate of the Year. Every June, a winning Playmate is selected from the previous year's 12 candidates and is awarded $100,000, a new car, a new pictorial, and a cover. Most girls who rotated through the *Playboy* revolving door prayed that they might eventually be chosen as a Playmate so that their names would be in contention when it came time to choose the Playmate of the Year.

Hef's new girlfriends weren't all necessarily Playmates, but they definitely all *aspired* to be. In fact, to an outsider, it could easily be misconstrued that the only way a blonde was eligible to be featured in the magazine was to date its editor-in-chief. Month after month, they appeared: Brande Roderick, Buffy Tyler, Katie Lohmann, Kimberly Stanfield . . . Tina Jordan and three of Hef's other girlfriends were in the process of shooting soon-to-be-published Playmate pictorials as well.

Hundreds of women were invited to each mansion party, so of course not all of them could be Playmates. Some of the Playmate hopefuls unable to land one of those 12 coveted spots modeled for less prestigious "minor pictorials" in *Playboy* or for pictorials on Playboy.com.

The guest list for the Sunday pool parties was much more selective, so I have to admit, I was flattered to have been included. Only 20 or so girls were invited to these more intimate events splashing the day away. Yet it was rare to see any of Hef's then seven girlfriends at the pool party for any length of time. I remember it striking me as odd that they chose to hole away in their mansion bedrooms, but I didn't give it much thought beyond that. (I would later realize that they considered it dues they no longer needed to pay.) As for Hef, he would tuck away in a corner of the pool and play backgammon with two friends—usually the only other

males allowed to be in attendance. Occasionally they would stride over and join the girls in a drink or a game, but they mostly kept to themselves and always focused their attention on Hef. After all, they wanted a repeat invite and Hef, without actually saying a word, made it clear that the girls were solely for his amusement. The staffers—who strictly refused all tips—were readily available to wait on us hand and foot, the mansion gym was available to any of the girls who wanted to work out during the party (perhaps a red flag to the expectations placed on the women of *Playboy*), and a masseuse was on call in the bathhouse for guests looking to further unwind.

One afternoon I was freshening up in the bathhouse and talking with a girlfriend when a buxom woman named Nicole bounded in and introduced herself. She was very sweet, but I could barely stop gaping long enough to get a word out. This woman had the *largest* breasts I'd ever seen, so large that it looked like the implants were struggling to escape from under her skin. The masseuse had to go rustle up an extra stack of towels just so Nicole could lie on her stomach for the treatment. (Years later, I was flipping through an issue of *Playboy* and recognized the busty blonde from the bathhouse—only this time her name was Coco and she was married to the rapper Ice-T. It's been her booty that has earned her the most attention, but strangely enough I didn't notice her butt as unusually large back then. Probably because I couldn't take my eyes off of those boobs!)

When the light would eventually dip below the hills in yet another picture perfect sunset, the service staff would busy themselves with preparations for the evening's dinner and movie screening. The pool party guests would excuse themselves to freshen up as the festivities moved inside. Eventually, some of the girlfriends would trickle down from upstairs and idly take their obligatory seat next to Hef at the dining table for the pre-movie buffet. I could never understand their lack of enthusiasm; they seemed to have it all. Initially, I assumed they were spoiled, jaded, or just not a good fit in Hef's world—maybe they hated the social scene or hated

watching old movies every week. Since those were things I happened to love, I couldn't understand it.

Because I was an L.A. transplant, the concept of "being fake" was still a bit lost on me. Don't get me wrong; I was familiar with fake tans, fake nails, and of course fake boobs, having already undergone my breast enhancement surgery. But I didn't have any idea how insincere and calculated people could be. It never dawned on me that the girls I was about to be spending a lot of time with had ulterior motives beyond simply being friendly, and that all of their encouragement was just for show. As I'd come to learn, they saw me as a useful pawn in their twisted game of *Playboy* chess.

In those early days, Vicky and Lisa (two of Hef's live-in girlfriends) were incredibly welcoming—the other girlfriends weren't particularly mean, but they didn't exactly roll out the red carpet, either. I knew that the role of girlfriend was coveted by many and fleeting for some, so I expected the women to be defensive, protective, and, quite frankly, bitchy—especially this crop of girls who looked more like garden variety strippers than dazzling *Playboy* bunnies. I was surprised with how wrong I *thought* I was. They were accepting and encouraging—some more than others—and Vicky, one of the more seasoned girlfriends, even offered to take me under her wing as I navigated this new, foreign world. It really didn't occur to me that they had their own agenda, which I would soon learn.

The girls would rattle on about how glamorous it was being a "girlfriend" and how every girl that moved into the mansion would eventually become a Playmate; they all had a weekly allowance to buy club clothes and get their hair and nails done; and the afternoons free to spend however they like. As a girlfriend, you just needed to be available on the nights when Hef hosted events at the mansion, went clubbing in Hollywood, attended red carpet parties, etc.

This may sound naïve, but I didn't immediately realize that they were actually *required* to sleep with Hef. Back then, none of the girlfriends

talked about it. When I inquired about the more intimate duties, Vicky fiercely denied that anything sexual went on with Hef.

"It's all for show," Vicky said, explaining that the whole thing was basically a Hef-orchestrated publicity stunt.

The girlfriends were simply dazzling arm candy to help keep up his *Playboy* image. It sounded more like a job than an actual relationship—and they sold it to me so matter-of-factly I was able to overlook what this "job" really sounded like. Hef's former girlfriend Katie Lohmann had recently left, and Vicky told me that when she went on Howard Stern after scoring her centerfold and cheerfully denied that any of the girls slept with Hef with a dismissive laugh, she was promptly kicked out of the mansion. (Years later I found a taped copy of the interview in Hef's press collection with a skull drawn on the label. He must have really hated that one!)

I would be lying if I said I still didn't have dreams of one day scoring a pictorial in *Playboy*'s iconic pages, and mansion parties were a fun way to spend the weekend, but my main focus was either pursuing an acting career or going back to school. I didn't have time to be Hugh Hefner's on-call trophy girlfriend seven days a week, nor did I really think I had what it took. When I first started coming around, Hef was dating the Bentley twins—those two sophisticated glamazons that seemed to pay homage to the glory days of *Playboy*. With the right hair and makeup, I considered myself a pretty girl, but Mandy and Sandy looked like movie stars. After they departed the mansion, the "Sloppy Seven" invaded and lowered the bar.

It's almost unsettling how quickly your priorities can shift.

Over the past year, I had been working long hours to afford my rent and I'd been auditioning like crazy. Luckily, I had no trouble getting an agent—and even managed to land a few bit parts here and there. They didn't pay much, but it was enough to encourage me to continue pursuing my dream. My two closest friends hadn't been as fortunate. Heather had

given up and decided she was moving back to Pittsburgh. My roommate Nora hadn't landed a single thing, either. The lease on our apartment was ending and she told me that her parents had agreed to pay her rent on a new lease—but only if she had her brother (an alcoholic who needed constant babysitting) move in. Just like that, I had to go.

It was like that scene in *Bridesmaids* where Kristen Wiig gets booted from her apartment by Rebel Wilson and her on-screen brother—only not funny. Nora knew I had no credit and was broke as a joke; I couldn't believe she was doing this to me. But as hopeless as the situation seemed, I refused to go back to Oregon. Not only did I not want to burden my parents, I also knew that leaving now would set back any progress I had made in becoming an actress. The desire to perform is what drove me to Los Angeles, and the thought of returning home miserable and still dreaming of Hollywood killed me.

I started to wonder, *Couldn't Playboy help me reach that goal?* I'd seen it before: *Baywatch Hawaii* executive producer Michael Berk was a mansion regular and Hef's former girlfriend Brande Roderick landed a leading role on the show shortly after appearing as a centerfold. The more time I spent at that enchanting Holmby Hills compound, the more I started seeing opportunities like these. It's very easy to get transfixed by the magic of this curious world where even the impossible seemed possible—where a small-town girl could rub elbows with movie stars and be made to feel like a fantasy. I had spent so much of my youth searching for that kind of opportunity and it seemed *Playboy* could hand it to me on a silver bunny emblazoned platter. One weekend while waiting outside of the mansion's front door for the valet to pull up my beat-up old car at the end of a "Sunday Funday," I looked up at the glowing second-story windows and wondered what it would feel like to call that place home. It looked so cozy and safe.

Vicky had once given me a peek inside her room—and I was surprised at how much it looked like the type of room I would have liked to have. The plush bed was covered in pink candy-striped satin sheets

and piled high with Playboy-branded clothing—free gifts for Hef's girl-friends. Disney paraphernalia was everywhere from a recent shopping spree at Disneyland—all on Hef's tab, of course. And a dreamy window-seat overlooked the backyard.

We even ordered cheeseburgers from the kitchen, which may not sound like much, but it was. Once upon a time, Hef's guests could order whatever they wanted from the kitchen, whenever they wanted. It was even said that Jack Nicholson used to treat the mansion as a drive-thru back in the '70s. He would call the butler's pantry ahead of time, order a meal, and have it brought out to his car as he drove up the driveway. After the food was delivered to him in a paper sack, he would supposedly speed out the back gate without so much as a hello. Since then, guests' access to the kitchen became a little more limited, but Hef's girlfriends could still order whatever they wanted, 24 hours a day. To me, someone used to scraping together pennies in order to eat at Burger King, this was on another level!

I had to admit: the whole girlfriend thing was starting to look pretty appealing.

Around that time, a few of the girls had suggested that I come out with them for one of the biweekly club nights. One of the girlfriends, Kimberly, had recently been kicked out, which meant there was an open spot Hef was ready to fill. "Talk to Hef," Vicky encouraged after I confided in her about my housing problems. Never did it occur to me to simply approach him myself. It also never occurred to me that the then-seven girlfriends wanted me around only because my "ordinary" appearance was nonthreatening. They wanted to make sure whoever filled the empty space wasn't competition.

On Sunday, I worked up the nerve to mention the idea to Hef when he finally appeared poolside. "I'd love to come along with you the next time you all go out," I said, bracing myself for a less than exuberant response. Much to my surprise, he immediately took to the idea and invited me to join them that coming Wednesday.

"Awesome," I cheered, with a little hop. "Thank you!" Hef seemed amused by my childlike excitement, but quickly turned back to his friends.

When I found Vicky to share the good news, she filled me in on all of the details: I was to meet Hef and the girls at 10 P.M. in the mansion's main entry hall dressed to impress in my sexiest club wear before heading to Las Palmas—Hollywood's hottest nightclub.

Every girl at some point has uttered the phrase, "I have nothing to wear." But in my case, it was sort of true. I spent the next three days staring at the approximately 10 items of clothing hanging in my closet wishing that something appropriate would magically appear. I figured that if Hef approved of how I looked, maybe he would consider offering me a role as a "girlfriend." It felt like a long shot, but there was always a chance. And my alternate options were becoming more and more grim. I would *not* be going back to Oregon. I just couldn't! Still, I was too embarrassed to ask any of my friends to borrow anything—probably because doing so meant I would have to field questions I wasn't prepared to answer.

Eventually, I decided to pair a black miniskirt (which, despite its name, was about three inches longer than anything any of the girlfriends wore) and a baby blue top with metal mesh overlay that tied in the back. After analyzing my every angle in the bathroom mirror, I took a deep breath, jumped in my car, and made the 10-minute drive to Hugh Hefner's place. I pulled into the driveway at 9:55 P.M. petrified that I would be the last to arrive—I've always been a stickler for punctuality. I quickly discovered that was a rarity at the mansion. I waited in the entrance hall for more than 10 minutes before any of the ladies made their way down the cascading old English staircase. There was another girl waiting downstairs named Candice who appeared to be "auditioning" for the open girlfriend spot as well. She was quick to tell me that she had already been out with the group the previous Friday and also how fond Hef was of her.

Oh shit, I thought, *maybe I was a day late and a dollar short. Candice might get offered the empty girlfriend spot before me.*

In passing, the mansion looks decadent, but when taking the time to

truly look at some of the nooks and crannies, it's amazing how neglected it was. I would come to refer to the décor as "'70s porn chic." At the time, there were nine dogs living in the mansion (most of them named after fashion designers or luxury car brands, naturally), and the ancient yellow carpeting on the grand staircase was covered in urine stains. I remember thinking that the carpet must have been older than any of his girlfriends. That being said, at the time, it was by far the nicest home I'd ever stepped inside.

Finally, the girlfriends emerged in ascending order: newest to the oldest. At that particular time, the cast of characters was a motley crew of bottle blondes: a quiet girl named Carolyn, upcoming Playmates April, Adrianna, and Lisa; Vicky; and Tina Jordan (Hef's "main girlfriend"). The scene was almost comical as each girl bounced down the *Gone With the Wind*–esque staircase like a carbon copy of the girl before her: white-ish blond hair in large barrel curls, the skimpiest sparkly dress imagin-able, and the kind of strappy platform heels you'd expect to see on stage at a strip club. I would have thought Hugh Hefner preferred his girlfriends sexy and retro, but his taste was surprisingly . . . well, cheap. As for Tina and Hef, they would never arrive until everyone was already in place— like some antiquated nod to the hierarchy that existed.

One of the butlers arranged us in the hall and snapped a few pic-tures for Hef's scrapbook before we piled into the limousine—another *Playboy* tradition to satisfy Hef's endless desire for mementos (the next morning prints would be placed outside each girl's bedroom door, which only amplified the massive pressure to always look perfect and caused the girlfriends to spend hours critiquing their appearances).

When we finally arrived in Hollywood, the scene outside of the night-club was absolute chaos. Hundreds of men in Von Dutch trucker hats and women in their obligatory low-rise Frankie B. jeans and fedoras (because in 2001 every club girl was just *dying* to be mistaken for Britney Spears) were bombarding the entryway, clamoring over one another to get the attention of the resident doormen stationed behind the red velvet rope.

From the looks of it, you would have thought Oprah was inside giving away free cars. As the limo door opened, four security guards rushed to part the sea of club-goers so we could make our way inside. I had been to nightclubs before, but I was usually one of those unlucky souls not "on the list" and relegated to the milelong line that wrapped around the block. I was one of the first to step out of the limo and every set of eyes turned to check if I was someone worth knowing. I started fussing with my top, unnerved by this unexpected attention. One by one, each bottle blonde piled out of the limousine—waiting for Hef before we made our way inside. Vicky must have noticed the astonishment in my eyes because she leaned over and whispered, "'NSYNC *and* Christina Aguilera were here the last time we came."

When Hef finally emerged from the car, the crowd went wild. People were shouting his name and shoving one another to get a better look. He lifted a hand to wave to the crowd as if he were some kind of dignitary. The whole thing seemed incredibly strange to me, but for Hef it had become a regular part of his weekly routine on the L.A. club scene. For decades, Hef was an infamous homebody. After all, he created his own version of paradise at the Playboy Mansion, so why would he ever want to leave? Throughout the '70s, '80s, and '90s, it was extremely rare to see him out and about. In 1999, when he separated from his wife of almost 10 years, Kimberley Conrad, a few of his friends persuaded him to leave his compound for a night on the town. What happened next was a surprise to everyone. People went absolutely crazy to see this 70-something icon from another era at an L.A. nightclub. Shortly thereafter Hef instituted his biweekly club nights. *Rolling Stone* magazine called it "Hugh Hefner's Resurrection." (I would later learn that this sort of behavior wasn't atypical. The only thing Hef loved more than the mansion was himself. The sort of super fandom he saw at these nightclubs was all the fuel this senior citizen needed to keep painting the town red.)

It was during one such evening, after his separation, that Hef met Sandy and Mandy Bentley. Immediately he began dating these two blond

bombshells, along with another blonde, Brande Roderick. This unusual foursome made Hef even more of a sensation. The age difference, the number of girlfriends, the hint of incest, the fact that all three of the girls' names rhymed, along with Hef's constant public insistence that he had to take Viagra to keep up with all of these women made the situation truly bizarre. In Los Angeles the bizarre is often appreciated, if only momentarily, and at that moment in time Hef and his blond entourage had become adored mascots of the L.A. nightclub world.

As soon as we entered past the velvet ropes we were whisked away to a private area next to the dance floor. Hef settled into the plush booth flanked by Tina and Lisa. Our VIP table was already stocked with an array of alcohol and mixers—this was the golden age of bottle service and Hef indulged in every luxury. Security lined the velvet ropes separating our table from the rest of the crowd. If a guy was brazen enough to try to get the attention of one of the girlfriends, security would block them from our table—and occasionally escort them outside, depending on how persistent he was. Since most nights the girls were locked up in the mansion like some twisted version of Rapunzel, they used these evenings out as opportunities to meet other men.

Yes, most of Hugh Hefner's girlfriends had other boyfriends. In fact, during my time at the mansion, I can only say for sure that two of us remained faithful (my future BFF Bridget Marquardt and myself). Needless to say, this was all very hush-hush, because Hef strictly forbade any of his girlfriends from dating other people. While Hef could date an entire sorority house full of girls, we were to remain totally loyal. Looking back, I'm pretty sure that rule existed not so much because Hef was jealous of other men, but because the truth would have burst the public persona he had spent decades crafting. Girls who were caught "cheating" on Hef would be thrown out of the house immediately. While the girls took that rule extremely seriously, it didn't mean they would actually obey it. So, on these club nights, the girls would dip off "to the ladies' room" and head to a corner of the bar hidden from Hef's view, making "friends"

and exchanging numbers with men . . . like normal 20-something girls *should* be doing.

I stayed close to Vicky most of that night and followed her lead: dancing, drinking, and making sure to pay lots of attention to Hef. At one point when he stood up to dance with us, his rhythm was so off that I was certain he was joking and let out a big laugh. Vicky shot me a look that made it very clear: he was *not* joking. Luckily, he didn't register my laugh as mocking and continued dancing.

Oh my god, I thought, genuinely mortified for him. Had no one told him how silly he looked? He pulled out some truly ancient dance moves that I can't imagine were remotely cool in any era other than the '70s. I felt a bit sorry for him dancing around like the punch line to a bad joke. *Did they always allow him to look so foolish?* I wondered why these women, his seven dingbats, didn't care enough to protect him from the embarrassment—surely they owed him at least that. And worse yet, they encouraged his awkward dancing about. Back then, he seemed like such a sweet man to me and this felt unnecessarily cruel. Regardless, I knew it wasn't my place to break the news to him—not that night anyway. I was so eager to make a good impression that I could hear my heart in my ears. I was grateful that Hef allowed me to tag along in the first place. He seemed like a good man and talked as if he wanted the world for his girls.

But like all that glitters and sparkles, this opportunity wouldn't come without a steep price.

"Would you like a Quaalude?" Hef asked, leaning towards me with a bunch of large horse pills in his hands, held together by a crumpled tissue.

"No thanks," I answered cheerfully, as if I were interviewing for a job. "I don't do drugs."

"Okay, that's good," he said nonchalantly. "Usually I don't approve of drugs, but you know, in the '70s they used to call these pills 'thigh openers.'"

I laughed nervously—unsure of what to say. I was proud of myself for saying no; it was the right decision. I still felt in control of the situation and was prepared to tackle whatever came my way with sober eyes.

Today, I want to scream "PAUSE!" and freeze frame that moment of my life back in late August 2001. I want to grab that young girl, shake her back into reality, and scream, "What the hell are you thinking?"

Hef was a notoriously lecherous 70-something old man offering me Quaaludes that he referred to as "thigh openers." Are you kidding me? Why didn't I run for the nearest exit? It doesn't get much creepier than that.

But I suppose I had already made up my mind at that point. Looking back, I can't imagine what I *was* thinking, but I'm also so far removed from what I was feeling back then. I was about to be homeless. I had no place to go and was panicking over what to do next when this opportunity with Hef just sort of fell into my lap. If I became a girlfriend, I would have somewhere to live. If I became part of *Playboy*'s inner circle, perhaps that could even help my career. It felt as if my stars were starting to align. I decided to take the chance and see what this strange, legendary world was all about. For as long as I could remember, I had been searching for a great adventure, and this was already the craziest night I'd ever experienced. Like watching a bizarre old movie, I was utterly transfixed by this strange universe.

Despite my initial intention to keep a clear head, I foolishly proceeded to get really, really drunk without even meaning to. I can't even begin to tell you how much vodka and champagne I consumed—aided by the helpful hands of the other girls, who were all too eager to continue plying me with drinks. While I patted myself on the back for turning down the pills, by the time we left the club, I couldn't have been any more incoherent.

On the limo ride back to the mansion, Candice leaned over and whispered to me that all of the girls, myself included, were expected to join Hef in his bedroom. She had a small smile on her face as she watched me

absorb this news, which I immediately registered as odd . . . almost as if she relished my shock. For the better part of the year, the girlfriends went out of their way to convince me that no one was actually intimate with Hef. Was Candice just trying to scare me off?

I wasn't an idiot. Despite their staunch denials, it was still a widely accepted public theory that Hef slept with all of his girlfriends. But when I asked them about it directly, they were incredibly convincing, acting almost *appalled* by the idea. This important factor was the touchstone of their entire sales pitch, and the fact that sex would actually be required wasn't exactly something I had prepared myself for—*especially* for my first night out. But at that point, I felt like it was my only option.

Maybe it wasn't that torturous, I thought. *Why else would all these pretty young girls be jumping through hoops to be girlfriends? I could just see what it's all about. If it's that bad, I'll leave.*

What happened next is all sort of a haze. With roughly a third of a bottle of vodka sloshing around my stomach, I stumbled up the mansion's grand staircase and was ushered by the girls towards Hugh Hefner's bedroom suite. Tina brought me into the back door of the bedroom, which led into the large black and yellow bathroom. All the girlfriends—in various stages of undress—conglomerated around the large black marble bathtub with their feet dangling in the pool of hot water. I followed Tina's lead, took off my shoes, and dipped my feet in. I have to say, after a full night of dancing (in very high heels!), the hot water felt amazing.

Before I even had a chance to register much of what was going on, the girls quickly got up and hightailed it into the dark, cavernous room beyond. (They all hated the bedroom routine and tried to get it over with as quickly as possible.) Tina handed me a pink flannel pajama set to wear, which matched the ones all the other girls were grabbing out of Hef's massive closet area. (Yes, Hef's harem wore flannel pj's. How's that for a fantasy?)

As Tina led me into the bedroom, I stumbled over and weaved through massive piles of junk covering the floor. It appeared that Hef

liked to collect more than just women. Ceiling-high piles of videotapes, stuffed animals, art, and gifts littered the room. It was like an episode of *Hoarders*. But perhaps in his case it would be more appropriately titled *Whore-ders*.

Two huge television screens projecting graphic porn lit up the otherwise dark bedroom. In the middle, a very pale man was tending to his own business (if you're catching my thinly veiled innuendo) and puffing on a joint before passing it around to the nearest blonde. The girlfriends, in various stages of undress, were sitting in a semicircle at the edge of the bed—some kneeling, some standing, and some lying down.

I sat myself on the edge of the bed—unsure of what to do next. I leaned into Vicky—after all, she was the one I was most comfortable with.

Maybe if I hide behind her, I thought, *I'll go unnoticed for the night.*

"Fake the fuck!" she hissed in my ear and pulled me towards her. "I'll explain later!"

She didn't have to explain. My eyes had adjusted to the darkness and I could see that all the girls, backlit by the large screens, were putting on a show: they were going through the motions as if they were getting it on or making out with each other, but no one really was. It was just a big façade. No one was actually in the mood (besides Hef, I assumed) or turned on in the slightest. Like the porn itself, it was all just for show. There was loud music blaring, but if you got close enough to any of the girls, you could hear them gossiping with one another or making fun of what was going on in front of them. If smartphones had been around then, I'm pretty sure they would have been texting or checking their Instagram when Hef wasn't looking.

When I think about it now, it's almost comical. Every red-blooded American male has no doubt fantasized about what went on in Hugh Hefner's bedroom with his harem of blond bombshells. The answer? Not a whole lot.

Looking back, I don't know if Hef believed the charade. Truthfully,

I don't think he cared one way or the other. Whether it was real or fake, he would be satisfied in knowing that the only reason it was happening at all was for his own personal pleasure.

The girlfriends, and Vicky, it seemed to me in particular, were desperate to bring as many new girls up into the bedroom as possible. With more "fresh meat" available for Hef, it was less likely that they'd be called on to have sex with their "boyfriend" as often. Hef could keep up with only so many girls in a night, so, as I saw it, Vicky had quickly figured out that recruiting new girls effectively achieved two goals at once: not only would she most likely avoid having to have sex with Hef, but she'd also earn his favor by bringing around pretty new young things for his enjoyment. Of course at the time, I knew none of this. Despite the bimbo label often placed on Hef's harem, some of these girls were quite savvy. Girlfriend politics was serious business: ruthless, calculated, and complex. On that particular night, Candice and I were the newest victims—and it definitely felt to me that our new "friend" pushed us into the action.

"Heeeef . . . don't you want to be with the new girl?" Vicky screamed over the loud music as she reached over and pushed him towards me.

Much to my surprise, my turn was over just as quickly as it started. By the time I was able to wrap my head around what was happening, Hef had already moved on to Candice, then to a few of his actual girlfriends before finishing off by himself, as he always did. I have never had a more disconnected experience. There was zero intimacy involved. No kissing, nothing. It was so brief that I can't even recall what it felt like beyond having a heavy body on top of mine.

Even though it was just a few short minutes of my life, I had never taken intimate experiences lightly, so it weighed heavily on me. I was disappointed in myself that it had come to this. Even in my drunken haze, I knew that it was a big decision I would have to live with.

Some of the girls leaned over and quickly pecked Hef on the cheek—in the same unattached manner that most would probably kiss their grandfather. The girls began filing out of the room, offering Hef a few

candy-coated "good nights." Quickly, I pulled on my pajamas and followed Vicky down the hall and into her bedroom. I was so wasted that I forgot to grab my club clothes and purse—which were strewn about somewhere on the floor of the master suite. Vicky ordered cheeseburgers and fries to the room as if it were any other night, but I passed out before the food even arrived.

Over the years, I would see so many girls come and go through that cavernous master bedroom. I never encouraged anyone to come up there and was often downright cold to some of the girls Hef would invite out with us. It wasn't because I felt threatened or even due to my own embarrassment, but mostly because I didn't want to do to those girls what Vicky had done to me. I had hoped my hard exterior would dissuade them from making my same mistakes. Vicky had tried to act all buddy-buddy, like we were just friends having fun together, like she wanted me to be a part of her club, but I had been used: plain and simple. Unfortunately, it took me a while to realize that. At the time, I wanted to believe that Vicky actually liked me, and only pushed Hef towards me because she wanted me to become a girlfriend. Like I said in the beginning, I was naïve.

THE FOLLOWING MORNING, I woke up feeling terrible—and it wasn't just the hangover. Vicky escorted me back to the master bedroom to help me look for my clothes and purse. And just as if it were any other morning, she gave me a friendly hug good-bye.

But I couldn't just leave. I *had* to find Hef.

After asking one of the butlers where he might be, I finally found him in the library busying himself with notes for that Friday night's mansion movie screening (before each movie he always prepared a sort of speech).

"Hef, can I bother you for a second?" I squeaked, my voice breaking midsentence (I would quickly adopt this as my "go-to" pitch when speaking with Hef—the higher octave made it easier for him to hear out of his one good ear). Without even looking up from the pages, he gestured

with one hand that I enter his lair. In light of the evening prior, I was even more nervous in his presence than usual. Hef was so used to girls coming in to ask for favors, though, that he didn't seem at all surprised by my impromptu interruption. I had gone from hoping to move into the mansion to downright determined. There was no way I was not going to get what I wanted after having to sleep with him the night before (or, rather, earlier that morning).

In the years that would follow, I noticed that after being intimate with Hef, the new girls fell into one of three categories: the hustler, the runner, or the fighter.

Most of the girls that ended up becoming girlfriends reacted the same way: they were very nonchalant about their "initiation." Before the sun even rose the following morning, these hustlers were already calculating just how many pennies they could squeeze out of the arrangement.

Next, we had the runners. While the hustlers were scheming, the runners were fleeing. Like a hit-and-run, these girls would bolt from the scene, never to be heard from again. While most—if not all—had hoped to land a pictorial, they disappeared off the face of the planet, never re- turning for another night out or party, despite being invited back. The "runners" always seemed like inexperienced girls, so I assumed they didn't come back because they didn't like what they had seen or done in Hef's bedroom while under the influence of alcohol, Quaaludes, or both.

My reaction fell into the third category: the fighters. I was freaked out and, frankly, ashamed by the experience. After disappointing myself like that, I had to come away with something positive, something to make it right in my mind, somehow. I knew that if I couldn't find a silver lining, I couldn't forgive myself for the night before. The other girls who would react as I did were probably the most damaged and affected—we couldn't so easily shrug off what we had been reduced to. It would haunt us, but in order to move forward we needed to find an upside.

For me, asking to move in therefore seemed like the next rational step—or so I convinced myself—and I decided to bite the bullet. After

all, it hadn't occurred to me to invite myself out to a club night until prompted—and I had met a very welcoming response—so I figured I might have the same luck with moving in. I was a young blond girl with a small waist and large boobs, but I wasn't quite as polished as the girls that usually decorated *Playboy*'s pages—and hallways. Still, for the most part, I fit the bill of "girlfriend."

I can do this, I thought.

It might be hard to understand, but in that moment, I didn't blame Hef for anything creepy that had gone on the night before. He had the "nice guy" act down pat and it worked. At the time, Hef still had a certain swagger. There was a gentlemanly air about him that belied his reputation. And there was never a shortage of Hef's friends lingering around the mansion who were all too eager to remind every pretty young thing that stepped through the doorway what an amazing, kind man Hugh Hefner is. It was easy to fall under the spell. If anything, it was the other girls I felt used by, and I couldn't let them win.

"Can I ask you something?" I let out another squeak. He looked up at me for the first time and I flat-out told him that I had no place to live. "What do you think about me moving in?"

He took a brief moment to consider what I had just asked before finally saying, "You can stay for a while and we'll see how it works out."

CHAPTER 3

"It's really dreadful," she muttered to herself, "the way all the creatures argue. It's enough to drive one crazy!"
—Lewis Carroll, *Alice's Adventures in Wonderland*

It only took me one trip in my beat-up red Toyota Celica to move my entire life from a tiny Westwood apartment into a Holmby Hills estate. No one offered to move me in, but I didn't really need the help. I didn't have much to bring besides the few outfits I owned, some makeup, my college books, and a handful of childish knickknacks, like Disney Princess picture frames and Star Wars figurines. I don't even think I owned a curling iron at the time. I left my single twin mattress next to a Dumpster.

As I pulled up the iconic driveway on Charing Cross Road, it couldn't have felt less like "home." The gates opened for me, and just like that, I was the newest resident of the Playboy Mansion. I pulled my car through the driveway and gave the keys to one of the staffers, who then made a call to one of Hef's secretaries. She directed me to my room and presented me with my room key.

Less than an hour later I had moved my belongings into the bedroom that Hef's secretary designated for me, and that was that. None of the

girls even poked their heads out of their bedrooms, let alone offered to help. I was pointed to my room and left alone. *Now what?* I thought. It was entirely bizarre.

I didn't tell many people about my decision to move into the mansion—I quickly learned that not everyone had the most positive reaction. I had naïvely thought of myself as an adult who was free to make her own decisions, out of high school, away from small-town Oregon, and far from the type of people who would judge me for my personal decisions. I was so wrong.

When I told Nora I was moving into the Playboy Mansion, her jaw dropped so quickly I thought it would hit the ground. Nora was hyper-materialistic and wasn't expecting me to go from "rags to riches" faster than her. In my excitement, I also told the first acquaintance I had run into while doing errands. His reaction wasn't what I had expected, either.

"You hooked up with an old dude?" he cried, his face scrunching up. "Gross!"

All I had said was that I was moving in—nothing about being intimate with anyone. I guess not everyone was as naïve as I had been. Seeing the angry look that appeared on my face, he quickly switched gears.

"So," he said, his voice much friendlier, "can you get me on the list for the parties?"

This guy clearly had no shame. Needless to say, I told him no.

After my friends' less-than-supportive reaction, I was too terrified to tell anyone else. I was naïve enough to believe that the decisions I made in the relative privacy of that dark cave of a bedroom would remain just that: private. I was by no means prepared for the large scarlet letter that had been branded on my chest.

I knew my close friends and family wouldn't approve, but I had already made the decision. Listening to their words of warning and disappointment would only make me feel worse. To be totally honest, I was

already ashamed enough and I wanted to delay any further conversations until I had a better understating of what my life would be like.

Any remaining doubts about my decision vanished when, on an early morning about a week after I had moved in, Vicky stormed into my room screaming: "We've been bombed! We've been bombed!"

It was September 11, 2001.

"New York and the Pentagon," she shrieked. "We've been bombed!"

I hobbled into the bathroom feeling sick to my stomach and paralyzed with fear. I imagined that terrorists had bombs aimed at every major city in America. Were we next? In that instant, I couldn't have been more grateful to be inside this great big, safe house.

Of course I soon discovered that we hadn't actually been bombed: but the reality was no less scary. Terrorists hijacked four American airliners and crashed two of them into the World Trade Center towers in lower Manhattan (as well as one into the Pentagon in Washington, D.C., and one in rural Pennsylvania).

Thank God I'm here, I thought. I would have been so much more scared had I been out on my own, couch surfing or worse.

The first few nights I slept in Bedroom 3—one of the biggest guest rooms in the mansion with three beds and a private bathroom, but like all the other guest rooms in the house, relatively plain. Strangely, it also doubled as a bedroom for Hef's two sons Marston and Cooper (who were 9 and 10, respectively, at the time) if they ever were to spend the night in the mansion. Though they never stayed over while I was there, there were still toys scattered across the bedroom floor—which made for an incredibly odd and, frankly, creepy juxtaposition.

April was also residing in Bedroom 3, and she intimidated the hell out of me. She was taller and bigger boned than Hef's usual type and had an in-your-face personality. I had heard she used to be a stripper even though *Playboy* has a somewhat hypocritical "no stripper" policy when it comes to Hef's idea of the wholesome Playmate image. She also had

a constant need to be the center of attention—and would do whatever she needed to keep the spotlight on her, no matter how raunchy. She also made zero effort to hide the fact that she felt I was intruding on her space.

That week, another girlfriend, Adrianna, announced her departure. It was assumed that April would move into her old room (Bedroom 5) and I would be staying in the shared room. April was new to the mansion herself, but since she had moved in several months before me, still had seniority when it came to rooms. Bedroom 5 was one of the smallest rooms, but it was private. And as I would quickly learn, privacy was *key* when it came to surviving the mansion mayhem.

April, however, had another idea. She asked Hef if she could have Bedroom 3 to herself. The mansion was not without its fair share of politics, and when it came to the girlfriends, you had to put in your time and work your way up the totem pole when it came to certain privileges, particularly rooms. New girls who immediately began demanding certain luxuries were seen as "pushy" or "ungrateful." Bedroom 3 was meant to house three girls; April scoring it for herself would have been a major coup.

Surprisingly, Hef approved her request.

I moved out later that day—along with the toys. (For months to come April complained that Marston and Cooper were hostile towards her for taking over their room. I must say, I couldn't really blame them.)

April taking Bedroom 3 meant that I would be moving into Bedroom 5. I couldn't have been more thrilled to be getting the privacy of my own room in my very first week at the mansion. The arrangement wasn't without its downside, though. Bedroom 5 shared a bathroom with Vicky's room. Little did I know that she had a love of laxatives that made sharing a bathroom—with thin walls—pretty disturbing.

It was standard practice for girls to redecorate their rooms when accepting an offer to move in, but I was grateful simply to have a roof over my head. Even if I had wanted to redecorate, I would have been disappointed. Hef's idea of "redecorating" a girl's room meant replacing the carpet (which he always insisted on being white, despite all the dogs con-

stantly relieving themselves everywhere) and having the walls repainted. The girl could choose the color, as long as it was one of the chalky, matte pastel shades he favored.

All of the bedrooms contained mismatched, beat-up furniture. Bedroom 5 had an old wooden dresser tucked into one corner, a small TV mounted on the wall, and a bed so large that there wasn't much space left to move around the floor. Faded pink curtains covered the small windows that looked out onto four parking spots next to the outdoor kitchen. There was a tiny walk-in closet that housed the few clothing items I owned, plus a black Playboy-brand dress Adrianna had left behind. Clearly, I had a clothing complex and was terrified that I would quickly run out of club-appropriate attire, so finding this little black dress was a huge relief.

But that wasn't Adrianna's only parting gift. She had also worked as a Hawaiian Tropic girl and we had met on a few occasions before she had moved in. While we were by no means close, she made it a point to find me before she left to wish me well. When I asked her why she was choosing to leave, she said, "I don't really feel like it's the right thing for me anymore.

"I know you're just moving in, but this place can be kind of rough," Adrianna went on, offering me just a bit of warning. At the time, I wasn't quite sure what she meant, but I later learned that since she scored a centerfold almost immediately, the other girls were pretty hideous to her.

My first day in Bedroom 5 was quiet and uneventful. I remember it was a Thursday, which was the only night of the week there was nothing planned on Hef's agenda. When I asked Vicky if she wouldn't mind filling me in on the schedule, she acted as if it were some big annoyance. It's not like anyone handed you a pamphlet when you walked through the door and I was terrified that my "trial period" would come to an abrupt end, so I wanted to make sure I was playing by all the rules. I chalked it up to a bad mood, but she didn't seem that excited to have me as a neighbor.

After some coaxing, she finally offered me the rundown:

- Monday was "Manly Night." Hef would have his guy friends over for a buffet dinner and a movie in the mansion's screening room.
- Tuesday was "Family Night." Hef's wife and two sons, who lived next door in a house Hef had purchased for them, would come over to all spend time together.
- Wednesday and Friday were "Club Nights." We were all expected to be ready by 10 P.M. to be shuttled off with Hef to exclusive nightclubs all around Los Angeles.
- Thursday (like Monday and Tuesday) was an "Off Night." While we had the evenings free to do as we pleased, the girlfriends were still required to be inside mansion walls by 9 P.M.
- Saturday was a buffet dinner and movie with Hef.
- Sunday was the "Fun in the Sun" pool party during the day and dinner and a movie at night.

No one gave me a tour of the mansion when I arrived, either. I knew my way around the grounds and most of the main house, but for weeks I kept discovering new places on the property. There was an underground secret passage that led from the main house to the gym, which was in the basement level of the bathhouse. The mansion itself had a large basement, full of employee lockers, storage closets, and laundry facilities. A panel in the wall of the living room could pop out to reveal a secret wine cellar, which was used as a speakeasy in the 1920s when the house was built. The master bedroom had an attic level where Hef kept a personal office, of sorts. The adjacent bathroom truly looked like a time capsule or the land that time forgot. Gold shag rug covered the floor. A tray of toiletries from the 1970s sat untouched on the counter. The sink handles were carved to look like naked ladies.

There was a four-bedroom guesthouse on the grounds that hosted Playmates and Playmate candidates when they were brought in from out

of town to shoot at Playboy Studio West in Santa Monica. I assumed the Playmate guesthouse would be plush and clean, like a hotel, with perhaps some Playmate memorabilia strewn about to give it a sense of atmosphere. In reality, the guesthouse could have been described as "Grandma's attic meets rent-by-the-hour motel." In the '70s, Hef's girlfriend Barbi Benton had decorated the guesthouse as a charming early-American cottage, but over the years the theme fell apart. What was left was dark, dingy, and depressing.

There were many rules to living in the mansion, but most of them I had to figure out on my own. Like I said, no one handed me *The Playboy Mansion for Dummies* when I arrived. I also learned that the other girl-friends weren't so eager to help out the newbies, since it was in their best interest for us to stumble around in order to make all of them look better.

First, there was a curfew. For being an older man, Hef stayed up reasonably late (usually tucking in around 11 P.M.), but he required his girlfriends in by 9 P.M. Apparently, we couldn't get into too much mischief outside the walls before that hour. I had been present once when Vicky and Lisa had rolled in a half hour past curfew and got a major dressing-down from Hef (no pun intended). He kicked his feet, mustered up some questionable crocodile tears (*was he really crying?* I thought), and told them that if they wanted to "stay out late" they could move out. Needless to say, his temper tantrum made a lasting impression on me.

Next, the girlfriends were not allowed to "fraternize" with the staff unless *absolutely* necessary. This rule was not to be taken lightly. Hef would totally lose it if he caught one of us talking with anybody on the service team (and I eventually witnessed his irrational freak-out firsthand when future girlfriend Kendra Wilkinson spent too much time in the butler's pantry). According to mansion lore, there were two instances of girls having relations with mansion staffers. First, his ex-wife allegedly had an affair with one of the members of the security team—and Hef found out. Second, one of the girlfriends had supposedly been caught

sleeping with a butler. Now, I can't prove that either of these things happened, but it would explain why he was so overly sensitive about this particular rule. In the beginning, I'm sure the staffers thought I was terribly aloof and cold, but I was honestly just scared shitless. If I got kicked out, I had nowhere to go. I couldn't risk it.

Each girlfriend was given a weekly "clothing allowance" of $1,000 for expenses. It was expected that we use this money to purchase clothing to wear for evening events as well as beauty treatments (hair, nails, waxing, etc.) that weren't covered by his in-house account at José Eber Salon in Beverly Hills. This was a welcome relief for me. It was clear that Hef preferred we dress in a particular way when we were out on the town with him, and I was desperate to revamp my wardrobe and fast! Hef made it abundantly clear that he preferred us in very over-the-top, sort of trashy outfits (think BeDazzled rhinestone bustiers and skirts so short there was barely a point in wearing them). When he would compliment a girl on a particular dress, pair of shoes, or even the way she wore her hair, we all felt the need to replicate it for our next evening out.

The last major requirement was that girlfriends attend the events designated on Wednesdays, Fridays, Saturdays, and Sundays. While the girlfriends were always eager to party at the hottest Hollywood nightclubs on Wednesdays and Fridays, it was clear they used whatever excuse they could to get out of "dinner and a movie" nights. Oftentimes, it would just be April and me flanking Hef at the main dining table. We were still the two newest girls, so paying our dues was part of the program. The other girls stayed out until 9 P.M. on the nose, not wanting to miss even a single minute of freedom—which usually meant visiting the boyfriends that they kept on the side.

How these "side boyfriends" felt about their girlfriends dating Hugh Hefner, I don't know. I imagine the girls weren't forthcoming with these men and probably denied that they even had sex with Hef (they denied it to everyone). Most of them referred to "dating" Hef as a big publicity stunt to help them launch their careers. Maybe some of the guys got a

perverted little kick out of the fact that they were dating the same girl as Hugh Hefner. Who knows?

Contrary to popular belief, most nights at the mansion were pretty boring. We usually ended up in one of the bedrooms gossiping or watching TV. One night Lisa was hanging out in Vicky's room and the doors to our connecting bathrooms were open. When Tina came to visit, I went into Vicky's room to try and make an effort to be friendly with the girls. Tina was excitedly talking about her "boyfriend," and like the socially awkward person I was, I asked her, "Do you feel like he even takes you seriously when you live with Hef?"

My intention wasn't to be mean; I actually wanted these girls to like me! I was genuinely curious. When I shared the news that I'd be moving into the mansion, I hadn't met the warmest response, so I wondered how everyone else's friends, families, and even boyfriends felt about it.

Tina whipped her head in my direction and snapped a dismissive response at me. I grimaced and tried to apologize, but Tina wouldn't even look at me. She just rolled her eyes at Vicky.

As you could have predicted, Tina's boyfriend didn't stick around long. In fact, none of the "side boyfriends" ever stayed longer than a few months at most. I don't think the men took them seriously. I always assumed most men were just using the girls to check some Playboy Bunny fantasy off their bucket list. I only ever saw one "side boyfriend" stick around: Hank Baskett.

Following the rules wasn't difficult for me. I didn't know too many people in Los Angeles and I quickly cut out the small group of friends I did have—either because I didn't want to be subjected to their judgment or because they started to call asking for invites to the mansion and other favors I couldn't grant. Plus, I've always been a bit of a homebody and much preferred the delicious home-cooked meals the staff provided to dancing the night away at nightclubs (where I would usually get pretty drunk purely out of sheer boredom). Most of the girls would have rather died than sit around the dining table with men three times their age,

but I found Hef's friends funny and interesting, and genuinely enjoyed listening to all of their stories. Eventually, I would convince myself that this was yet another component of the common ground Hef and I shared as a couple.

Usually the movie nights included a steady rotation of Hef's favorite classic films and I adore old movies—something we were truly starting to bond over. Every Sunday night, Hef's office would arrange to have studios bring in movies that were still in theaters—and armed guards would enter the mansion with giant film cans to screen the newest Hollywood blockbuster for us. It was pretty cool, but it also was sort of bizarre, because oftentimes celebrities or other important Hollywood power players would join us for the screenings and be relegated to spending roughly two hours squirming in uncomfortable metal folding chairs. For being a super upscale home, it wasn't without its downscale touches. One of the most memorable was the tray of Johnson's Baby Oil, Vaseline, and Kleenex that was in every bathroom, in the grotto, and at the tennis courts and the pool bar. I still don't know whether to be disgusted or amused by those trays.

At first, my constant attendance at all of the events deemed "boring" by the other girls earned me a bit of good grace with them. They felt that I took some of the attention off their recurring absences while they busied about with their outside lives. Girls would find crafty ways to sneak out past curfew when they thought it wouldn't be noticed—like hiding in the trunk of someone's car as they drove off and onto the property!

While evenings at the mansion were pretty regimented, during the day we were virtually free to do as we pleased. Hef was usually awake by 10 A.M. for breakfast, then meandered down the hall to his office wing, where he would work on the magazine, various book projects, and other business. He wouldn't emerge again until the evening.

In the beginning, I spent most days with Britney—a nice girl that I had met at the Sunday pool parties. We'd go to the gym, tan, lay by

the pool, and cruise around L.A. searching for bargain clothes. The only other girl I remember spending time with was Lisa.

Besides me, Lisa was the youngest girlfriend in the group at that time. She lived in Bedroom 2, the largest of the bedrooms, and was still celebrating the release of the issue in which she was the centerfold. She was a cute country girl who, according to the other girls, dated Kid Rock on the side, though I never saw any evidence of it. She had first auditioned for *Playboy* over a year prior to her Playmate pictorial finally being published. Somewhere along the way, she met Hef, became a girlfriend, and secured a centerfold after acquiring a new set of Hef-financed breast implants to lift the mammaries that he'd deemed "too droopy" for a Playmate.

Like most of the other girlfriends, she was both manipulative and manipulated. Becoming a published centerfold didn't happen overnight. In fact, Playmate features were often shot 8 to 12 months before they actually hit newsstands. According to Vicky, Lisa had been a girlfriend for several months before losing patience.

"She threw a fit when we were out one night, asking when she was going to finally shoot her centerfold," Vicky once explained to me, rolling her eyes and exhaling cigarette smoke. "She's the baby, she always gets what she wants."

"This is like a boy band," my friend Britney added. "Hef has to have an old one, a young one, a wild one . . ."

This brought a cackle out of Vicky, who rolled her eyes.

"He always plays the oldest one against the youngest one," Vicky explained, eager to share her expertise on the topic as we gossiped about the situation. "Tina may be his main girlfriend, but she's older, so he likes to play on her insecurities by playing favorites with whoever the youngest one is. And Lisa isn't special. Before her, he used Buffy to play against Tina."

I took note of this, but at the time I didn't want to believe a man as old

and accomplished as Hef could be that petty and immature. Vicky was starting to show her nasty side, so I wrote it off as jealousy on her part.

Lisa was one of the friendlier girlfriends. In fact, when I walked by her room one morning, she called me in.

"Hey, wanna go to Target with me later? I need to run some errands."

"Yeah, sure, lemme know what time!" I said, feeling lucky to be invited. I was hoping she could fill me in a little more on how things worked around the mansion, since Vicky and the others had given me the cold shoulder.

"Ugh. I need to get lipo," Lisa croaked, looking down at her belly and pinching her spare tire. She was adorable, but had been told to lose weight by a *Playboy* photo editor.

"No you don't," I said. "You look fine."

"Thanks!" she replied through a toothy grin.

As I knelt down to pet one of her three dogs, she picked up the phone next to her bed, pressed 0 for the butler's pantry, and ordered a piece of chocolate cake and a glass of chocolate milk for breakfast. Was I in the twilight zone? Plastic surgery was so commonplace for these women that liposuction sprung to mind as the obvious weight loss cure before, say, taking chocolate cake out of your breakfast routine.

"Hang out here while I get ready," Lisa demanded while hopping into the bathroom. After she had chattered on about herself for about 10 minutes, her cake was finally delivered. She thanked the butler, plopped the tray down on her bed, started shoveling the cake in her mouth, and asked, "So, how do you like it here so far?"

Finally, someone I can talk to! I thought with relief. Now was a good time to ask a few questions and confess a few of my insecurities about this wild world I had just entered. I confided in Lisa that I wasn't too fond of April, that she really intimidated me.

"That's okay, the rest of us don't like her, either," Lisa stated, wrinkling up her nose. "Hef just likes her because she's wild."

"Oh, wow, thank God it's not just me!" I sighed, feeling relieved.

Maybe April wouldn't last that long and then we could all really be like sorority sisters; all on the same team.

Feeling more and more comfortable with Lisa, I thought I would ask her opinion about something that had started worrying me the past few days.

"Hef hasn't given me a bunny necklace yet," I admitted meekly. "Do you think that's weird?"

Every Playmate and every girlfriend was presented with a bunny pendant necklace from Hef. At the time, I (along with everyone else in L.A.'s 30-mile zone) thought these necklaces were made with real diamonds. They had looked so glamorous, glittering on the chests of the chosen ones who flitted about the Playboy parties, the hottest nightclubs, and the spendiest shopping districts in L.A. (In reality, the pendants were cubic zirconia, and if you could track down the Downtown L.A. jeweler who made them, anyone could purchase one for just $100.)

My interest in acquiring a necklace had nothing to do with its value, however. Sure, I coveted one, but my worry stemmed from what it symbolized.

Hef's words echoed in my mind: "You can stay for a while and we'll see how it works out." Maybe I wasn't making the cut. That had to be why he hadn't graced me with a necklace yet. In the few weeks I had been there, he had presented one to Charis Boyle, an upcoming centerfold, whom he had met after me. Somehow I had been skipped over.

"Oh, he hasn't?" Lisa asked, feigning amazement. "Ohhhh. Yeah, I dunno why that is." She purred as she put down her fork and sauntered back into the bathroom.

I felt a knot form in my stomach. That was definitely not the reaction I had hoped for. Lisa's sisterly vibe had me hoping she would reassure me that this was normal or perhaps even offer to ask *for* me—after all, she seemed so comfortable around Hef and was certainly good at getting whatever she wanted.

As Lisa readied herself for the day and led me down to her car, my

mind was in turmoil. Was my time here almost over? I had barely been at the mansion two weeks and already I didn't seem to be making the cut. What would I do now?

As it turns out, I wasn't the only one with these kinds of anxieties.

As we wound our way through L.A. traffic down to Target in Culver City, Lisa kept babbling about herself. I found her stream-of-consciousness narrative fascinating, as her anxieties mirrored mine. The only difference was that she had been here longer and had a centerfold under her belt.

"See this?" she bragged, holding up her checkbook for me to see the balance, which hovered just above $25,000.

"It's the money I earned doing my Playmate pictorial!" she exclaimed proudly. "I haven't touched a penny! You know, the other girls aren't even thinking. They have Hef leasing them cars they could never afford and they spend money like there's no tomorrow."

She looked pleased with herself.

"Everyone made fun of me for getting this car," she said, patting the steering wheel of her brand-new Toyota RAV4. "But I want something I can afford after I move out. I don't need a Porsche."

Smart, I thought. In fact, it was the first sensible thing I had heard out of any of the girlfriends' mouths so far.

As we roamed through Target, she filled her shopping cart with everything from a nose hair trimmer to dog toys. "I always spend so much at Target," she sighed. "You always walk out of here with more than you need."

I smiled and nodded my head in agreement. Before another pause could pass, Lisa started babbling again.

"You know, I don't know if I could ever go back home," Lisa continued. "One of my guy friends from home, the other day he got real rude with me on the phone and said the only reason I got centerfold was because I fucked Hef."

I wasn't 100 percent sure if she was even talking to me anymore—or just thinking out loud.

She shrugged her shoulders and tried to offer a halfhearted smirk, but I could tell the comment bothered her deeply. I could certainly relate. Like me, I think she got into this situation without quite realizing what a public decision it was.

"It's not true. You're gorgeous," I offered, trying to cheer her up. "You could have become a centerfold anyway." And it was true. She was curvy, cute, and baby-faced, resembling a petite version of Anna Nicole Smith.

"Thanks," she sighed, offering a weak smile. "But I can't go back home. I mean, what am I supposed to do? I'm not above working a real job, but, like, if I'm working at a counter somewhere everyone I know is gonna come up and be like 'ohhhhh, Lisa, look where you are now after posing naked.' It's embarrassing."

I was just as anxious as Lisa was about the life that waited for me outside the mansion gates. So many things seemed to be grounds for dismissal that I was petrified to step out of line. While becoming an actress was still a passion of mine, it was always best to keep any auditions quiet. After Brande Roderick had left Hef for *Baywatch Hawaii*, he kept a much closer eye on any acting work the girlfriends tried to pursue. I secretly hoped to land a role big enough that it would allow me to leave the mansion after a few months, but those kinds of dream jobs are few and far between. Eventually I would receive offers for smaller parts in music videos and low-budget films—but the hours often went past our curfew and the jobs rarely paid much, so they hardly seemed worth it. If anything, they would only land me in hot water with my boyfriend who, as the weeks passed into months, appeared more and more controlling. It seemed my acting dreams were stalled for the time being. I felt caught between a rock and a hard place. I thought having a rent-free roof over my head would make chasing my dreams so much easier, but that wasn't turning out to be the case.

I had managed to hold on to my day shifts at Hooters for a few months—I guess Hef didn't feel particularly threatened by a lowly waitressing job—and I was able to slowly start paying off the debt I had

amassed in college. It wasn't much, but it was a start. As they do every year, Hooters chooses a waitress from each region to be featured in the *Hooters* magazine and participate in their national bikini contest. One day, the general manager called me into her office and told me that Hooters wanted me to represent Santa Monica.

I was very flattered. There were so many beautiful girls that worked at the restaurant and they had chosen me! My friend Roxy had been chosen the year before and had told me how much fun it was and how many people she had met. I was still hoping to break into the entertainment world and was eager to take any opportunity—even if it was just a pageant title.

"No," Hef said when I told him about the offer and asked permission to leave for two days. I expected him to maybe pout a bit, but I wasn't really anticipating a flat-out no. Hef never seemed bothered by my job, and since he wasn't eager to feature me in *Playboy*, I couldn't imagine why he would care about me being in another magazine, especially since there was never anything racier than a bikini photo in the *Hooters* magazine.

"You can't do it," he shouted, pounding his fists on his desk. His voice had become irrationally loud.

"Why?" I asked. I had already agreed to do it and was totally perplexed by the strange tantrum he was throwing.

"Because you working there makes me jealous," he yelled, his hands flying in the air, doing his best to well up some more fake tears.

In the months I worked at Hooters, Hef never once expressed feeling threatened by my being there. But now that I was getting an offer to do something fun, something that made me feel special, he all of a sudden had an issue with it? The timing was a little too convenient.

Hef was waiting for me to argue or to cry, but I just stood silently in front of his desk. I could see the anxiety creep across his face; he didn't know how to read my nonreaction, so he took it a step further: "I don't want you working there while you're living in this house," he shouted, hoping this would evoke some response. He thrived on this kind of

drama; he was half hoping for me to surrender and half hoping for a fight.

Without saying a word and as stoically as possible, I turned around and saw myself out of his office. Inside, I was crushed, but I was trying to keep my dignity.

The next day, with a heavy heart, I called the general manager and let her know that not only could I not attend the pageant, I was quitting my job as well. Honestly, I can't even remember what I said. It was a crushing defeat—and it felt like I was saying good-bye to a part of me. In hindsight, that incident should have been a blaring indicator of what my life was going to be like behind those gates, but I still had high hopes.

I felt like my last shred of independence was gone. But at that point, I thought I'd seen the worst of it. It wasn't an ideal world, but I could make it work. *I could find some happiness here while I figured out my next move,* I reasoned with myself. After all, it would only be a few months, maybe a year . . . at most.

"Now, here, you see, it takes all the running you can do,
to keep in the same place. If you want to get somewhere
else, you must run at least twice as fast as that!"
—Lewis Carroll, *Through the Looking-Glass*

You girls are basically Hef's traveling harem, right?" asked the eager *New York* magazine reporter, sticking a small silver voice recorder in my face.

Only a few weeks after I had moved into the mansion, Hef whisked us away on a trip to New York City for his *Comedy Central*'s Friars Club Roast. I'd never been to New York before; I'd actually never been off the West Coast before. It seemed so surreal—and slightly absurd—that a reporter would be questioning *me* about *my* life with Hugh Hefner.

"Umm," I began, through a short laugh. I wasn't quite sure how to respond to this older, bespectacled journalist with the practical brown bob. Despite what the nature of the event may suggest, I couldn't be certain if she was joking or not.

This particular roast had special meaning to New Yorkers. In the wake of the September 11 tragedy, a dark cloud hovered over New

York—and the entire country for that matter. *Comedy Central* reasoned that giving people an hour of time to laugh again might help kick-start the healing process, and they decided to move forward with Hef's scheduled roast.

The day before the event, Hef, his girlfriends, and his staff (including his longtime assistant Mary O'Connor, his personal photographer, and a team of security) boarded a chartered private jet at Van Nuys airport and headed to New York. The network hosted us at the New York Hilton Midtown. Hef and Tina occupied the hotel's regal presidential suite while the rest of us were given gorgeous rooms with breathtaking views of the city.

Whose life was I living? Private jets! Luxury hotels! Last month I was barely making rent on a shitty shared apartment. There were many perks to being one of Hugh Hefner's girlfriends, including the VIP treatment everywhere we went. I'll be honest, being treated like royalty wasn't necessarily a hard routine to fall into. Sure, it was mainly directed at Hef and we were considered ornamental, but reaping the benefits of his celebrity certainly had its moments.

Prior to the festivities, Hef was expected to walk the red carpet with his seven girlfriends for brief press interviews and to pose for photographers. The attire was black tie, so each girlfriend packed her most glamorous cocktail dress or pantsuit. With my clothing allowance I was able to buy a retro style Betsey Johnson black and white ball gown. I loved it, but I felt a little out of place after I realized how conservative my poufy, below-the-knee dress looked next to the other girls' tighter and more revealing ensembles.

When we arrived in our stretch limo to the Waldorf Astoria hotel, my heart fell into my stomach. I'd never been to an event like this in my life—let alone on the arm of the guest of honor.

As we piled on each side of Hef for photographs outside the ballroom, I began shadowing the other girlfriends. Terrified to make any kind of noticeable mistake, I mimicked the girls who appeared to be veterans at

this point. Like the other six, I plastered on my brightest smile and stood patiently behind Hef as he conducted one interview after the other. I had to watch my step, though. Simply falling into place in line didn't work for the other girls. One girlfriend, Carolyn, shamelessly shoved me out of the way so she could stand closer to Hef. (Because we were in front of the press, all of sudden, being as close as possible to Hef was really important to all of the girls, who normally couldn't be farther away.)

When the *New York* magazine reporter shoved her device under my nose, I was taken off guard. I didn't want to seem unfriendly or rude, so I answered her questions as politely as possible and excused myself to follow the rest of the girlfriends into the ballroom.

"What did that reporter ask you?" Vicky hissed as I sat down at the large banquet table closest to the stage.

"She asked me if we were a harem that travels with Hef." I let out a small laugh. To me, it was just a silly sounding question.

"What did you say?" Vicky asked me, her eyes like slits.

"I just sort of laughed and said, 'Well, I guess so,'" I told her, a smile still stuck on my face, completely unaware that I might have done something wrong. I didn't take the question literally. When she said "harem," I just thought she meant an ornamental group of women, not sex slaves. I had been around only a few weeks, how was I supposed to know how to answer a question like that? I'd never spoken to a reporter in my life!

"No," Vicky spat at me, exasperated. "Don't *ever* say that we sleep with him. We always tell people that only Tina does that." I could see that I rattled her pretty hard. As Hef took his throne on stage, Vicky spent the rest of the evening ignoring me and whispering to the other girlfriends in between venomous glances. She'd clearly misled me in the beginning; I guess I shouldn't have been so shocked that she was trying to mislead others, too. But exactly who did she think she was fooling?

The irony wasn't at all lost on me that the entirety of the evening consisted of sex jokes implying that Hef was intimate with each of the seven blondes sitting at his feet.

"I've read just about every issue of *Playboy* since I was 15 years old," began the host, Jimmy Kimmel, "And not once did I see a Playmate say that one of her turn-ons was fucking a 75-year-old man."

INSIDE THE MANSION, LIFE wasn't at all like what I dreamed it would be. Instead of a nightly slumber party with six of your best friends, I had entered the lion's den. It gave a whole new meaning to the phrase "keep your enemies close" and made a sorority house look like Bible study.

By the time I had arrived, fewer and fewer opportunities were being offered to girlfriends to appear in the magazine—which meant the pack was getting restless. Over the years, Hef had become wiser to the girls' true motivations. After achieving Playmate status, they no longer found it necessary to stay at the mansion—or with Hef.

The truly gilded age of *Playboy* had long since passed and our nightly rituals felt more *Golden Girls* than *Playboy Club*. Girls stuck around on the off chance that they'd one day become a Playmate (or until a better option came along), and Hef knew it. He decided he wasn't going to make any more of his girlfriends Playmates, but he never told that to anyone. He dangled the *possibility* of Playmate-hood in order to keep the girls interested. The more aggressive girlfriends would take whatever measures necessary to secure a centerfold, even ruthlessly throwing another girl under the bus if that meant she would gain favor with him.

As always, Vicky was eager to bring as many girls up into the bedroom as possible. I could guess her reasoning: the more options Hef had, the less likely she'd be called to duty. It seemed to me that she made it her mission to lure every new Playmate up to the bedroom to pay their dues. In those first few years, I would say the majority of the Playmates eventually selected had found their way into Hef's bedroom. I guess Vicky figured that if she had to sleep with Hef, they all should have to sleep with him.

I was too naïve to realize it at the time, but Hef was the catalyst for all

the drama I was to experience at the mansion. He recognized that some of the girls were warming up to me and began using my perfect attendance as one of his many tools to manipulate and control his wild pack. Pitting the girlfriends against one another created an aggressive, competitive atmosphere where he alone benefited. During one of my first nights at the mansion, the girlfriends had banded together on a Friday evening and told Hef they didn't feel like going out that night. I was the newest member of the crew, so I just sat there, observing the confrontation.

"So . . . what do I say to my Party Posse?" he said, throwing up his hands and wearing the most disappointed look ever on his face.

"Sorry, Hef," Lisa said. "We'll go out next week."

Needless to say, Hef decided then and there that the girlfriends' days of being chummy were over. After all, he couldn't be outnumbered, could he?

It was in his best interest to have us wallowing in our own insecurities and pawing for his acceptance. Girlfriends that didn't get along gave him the feeling of being fought over—and being fought over made him feel desired, something he was desperate to feel in his old age. A stable environment among the girlfriends wasn't much fun for him, so he began using me as a means to reprimand them.

"Why can't you just be a good girl like Holly?" Hef bemoaned to a girlfriend who wanted a curfew extension, knowing full well that his small remark would pin a bull's-eye on my back for weeks. They began resenting me for the very reason they initially accepted me.

A few weeks into my residency, it was obvious that Vicky was regretting the role she played in recruiting me into the fold. Initially, Vicky must have thought that she could use what little relationship I had with Adrianna to her advantage. Hef was totally smitten with Adrianna—who looked like a perfect, fresh-faced beach bunny—so Vicky, who was as mean as a snake, must have thought that I would have some useful information she could use to help take her competition down. Since Adrianna had moved out of the mansion, it was clear to me that my pres-

ence was no longer of use to Vicky. I think she continued to deal with
me because she considered me average looking compared to the rest of
the girlfriends. (They all tried the best they could to re-create that ideal
of Pamela Anderson—I on the other hand wasn't interested in trans-
forming myself into a Spearmint Rhino version of the *Baywatch* beauty. I
wanted to look good enough to be a Playmate, but still hold on to some of
what made me unique—and, frankly, avoid looking like a blow-up doll.)
But as soon as Hef started using me as a behavioral example, Vicky no
longer wanted anything to do with me.

Today, trying to recall how particularly hideously some of the girl-
friends treated me is a bit difficult. I liken it to being the dorky girl in
the lunchroom who eats her sandwich quietly with her nose buried deep
in a book, praying she didn't attract the unwanted attention of the pop-
ular kids. That's sort of how I felt, but unlike that little girl at school, I
couldn't look forward to weekends or nights free from these mean girls.
I lived with them.

Prior to moving into the mansion, I'd been a fairly confident person,
but it didn't take long for my self-worth to start to crumble. After being
identified by the other girlfriends as persona non grata, I had become the
victim of their ruthless "mean girl-ing." During dinners or movie screen-
ings, it wasn't out of the ordinary for me to overhear their loud whispers
criticizing my appearance (my hair, my face, my clothes). According to
their ruthless taunting, I was the "hick girl" from Nowheresville, USA.
They found my optimistic attitude corny and my confidence threatening,
so they did whatever they could to tear me down. Sadly, I have to say it
worked. Any Playmates or Playmate candidates they befriended would
join in, mocking me as well. Hef's hearing was already pretty deterio-
rated, so like him, I acted as if I did not hear their harsh remarks. My
silence only further incited them and their attacks became more vicious.

Once I started acquiring a decent wardrobe, my clothing began mys-
teriously disappearing. When I would send things downstairs to be laun-
dered, they would never make their way back. As a gift, each girlfriend was

given a gorgeous embroidered burgundy silk robe. We all sent ours to be cleaned before an upcoming event, but only mine went missing. I reverted to writing my name on the inside of each label like a third-grader going away to camp, but even that wasn't really any kind of insurance policy.

I quickly learned that complaining about the girls' antics served zero purpose. You know the phrase "Don't shoot the messenger"? Well, Hef *loved* to shoot the messenger. He would make sure to twist any complaint around into my own doing—and I'd end up apologizing to him. He cultivated an environment where we were perpetually indebted to him. My priority became remaining in his good graces.

Regardless, whenever Hef was around, I stayed close to his heels. Even though his presence didn't necessarily protect me from their bullying, I felt somehow safer. The "Mean Girls" couldn't be as obvious for fear that he might turn his wrath on them.

Two months into my mansion residency, I finally got to attend my first Playboy party as a girlfriend. With my clothing allowance, I was able to go to Trashy Lingerie, a popular boutique, to pick out my costume (despite its name, it was way out of my price range before). I chose a frilly Alice in Wonderland costume that came with a purse shaped like a slice of cake with "Eat Me" written cheekily on it in white Puffy Paint. The outfit was supposed to be sexy, but once again I had chosen something quite conservative compared to the body-hugging ensembles the other girlfriends chose.

When it came to public events and appearances, there was a protocol for the girlfriends to follow. Each of us was expected to meet Hef in his room so we could all make our grand entrance into the party together. It wasn't as exclusive as it might sound, as many of the girlfriends brought their female friends, who joined us for our entrance. Everyone was dressed in something skintight: a spandex-clad race car driver, a spandex-clad taxi driver, and a few spandex-clad cops. By comparison, I felt like a giant frilly cream puff. When the time came to walk downstairs, we all trailed down the grand staircase slowly with Hef's house

camera crew filming every moment for posterity. Hef trailed behind us, wearing the black-and-white-striped "Prisoner of Love" jailbird costume he wore every year. When we arrived at the foot of the stairs, we were instructed to line up in two rows so Hef's house photographer could take our group portrait. After the short photo session was finished, I followed the group out into the tented backyard and towards Hef's table next to the dance floor. On our way out, a naked woman clad only in body paint shoved a tray in front of me.

"Jell-O shot?" she asked.

"Don't mind if I do," I said with a smile, grabbing a green one off her tray.

"The red ones are the best," Vicky snapped at me with a cold smile as soon as I reached Hef's table with my green shot in hand. She was right; the red ones did taste the best. Never having had a Jell-O shot before, I was amazed at how delicious they were—and clueless at how potent they were. Needless to say, I got wasted. Fast.

The girlfriends pretty much ignored my existence the whole night, so luckily I spotted some of my old Hooters friends and motioned for them to come over and talk to me. The novelty of my position as "Hef's newest girlfriend" hadn't worn off yet, so everyone had plenty of questions (the less polite of which I dodged with non-answers).

As girlfriends, the protocol was that we stay at Hef's table all night. We could get up and dance, as long as we stayed on the dance floor in front of the table. The only time we were allowed to leave was to go to the bathroom. There were times when some of the girls managed to get away for short periods of time, due to the fact that Hef was so distracted by all the partygoers clamoring for his attention. Star fucking was a priority for most of the girls, so they tried to sneak away and meet as many famous men as possible. One of the biggest running jokes among the girls was when a girlfriend (who owned a pet capuchin monkey she liked to tote around for attention) took Jennifer Lopez's ex-husband Cris Judd up to her room to "show him her monkey."

When Hef was ready to leave the party (usually around 1 A.M.) we had to go upstairs with him. Of course, there were always girlfriends who snuck back down to the parties after Hef was asleep, to chase men or hobnob with celebrities, but they were always very discreet about it. After all, Hef's videographers wandered the parties until the wee hours capturing all the goings-on, and none of the girls wanted to get caught on tape. By the next afternoon, Hef's video department would have a tape sitting outside Hef's door with a "highlight reel" from the last night's party, copies of which would be sent to local news stations. So much for "what happens at the mansion stays at the mansion!"

That year, *Playboy* would collaborate with *Girls Gone Wild* to release a DVD titled *Playboy Mansion Parties Uncensored*. The DVD—a compilation of all kinds of random party footage, including nudity and celebrity sightings—flew off the shelves. The effect that particular business venture had on the brand was questionable, however. The overeagerness of *Playboy* to exploit what went on at the mansion parties dirtied the cachet of these events that were once considered exclusive and glamorous. No longer feeling like their privacy was being respected, fewer and fewer A-list celebrities wanted to attend anymore. Understandably so.

The night ended with me passed out on my bedroom floor with a cheeseburger in my lap. It had become clear to me that being a part of Hugh Hefner's "party posse" wasn't as glamorous as it seemed. This was a far cry from what I pictured life here would be like when I first laid eyes on the gorgeous Bentley twins a year and a half earlier at the Midsummer Night's Dream Party. The situation was also much lonelier than I could have ever imagined. Not to mention more stressful.

The day-to-day stress of mansion life had taken such a toll on me that I could feel myself mentally regressing. My memory started to dull—and things I used to know with certainty started to fade from my mind. I've always considered myself an intelligent girl, but I could feel myself getting dumber and began second-guessing everything. That

might sound insane, but I suppose you are the company you keep . . . and let's just say the other six girlfriends weren't necessarily winning any spelling bees.

I was so constantly on edge that I eventually developed a stammer when speaking, so I tried as best I could to stay quiet and not risk the embarrassment of tripping over sentences.

To Hef, my shrinking violet personality was a sign of submission that he used to manipulate the other women. It helped my rise through the girlfriend ranks to become among Hef's favorites.

Over time, I convinced myself that I did actually care for this man . . . that I *wanted* to be in a relationship with him despite the fact that I didn't really know him. Of course, living with someone, you learn things about their personalities, their tics and their annoyances, but Hef and I never really talked . . . not about things that mattered. There were no deep conversations or romance between us.

As far as his girlfriends were concerned, we were better seen and not heard. His friends were there for his intellectual stimulation; my job was to show up and look pretty. Even our daily dialogue was superficial. If ever I tried to speak to him about books, politics, or world events, he would scoff at whatever I said. It didn't matter if my remark was educated or even correct, because if I said it, it must be wrong. During movie nights, he would lean over to me to explain plotlines and time periods in the most condescending of ways. Oftentimes I would have to bite my tongue. It was all I could do to keep from screaming: "I know!" Clearly he was used to, or preferred, a woman with no more than a grade school level education.

But I was young and blinded by his fame and accomplishments. *What wasn't to love about Hef?* I told myself. Because of his generosity, I was living on this gorgeous estate, attending swanky Hollywood parties, and had money to spend on clothes, shoes, hair, and makeup. So I reasoned with myself that no two people are exactly the same. *Of course we won't see eye to eye on everything,* I thought.

With that in mind, I began noticing only his good qualities: he was smart, kind to his friends, appreciated the arts, and had a sense of humor. I chose to see my world through rose-colored glasses and ignored all of his bad qualities, no matter how over the top they were.

Like Beauty locked up in the Beast's castle, I developed my own brand of Stockholm syndrome, identifying with my captor. I felt like there was no one I could turn to besides Hef. I thought I could trust him.

Somehow Hef became the "good guy" in my eyes. Slowly I started to isolate myself from the other girls (for good reason) and from everyone outside the gates (for other reasons). I developed a reputation as an ice queen, since I was so quiet and kept to myself.

On the outside, Hef appeared to be the perfect gentleman—an act that paired nicely with my delusions. He always described himself as a "hopeless romantic" and acted as if his womanizing was some long search for the perfect woman that didn't exist. Whether this image was calculated to make him more palatable to the public, more endearing to potential conquests, or both, I don't know. All I know is that it worked on me like a charm. I felt strangely protective of him. The other girlfriends used him, mocked him, and even cheated on him with the boyfriends they kept outside the mansion. They made him look foolish and I resented them for it, all the while overlooking the fact that we were mice trapped inside the glamorous maze he created. It was survival of the fittest and we all were just trying to come out alive.

I convinced myself that I could look past his age and appearance. *Perhaps we're right for each other,* I routinely told myself. After all, I had never fit in anywhere else before and *certainly* hadn't had any luck at love. *Maybe guys my own age just weren't for me,* I thought. *Maybe I was always meant to one day find Hef.*

And just like that, I was in love. It didn't seem to matter that I couldn't recall how or why. Simply put, it was just a decision I made.

*　　*　　*

BY THE TIME CHRISTMAS rolled around, I had already been at the mansion for four months. Nobody told me beforehand what the expectations were for us as girlfriends during the holidays, so I was surprised to find out that Christmases were *always* spent with Hef. Girlfriends were given "off" days before or after the holiday to visit family and friends, but there were no exceptions for the actual day itself. That was the one house rule that no one seemed to mind, because Christmas was when Hef was most generous with his girlfriends.

Hef really is a big kid at heart—and he loves the magic of Christmas morning. The mansion was always decorated from top to bottom, a formal Christmas dinner was held every year, and he spared no expense under the Christmas tree.

Each girlfriend was given $500 to spend on gifts for each girl living at the mansion at that time and $500 for ourselves—the idea was seven sets of matching gifts. With six other girls in residence, that was $3,500 to spend!

I selected elegant Louis Vuitton leather evening purses for each of us—they would be perfect for our nights out! My understated choice wasn't gaudy enough for Tina, however, she returned my gift in exchange for a Louis Vuitton bucket purse with the brand's logo emblazoned all over it.

Carolyn got us Gucci purses; April chose fur jackets (I ended up donating mine to the Goodwill—real fur has never been my thing); Candice (who had stepped into the spot Adrianna had left vacant) picked out large Gucci travel totes, and Vicky selected Gucci shoes.

While the showering of luxurious items was beyond anything I'd ever imagined having just a few months earlier, we didn't have the financial freedom many people assumed. Not even close.

Obviously, we all wanted to save money. But Hef knew that money equals freedom to walk out the door, so he was exceptionally careful how he spent it on us. When Tina and Lisa chose Best Buy gift certificates to give each girlfriend at Christmas, Hef let it be known that he was severely displeased. I suppose gift cards too closely resembled cash for his taste.

After Christmas, Lisa became the first girlfriend to depart since Adrianna had left four months earlier. She found a modest apartment in L.A. and sent her three dogs home to her mom back east. And just like that, she packed up her things and drove off the property. Despite working regularly with Playmate Promotions, rumor had it she ran through her savings in just a few months and ended up moving back to her hometown after all. When I heard the news, my heart sank for her. She wanted so desperately to make it, to prove wrong all of those cynics back home who judged her decision to pose for *Playboy*. But I couldn't help but think that they'd been right. Where did it get her?

"She thought she was such hot shit," some of the girls gloated. "She thought she had it made because she was a Playmate and she couldn't even cut it out there on her own for a few months."

Wow, she had a centerfold and everything, I thought. Even booking appearances as a Playmate couldn't keep her afloat in L.A. They were talking about her as if she were a laughingstock. It was clear I needed to land a good job or a few decent roles before I could ever go back out on my own. I wasn't having any luck landing a centerfold and even that wasn't looking like the most secure gig anymore.

When it came to our weekly clothing allowance, I socked away as much of it as I could to pay off my student loans and credit card debt and begin creating a modest savings. It proved difficult, though, because we had to make sure that our allowance always appeared well spent.

When Hazel, one of Hef's administrative assistants, suspected that a girl wasn't spending the money the way it was intended, she would let Hef know. Most of the girls were intolerable to the staff—and she was sick and tired of all the users.

"You should stop giving them so much clothing allowance," Hazel told Hef. "They just wear bras and panties to the parties—they're clearly not spending it on clothes!"

This would always send him into a tizzy and Tina would end up having to go to bat for herself and the other girls to make sure Hef didn't

lower the allowance. It was clear that we had to have something to show for the money he gave us and therefore it became a balancing act: save as much money as you could, but spend enough so that our allowance doesn't get cut.

Another well-placed catch-22 was the car situation. Girlfriends always got new cars while living at the mansion. Like everything else, what we drove around town in was a direct reflection of *Playboy*—and we had to keep up the image (not to mention, these new fancy cars kept many females salivating over a spot in Hef's harem). Although Hef could easily buy each girl a car 10 times over if he wanted, he knew better than to buy the vehicles outright. Instead, he leased the cars for us. Doing things this way protected him from having girls drive right off in paid-for cars. Plus, it was another genius way to control us. If a girlfriend decided to leave the mansion, it's unlikely she would be able to meet the payments on her extravagant new ride. So she either had to stay, risk the car getting repossessed, or leave it behind.

One such car was a white Cadillac Escalade with monster truck tires, a lift kit, rims, and every other possible tricked-out add-on that was leased for former girlfriend Buffy Tyler. Buffy was a baby-faced, snub-nosed girl from Texas who had recently moved out after becoming Miss November 2000. Mary O'Connor, who had taken a liking to me, actually came to my rescue and suggested that Hef let me drive the repossessed SUV. When she mentioned my Celica, she wrinkled her nose. She was right. It looked like it belonged in a scrap yard—not in the driveway of the Playboy Mansion.

Happily and gratefully, I accepted, even though the car was way too big and gaudy for my taste. After all, beggars can't be choosers. Little did I know that accepting the new ride would cause the other girls to hate me even more (if that was possible). Not only was the Escalade more expensive than anything the other girls drove, but Hef had paid for all the pricey bells and whistles Buffy had installed on the car, something he wouldn't do for any of the other girls. (Playing favorites and causing

jealousy among the girlfriends was yet another little game he enjoyed.) Obsessed with counting every last penny of who got what, the girls knew the value behind all the features Buffy had chosen for the luxury SUV. The cold shoulders I received were extra frigid for a good month after I started driving that car.

Besides Christmas, clothes, and cars, the other large expense that Hef was happy to spend his money on were cosmetic enhancements.

People often ask me if the girlfriends were required to have plastic surgery while living in the mansion, because it was clear so many of us did. The answer is both simple and complex. No, we were not obligated to have plastic surgery while living there. However, the mansion was a virtual breeding ground for superficial insecurities. And most girls who lived there ended up with body dysmorphic disorders. No matter how beautiful they were, these women would pick themselves apart— ordering one procedure after the next.

It was known that if a girlfriend *did* choose to undergo some sort of plastic surgery, Hef would foot the bill. The most popular procedures among the girlfriends were breast augmentations (both new and redone), rhinoplasty, and liposuction. Eventually, I would ask for my own nose job, but that was only part of my *Playboy* makeover.

During my first few months at the mansion, I was still a college-aged girl who actually liked herself. Without school and work, I quickly became bored and filled my days with activities typical of a 22-year-old girl: shopping, working out, getting my belly button pierced, things like that. One day, my friend Britney and I decided to go get tattoos. I got a small Playboy Bunny tattooed in the middle of my lower back (talk about a tramp stamp!), because I thought it was a cute, fun way to commemorate this crazy experience. This was back when I thought my mansion stay was going to be a short-lived stepping-stone that would soon lead me to something bigger.

At the time, my only real beauty routine consisted of bleaching my own roots with Clairol ultra-blue from the drugstore. One day, as I was

performing the ritual in my bedroom with the door open, one of the girlfriends popped her head in.

"What are you doing?" she snarled, with a scrunched nose.

"Dying my hair," I said, defensively. What did it look like I was doing? I knew these wannabe Beverly Hills bitches looked down on anything do-it-yourself. "I need to save money. I can't spend it all at the salon."

I actually hadn't been to a salon in my life.

"Ohhhh," she cooed maliciously, a smirk slowly spreading across her face. "That's smart." She laughed and sauntered down the hall.

What she failed to tell me was that Hef had an open tab at the José Eber Salon in Beverly Hills, and all the girlfriends had their hair and nails professionally done there several times a week. None of the girls had bothered to share this piece of information with me, because keeping me as homely as possible was in their best interests.

Finally, I found out about the salon privileges when Vicky had lost patience with me using the strong-smelling dye in our shared bathroom.

"You know you don't have to do your own hair, right?" she finally snapped.

When I arrived at the José Eber Salon, it was like arriving in a whole new world. The staff whisked me into the salon and immediately changed my bright gold hair into the light platinum blond Hef loved. They straightened my naturally frizzy mane and planted long acrylic nails on top of my short ones.

Meanwhile, months of utilizing the mansion's gym and tanning beds had taken about 10 pounds off my figure and bronzed my skin into a smooth, perfect tan. Hef's dentist had given me a bleaching kit for my teeth, which gave my smile a perfect bright Hollywood glow.

The pictures we received the morning after each of our club nights out provided me with countless opportunities to study how I photographed. I quickly set about honing my makeup skills (which were virtually nonexistent before the mansion). During my first few months there,

I don't think I wore much besides powder and maybe a little mascara. Compared to the Playmates' carefully contoured faces, my sparse and natural look wasn't cutting it. My work-free days gave me hours and hours to shop for and experiment with makeup. I learned how to make my lips look bigger, my eyes more catlike, and my eyebrows fuller and more defined. I felt like I was finally beginning to look like the glamorous Playmate I had always wanted to be!

Staring at my photos, though, I knew there was one last thing to fix. I'd never really been fond of my nose—it was a little too big for my taste, but I rarely thought about it. It wasn't until I started seeing countless pictures of myself day after day that I realized it photographed even bigger than it was. I compared myself with the Playmates in our group photos—most of whom had tiny, unnoticeable noses. Hef's favorite girls had "baby faces" with upturned snub noses. I started to feel like it was about time I did something about it.

While plastic surgery was a common request among the girlfriends, I was still terrified to discuss the idea with Hef. I was uncomfortable enough with my current living situation, so the last thing I wanted to do was ask for anything more. I already felt like enough of a hooker—I didn't need to fan the flame. Eventually, though, I caved.

All the other girls get procedures, I told myself. *It's only fair that I should be able to get one, too.*

I took a deep breath and approached Hef. I had spent time doing my research and decided to enlist the help of the same doctor who had performed a nose job on one of Hef's former girlfriends—a surgery so successful that Hef said he'd "never seen such a transformation before." After dinner one night, I nervously brought the quote from the plastic surgeon to his room and shakily explained that I wanted to get my nose fixed. He gave me an obligatory two-minute speech about how I didn't need the surgery, but quickly approved it despite his short-lived chivalry.

It felt like a victory at the time, but I now recognize that it was one of

those watershed moments in life. Sure, my new nose gave me a temporary surge of self-confidence (and I was absolutely thrilled with the results), but it wasn't my appearance that was in need of immediate attention.

In a few short months, I had gone from a friendly, optimistic, confident woman to a confused girl with a nervous stammer who second-guessed every thought that went through her head and rationalized every bad decision she made. I was so focused on "making it" and turning this bad decision I had made into something positive that I couldn't see that all I was really doing was running faster and faster in circles trying to please Hef and simply stay afloat in his twisted world. I had no time or energy left to chase my dreams.

By this point, Tina Jordan had moved out and Hef had promoted me to his "main" girlfriend. One might think this would offer me some kind of protection from the "Mean Girls," but no such luck.

Actually, the other girlfriends all but shoved me into the number one slot. As Hef's main girlfriend, you were under the microscope. The "Mean Girls" reveled in their lives outside the mansion and didn't want the extra responsibility where Hef was concerned. Unlike the other girls, I didn't mind most of the rules. I didn't have an outside boyfriend and I wasn't crazy about clubbing, so I didn't mind the 9 P.M. curfew. The "Mean Girls" viewed it as a win-win. If I was ever present as the main girlfriend, their lack of perfect attendance wouldn't be as heavily scrutinized, but I wasn't "hot" enough to be any kind of real competition for the limited Playmate of the Month spots. If they were ever asked why Hef preferred homely little old me best, I'm sure they would lie and say it was because I was the only one who slept with him . . . just like they had all said about Tina.

Despite the presumed prestige in its title, there was nothing ceremonious about becoming Hef's number one girlfriend. After Tina's centerfold was published and she announced her departure, Hef simply asked me if I wanted to move into his room. That was sort of it. No promises were made; no piece of token jewelry was given. I simply prepared to

pack up my things and move them down the hall . . . but not before Tina took the opportunity to remind me who was boss.

Just as I was beginning to move to Hef's room, Tina dropped another bomb. She announced that she had decided not to move out after all. The other girls didn't even try to hide their smirks as she shared this news with me (in front of everyone). It was clear I was the only one left out of this loop. My face burned red with embarrassment.

"So, you can just quit packing up your things," Tina said in her fake singsong voice as she picked up her purse and followed an oblivious-acting Hef out to the limo. I was hurt and embarrassed, but the subject was never broached again that night, so I just pretended the whole thing never happened.

Over the next few weeks, Tina would show up halfway through movie nights only to shove me out of the way so she could sit next to Hef. She did the same thing with buffet dinners and would make a huge show out of forcing me to move my chair over so she could sit by Hef.

I'm not sure if Tina was trying to make an impression on Hef so that he would be more likely to give her Playmate of the Year or if she simply had that much fun torturing me. Eventually, though, the novelty wore off and Tina left for good.

Being tossed back and forth like a useless rag doll by the man I had come to look to for approval did a massive number on my self-esteem. When I finally made the official transition into Hef's master suite, it felt anticlimactic. I was actually moving all of my belongings from a normal-sized bedroom into a tiny corner of Hef's closet called "the Vanity." These cramped living quarters—without even a speck of privacy—was another reason none of the other girls were clamoring for the title of "girlfriend number one." The back area of Hef's closet contained a vanity, an island dresser, and closet space lining the walls. There was just enough room to walk between the island and the vanity, but that's it. In what looked like a castle's tower from the outside, the vanity had a few thin windows that looked out over the driveway. A musty rose-colored

chair and a nightstand with a small box TV were wedged in front of the windows.

I later talked Hef into installing a desk in place of the TV and chair and putting down beautiful hardwood floors in place of the white carpet, which had long ago been ruined by dogs and Lord knows what else. I had a hard time believing that an elegant man like Hef (or so I assumed) preferred the nasty old carpet to the classic hardwood floors that so complemented the rest of the room. I was wrong. Instead, Hef insisted the change was a *huge* sacrifice he made for me and that "if this doesn't show you how serious I am about you, nothing will."

Did he really just suggest that his love for me was reflected by his willingness to rip up decades-old carpet? I thought. Yes, yes, he did.

Speaking of declarations of love, now that I was Hef's number one girlfriend, the vows of love flowed freely, just as they had to Tina days earlier. "I love you" was something he said often and to anyone he was even remotely involved with, including me on what was our second night out together. I realized that was abnormal, but I came to hope that those feelings were true, particularly as he started referring to me in front of friends as the "love of his life" and telling the press he expected to spend the rest of his life with me. That last quote quickly turned into a punch line as late-night comedians speculated if the "rest of his life" meant one or two more years.

I suppose the main girlfriend role did have some other "perks." Suddenly, Playmates who had once mocked me were kissing my ass, bringing me gifts, and showering me with compliments now that I was Hef's number one girlfriend. The sudden shift in the way some of those girls acted was completely obvious and shameless, but I suppose they thought I was too dumb to notice or that I would be so grateful to be treated kindly for a change that I wouldn't object. The reality was, I knew I had to choose my battles wisely. I graciously accepted their gifts and their compliments, but I wasn't stupid and I never forgot how they had treated me before, when I was just the lowest blonde on the totem pole.

Despite being on the receiving end of Hef's romantic declarations and suddenly being "popular" with the Playmates, I still wasn't exempt from Hef's harsh criticisms. Among the many unspoken rules at the mansion, the red lipstick rule was one of the more notorious. Hef *hated* red lipstick. It was one of the few helpful hints I managed to squeeze out of Vicky. I'm not overexaggerating here; Hef absolutely despised red lipstick and wouldn't allow his girlfriends to wear the color.

"Maybe he doesn't want lipstick on his collar," Vicky had suggested years earlier. I always found it so hard to believe, because Hef has such a deep appreciation for the gorgeous film stars of the golden age of Hollywood. Betty Grable, Alice Faye, and his muse, Marilyn Monroe, were always painted with succulent red lips. It didn't make any sense that he wouldn't want his girlfriends to exude that same kind of glamour, so I didn't take her warning too seriously.

I would learn my lesson the hard way.

About six months after moving into the mansion, I felt ready for another makeover. I loved my waist-length thick, natural hair. In fact it had long been the physical attribute I was most proud of—mainly because it was the only thing I had that all the other girlfriends, with their extensions and clip-in locks, had to buy. New girls were always coming through the mansion's revolving front door, but I was the only one with enviable hair.

Until Mary Jo. She was a southern belle flown out from Alabama for a Playmate "test shoot." She had ass-length blond all-natural hair and was dead-set on becoming Hef's newest girlfriend. This woman wasn't just any old blonde; she was single-handedly hijacking the only thing that made me different. I couldn't believe how threatened I felt by her. The fact that I could be so easily upset by something like this made me want to rebel, to do something that would make me an individual, so that I wouldn't constantly feel so replaceable.

I was cracking under the pressures of living at the mansion and resented the fact that everyone had to look like such a clone. Save for the

blond hair, the big boobs, and our shared address, I had absolutely nothing in common with these girls. So why should we have to look like we were carbon copies of one another?

I decided to take it upon myself to embrace a more retro aesthetic—a look that captured the old Hollywood glamour I was so fascinated with. Think: more Marilyn, less Pamela.

One sunny afternoon, I decided to do the unthinkable: chop off all my hair. I drove directly to the hair salon and instructed my stylist to cut off about 20 inches of platinum blond hair. It was a drastic move, but I felt liberated by my short new coif. While all the girls were in a race to see who could have the longest hair possible, I had a flirty chin-length bob. I completed the look by having the hairdresser and makeup artist style me like Marilyn Monroe. Though I was making the change for me, I was also sure that Hef wouldn't mind. After all, he worshipped Marilyn and often cited her as the ideal in feminine beauty.

When I got back to the mansion, complete with curled bob, black eyeliner, and red lips, I sat down at my vanity. *This is a fun look,* I thought, admiring my new reflection as I heard Hef shuffle into the bedroom.

"Come in here, Puffin," I said in a happy singsong voice, "I want to show you something!" I stood up and straightened out my white Juicy Couture jumpsuit when he finally appeared in the doorway.

"*What* did you do?" he spat at me. Instantly, I was taken aback.

"I got a little makeover," I said sheepishly, giving a slight pat to my new hair. Any shred of confidence I found over the last few hours was quickly evaporating. "I thought you would like it."

"Well, I don't," he hissed, taking a moment to analyze my new makeup and hair. My eyes immediately darted to the floor. I didn't know what to say. Of all the reactions he could have had, I was the least prepared for this one. I stood there, silent.

"Actually, I *hate* it," he continued, the words shooting like knives off his tongue. "I hate the whole look. I hate the makeup and I *hate* the red lipstick."

I couldn't help the tears that began streaming down my face, ruining the makeup I had been so excited about. I sank back onto the tufted stool. Was this really happening? He had never yelled at me like this before.

"Don't *ever* wear red lipstick again," he warned me in a low voice and turned towards the door. I was utterly dumbfounded; it was such an irrational reaction to something so small. Even once he saw me crying, there wasn't an ounce of sympathy in his voice; he only saw red (pun intended).

He paused and turned back around to survey my reaction. Deciding he hadn't done enough damage, he served me one final blow before storming out of the room: "You look old, hard, and cheap."

That was it; end of conversation. But that's how disagreements always ended with Hef; he would just stomp off and you were left to pick the pieces of your self-worth up off the floor. I'd invested every part of myself in Hef and the mansion and had nothing waiting for me outside those gates. I felt so trapped and so vulnerable to his criticisms. This old man had just humiliated me—and I sat there taking his ridicule like a child. I curled up on the vanity stool and sobbed for what felt like forever, in the one little corner of this whole giant mansion that was supposed to be my own. But even that wasn't real. It was his world—all of it.

He made no mention of the conversation again. When you're the king of all you survey, you don't really need to say much more. His point was clearly made. For many years his words rang in my ears: "old, hard, and cheap."

Who says that to a person they supposedly love?

The whole episode made me feel beyond ugly, as if all the beauty products and cosmetic surgery in the world couldn't make me look good. I felt like an idiot for even trying to be beautiful. Maybe I was just the homely girl who was "lucky" enough for Hef to allow into the mansion. That's certainly how his actions made me feel. Needless to say, from then on, I stuck religiously to corals, pinks, and nudes, never daring to try red lipstick in front of him again.

Just when I was starting to give up hope that I could ever find any real

positivity in Hef's twisted world, someone new caught my eye. I looked up from my book and adjusted the messy bun on top of my head that was disguising my poorly received new haircut.

I wonder who that is, I thought. A bubbly Carmen Miranda–costumed blonde sauntered across the pool area handing out shiny beaded necklaces with tiny bottles of Jack Daniel's attached to all of the partygoers.

"Happy Cinco de Mayo!" The girl beamed, a huge, gleaming smile on her face as she handed me a necklace. She had a large, red headdress balanced on top of her head and seemed unusually perky.

"Thanks!" I said, accepting the beads and watching her walk over to Hef's backgammon table. *How fun,* I thought. Lately, I had become used to putting on a cheerful facade, since on the inside I was essentially Eeyore with a rain cloud following my every step. This girl was like a ray of sunshine so unlike the other Fun in the Sun party guests, all of whom spent the days self-consciously preening themselves while wearing boring basic bikinis. She seemed to glide right out of an old Hollywood musical!

I assumed she had to work for *Playboy* or Jack Daniel's or something. I mean, you had to be getting paid to be that bubbly, right?

That evening, after freshening up, I wandered downstairs for dinner and heard someone blurt out, "You cut your hair!" My new look had been so poorly received that I wasn't expecting any sort of compliments when I arrived in the great hall. Immediately, I spotted Miss Chiquita Banana sitting on the bench in a *Clueless*-inspired plaid skirt and matching top.

"Oh yeah," I finally replied, self-consciously running my hand under my new blond bob. "I donated it to charity."

"Oh, Locks of Love?" she asked, seeming genuinely interested.

"Yeah," I said, feeling the tension in my shoulders begin to melt away. "They say they don't take colored hair, but my hair is really strong and it was super long, so I sent like 20 inches off in case they could turn it into a wig or something."

It was the most I had said in hours . . . maybe days. Something about

this girl allowed me to relax. I didn't feel like I needed to be on guard and I could sense that she genuinely wanted to be my friend.

"Oh, that's so sweet! I've always wanted to do that," she cooed before sticking her hand out in front of me. "I know we've met before, but I'm Bridget."

"I'm Holly," I said, a smile taking over my face. "It's really nice to meet you again."

Bridget started popping up around the mansion pretty regularly after that. Much to my surprise, she was just another girl invited to spend time at the mansion; her cheerfulness wasn't an act and she wasn't being paid to promote a brand, as I had initially assumed. She didn't have that same desperate air about her that plagued most of the girls who frequented Hef's place. Plus, she wasn't another platinum, plastic wannabe: this girl was refreshingly natural. She had dark blond hair, natural makeup, was plastic surgery free, and was always outfitted in some sort of themed ensemble. She was a walking, talking candy cane and I liked having her around. In a way, she reminded me of myself before Hef and his girl-friends had completely stripped me of my confidence.

It wasn't long before we became best friends. Her energy was conta-gious, making it nearly impossible to ever be in a bad mood when you're with her. Plus, it was a welcome relief to have a new friend in the house.

Eventually, Bridget Marquardt became one of Hef's girlfriends. When she moved in, I had already been at the mansion for more than a year and had been witness to the comings and goings of quite a few girlfriends. But for once, I didn't mind a new face taking up residence.

Looking back, I often wonder if having a friend like Bridget earlier might have saved my sanity. If I had had anyone else to turn to besides Hef, maybe I would have been able recognize the situation for what it was instead of convincing myself to fall in love with him.

CHAPTER 5

Alice thought the whole thing very absurd, but they all
looked so grave that she did not dare to laugh.
—Lewis Carroll, *Alice's Adventures in Wonderland*

Over the year I lived with her at the mansion, Vicky became increasingly hostile. She wanted desperately to be a Playmate, but Hef was done making girlfriends centerfolds—only we didn't know that then. Hef still let the possibility linger, knowing it was the key to attracting and keeping countless young girlfriends. Earning Playmate status became Vicky's obsession. A new crop of girls had moved into the mansion over the past year and Vicky was hell-bent on beating this new group to the coveted title. It seemed to me that she felt her seniority in the group gave her an edge or made her an exception when it came to snagging herself a centerfold.

"If he's not going to give me a centerfold, I'm at least going to get everything I can out of this place," Vicky fumed in my general direction. She had invited me to her room to "talk," something we hadn't done since my earliest days at the mansion. After Lisa became a centerfold and

moved out a few months earlier, Vicky moved up into one of the largest of the rooms designated for girlfriends.

I watched as she stumbled around the large pink room, trying to avoid tripping over the piles of junk she'd amassed in every corner, including those covering a long white couch that had occupied the room since the '80s. She motioned that I grab a seat on her bed, but I was unsure how to navigate the journey. I was fairly certain that this particular room had plush white carpeting, but you couldn't see the ground anywhere. Random trinkets, mementos, and tchotchkes were scattered about: a skateboard collection, a wall full of Barbie dolls still in their original packaging, an oversize aquarium, a Ping-Pong table covered with Hello Kitty merchandise, an oversize disco ball, and a stable of inflatable unicorns.

I mean, I love me some camp, but this was enough to make Angelyne cringe. If "getting everything she could out of this place" meant becoming a hoarder, then she was succeeding with flying colors (many of which were shades of pink).

I noticed that she had a piece of paper taped over a vent on the wall. "What's that?" I asked.

Vicky looked over her shoulder.

"Oh, that?" she asked, pointing towards the vent.

I nodded.

"The girls who were in here last night put that up," she nonchalantly explained. "They were up here smoking meth and it has this like, really foul smell, like rotten eggs, so they covered up the vent."

I nodded again, hoping the shock and amusement wasn't readable on my face.

"They knew if the smell made its way down to the butler's pantry, someone might figure it out and bust 'em," she continued.

"Huh," I said, going through a mental Rolodex of her girlfriends to figure out which ones she was talking about.

"Speaking of the other girls . . ." Vicky began, a new focus in her voice. "You know I can't stand Dianna, right?"

"No, I didn't," I replied. How would I know who was on Vicky's list of enemies?

At the ripe old age of 29, Dianna was one of the oldest in this new crop of girlfriends. She was beautiful, but there was something a little off about her. She had wild, violent mood swings and looked more like an attractive 40-something with a face full of Botox and fillers than a 29-year-old.

"Okay. Well, you know how when you do coke, there's like a pile in the center with some lines next to it for people to do?" She paused. It took me a second to realize she was waiting on me to respond. Quickly I nodded. I didn't do it myself, but I'd been offered cocaine countless times since moving in—it was definitely the drug of choice among the girls of the mansion.

Apparently satisfied with my response, she continued: "Well, Dianna doesn't do the lines . . . she does the whole fucking pile!" Her eyes were wild as her arms flew in the air. "It's like, bring your own shit."

I wondered if Vicky was high this very moment. It would explain her spastic behavior and even why she invited me into her room in the first place.

"You know Amanda, that new Playmate?" she asked, jumping to the next subject without missing a beat.

I actually had an answer for this one!

"Yes!" I exclaimed. I'd only met Amanda a handful of times while she was shooting her pictorial, but the wholesome dark-haired beauty definitely left an impression. She possessed an air about her, like she just walked off the pageant stage. I always noted her impeccable manners—a rarity in the Playmate world. "I really like her. She's so pretty and seems really classy."

"Well, she's not!" Vicky whirled around with a huff. Apparently that was the wrong answer, because Vicky unleashed her Amanda-focused tirade. "You know, don't you ever wonder, for a girl to want to pose nude, there has to be something *wrong* with her, right?"

I kept my mouth shut. Her eyes narrowed on me as she waited for my response. It seemed like a loaded question, since both Vicky and I were eager to become Playmates. I thought she might be getting to some sort of point—perhaps whatever it was that motivated her to ask me to her room in the first place.

"Well, she makes *a lot* of money," Vicky finally said, her claws momentarily retracted. "Like, thousands of dollars a night. Actually, almost all of the Playmates make that kind of money."

Vicky paused, waiting for me to take the bait and ask how they made that kind of money. She took a seat on top of what appeared to be a small mound of dirty clothes on the white couch and began casually petting the tiny dog that had crawled into her lap. After it was clear I wasn't biting, she continued her story on her own.

"Take Carrie, for example . . ." she continued, her eyes on the little animal.

A recent Playmate, Carrie was a 21-year-old with a 16-year-old face. She had striking green eyes, but no personality. I remembered seeing her a few days earlier at the Fun in the Sun party droning on about her swimsuit.

"Do these look like pumpkins," she had asked Vicky, stretching her orange-dotted Dior bikini over her chest.

Wow, I remembered thinking. *Playmates must make some pretty good money to be able to afford Dior bikinis.*

"Well," Vicky continued, snapping me back to the present, "she has a lot of sugar daddies. One pays for her apartment, one pays her bills, one takes her shopping . . ."

"No way!" I shouted, unintentionally cutting Vicky off. Rumors of Playmates working for "high class" escort agencies had plagued *Playboy* for decades, but it wasn't common knowledge and I'd never heard of it firsthand before.

"Yeah," Vicky said with a carefree laugh. "And everybody does it."

And as casually as if she were inviting me to tea, she asked: "Do you think it might be something you'd be interested in?"

"No way!" I said, almost laughing. Was she really asking me if I'd consider becoming a hooker!? Sure, I'd made a bad decision moving into the mansion, but I wasn't down for full-on prostitution. She wasn't going to get me this time.

My eyes fell on Vicky and I quickly adjusted my expression. I couldn't be certain, but I was fairly sure our newly rekindled friendship would be short-lived. "Umm, I mean," I sputtered, uselessly trying to recover, "that's just not something I'm into."

Her face was starting to morph from terribly offended to wildly angry. I kept talking, hoping it would stave off the shit storm I just walked into.

"I mean, it's just a little much for me, there's nothing special about it," I floundered, trying in vain to come up with anything that might not piss Vicky off. I could feel the blood pumping in my cheeks, certain I was bright red. Vicky had just opened the door to her secret little world and I slammed it in her face.

"Okay, whatever," she spat. "Hey, I need to get ready, so I'll see you later, okay?"

"Okay," I said, recognizing that it was my cue to leave.

Oh my god, I thought, *I can't wait to tell Bridget about this!*

I came to believe that Vicky was working for Hollywood madam Michelle Braun (the owner and operator of the high-end escort service Nici's Girls). In the late 1990s and early 2000s, "Nici" was the premier madam who prided herself on a reputation of having the most exclusive girls in the business—many of which were Playmates and even some of Hef's own girlfriends.

In a 2009 *New York Post* article, Braun boasted, "at one time, seven of the eight girls living in the Mansion were working for me. I had one of his girlfriends in the Mansion just to recruit for me."

When I read this article, it was obvious to me that Vicky must have

been her recruiter. I compared notes with a few of the other girlfriends and found that they had also been approached by Vicky. One of the girls said Vicky had confided in her that she got a cut or fee for the girls she was able to introduce to Braun. Girls were routinely convinced that these men were willing to pay a premium for simply the pleasure of their company and not necessarily for sex—but, from what I understand, that was almost never the case. While I was at the mansion, there were a handful of girlfriends who refused the invitation to hook (Bridget was never even approached), but I have no idea what went on before I got there.

A few years ago, Braun's client and employee list, circa 1999, surfaced on the Web (gossip site HollywoodInterrupted.com published the documents). Among the many notable names were Hef's former girlfriends Mandy and Sandy Bentley, as well as his former main girlfriend Tina Jordan. (In 2009, Braun was indicted after pleading guilty to transporting women across state lines for the purpose of prostitution and money laundering and was sentenced to three years' probation and six months of house arrest.)

The women were tempted with the lavish life that a $1,000 weekly allowance certainly wouldn't provide for. They would travel all over the world and make upwards of $25,000 to spend an evening with whoever was willing to shell out the cash. Girls were making money hand over fist! They became addicted to L.A.'s opulent lifestyle—expensive cars, designer handbags, luxury apartments—and sadly, for many of these women, the majority of their income went to supporting some pretty nasty drug habits.

At the end of the day, whatever their reasons for making this choice, I never judged them—and I certainly don't now. Vicky, however, disgusts me. If she was indeed Michelle Braun's recruiter, then she preyed on the young, naïve women who tumbled into L.A. with stars in their eyes, and used them for her own gain.

In 1997, '80s Playmate Rebecca Ferratti made headlines when she participated in an *E! True Hollywood Story* titled "The Sultan and the

Centerfold." Ferratti recalled her spiral into the world of prostitution. In her day, high-end call girls were being shipped off to Brunei to meet their clients. In the early 2000s, Turkey was the hotspot for these L.A.-bred escorts.

Braun said during a 2008 *Rolling Stone* interview that her big break in the escort business was landing Turkish billionaire Hakan Uzan as a Nici's Girls client (the article named Playmate Tishara Cousino and *Playboy* cover girl Ashley Massaro as employees, as well as Tina). "Hakan would send me an instant message at 3 A.M., and I would have to get four Playmates ready right away," Braun told the magazine. "The first flight to Istanbul was around 6 A.M. through Paris, and sometimes I'd wake them up in the middle of the night for that flight."

The madam was arrested in 2007 and revealed details about her global hooking empire during the *Rolling Stone* interview, but *Playboy*—and Hef—had known about the racket for years. In fact, Hef even launched his own private investigation into the matter in hopes of shutting down Nici's Girls and other agencies standing on the shoulders of the *Playboy* name. The hypocrisy here is palpable. Considering Hef kept his own "harem" of sorts, it's easy to see the mansion as a gateway to hooking. But Hef was determined to plug this leak—not necessarily for the benefit of the girls, I believe, but to maintain *Playboy*'s image. It wouldn't look that good if a majority of Playmates graduated to sex for pay. *Playboy* was supposed to be "classy," after all.

Eventually, I learned more about the situation from Mary O'Connor, who had become a close friend. During my morning visits to her office, I would hear about the goings-on and frequently come across documents pertaining to the investigation. Instinctively, I grabbed a stack of contact sheets off Mary's desk, thinking it had to be negatives from the newest Playmate test shoot—something I always pored over.

My heart sank when I saw what the images actually were. In the photos was a red-faced, swollen-eyed Playmate, one that I knew well. Wearing a hot pink wig, looking like she was drugged out of her brain,

posing nude for the unknown photographer, she was subjecting herself to the most repulsive and demeaning positions. She was showing parts of her anatomy never even seen in the pages of *Playboy*; in fact I'm not sure you'd even see some of this in *Hustler*. In her drug-fueled state, she must have thought the hot pink wig would sufficiently mask her identity . . . despite her face being very clearly on display.

Hef was determined to put an end to the *Playboy* prostitution ring—still unaware he had an enemy under his own roof—and put new restrictions in place to better ensure that his centerfolds weren't participating in Nici's Girls.

If he found out that one of his Playmates had been associated with this ring, that person would be stripped of any Playmate responsibilities. (I don't even think he considered that any of his girlfriends had been participating.) As soon as word of these new restrictions started circulating, it didn't take long for girls to start panicking.

"Holly, I need your help," the breathless caller squeaked through the splotchy connection.

As 2002 was nearing its end, it was time for Hef to select Playmate of the Year. Amanda was in close contention with a handful of other girls, and I was not so quietly rooting for the fresh-faced beauty. I thought she was warmer and friendlier than most of the other candidates and would make a good representative for the magazine.

While Amanda and I had met a few times, we were by no means close, so when one of the mansion butlers rang my room from the pantry switchboard to tell me Amanda was on the line, I was surprised.

"Sure, what do you need?" I said. I figured she wanted me to put in a good word with Hef about her candidacy. People always thought I had a lot more leverage than I did.

"I need you to talk to Hef," Amanda begged, sounding desperate. "They told me I was getting Playmate of the Year, but now they're saying they aren't going to give it to me."

Immediately, my conversation with Vicky months earlier popped into my head.

"Why?" I asked, hearing my own trepidation.

"They asked to see my passport," she explained urgently. "And I don't have it."

"Why do they want to see your passport?" I asked, already suspecting the answer.

"I don't know," she lied.

"Well, where is it?" I felt like I was interrogating her, but it was clear she was trying to manipulate my position. If Hef knew she was a prostitute, I couldn't very well campaign for her as Playmate of the Year.

"I left it at my mom's in Washington," she cried. I could hear the panic in her voice. Her dreams were vanishing before her very eyes.

"Can't she just FedEx it?" I said, offering the simplest solution. She probably had her passport sitting in front of her as she spoke to me, but I couldn't let on what I suspected.

"No," she said, offering no further explanation.

There was no place left for the conversation to go.

"I can try to talk to him, but he doesn't always listen to me." (Ever *listen to me,* I thought.) "But if this is really important to you, you should try to get your passport."

"Thanks, Holly," Amanda said, letting out a defeated sigh. "I know you were supportive of me and I really appreciate it."

I later discovered that in order to stop the prostitution problem, Hef mandated that any Playmate found to be working as a call girl would be banned from working any promotional appearances for the magazine. (The same fate applied to girls who posed for competing magazines such as *Penthouse* and *Hustler,* as these were much more explicit, competing publications. Hef considered this a branding issue.) To serve as a message to future Playmates, that year's Playmate of the Year candidates had to submit their passports for review. They were onto the Turkey connection,

and if any girls had a stamp from that country, they were taken out of contention (as were girls unwilling to hand over their passports, apparently).

While many Playmates continued working for Nici's Girls (the promotional pay from *Playboy* couldn't compete with the escort business), I understand that Hef eventually decided to call off the investigation just as they had gotten close to a bust (no pun intended). Maybe he knew he couldn't do anything to control the former Playmates, but hoped that word of the Playmate of the Year passport check had done enough to scare the following year's group of girls. Plus, Hef must have wanted to avoid the story leaking to the press (as it eventually would). At the end of the day, "Playboy Playmates Turn Prostitutes" still isn't a good headline for the brand.

But while Hef knew many of the Playmates were moonlighting as call girls, he and his detectives were still completely oblivious to the business Vicky was apparently conducting under his very nose with his own girlfriends.

Why didn't I tell Hef what I believed about Vicky? Because I knew that if I told him that I thought Vicky had tried to recruit me to be an escort, he would run and tell her verbatim what I said. She would of course deny any involvement; Hef might choose to believe her, reprimand me for spreading catty gossip, and then I would be subjected to Vicky's vengeful wrath.

No, thank you.

Even after reports came out implicating Hef's girlfriends in the Nici's Girls escort ring, I don't know if he ever figured out who was Braun's inside girl. In the end, it was a different moneymaking scheme that sealed Vicky's fate.

Back in the early 2000s, invites to the mansion were still a prized commodity, and there was a market of wealthy men willing to pay top dollar for a spot on Playboy's exclusive party guest list. As girlfriends, it was understood that we could invite a few family members and friends to attend each of the mansion's decadent soirees. Ever the hustler, Vicky saw

this as the perfect opportunity to make some extra cash. Like she said, she was going to milk this place for all that she could.

For a small fortune, Vicky would secure eager partygoers a spot on the coveted guest list under her own name (telling the office they were cousins or close friends). And because greed seeped out of her pores like sweat, she couldn't help but recruit the other girlfriends to do the same. Vicky would do all the heavy lifting (for a cut of the profits, naturally) and all the girls had to do was give the names to the office administrators before the party. I believe I was the only girlfriend she didn't approach about this scheme. My reaction to her hooking proposal must have turned her off.

Vicky's greed became her own worst enemy. While it was in everyone's best interest (the clients and the girls) to keep the escort ring as discreet as possible, the *Playboy* guest list racket was less distasteful. So, naturally, people talked . . . and word eventually found its way to Hef.

A few days before the annual Playboy Halloween bash, I had come down with a nasty case of the flu. I curled up in bed all day, barely able to move a muscle or even lift my head off the pillow. Unbeknownst to me, Hef had recently found out about Vicky's guest list scam and confronted her. He was furious with Vicky and the "Mean Girls." When some of the names on the guest list aroused suspicion, the "paying customers" were called by one of Hef's secretaries, asking how they got the invite. They simply told the secretary that they paid one of the girls to get in. Amazingly, Vicky had neglected to tell them it was a secret. Needless to say, they were totally busted and even Vicky couldn't deny it.

Of course the evil witch was convinced that somehow I had been the one to snitch, even though I hadn't even known about the scheme at that point. Part of me wishes I could now take credit for what would be her demise, but it was not my doing. None of that mattered, because regardless of what I did or didn't do, Vicky was hell-bent on making my life miserable.

"Honeeeeeyyyyyyyyyyyyy, weeee'rrrreeee hooooooommmmmeeee!" Vicky squealed through the doors of the master bedroom, dragging out

each word in a singsong childlike tone. Terrified they were going to get kicked out, Vicky and the "Mean Girls" had all gone to a local tattoo parlor to get bunny head logos inked on their ankles (an expression of their undying devotion to *Playboy* and Hef).

"Honeeeeeyyyyyyyyyy," she cooed again, only louder. Uninvited, she flung open the doors and screeched like nails down a chalkboard, "We have something to showwwwww yoooouuuuu."

"He's in the library," I croaked from what felt like my deathbed.

"What?!" Vicky shouted, as if she was shocked I dare even speak to her. Leaving the other girls in her wake, she charged up to my side of the bed, her nostrils flaring like an enraged bull and her fists clenched at her side.

She came on so aggressively I worried she might hit me. It wasn't out of the question. I'd seen some of the girlfriends resort to throwing punches over things as trivial as someone cutting the bathroom line at a nightclub, but I'd never seen Vicky *so* incensed before. I think mansion life was eating away at her: she had become desperate, paranoid, and apparently volatile. Panicking, I felt my sore muscles tense, preparing for a blow.

"He's in the library," I croaked again, a bit softer, praying they would all just leave.

"He's in the *LI-BRAAARY*," Vicky shrieked, raising her pitch in an attempt, I assumed, to mock me. She was hovering over my quivering body, her eyes crazed and a vicious smile creasing her puffed lips. I stiffened, half preparing myself to run towards the door. I had no idea what had set Vicky off this time.

"Fuck!" one of the other girls shouted, sounding similarly enraged. "Let's go!"

Relief washed over me as Vicky turned around and began stomping away. Suddenly she spun around and at the top of her lungs screamed, "FUCKING BITCH!" and slammed the heavy door so hard the pictures on the walls shook as if an earthquake had rattled the house.

What had just happened? I thought, adrenaline pumping through my

veins. I took a few slow, deep breaths to calm myself so that I could process the encounter. I was so rattled that I lay in bed paralyzed by fear, praying that Hef would quickly return.

It felt like hours before Hef finally returned to the bedroom. He relayed the story to me about how he had caught the girls adding names to the party guest list and how upset he had been at each of them. For a moment, I felt relief.

Oh my god, I thought. *He's going to kick them out. They're actually going to be gone.*

But when he got to the part where they had gone to get their bunny brands as a sign of loyalty and how very sorry they all seemed, his eyes started to gleam with pride as a small smile spread across his face. His voice was shaking in that way that it did whenever he told a story that "touched" him."

Are you fucking kidding me? I thought. *He wasn't actually falling for this . . . was he?*

"You mean, you're really not going to do anything?" I asked, my raspy voice barely escaping my mouth.

"What do you mean?" Hef asked, truly befuddled. I could sense he was shocked by my response. "They are genuinely sorry, Holly. They said they didn't mean to hurt me and are now more devoted than ever."

I didn't say anything, but it was clear my silence spoke volumes, so he continued.

"They said they're going to put in a lot more time around here," he proudly stated. "They even expressed an interest in coming in and watching movies with us at night. Do you know Dianna actually loves black-and-white movies?"

I could feel the tears burning my eyes as I tried to hold them back. Of course, I didn't know Dianna liked old movies—because she *didn't*! All the "Mean Girls" rolled their eyes behind Hef's back whenever he made mention of his beloved black-and-white films. Hef and I usually watched movies alone most weeknights, which for me was a much-needed re-

prieve from having to be around all the other girls. Surely the Mean Girls would have made good on their promises to Hef, not only in order stay in his good graces, but also to drive me crazy with their ever-obnoxious presence. There was no way I could tolerate any more time around those girls than I already had to.

No, I thought. *I won't.* I just couldn't stay any longer.

"I can't believe you aren't going to do anything!" I cried, tears now cascading down my cheeks. "I can't stay here anymore! I can't live in a house with Vicky—someone who is that mean to me!"

Even though we never talked about it, Hef knew the girls were terrible to me. He just chose not to do anything about it.

"This is *my* house!" Hef screamed at me, his face red with anger. "How dare you complain to me! I treat you like a princess!"

More like Rapunzel, I thought. I shifted my gaze downward and refused to react to his tantrum, which luckily proved to be short-lived. Hef calmed down just as quickly as he became upset.

"Well, I'm hesitant to get rid of Vicky, because other girls seem to really like her," he said thoughtfully, folding his hands in his lap. This was code of course for her ability to recruit other girls into the bedroom. While he knew I was in the room, I wasn't completely sure if he was talking to me or just aloud, so I kept quiet.

As he sat there weighing his options, I felt defeated. Supposedly I was the "love of his life," as he liked to say, but he was weighing my worth against Vicky's. We sat in silence for a long while.

Maybe no one would recognize me as a former Playboy *mistress,* I thought. That was it. I would leave the mansion for good, my bunny tail tucked between my legs—and Vicky would win. Just as I was about to pull myself from the haze I'd been living under, Hef broke the silence.

"Well, you know," he conceded, "I think Vicky *was* the ringleader in this whole thing. She really was the one that led those girls astray." I held my breath as he surely pondered his poor little damsels being manipulated by her.

"I think I'll tell her it's time for her to leave after the Halloween party," he said matter-of-factly as he picked up the bedside telephone to order his dinner.

I didn't say a word. Even to express my gratitude might unintentionally change his mind. I just nodded as if the decision was an unemotional, practical one.

On the inside, I was bouncing off the walls with happiness. Vicky was going to be kicked out! But on the outside, I had to remain calm and unaffected. I knew the battle was over, but I was careful not to rock the boat. That's always how things were at the mansion: you were constantly fighting just to stay afloat, to keep yourself from being kicked out onto the street. Losing sight of what it was I had even wanted before moving in, I became obsessed with being the last one standing in this perverted elimination game . . . I was determined to win.

CHAPTER 6

*"I can't explain myself, I'm afraid, Sir," said
Alice, "because I'm not myself, you see."*
—Lewis Carroll, *Alice's Adventures in Wonderland*

In just one year, I had gone from the newest member of Hef's Party
Posse to the one with the most seniority. Tina, Vicky, April, Lisa,
Candice, and Carolyn had all gone their separate ways. In their place
was an entirely new cast of characters: Bridget (my sole friend), Daphne
(a pretty, cunning girl who quickly became one of Hef's favorites),
Dianna (Hef adored her because she had the helpless "damsel in distress"
act down pat), Elizabeth (one of Daphne's sidekicks who was low on the
totem pole because Hef found her shrill and demanding), Whitney (at
30, the oldest girlfriend and Hef's least favorite because he considered her
"pushy"), and finally Amber (a seemingly sweet as sugar, quiet girl who
defected from side to side when it came to the battle between the Mean
Girls and me).

While the girls were different, some things never changed. With the
exception of Bridget, I was no more successful in making friends with
this group of girls than with the last. To make matters worse, since none

of these new girls were being given the Playmate pictorials they so badly wanted, they therefore weren't kept busy with photo shoots, video shoots, and promotional appearances like the last batch of girls had been. With all the extra time the new girls had to spend at the mansion counting their frustrations, the claws were perpetually out.

The Wednesday and Friday nightclub outings, which had seemed so exciting to me when I first joined the group, became dreadfully monotonous, not just to me, but to all of the girls. On Wednesdays, we would go to Concord or the Standard Lounge, and on Fridays, we would go to the upscale, but not star-studded, Barfly on Sunset Boulevard. Since there were no celebrities to be seen at Barfly, the girls hated it and referred to it as "Barf Fly" behind Hef's back. Each night out would begin with a limo ride to the nightclub, with Hef passing out his "thigh opening" Quaaludes to the girls in attendance. I still refused them, but many girls didn't. The evening out would always end with the girlfriends trying to convince Hef to go home a little earlier than usual. He usually insisted on staying out until 1 A.M., but on the rare occasion he agreed to leave early, we all breathed a collective sigh of relief. Daphne, Dianna, and Elizabeth would beg Hef to bring us to cooler night spots instead of "Barf Fly," but he was loath to change his routine. Also, his cachet on the nightclub scene had subsided over the past year. He had been going out so often, he was no longer a novelty, and he was too high maintenance (always bringing a huge group and always demanding the best booth in the house) for the A-list clubs to be bothered with him anymore.

The dreaded "bedroom routine" still went on after each club night, but the parade of new girls joining the antics had subsided. In fact, anytime a woman the girls found to be a potential threat got too close to Hef, one of them (I was never sure who) would give her a "friendly warning" that herpes was "going around the mansion" and she would instantly back off. The rumor gained such momentum that I was witness to two instances of girls (who had slept with Hef; one was a former girlfriend, one was a weeklong fling) calling his office and asking that he pay for

their herpes medication. Even though he grumbled about how he received a "full physical" every year, therefore it couldn't have been him that they got herpes from, he always ended up paying for the medication. I suppose he did it to keep them quiet and make them go away.

Daytime at the mansion was still as uneventful as ever. Looking for something to occupy our time, Bridget and I became official mansion tour guides. The job required that we familiarize ourselves with every fact about every nook and cranny of the 21,987-square-foot house and the 5.3-acre property. We hosted the frequent morning tours—mostly to servicemen and charity raffle winners—and we were even given custom Bunny costumes made specifically for us, which was a real treat considering that even Playmates weren't allowed to keep theirs. (While most people use the term "Playboy Bunny" to describe anyone associated with the magazine or Hef, the term actually refers to the waitresses who wore the Bunny costumes at the Playboy Clubs, which existed in the middle part of the last century. In the absence of these clubs, Playmates occasionally donned the costumes for photo shoots or public appearances.)

I spent a lot of time in the mansion's zoo, learning about the animals from the wonderful zoo staff. Hundreds of exotic birds and three types of monkeys called the grounds home. I made friends with a large spider monkey named Coco whom we eventually trained to be able to walk around on a leash.

One day, as a favor to Hef, I decided to take on the project of "organizing" his bedroom. Even for someone with a lot of time on her hands, it was a formidable task that ended up taking several days. From the first time I'd ever seen the inside of his bedroom to my days as his main girlfriend, Hef had managed to collect even more junk. A recent *Premiere* magazine profile of Hef had referred to his room as "the lair of the Playboy pack rat."

One of his most prominent collections was his film library. At that time, many of the films he had collected were still languishing in stacks on his bedroom floor, in the form of ¾-inch tapes (which look like larger

versions of traditional VHS tapes, all in generic gray clamshell cases). My main order of business was carrying all the tapes upstairs and filing them in one of his many video closets so they could await conversion to DVD by his "video staff" (who also operated as a human TiVo, taping every television program he circled in the *TV Guide*).

This ended up becoming quite the workout; I must have climbed up and down those stairs more than 300 times carrying heavy stacks of tapes. It was particularly unpleasant when I'd unearth a tape and realize it was coated in years-old dog urine.

As the piles diminished, ornately carved walls I had never seen (and which probably hadn't seen the light of day in a decade) appeared. While it felt good to see the room come together, I must say I found some things I would have rather not seen. Topping the list? An old reel stashed away in a drawer full of porn labeled "Girl and Dog."

It made me wonder if Hef had ever thought about who was going to go through his things one day after he passed away. He was so fastidious about his public image and about having every moment in his life documented and recorded in a way that showed his life the way he wanted it shown.

I was disheartened to learn from one of his friends that he had plans to donate his scrapbook collection to a library or university after he passed, though he hadn't settled on which one at that point. It was such a personal and private collection, not just for him, but for anyone who'd ever been in his life.

Hef holds the Guinness Book of World Records title for largest scrapbook collection at over 2,000 volumes. He keeps them in his attic along with desks and supplies for his scrapbook staff (yes, he has a scrapbook staff) to paste everything together. Good or bad, anything written about him goes in the scrapbook. Every picture his photographers take ends up in the scrapbook. Every girl he takes out is pictured in the photos, and the insinuation that they slept together is there along with nude photos, in some cases. I'm sure many girls included in the scrapbooks wouldn't be too thrilled to learn they could be public property one day soon.

I know I wasn't. Granted, there wasn't anything scandalous about me in the scrapbooks, but it was humiliating to think that *anything* personal I had trusted him with could end up public property via their inclusion there, even if it was just something trivial like a sad note I had written to him. It was another thing that made me feel embarrassed, trapped, and forever branded.

In another attempt to occupy my time (and my brain), I began taking French lessons, acting classes, and real estate investment courses at UCLA. I needed to do something to stimulate my mind and avoid permanent bimbo status. The stammer I had developed continued to creep into my speech, and I hoped that furthering my education might somehow help. Bridget and I truly were kindred spirits. She had already received her master's degree, but felt the weight of mansion life affecting her head, too, and began taking classes as well.

The classes were the only part of my day that didn't in some way revolve around impressing Hef or conforming to his rules. He couldn't have cared less about what I was learning. To him, a woman's beauty is her most powerful asset . . . unless of course she happens to be famous.

Above all things, Hef is fascinated with fame (both his and other people's). He is obsessed with cataloguing his life as a public figure and keeps records of every press interview he's ever done. Celebrity is one of the few things that can't be bought—and Hef prides himself greatly on his 60-plus years in the spotlight.

Whenever even the most Z-list celebrity would grace him with his or her presence, Hef would drop everything to accommodate the "star." It made me feel so incredibly insignificant, and it was embarrassing to watch him act even cheesier and more fake than he usually did. Hef never even bothered to introduce us to his guest—as if we were some lifeless mannequins unworthy of such an "honor."

While I had always dreamed of one day becoming an actress, it wasn't until I lived at the mansion that I began craving fame strictly for fame's sake. In some corner of my mind, I thought that maybe if I became

famous I would have some value. Perhaps I would earn Hef's respect after all. Maybe I could even score a pictorial in the magazine.

My life had become so backwards. I had once looked at a *Playboy* pictorial as a stepping-stone to an acting career, but over the past few years I had become so absorbed by *Playboy* that I started seeing fame as a stepping-stone to a pictorial. I was completely coming undone.

"WE HAVE *PINK PUSSIES*!" a loud baby-voiced blonde shrieked, charging past security into our roped-off table at one of our regular night spots.

Hef *adored* Paris Hilton. Before she became a household name with her television show *The Simple Life,* Paris was a notorious socialite who was regularly mentioned, along with her sister Nicky, in Page Six.

With some sort of murky pink liquid (these shots were the "Pink Pussies" Paris referred to) sloshing out the tops of three shot glasses, Paris squeezed her way into our VIP section of the club. Like clockwork, Hef motioned for us to scoot down to make room next to him for Paris. According to Hef, she was a "celebrity" (even though her meteoric rise to fame was still months away).

I took it upon myself to always take note when a celebrity would make the effort to introduce him- or herself to us or even simply blanket the group with a simple "Hi, girls!" Many of them ignored us entirely and spoke to Hef as if he were the only person in the room. Since Paris took the time to introduce herself, she fell into the "nice" category.

It was the heyday of the club scene in Los Angeles, so we would see Paris around semi-regularly. She'd always make a point to come over and say hello to us—and each time Hef would just beam like a perverted grandfather. At one point, I heard, she even began discussing the possibility of doing a pictorial with *Playboy* photo editor Marilyn Grabowski.

But a few weeks later, Paris, in the lowest low-rise jeans, the skimpiest blue top, and the darkest spray tan I had ever seen, appeared tableside during one of our club nights at the Standard Lounge to speak with

Hef. I noticed she seemed more subdued than usual as she leaned into his "good ear." She appeared to be explaining something to him. When she eventually walked away, Hef turned towards me and said: "She can't pose for the magazine because her mother said she would disinherit her." Whether that was true or if it was just an excuse she made up in order to back out of the discussions, I don't know.

Right before her new Fox reality show aired, Paris's now infamous sex tape surfaced, making her the most talked about woman on the planet. *1 Night in Paris* quickly became one of the bestselling porn videos of all time. Posing nude for *Playboy* wouldn't have been nearly as controversial as her sex tape. What nude photos did for Marilyn Monroe in the 1950s, sex tapes were now doing for 21st-century starlets. *The Simple Life* premiered to more than 13 million viewers.

I certainly wasn't planning on ever making a sex tape, but any TV appearances I could get—even it was just as "Bunny Number 2"—I jumped on. Given our roles as mansion tour guides, Bridget and I were often drafted to help play hostess when television shows came to film. During a shoot for MTV's *Doggy Fizzle Televizzle,* Bridget and I gave Snoop Dogg the official tour. When MTV returned to shoot an episode of *Viva La Bam* on the property, I was asked to be the Bunny who interacted with the cast. Desperate to swipe the spotlight away from me, Daphne came to crash the shoot, but her spot ended up on the cutting room floor. Shucks.

When MTV Cribs shot a Playboy Mansion episode, only one girlfriend could fit in the doorway alongside Hef for the opening shot—and since I was his main girlfriend, I got the part. The crew took a liking to me and asked that I lead them along on the tour. (One of the other girls in particular tried shoving her face on camera as much as she could. She was green with envy that I was getting this opportunity and rolled her eyes whenever they asked me to say something on film.)

Rarely would a request come through to shoot all the girlfriends together, but before the holidays one year, a Los Angeles news station asked to film a segment with all the girls in our pajamas in front of the man-

sion's Christmas tree. Hef insisted we each wear the same matching over-size flannel pajamas he kept in bulk in his closet, but I decided to wear my own slim-fitting pajamas with red Playboy Bunny heads printed on them. Hef was extremely offended and demanded that I march back up-stairs and put on the de rigueur pink flannels. Was I one of his children?

I refused. I hated having to conform, especially to this group of girls. I also found his baggy, faded flannel pajamas terribly unflattering. I wasn't granted permission to wear my outfit of choice without yet another ar-gument complete with flowing tears from Hef. (He later apologized for being so upset after he saw the other girls pile around the tree with delib-erate markers of their own: a yellow duck beanie, a Pomeranian puppy, etc. I wasn't the only one desperate to stand out.)

Those TV spots were fun, but I was *really* excited when Fox started shooting a reality television show called *Who Wants to Be a Playboy Cen-terfold?* (The show was intended to be a series, but ended up getting cut down into just a one-time special.) I thought this could be a chance for me to learn more about the behind-the-scenes operations of television, and who knows, maybe even get discovered myself. The show was shot mainly in a ranch-style home across the street from the mansion that Hef had recently purchased, which we would later take to calling "The Bunny House." Twelve contestants vying for a chance at a Playboy centerfold were moved into the house, three or four girls to a room. The girls would participate in several photo shoot challenges as they were eliminated one by one. Finally, a winner would be chosen to be Miss July of that year.

Much to my dismay, Hef deliberately kept his girlfriends far, far away from the production. Desperately bored with my day-to-day life, I became obsessed with learning every behind-the-scenes detail about this television special. I even snuck into the living room during a production meeting to listen in as Hef clandestinely discussed the next round of contestant elim-inations with the producers. I casually flopped down into a pile of pillows in the corner of the room so I could secretly hear their conversation.

"We have to keep her! She's the bitch!" a female producer exclaimed after Hef pointed out who he would like to eliminate next. "She makes great television!"

"I dunno, I think she's a little overweight," Hef grumbled.

"She's right, we need to keep her," an enthusiastic male voice chimed in. "She's confrontational with the other girls in the house. She adds conflict."

"Okay, well, we'll keep her for the next round and see how it works out," Hef slowly acquiesced.

Wow, I thought. I was familiar with *America's Next Top Model,* the show that this Playmate competition show appeared to be based on, and never would have guessed that contestants were kept on strictly to stir the pot. It made sense, but in the early days of reality TV, viewers weren't as wise to the process as they are now.

Interestingly enough, the girl Hef had deemed "overweight" became a favorite of a *Playboy* photo editor, and her centerfold was so well produced, Hef ended up selecting it as the winner. Since viewers wouldn't be happy with an antagonist winning the competition, the show was quickly re-edited to take out those "pot-stirring bitch" moments and make the winner look like America's Sweetheart. (By the way, I always found the winner to be a nice person. I suppose she was a little more honest and blunt than the rest of the contestants, hence the "bitch" label that people like to throw onto assertive women.)

Anything is possible, I thought. *Maybe Hef will one day change his mind about my chances of being a centerfold, too.*

The television special was just the latest in a slew of media opportunities Hef had begun participating in over the past few years. Two of the most substantial, documentaries titled *Playboy: The Party Continues* (2000) and *Inside the Playboy Mansion* (filmed before my arrival in 2001), followed Hef's new life as a 70-something swinger. Any time a *Playboy*-related program aired, it scored fantastic ratings. Middle

America was still buying into the intrigue and racy glamour of the *Playboy* world, made interesting again by Hef's reemergence onto the social scene.

Hef loved the documentaries that covered his life, but he also loved any chance to cross over to a younger audience (he was obsessed with appearing "hip" and relevant), which is how we found ourselves doing press in the middle of a Justin Timberlake video shoot in the mansion's backyard.

"So, do you listen to hip-hop?" the MTV reporter asked.

"Uhhh," Hef began, seemingly at a loss for words. "Ummm . . ."

In early 2003, Justin Timberlake was at the top of his game. You couldn't spend more than 10 minutes at any nightclub in Los Angeles before hearing a track from his latest album *Justified* (so much so that I *still* can't listen to a single song without being overcome by painful memories). When a request came through *Playboy* asking to shoot a music video at the mansion for the Nelly track "Work It" featuring Justin Timberlake, the answer was of course yes.

When it came time to shoot the video, the director offered Hef and his girlfriends small roles. Because some of the other models in the video were topless, it was deemed too racy for the United States and only aired internationally. During the shoot, Hef sat in his own wooden throne-like chair bobbing along to the beat and wearing black sunglasses, with Nelly and Justin Timberlake on either side of him, while we danced around them in skimpy outfits. After filming wrapped, Hef was asked to do an interview with MTV news. All the girlfriends gathered around Hef, and I took my place at his immediate right.

"Uhhh," Hef continued to fumble. This nonresponse was completely out of the ordinary. Usually he was a pro at these interviews, able to call upon a laundry list of canned responses to just about any question you can imagine. I listened to Hef rattle off the same answers he'd given a million times before, often word for word. I think I had unintentionally memorized some of them myself. He struggled for so long, it was becoming

awkward and I feared the reporter had only asked about hip-hop to trip up the 76-year-old man, so I decided to cut in.

"You listen to it out at the clubs," I offered, looking at Hef with a warm smile, aware that all eyes were on me.

"Er, um, yes, yes," Hef said, regaining some composure. "We listen to it when we go out." He coasted through the rest of the interview on his Rolodex of previously used responses and we wrapped.

When I finally managed to get up to the master bedroom to change out of the red skirt and lace cropped halter I had worn for the video, Hef had beaten me there and was already standing in front of the bathroom sink.

"YOU," he began loudly when I appeared in the doorway, "have NO answers! You are to keep *quiet* during interviews!"

"Sorry, I was just trying to help," I mumbled as I darted around the corner into the vanity. My eyes started filling with tears—as they did almost daily back then.

I was to keep quiet, I repeated in my head. He was treating me like a dog. Sit! Stay! No barking! Only I'd never seen him be so mean towards his animals. I had tried to help my boyfriend navigate a sticky situation and now I was being punished for it, which made the reprimand hurt all the more. Despite his many abuses, I had grown protective of Hef and felt like the interviewer could easily have made him look like a fool. In the few years I'd been at the mansion, I'd never seen a question throw him so entirely off his game. What if the producers decided not to be kind that day? The way he was sputtering in front of the camera, they could have easily made him look like a senile old coot.

But he clearly would rather have looked like an idiot than get help from one of his "dumb blondes."

When would I ever catch a break? I wondered.

FOR THE MAGAZINE'S 50TH anniversary, A&E wanted to shoot a TV special to air on the network. The program included a party at the mansion

celebrating the magazine's iconic run and honoring *Playboy*'s most famous Playmates. As girlfriends, we had no role beyond getting glammed up and sitting quietly next to Hef, but I used it as an opportunity to try to give myself a much-needed boost of self-esteem. I decided to treat myself to something really special: a red, Jessica Rabbit–inspired Baracci gown that cost a few thousand dollars. I never spent that much on clothing, since I was trying to put away as much money as I could, but I felt I finally deserved the treat. I always remembered how stunning the Bentley twins looked in their glamorous Baracci gowns, and seeing as though this was an extra-special event, I figured I could splurge!

"You know, you will look back on this time as the best time of your life," Mary had said to me after one of my vent sessions. "All the dressing up and things you get to do." I trusted Mary and always told her how I felt, but if this is the best time of my life, *shoot me now,* I thought.

Foolishly, I'd long believed that becoming a *Playboy* centerfold was the fast track to fame and fortune. Boy, was I wrong. There have been more than 720 Playmates in *Playboy*'s history. How many of them can you name? Even if I did happen to score a pictorial someday, it didn't necessarily mean anything beyond validation. More than ever, I had begun to accept that I would never achieve anything greater than my role as "Hef's main girlfriend."

The handful of Playmates who *had* become famous were all in attendance that night. Playmate and TV personality Jenny McCarthy hosted the event (her beauty is matched by her wit—she ended up being the best part of the show, by far!), which included musical numbers and stand-up acts. Nineties Playmate stars Anna Nicole Smith and Pamela Anderson were also in attendance.

Barbi Benton, Hef's main girlfriend in the '60s and '70s, attended the soiree. While not technically a Playmate, Barbi was featured in several pictorials and on four *Playboy* covers. Hef went out of his way to keep in touch with many of his ex-girlfriends—partly out of sentimentality but also, I believe, as a form of damage control. Keeping in the good graces

of his ex-girlfriends was a sort of insurance policy. I guess he figured the regular invites back to the mansion would keep anyone from speaking negatively about him.

Barbi would end up becoming a regular guest star on *The Girls Next Door,* and I ended up really liking her. She was quirky, friendly, and creative. Barbi wasn't a close confidant, though. Despite having dated the same man, we couldn't really relate on that subject. Sure, Hef was much older than she was when they dated—old enough to be her father, though, not her grandfather. Plus, Barbi didn't have to share Hef publicly. He wasn't faithful to her by any means, but she could at least pretend the other women didn't exist. Never was she forced to one side or the other to make room for a gaggle of giggling blondes to line up around him.

It was a surprise to me how mannered and reserved many of the former Playmates were. Despite presenting Hef with a birthday cake to-tally nude while filming an episode of *Girls Next Door,* Pam Anderson always struck me as incredibly guarded and quite shy. Spending a decade being chased by paparazzi must have made her cautious around people. Like Pam, Anna Nicole was surprisingly quiet and very polite. I met the towering blonde only briefly, but she exuded the charm and etiquette of a real southern belle. Like most former Playmates, they were cordial with Hef, but I don't believe they knew him very well. During the Pam/Anna Nicole era, he was married to Kimberley and didn't socialize with the Playmates much (if at all). Needless to say, those Playmates didn't have to endure the Playboy "casting couch" that existed after the end of his marriage.

I was beyond thrilled to meet 1950s pinup Bettie Page—a living legend! While her hair had long ago turned gray, she still wore it neatly styled with those short iconic bangs. In her later years, Bettie became a born-again Christian and conducted herself like the gentle, churchgo-ing lady she was. Her name and likeness had become popular again in the '90s, and it was Hef and his friend Mark Roesler who found Bettie and reconnected her with the business end of her pinup past. As a small

memento, I gave Bettie a "Miss January" necklace to commemorate her January 1955 centerfold. She later told me she hung it on her wall so she could always "look at it." When she passed away in 2008, I was heartbroken but grateful that we were able to have met.

Despite the odds, a part of me still held on to my dream of one day becoming a famous Playboy Playmate. And after meeting these iconic women that night, I felt like I should at least *try* to make my dream come true!

"Do you think I could ever be a Playmate?" I squeaked nervously to Hef, my voice coming out even higher pitched than usual.

I held my breath.

After living at the mansion for quite some time, I finally got up the nerve to ask about the possibility point-blank. I spit the question out one evening while he was reviewing Playmate videos in his room.

"I knew you would eventually ask that," he replied solemnly, his eyes still focused on the video. Finally he let out a sigh and said, "I don't think so, Holly. There are a lot of blondes scheduled for upcoming months already."

A massive lump formed in my throat. *Okay,* I thought, fighting back the tears. *I can take that. It seemed reasonable: too many blondes.*

"Besides," he continued, now looking directly at me. "You don't have the look. You just don't photograph well."

"Oh," I said slowly, careful to keep my voice from quivering. "Right." I'd always felt that Hef didn't think I was very pretty and that he thought I was lucky to be living at the mansion. But hearing him basically say that hurt even worse than I could have imagined. I had prepared myself for a negative response, but I had thought he would have been more tactful. Luckily, his eyes remained riveted on the TV screens, so I could wipe away my tears discreetly.

"I'd let you shoot for 'Cyber Girl,' though," he offered, as if it were some kind of consolation prize. Playboy.com featured a new "Cyber Girl" each week—these were usually just photos pulled from the rejected

Playmate test shoots. It was a throwaway offer. He knew it; I knew it, and I wasn't interested in being one of the many girls haphazardly tossed online without ceremony. If I was going to take the leap and pose nude for the world to see, I wanted to become Playmate of the Month.

But then I thought, maybe posing for a "Cyber Girl" shoot would show Hef that he was wrong about me. Perhaps the photos would actually turn out good enough that he'd *have* to reconsider me for Playmate. On the other hand, if the photos were a total disaster, maybe all those flaws that he saw in me were real and I'd finally be forced to face them dead-on. Was I so hideous that I couldn't be a Playmate?

"Okay, open your knees a little wider," directed the photographer, as I sat facing the camera on a red sofa without a stitch of clothing on my body.

The shoot took place at the Bunny House—the brightly colored midcentury home right across the street from the mansion. Naturally, I was a bit anxious, but Sarah the makeup artist (who has since become a good friend) made me feel at ease. The photographers were tired of the heavy-handed, '90s-style makeup Hef still liked on Playmates. Since this was not a Playmate shoot, they took the opportunity to use a more natural style, which I ended up liking.

When the stylists wheeled in the wardrobe options on a metal clothing rack, my stomach tied itself in knots. As Hef's main girlfriend, they wanted me in a short satin kimono robe touting a plastic prop pipe (say that three times fast!) to pay homage to my boyfriend (the Hef tribute had been done once before by his second wife, Kimberley, and would be done again by his third wife, Crystal). The remaining selections felt more downscale stripper than the old Hollywood glamour style that I would have preferred.

"Can't you see too much?" I asked timidly. *This was* Playboy, I thought. *Not* Hustler.

"No, you can't see anything from this angle if you lean forward," the photographer reassured. "I swear."

The photographer assigned wasn't one of the two used to shoot the Playmate pictorials, and I was worried that I was wasting my time. Since I wasn't getting the opportunity to shoot with the best of the best, I was terrified that my photos weren't going to be the home run I had hoped they would be. Despite what my gut was telling me, I continued with the shoot. I didn't want to seem ungrateful or bratty.

"How did the shoot go?" Hef asked when I appeared in the master bedroom. After a long day (which included a car wash scene, in February) I was cold and exhausted and wanted nothing more than to shower and crawl into my pajamas.

"I'm not sure," I answered honestly. "I don't know if I'll like the photos."

When the slides came back (Playboy was still shooting on film in 2003), I hated them. As I predicted, they were far more explicit than I wanted them to be. I felt like a fool for listening to that photographer.

Adding insult to injury, the slides were accompanied by a memo from *Playboy*'s Chicago photo editor, saying something to the effect of: "Hef, do you want us to use these? They look like they were shot in your room with her wearing your robe and smoking your pipe."

The comment made it sound like I was some interloper sneaking around the Playboy Mansion taking photos without permission. Was the editor not aware that I was Hef's girlfriend? I felt so embarrassed. Usually, Hef made such a public fuss over whoever his main girlfriend was—I felt like I was the first one he neglected to do that with. It made me feel like I was not beautiful or glamorous enough to merit such praise. In hindsight, I know he was just sick of the high turnover with his past girlfriends. They were lasting, on average, about six months, and he was done floating any girl's ego. He had come to the conclusion that if he kept us broken and needy, we would stay.

Broken and needy were definitely two adjectives that perfectly de-

scribed me during that time. After about a year of stubbornly trying to maintain some semblance of individuality, I finally gave up on my short hair and started wearing clip-in extensions to give me the long hair Hef preferred. I was feeling more disconnected than ever from the goals I once had; mansion life had eaten away at my self-esteem. I found myself constantly trying to compete with the other girlfriends who were all caught up in who was prettiest. It was a perpetual contest to see who could be the skinniest, tannest, bustiest, most baby-faced with the longest, whitest hair.

We were all striving to win. We were trying so hard to stand out and be coined the "hottest" of Hef's harem that we completely missed the fact that we were making ourselves indistinguishable from one another.

After thinking about it for a few days, I finally worked up the courage to ask Hef to scrap my Cyber Girl shoot. With a huge knot in my stomach I explained that I wasn't really comfortable with the results and would rather the photos weren't floating around the Internet. He assured me that he would let the Chicago office know—and he did, but only after the pictures had already been posted on Playboy.com for a few hours. The editor took them down immediately, but that doesn't mean much. Once something appears on the Internet, it never really goes away. To this day, those photos are probably floating around somewhere.

Oh well, I thought. *I guess there could be worse things out there.*

WHILE I WAS RACKING up disappointment after disappointment in the pursuit of a career, my "social life" at the mansion wasn't faring any better.

Most of the other girlfriends seemed to hate me with a passion, though I never did anything to them besides keep my distance. Daphne was the alpha female of that group and the other girls followed her like sheep. It didn't take a genius to figure out that Daphne would have loved to install Dianna in my place as main girlfriend. They felt my role as main girlfriend was to be a sort of representative for the other girls and make

sure that we continued to enjoy all the perks of living at the mansion. Under their breath, when they weren't making comments about my appearance (Daphne loved to make fun of my "thin lips" since I was one of the few who didn't have my pout inflated with fillers), I'd overhear them make comments alluding to the fact that I didn't "run things" as well as Tina, since Hef had so noticeably tightened his purse strings with the girlfriends in the last few years.

The majority of the women who had done time at the mansion were born hustlers who knew how to milk a man for every last cent. That ability to manipulate just wasn't a part of my DNA. I was way too timid, and besides, I actually liked Hef. I wasn't interested in scamming every penny I could get out of him! Prior to me, Hef's girlfriends were masters of the hustle.

The Bentley twins were showered in lavish gifts: Rolex watches, fur coats, matching BMWs, designer gowns, and even furniture for their off-property apartments (which were also paid for by Hef). When the twins (along with Brande Roderick) moved out, the original seven moved in and Hef decided to tighten up the purse strings. Still, Tina was skillfully calculating and was able to secure each girlfriend a leased car, a sizable wardrobe allowance, and lavish Christmas gifts. But it was nothing on the scale of what the twins had managed to bank.

When Tina left the mansion, Hef tightened his belt even further: no shopping sprees, less allowance, and off-site apartments were now strictly forbidden.

Anyone who joined the *Playboy* harem was after something. Most of the girlfriends were looking to get their pictorial and as much cash as humanly possible, like hookers on the clock. While I wasn't after Hef's money (I was just grateful to have a roof over my head!), I too saw my stay at the mansion as a once-in-a-lifetime sort of thing that could lead to potential opportunities for my future.

"I don't care about money, I just want to be wonderful," was a Marilyn Monroe quote I lived by. I wasn't looking to get rich, but I was hungry

for a career. I just wanted to accomplish something . . . anything! Sure, I believed I had come to care for Hef, but let's get real: it wasn't love at first sight and I had my own set of goals. Greed just wasn't part of it.

During a trip to New York City for *Playboy*'s 50th Anniversary Party (one of many anniversary parties that would be held that year), Bridget, Amber, and I were excited to spend a few days touring the city in style! While Hef busied himself with press interviews, we spent time visiting Central Park, ice-skating in Rockefeller Center, eating New York–style pizza, and jumping on the giant keyboard at the FAO Schwarz on Fifth Avenue.

As required, we invited the Mean Girls to join us, but they couldn't be bothered. Instead, they ran off to Bergdorf's and purchased three incredibly expensive designer handbags. Though Hef threw a fit about the purchase, he let them keep the bags.

While Bridget, Amber, and I were focused on the experiences and actually liked *some* things about Hef and his lifestyle, the Mean Girls seemed to be focused only on the money. It felt like each side thought the other side prevented them from getting what they wanted. Knowing damn well what the previous roster of girls had been given, it seemed the girlfriends decided I was the reason their pockets weren't lined with cash and jewelry and decided to take matters into their own hands.

"Holly, Hef would like to see you in his office," the secretary said through the phone line. The Mean Girls made sure I was routinely called down to the principal's office, so to speak.

What was it this time? I thought. One girl in particular loved to whip up fictional stories about how I had supposedly wronged her. Any time she would get heat from Hef for not following his rules to a T (this happened constantly with most of the girlfriends), she loved to deflect attention from herself by making something up about me. Every time she made a mistake, it was somehow my fault, though we had virtually nothing to do with each other. It was all bullshit. Hef saw through her. After all, she wasn't that clever, but he loved playing the game too much to call

her out on her lies. Being able to hold her stories over my head was just another tool Hef used to manipulate me. Watching me get upset and squirm was just another way he satisfied his perversions.

Every year since I had moved into the mansion, I made a trip to Disneyland for my birthday. I expected all of the girlfriends to attend—simply because girlfriends were required to attend all planned events on Hef's schedule—but only Bridget, Amber, and my friend Britney showed up. The message was received loud and clear: I was being boycotted. They were trying to convince Hef that things would be better if I weren't around, because, after all, he was constantly saying that he just wanted "harmony" among the girls.

I don't believe that he really wanted harmony—not for a single minute. He *thrived* on catty drama among the women. Nothing made him feel more important than a bunch of girls "fighting over him." At the time, though, we were all naïve enough to believe what he told us.

Unfortunately for the Mean Girls, their Disneyland boycott backfired. Not only did it make them look like pouty little children, which Hef hated, but it also allowed me to have the most enjoyable birthday celebration I'd had in a while!

They wouldn't give up that easily, though.

In an attempt to further drive their point home, they had all gone out to the Santa Monica Pier together and had a group caricature done for Hef as a gift.

"Knock, knock!" one of the girls squealed loudly through the master bedroom door. Hef and I were sitting in bed eating dinner and watching the news, as we usually did on weeknights, when the Mean Girls came in to present him with the gift. As he fawned and cooed over the picture, I noticed the girls exchange a few sly glances and smirks. It was as if they were saying: "See how great we all look . . . without Holly and Bridget."

If Bridget or I had chosen to get a gift for Hef without including the other girlfriends, we would have been reprimanded for not including everyone. Yet no one—Hef included—acknowledged my presence in

the room or my glaring omission from the drawing. It was as if I were a ghost.

What Daphne and Dianna didn't realize is that they'd never be able to push Bridget and me out as long as they were still aligned with Elizabeth and Whitney. Shrill Elizabeth and "pushy" Whitney were never Hef's cup of tea. I heard he turned each of them down the first time they had asked to move in, but eventually he kept them around as filler—so he could reach the "seven girlfriends" quota that had become his trademark. (Over the previous year or so, since his girlfriends hadn't been gracing the pages of the magazine as often as they once did, the number of girls clamoring to be included in his "party posse" had understandably subsided.)

Whitney had always been Hef's least favorite—in part because she came into the group under some unsavory circumstances.

"Hef, do you think Whitney could start getting an allowance?" Tina had asked. Despite having left the mansion months earlier, Tina still trotted around from time to time to see what she could squeeze out of Hef. "She works really hard to get all dressed up for you and to come to all the events. She'd make a really great girlfriend."

At the time, Whitney was good enough to join him in the bedroom, but he wasn't too keen on asking her to move in. Tina had clearly been recruited to go to bat for her.

"Actually, Tina, I'm hoping that with this next set of girls, expectations won't be so high," Hef explained to his former girlfriend. "Do you know I spent two million dollars just on girlfriends and trips in the past few years?" (Most of that went towards the private planes he chartered, sometimes on the company tab, and the trips he took his girlfriends on—including a lavish European tour before I had arrived.)

"She's putting in all this time and all she's getting out of it is a drink and a fuck!" Tina said, clearly frustrated that she wasn't getting her way. Like I said, this girl was a hustler.

God, I thought. *I could never get away with talking to Hef like that.*

The room got very silent as Hef sat staring at Tina.

"I like to think of this as all of their dreams coming true," he said very solemnly. Even Tina was struck silent by how serious he was. Did he really mean what he was saying? It sounded so conceited to assume that simply being in his presence (or bedroom) was a "dream come true" for these women. The "hurt" expression he held on his face forced Tina to abort her mission.

"Okay, sorry," Tina offered and leaned over to give him a peck on the mouth. As she walked out the door, she called out a thoughtless "Love you!"

For months Hef continued to reject Whitney's pleas to become a girl-friend, but eventually her persistence paid off and one day she moved into the mansion. We quickly discovered she was a pathological liar—and it was actually pretty amusing. Her age, former professions, and life story changed daily.

"Darlin'?" Hef asked, appearing in my dressing area one afternoon.

"Yes?" I asked, pulling my nose out of my French homework.

"I need to talk to you about something," he said, his brows furrowed, and pulled up my vanity stool. His somber eyes connected with mine. "Did you drug Whitney's drink last night?"

"No!" I exclaimed through a fit of laughter. "Are you serious? Did she really say that?"

The night before we'd gone to the Saddle Ranch on Sunset Boulevard for dinner. Whitney had quite a few cocktails and decided to ride the mechanical bull. While no one really thought twice about it, she was apparently mortified by the decision and desperately searched for a reason to excuse her behavior.

"Yes," he said. "She feels silly about last night and says she would never have done it normally and believes you and Bridget drugged her drink."

The smile disappeared off my face as I realized that he was taking her insane accusations seriously.

Bridget and I were so square we wouldn't even have known how to

get drugs, let alone be tricky enough to slip them into someone's drink unnoticed. In front of a whole table full of enemies, no less. I made this immediately clear to Hef.

Come on, Whitney, I thought. *At least go for something somewhat believable.*

"That's what I figured," Hef said, a smile slowly cracking on his face. "But you know, I just had to be fair and ask."

Phew. Luckily for me, it was Whitney making the allegations. I don't think things would have gone so smoothly if his beloved Dianna or Daphne had made the claims.

Why can't Hef see how awful they are? I wondered.

I started questioning who would last the longest: me or the Mean Girls? I wasn't sure how much more of the absurdity I could take. After more than two and a half years at the mansion, I felt no more surefooted than I had on the day I arrived. I felt like I was constantly walking on eggshells, trying not to set off a land mine of drama each day.

At the time, I had no idea that their days were numbered. But I wouldn't be the one who took them out. It would take someone else to get rid of them. Someone a little bit more Hef's type than I was: someone younger, blonder, and much, much ditsier.

CHAPTER 7

Alice felt so desperate that she was ready to ask help of anyone.
—Lewis Carroll, *Alice's Adventures in Wonderland*

It was April 2004 and the air had grown stale at the mansion. Bridget and I were constantly at odds with the other girlfriends. I could sense that even Hef felt he was ready for a change. It was only a matter of time before Hef started spring-cleaning and invited in a new girlfriend.

And just who would it be?

Please be someone nice, I prayed.

As you might imagine, Hef is both meticulous and exceptionally picky when it comes to his women: girlfriends, Playmates, etc. He has a picture of every girl that's ever come to the mansion—mostly Polaroids. If you were visiting the compound for the first time, a designated staffer would snap a photo of you before you entered the party (as they did to me years earlier), and those Polaroids were compiled for Hef to review the next day. He would label them A, B, or C (based primarily on their looks but also on how scantily clad they were) before having them catalogued in his social secretary's office.

The A category was the most elite—meaning those girls were al-

lowed to be invited back for all events or perhaps even a Playmate test
or an evening out with Hef. The B category was reserved for girls Hef
would be comfortable inviting back for larger mansion parties (like Mid-
summer Night's Dream) as well as some of the smaller Fun in the Sun
pool parties. The C category was the label bestowed on girls that were
to be invited back only if they were absolutely desperate for more warm
bodies.

Whether it's for his scrapbooks, his parties, or his magazines, Hef is
obsessive about photos. When I lived there, he still reviewed most of the
magazine submissions himself—and always gave his final sign-off on an
issue. He also felt it necessary to see pictures of every model that would
be working one of his parties.

Inside his room there was a calendar of upcoming events, and next to
it was a wooden box. Inside the box were photos of Playmates and poten-
tial Playmates attached to a notecard with the girl's information printed
on it. This was a distinctive pile, because *these* were the girls Hef was
considering inviting out for a night. Occasionally there would be a pile in
front of the box with photos of girls that had attended a mansion party
or girls that had submitted photos to the magazine and weren't being
considered as Playmates, but were still cute enough for Hef to consider
taking out. For so long, this box was my nemesis, as I dreaded possible
new additions to the harem. This time, however, I was determined to
finally use the box to my advantage.

Bridget and I were beyond tired of the Mean Girls, but we knew Hef
wouldn't be content with just the two of us. We just got along too well for
his taste. How could Mr. Drama King feel fought over, coveted, or inter-
esting if his girlfriends actually got along? I knew Hef felt he needed to
be seen with a gaggle of women in order to keep up his macho Playboy
image, and since he viewed Bridget and me as virtually the same person,
I knew a new girlfriend would have to move in in order for us to have a
chance at getting rid of the others.

The Mean Girls had already checked out, mentally. Daphne, Dianna,

and Elizabeth had been at the mansion for more than two years—and by this point probably assumed they'd never be offered a pictorial. They each began focusing more on their lives *outside* the gates (aka other boyfriends, in some cases), so it was only a matter of time before they moved out or Hef asked them to leave. But even that wasn't soon enough. Bridget and I knew that if we wanted any sort of influence in kicking these girls to the curb and figuring out who their replacements would be, we'd have to act quickly.

A few days before Hef's 78th birthday party, I noticed three pictures stacked in front of the wooden box in Hef's closet. I grabbed the photos and info sheets to scope out our options: Tiffany, Nicole, and Kendra. Apparently, the girls were auditioning to be "Painted Ladies" at the party, and the body paint artist had submitted the images to the mansion for approval. The photos eventually made their way to Hef's private "consideration" pile, which meant he would definitely be keeping his eye out for them at the party.

The day of Hef's soiree, Bridget and I went downstairs to the gym to meet the "Painted Ladies" as they got ready (it took most of the day for these girls to get covered head to toe in body paint). All three girls seemed nice enough, but Bridget and I decided that Tiffany was our favorite. She was easy to talk to and seemed really smart—plus, she had a knockout smile, long ash blond curls, and a gorgeous naturally curvy body. More than hot enough to be Hef's girlfriend, but a refreshing change from the bleached-blond Fembot look.

Unbeknownst to us at the time, Hef had also made a pilgrimage down to the gym to check out the prospects and made a beeline toward Kendra Wilkinson—the most platinum and plastic of the bunch.

Preparing for a mansion party took an entire day. The large parties were the highlights of mansion life, so the girlfriends were expected to look flawless. Couple that expectation with the fact that we girls had a lot of time on our hands, and you get marathon "beauty days." All of the girls started their day visiting the salon to spend hours on an elaborate

hairdo. That year I had purple streaks clipped into my long blond extensions. Costumes were customized down to the tiniest detail and diets were strictly observed in the weeks before a big party. I was so critical of my appearance—particularly my weight. A girl could rarely be too skinny at the mansion. After all, there were expectations that we become the *Playboy* fantasy everyone expected us to be. And in order to be that woman, it was essential that we looked the part.

Plagued by self-doubt, I was constantly troubled by an imaginary belly and would often add a single garter to my costumes to hide a tiny dot on the back of my left leg. God forbid, someone might think I had cellulite. These days I look back at photos from my mansion days and marvel how a girl that skinny could ever think she was fat, but I suppose I was a product of my environment. After spending much of my adulthood as nothing more than a trophy girlfriend whose sole occupation was to look good, I guess I can't really blame myself.

On the night of Hef's 78th birthday party we made our entrance into the great hall around nine o'clock. Hef's photographer Elayne snapped our obligatory photos. As was customary, Mark Frazier, the body painter, brought the "Painted Ladies" over for a photo with us as well. Kendra was already carrying a tray of Jell-O shots and she nervously offered them to us. Bridget, Hef, and I happily took one each as the Mean Girls just ignored her with an icy coldness.

Hef wasted no time inviting the "Painted Ladies" up to his bedroom. Nicole was physically the least Hef's type, with her curvier body and strawberry-blond hair, so I knew right away that she wasn't making the cut, despite her participation in the sack.

Tiffany was the only one who wasn't willing to go all the way (Good for her!), so even though I really liked her, I knew she wasn't going to be invited back.

Through the process of elimination, the 19-year-old platinum blonde from San Diego was in position to be Hugh Hefner's next girlfriend—if she played her cards right. In Kendra's book *Sliding into Home,* she de-

scribes Hef asking her to be a girlfriend and handing her a house key *before* he invited her up to the bedroom. Now, I don't know if Kendra is trying to sound extra-desirable, innocent, or if her memory is just super rusty, but of course that's not how it really went down. Hef isn't stupid. He never asked anyone to become a girlfriend before they joined him in bed. And he never made a habit of carrying around extra sets of room keys.

Because Kendra seemed pleasant, Bridget and I started encouraging Hef to ask her to move in. We openly (and loudly) chatted about how nice we thought she was.

"I don't know . . . she doesn't seem to have much personality," Hef responded.

I rolled my eyes. Since when did he care about personality? Only a positive comment from Bridget or me could turn Hef off to this girl who was so clearly his type. Did I mention he hated it when his girlfriends got along? I could see what he meant, though. In the early days, Kendra wasn't the bubbly, bouncy loudmouth you may remember from *The Girls Next Door*. Her personality could best be described as "deer in the headlights." It was difficult to get a word out of her, and she seemed to have fried her brain somewhere along the course of her life. At the time, I just assumed she was shy or afraid of making a misstep while trying to navigate Hef's world.

Despite his supposed reservations, he did continue to have her as a guest at the mansion. Kendra was still living in San Diego at the time, so Hef invited her to stay through a whole weekend and join us for the big Easter celebration that Sunday. Bridget and I had gone down to Melrose to pick out matching dresses for the festivities—including one for Kendra. I knew she didn't have a ton of clothes and was probably stressing out just like I used to.

Usually I wouldn't be so eager to dress like anybody's twin, but I knew how adorable Hef thought it was when the girls dressed alike. After nearly three years at the mansion, I was pretty attuned to Hef's

preferences. I imagined him seeing the three of us together in matching outfits and thinking, "Oh, how cute." By getting Kendra to dress the part of a new girlfriend, I hoped it would help Hef make up his mind and set us apart from the Mean Girls, who would most likely show up to the Easter event wearing jeans and bored looks on their faces.

When we got back to the mansion, I went out to the room in the guesthouse where Kendra was staying, holding the new blue dress. I told her it was hers to wear if she wanted and that Bridget was wearing a pink one and I had a pale orange version.

"Oh my god, girl!" she said, I could see the relief on her face as a big toothy grin emerged. "You have no idea. I was going nuts." She thanked me profusely. For the first time in a long time, I felt as though I could relax. I had a good feeling about this one. Just because Hef didn't want another Bridget or Holly didn't mean we couldn't all be friends. I wanted her to feel welcome.

Realizing that the opportunity might soon present itself, Kendra began asking questions about life as a girlfriend as she changed into the dress. She had already hooked up with Hef, so that part was no mystery.

"Can I bring my dogs when I move in? I have to bring my dogs," she stated. "I have two dogs. I need a really big room."

"I don't know what room you will get if you move in," I said. "That's up to Hef."

I have to admit, I envied Kendra's sense of entitlement. I had felt so lucky just to scrape by when I moved into the mansion, and here was a rookie who had just gone all the way with an old dude and her only concern was how big her room was going to be.

Though she wasn't as cunning or sophisticated as the other girlfriends who had inhabited the mansion in recent years, she seemed to have that same hustler mentality. Kendra was a stripper but had told Hef she was a college student, because the body painter gave her the heads-up that Hef didn't like strippers and preferred college girls. When Hef put a caption under one of the first photos of her that entered his scrapbook,

he referred to her as "Hef's new sweetheart: a 19-year-old coed from San Diego."

"I need a car, too, if I'm gonna live here," she barked. "I don't have one. And I want to get my teeth fixed. They are the only thing about me that I don't like."

The balls on this girl, I thought.

"Oh, you'll have to talk to Hef about that," I responded, shrugging my shoulders. I barely had the nerve to ask for anything for myself—I certainly wasn't going to ask for her.

The Easter ensembles worked. About a month after Hef's birthday, the Mean Girls were finally given the boot and Kendra was officially asked to be a girlfriend. After three years of misery, which at the time I felt was largely due to those bullies, it was over. They were gone—and I'd never have to see or hear from them again! It didn't really feel real. I actually went down the hall and peeked into each of their former bedrooms to make sure they were really gone.

"What did you say to them?" I asked Hef when he told me the girlfriends were leaving. I couldn't be certain that my prompting actually had anything to do with Hef's decision, but I silently congratulated myself either way.

"I told them that Kendra's moving in and Kendra had confided to me that she used to have a drug problem," he said, nonchalantly thumbing through a file folder he had in his hand. "Kendra told me they took her out to a club and offered her drugs. I told them I couldn't have that around her."

Of course, I thought. I wasn't sure how they managed to sneak out of the house with Kendra, but according to her story, they did. If the story was true, the Mean Girls must have seen exactly what was happening and made a last-ditch effort to save their asses and sabotage Kendra's chances. Thankfully, it backfired.

Kendra's arrival was the best news I had in a while! I was ecstatic to have those days of drama and backstabbing permanently behind me . . . or so I thought.

* * *

JUST AS HE HAD done with me when I first arrived, Hef quickly made Kendra his "golden girl." After all, she was the youngest and newest member of his harem.

Immediately, Kendra acquired a black Escalade that she "pimped out" with rims, speakers, and every extra accessory possible. She also snagged the room she wanted, Bedroom 2. It was the largest, most luxurious, and most plush of all the bedrooms—and she would instantly trash it. Kendra's room turned into a junk-dump of possessions and reeked so badly of dog urine that you could smell it down the hall. I always tried to avoid staying in her room longer than a few minutes.

Since the house was virtually empty, I decided to ask Hef if I could use Bedroom 5 again so I could have more room for my things—and a little privacy when I needed it. Living in the "Vanity" made me feel on edge. Hef's secretaries were constantly in and out of there throughout the day, adjusting his calendar and wooden box full of pictures. I liked all of Hef's secretaries, but I would have liked a little solitude, too.

"Absolutely not!" Hef squawked, setting down his reading glasses. "Do you have any idea how much those rooms cost to rent?"

Actually, I did. Playboy Enterprises (a public company at the time) owned the mansion. Not Hef. In order to live there, he had to pay a monthly rent on every room he and his girlfriends occupied. People may find it surprising that Hugh Hefner is nothing more than a tenant renting his room at the mansion, but that's exactly how it is. At the time, he paid approximately $25,000 a month for the master suite, $12,000 a month for Kendra's room, and $10,000 a month for Bridget's room (Bedroom 3). The three smaller rooms were priced between $5,000 and $7,000 a month. Should any of the rooms be vacant, Hef wouldn't be charged for them.

So Kendra's worth $12,000 and I'm not even worth $5,000, was what I

took away from the conversation. Since I lived in the "Vanity" corner of Hef's closet, he didn't have to pay any rent on my account.

Despite these little annoyances, things were actually going smoothly in the house between Bridget, Kendra, and me. To my great relief, Hef mentioned to his immediate circle that he was "downsizing" to "just" three girlfriends. Just when I thought this new "quality over quantity" arrangement might mean less drama, Hef decided to drop a bomb on us all.

During a Fun in the Sun pool party, Bridget and I were reading and sunning ourselves on side-by-side lounge chairs while Kendra sat on a floatie near the edge of the pool. As Hef shuffled along the flagstone walkway between us carrying his backgammon board, he paused and looked around at each of us.

"You know," he began, taking a swig from his bottle of Pepsi, "I've decided I'm going to do a pictorial on the 'Painted Ladies,' featuring you and Tiffany." He nodded towards Kendra, but spoke loudly enough for us all to hear.

"Oh, wow!" Kendra shouted. "Thanks!"

Pretending we didn't hear a word, Bridget and I kept our noses buried in whatever we were reading. We didn't know what to say.

"I just want to put my book down and leave," I said defeatedly. "He knows how badly you and I want to be in the magazine and he just had to make that awkward announcement in front of us?"

"I know," she sighed.

We knew that Hef was trying to make us jealous and feel like shit, but I felt helpless, like there was nothing I could say.

One particular day, Kendra appeared a little more somber than usual. Like all of us, she had her rough days—especially in the beginning—and we tried to coach her through, but that day she seemed really depressed. Bridget and I were desperate to win Kendra over and create the "happy family" we had always wished we had at the mansion.

"We're going out tonight," I declared, popping my head into her room.

Immediately, Kendra's eyes lit up. Clearly, she needed a night away—even if only until 9 P.M.

Hef was hosting his "manly night" at the mansion, which meant the girlfriends were required to make themselves scarce. Bridget and I thought it would be fun to take Kendra out for dinner. She was still new to Los Angeles, so we thought taking her out on the town would be just what she needed to lift her spirits. We decided on Nic's, a popular martini lounge in Beverly Hills, for appetizers and cocktails.

When evening finally rolled around, Kendra seemed elated to be outside the mansion gates *without* Hef's parent-like supervision.

"Girl, do you think there's anyone famous here?" she sort of shout-whispered in my general direction, craning her neck to see if she could spot a celebrity tucked into one of the restaurant's dark corners.

"I'm going to get a cocktail," I suggested, thinking we should toast our first-ever girl's night out. Nic's was known for their creative cocktails with their cleverly punny names, like "Last Mango in Paris" and "Coco Cabana." Bridget and I each ordered some fruity concoction as Kendra pored over the menu with a furrowed brow.

When it came her turn to order, Kendra announced that she would be having the "Sake to Me."

"Excuse me?" the waitress asked, clearly not understanding the order. Kendra had mispronounced the Japanese rice wine by saying "sake" as if it rhymed with "take."

"The 'Sake to Me,'" Kendra repeated, the same way she had pronounced it the first time, only slower and more aggressively. I felt myself wince.

The waitress appeared generally perplexed. I shot Bridget a look, but she was already making herself busy with the cloth napkin. One of my biggest pet peeves is people who are rude to servers. I could sense Kendra's frustration getting the best of her, but before I could intervene she groaned and snapped the menu off the table, pointing firmly to the drink.

"The 'Sake to Me,'" she barked, once again mispronouncing the main word.

"Oh, the 'Sah-keh to Me'!" the waitress echoed, clearly relieved that she finally understood what Kendra was getting at.

"Yeah, that's what I said," Kendra jeered, looking back at the table.

Unfortunately, the Playboy Mansion was a breeding ground for that kind of arrogant behavior—especially among Hef's girlfriends. And shortly after, Kendra's began to take off.

One day when I was out shopping, I fell in love with these adorable skirts at Bebe that I knew Bridget and I would both love. They were mid-length, flowy, and dripping in sequins. I picked out a pink one for Bridget and a cream-colored one for myself. I wanted to make sure that Kendra didn't feel left out, so I picked up the baby blue version for her.

When I got back to the mansion, I found Kendra in her room and handed her the bag.

"I found these really cute skirts today and picked them up for us in different colors. I thought we could wear them out to the club tonight if you want to," I said, helping myself to a seat at the edge of the bed.

Kendra lazily pulled the skirt out of the bag and ripped the tissue off from around it. She held it up for a moment before shoving it back into the bag.

"Yeah, I don't really like it," she said, wrinkling her nose and handing it back to me.

I ignored the glossy black bag being shoved at my face. Sure, I didn't want to be a clone, either, but couldn't she just have said thanks and tucked it into her closet? Up until this point, Bridget and I hadn't been on the receiving end of her snotty remarks, so I was a little surprised at the direction this conversation was taking.

"Well, I got it for you because I didn't want you to feel left out," I added.

"I won't wear it," she snapped back, dropping the bag to the floor

and turning her attention back to the TV that so frequently occupied her hours.

"You don't have to," I said finally and walked out her door, leaving the bag on the ground. Honestly, my feelings were hurt. I went out of my way to do something nice for her and it came back to bite me in the ass. I felt like I was damned if I did and damned if I didn't. I'm not sure if she ever wore the skirt. It's probably still sitting in Bedroom 2's closet.

Later that evening, after spending roughly 45 minutes twiddling our thumbs in the great hall waiting for Kendra to grace us with her presence, she finally emerged from her bedroom looking like a petite sex kitten in a red spandex dress, Lucite platform heels, large blond barrel curls cascading from her head, and bright, candy apple red lipstick applied with perfect precision.

Immediately I cringed.

Oh shit, I thought. *This was going to be bad.* Bridget quickly shot me a knowing glance, her eyes wide with concern. As Kendra sauntered down into the foyer, I braced myself for impact.

The last time I had tried to wear red lipstick was two years earlier, the day I had cut my hair and Hef had bit my head off for it. It was such a memorable moment that when Kendra appeared in the main entryway with her lips painted bright red, my entire body tensed. It had been two years since Hef's reprimand, but the humiliation still burned inside me.

I could tell that Hef was already irritated that she kept us waiting this long and now seeing the red lips . . . he was *not* going to be happy.

Slowly he made his way to his newest girlfriend to more closely scrutinize her face. My jaw clenched as he inched toward her.

What horrible thing was he about to say? I thought. I looked down at my hands and squinted my eyes. After what felt like an eternity just waiting for him to erupt, he finally let out a big guttural laugh.

My eyes sprang up to make sure I was hearing this correctly.

"Why, that red lipstick looks absolutely *wonderful* on you, Kendra!"

he boomed, grabbing her arms and kissing her on the cheek. "You look like you just stepped out of a 1940s movie!"

I looked over to Bridget, who had the same surprised look plastered on her face that I was sure I had on mine. Surely he was being facetious and was about to unload on her, right? Not only did he not despise the look, he thought she looked "wonderful."

My head was spinning. Kendra and I were not *so* unlike that red lipstick could have looked that much better on her than it did on me. What about Bridget? Tina? Vicky? April? Or any of the other five dozen girls who were told never to wear the hue?

I was waiting for the other shoe to drop when the house photographer gestured for us all to line up for a photograph, but nothing more was said. Did I somehow manage to stumble into an episode of *The Twilight Zone*?

"Are you kidding me?" I whispered to Bridget when we finally piled into the limo. I could feel the hurt boiling inside me.

She just shook her head.

"So he just *loves* red lipstick now?" I asked sarcastically. How could his decades-long opinion transform so suddenly with one girl? I was crushed. That was the reaction I had thought I would have received years earlier. Over such a minor thing, I was belittled and made to feel like trash. But Kendra did it and gets praised? I didn't resent Kendra; it wasn't her fault. It was Hef who made me mad.

All the Playmates who were waiting to go out with us noticed how taken aback I was. That's one of the things about Hef: when it came to humiliating his girlfriends, the larger the audience, the better.

"I think he was trying to get to you," one of the girls whispered, pretending to search through her purse. "I don't think he *really* likes it." It was her way of trying to comfort me.

Seriously? I thought. Sure, Hef had a habit of pitting the youngest girl against his main girl; that tradition had been going on since the days of "Mama Hen" Tina and "Baby Face" Buffy, but this was sick. Was he

really trying to stir up my feelings of inadequacy by praising a 19-year-old? I was only 25, which was hardly ancient (unless you're talking to Hugh Hefner).

"There's no way he remembers," I said, only half believing my own lie. "It was like two years ago."

"Holly," she said, taking a moment to meet my eyes. "You know he remembers *everything*."

I stared back at her and let this sink in. She was right. He knew exactly what he was doing. He catalogues shit like that for just these types of moments. Men don't achieve his kind of power and success by being idiots. He didn't want a big, happy family of girlfriends that all got along. He wanted multiple women frothing with jealousy and animosity towards each other. It was a part of his control game. I could never accuse him of doing it on purpose, because he would simply brush off my accusation by declaring how preposterous it all sounded. And he'd be right. It does sound insane, but that didn't make it any less true.

Quickly I shut off my pride and put on the biggest smile I could muster. If he can pretend he doesn't remember, I can too. I can't let him believe he succeeded; he wouldn't use Kendra as a pawn to get the best of me. But believe me, he would end up trying.

DESPITE MY ATTEMPTS TO befriend Kendra, she continued to push me away. Hungry for her own "team," Kendra desperately tried to make each new Playmate who arrived at the mansion her friend—and her friend alone. Kendra's plan rarely worked, though. Most of the new Playmates were nice girls who were eager to get to know all of the girlfriends. And, let's face it, Kendra wasn't the easiest person to have a conversation with. When the new Playmates would make an effort to spend time with Bridget or me, they were confused when Kendra suddenly lost interest in being their friend. A girl was not allowed to play both sides of the fence, so Kendra would toss her aside and find the next person to entertain her.

And as is true with any caged animal, it was dangerous when Kendra grew bored.

Her frustrations had been mounting for a while. She had been at the mansion for a few months, and Hef hadn't asked her to be a Playmate yet. Even though she was well aware that Bridget and I had never been in the magazine, she thought she was somehow different (perhaps because of the "Painted Lady" pictorial she posed for in the September 2004 issue) and couldn't understand why she wasn't already on the cover.

"I'm locked down," she would frequently say, referring to her new life behind the gates. It's no secret that Kendra was a pretty hard-core party girl before coming to the mansion. She battled drug addiction throughout her teenage years and eventually became a stripper to make extra cash. When Hef finally asked her to move into the mansion, Kendra thought she hit the jackpot. After all, wasn't *Playboy* all about excess? Money, parties, and sex.

But, as she quickly realized, those nights were few and far between—and rarely as much fun as you'd think. The public's image of the free-wheeling leave-your-inhibitions-at-the-door atmosphere of the Playboy Mansion was not a reality for any of Hugh Hefner's girlfriends. The atmosphere resembled the court of Versailles, with each guest obsessed with rank and standing. There was even a hierarchy among Hef's friends when it came to seats at the dinner table. At 19 years old, Kendra was stuck with a 9 P.M. curfew, a 78-year-old boyfriend, and a stricter set of rules than she had ever had at home. And now, adding insult to injury, she was finally realizing that she wasn't as special as Hef made her believe. She was just another blond girlfriend—and life at the mansion wasn't all she imagined it to be.

Much like the battle I endured—and ultimately lost—years earlier, Kendra was desperately searching for an identity of her own. Being a clone was soul sucking; you were simply another blond number on Hef's arm.

In the beginning, Kendra was very quiet. The raucous deep-throated

cackle that became her trademark on *GND* was something she affected in order to stand out. I know I have no place to talk when it comes to annoying laughs, but with Kendra, it was clear she was just being as loud as possible in order to make sure every head in the room turned her way.

"Why is Kendra laughing like that?" one of the visiting Playmates had asked me, unaccustomed to the new sound. "She's so annoying! If no one is paying attention to her, she just screams out of the blue!"

I just shrugged my shoulders, hoping it was just a passing phase. But Kendra wouldn't shut it off until she was certain all eyes were on her. The laugh never did vanish, though. Even today she still adopts that cackle. I bet by now it's almost natural. Almost.

Eventually, these sort of exaggerated antics became her trademark. For example: flying. She claimed to be so terrified of flying that she would put on a massive show in front of Hef during takeoff that resembled a loud, prolonged, frightened orgasm. It was embarrassing to witness. And wouldn't you know, when we were finally able to fly with Kendra on our own (read: without an audience of men for her to perform for), she was remarkably calm during the entire flight.

Kendra had been living at the mansion for close to a year when my patience finally started to wear. We were all out at the nightclub of the moment in Hollywood with some potential Playmates. Bridget and I flanked Hef in a corner booth while the other girls danced and partied around us. Always trying my best to be as attentive as possible, I remained seated next to Hef the whole night, drinking and watching the clock.

Immediately, Kendra hoisted herself to the top of the banquette. Surrounded by the Playmate posse (all of whom were her BFFs on this particular evening), Kendra put on a show dancing as provocatively and wildly as she could until she was certain every set of eyes in the nightclub were focused squarely on her. In all of her theatrics, Kendra didn't notice the large candles near her feet. One minute she was shaking her ass and the next a cascade of hot wax was scorching down my leg.

> "AND WHAT IS THE USE OF A BOOK," THOUGHT ALICE, "WITHOUT PICTURES OR CONVERSATION?"
> —Lewis Carroll, *Alice's Adventures in Wonderland*

Growing up in Alaska. *(Personal collection)*

Age 12, junior high
in Oregon.
(Personal collection)

Age 15, at
cheerleading camp.
(Personal collection)

Age 21, new to
California.
(Personal collection)

In Bunny costume.
(Erik Kabik)

With my favorite
Playmate, Jenny
McCarthy.
(Personal collection)

Bridget *(left)* and Kendra *(right)* behind the scenes of our first *Playboy* shoot with photographer Arny Freytag. The directors' chairs were gifts from Arny. *(Personal collection)*

Sightseeing with friends in New York City while promoting our *Playboy* cover. *(Personal collection)*

From left to right, Bridget, Playmate friend Liz Stewart, me, and Kendra at a signing, a blowup of our first cover hanging in the background. *(Personal collection)*

Behind the scenes
of our second cover
shoot for *Playboy*.
(Personal collection)

Dressed up for the mansion's annual
Halloween party with 2006 Playmate of
the Year, Kara Monaco *(right)*.
(Personal collection)

We were so excited
to see billboards for
The Girls Next Door
all over L.A.!
(Personal collection)

Filming my favorite episode of *The Girls Next Door*,
a trip to my hometown in Alaska.
(Personal collection)

Performing in *Peepshow*. *(Denise Truscello)*

The *Peepshow*
marquee in
front of Planet
Hollywood. I
couldn't believe
that was me
up there!
(Denise Truscello)

Filming *Holly's World* in Mexico.
(W.B. Fontenot)

Modeling some of
Marilyn Monroe's clothes.
(Denise Truscello)

The cast of *Holly's World (clockwise from top left):* Josh Strickland, me,
Laura Croft, and Angel Porrino. *(Personal collection)*

Claire Sinclair *(left)*, a new cast member for *Holly's World* season two.
(Denise Truscello)

Filming my birthday with *(left to right)* Jayde Nicole, Laura, Josh, Bridget, and Angel.
(David Becker)

Celebrating *Peepshow*'s third anniversary with Cheaza *(left)*, director Jerry Mitchell *(second from right)*, and Josh *(right)*.
(Erik Kabik)

Welcoming baby
Rainbow into the world.
(Erik Kabik)

Engaged!
(Chris Clinton)

Our wedding at Disneyland.
(Denise Truscello)

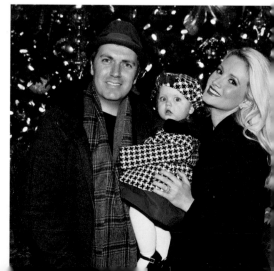

My family.
(Denise Truscello)

I jumped to my feet and began swiping at my thigh. Kendra took a brief moment to take in the situation before turning her attention back to the other Playmates and letting out a long, loud laugh, not even taking a moment to apologize.

Hef was oblivious to what had just happened—recognizing that something was wrong only when I stood up and started peeling the wax off my leg. He finally asked what had happened.

"Kendra dumped hot wax all over my leg," I said angrily. "She knocked that candle over while she was dancing, looked right at me, and didn't even apologize."

"I'm sure she didn't mean it," Hef said, ignoring how upset I was and turning his head back towards the crowd dancing in front of us. He decided it was time to leave a few minutes later. *Thank God,* I thought. I just wanted this night to be over so I could forget about this latest humiliation, just as I had tried to forget all the others I had experienced since joining the mansion fold.

As we navigated our way through the sea of gawkers, we were stuck in an absolute traffic jam. Picture Hugh Hefner, roughly 10 girls, and a handful of security guards trying to push their way through this dark, tiny, crowded nightclub. It was a nightmare. Not only was I angry and irritated, but my skin was still burning from where the wax had landed.

Kendra was bouncing along behind me, laughing and dancing with the other Playmates as we made our way to the door. She must have sensed my irritation (how could she not?) but still said nothing. Instead, as soon as our group stalled, she threw up her hands and screamed at me: "Move, bitch! Get out tha' way!"

I whipped my head back around and screamed right back. "Shut up!" I yelled in her face. "You spilled hot wax on me, don't say anything, and then call me a bitch? FUCK YOU!"

Kendra's smile faded and the Playmates got quiet. I never lost my cool like that, so everyone knew I was *seriously* pissed.

"What?" she said, her eyes like saucers and looking from side to side at the other girls, grasping for some kind of support. "It's a song."

It hurt enough to have to be constantly humiliated by Hef, but now I had to take it from a 19-year-old bimbo who I had been nothing but welcoming to? I was losing my patience. When we finally made our way to the door, I turned to Hef.

"She's totally inconsiderate," I grumbled. "How could she not even say she was sorry?"

I took my seat in the back of the limo, and much to my surprise, Hef finally opened his mouth.

"You know, Kendra, you really should apologize to Holly," he said, in a sort of fatherly, condescending tone.

That's when the train went off the tracks.

Kendra burst into tears—a hyperventilating, sobbing mess of tears.

"You guys are my family," she wailed, reaching for the bottle of vodka from the limo bar. "I'd stick up for any of you guys no matter what!"

She pulled off the cap and started downing the vodka. The entire limo fell silent. In between swigs, she cried and blurted out some mumbo jumbo through sobs that no one really understood.

One of the girls tried to calm her down, but Kendra was either too drunk or too crazy to control herself. Hef, Bridget, and I fell silent before telling her that we would be there for her, too. The whole display was shocking and kind of sad.

It simply wasn't normal. It seemed as if Kendra, finally finding herself on Hef's bad side, broke down and retreated into a drunken fit. Like a toddler throwing a temper tantrum, she guzzled down the vodka in hopes that Hef would feel that urge to rescue her or care for her. It was both manipulative and incredibly sad. From that night forward, I was always a bit more cautious with Kendra. A woman who allows herself to enter into a situation like the one we were in must struggle with personal demons—I know I did. Kendra was harmless, sort of like an annoying kid sister. Our relationship would have its ups and downs over the next

few years, but I learned to pick my battles and appreciate that she was just as damaged as the rest of us. She just had a different way of showing it.

There wouldn't be time to focus on such things moving forward. Our lives were about to change and the three of us would be further united on a brand-new project—like it or not.

"We're all mad here. I'm mad. You're mad."
"How do you know I'm mad?" said Alice.
"You must be," said the Cat, "or you wouldn't have come here."
—Lewis Carroll, *Alice's Adventures in Wonderland*

Would you say that Kendra is 'growing up' at the mansion?" posed Jerica, the young, freckle-faced field producer sitting across from me. It was 2005 and we were in the mansion's game house filming my first set of one-on-one interviews for a new unscripted E! series spotlighting Hef, his three girlfriends, and our lives inside the mansion. The question completely caught me off guard. Don't get me wrong, I was excited at the prospect of doing a television show—day-to-day life was so monotonous that I welcomed any sort of change, opportunity, or even that chance at fame I had once hoped for—but at the time reality TV still had a pretty negative stigma. My time at the mansion hadn't been all that rosy, so I was anxious about what the show would entail. Naturally, this particular question set off a siren in my head.

"No, I wouldn't say that," I said, a bit more defensively than intended.

"It sounds gross and inappropriate. Besides, she's 20 years old; she's grown up already."

It's not like we really had a choice when it came to doing the show, so all that anxiety was really for naught. Once Hef approved the idea, it was full steam ahead. No one even bothered to ask our opinions about filming the show, even if it was just a courtesy. "Trophy girlfriends" are better seen and not heard. But what did I really expect? At the mansion, it was always Hef's way or the highway.

We weren't given a choice in the nudity aspect of the show, either. When the first season started filming, we weren't shy about being in front of the camera in various stages of undress—we knew everything would have to be blurred out in order to air on television and the cameramen shot us from creative angles to avoid landing any nudity on the show. Halfway through the first season, though, someone must have realized that nudity could be shown in foreign television markets and on DVDs, so getting as much nudity as possible on camera became a priority. No one ever consulted the three stars of the show when it came to this issue, and I wasn't aware of the change until after it had been put into effect.

As intelligent as he is calculating, Hef saw the series as an opportunity to capitalize on the new genre of television that was sprouting up and once again reinvent the brand while bringing in a fresh audience to *Playboy*. And the needs of "the brand" always trumped those of "the girlfriends." It was understood that if we chose to continue living at the mansion, we had to agree to be featured on the series. I've always been a private person despite my public life, so I was wary about the repercussions. Would Hef feel the need to bring in *more* girlfriends for ratings? Would the spotlight bring out our worst? Would producers try to stir up drama among the three of us?

Jerica waited patiently for me to fill the silence, probably hoping I would break.

"After all, she *is* an adult," I said, rounding out my thought. I had shown up for the interview intending to look as wholesome as possible,

wearing a pastel print button-up dress shirt, my hair pulled back into a ponytail with newly cut bangs, and very light, fresh-faced makeup. Despite my years of acting classes, I'd never watched myself on camera being "myself." When we finally screened the first episode months later, I was absolutely horrified by my appearance. I looked so dour on camera, realizing that the corners of my mouth naturally turned down when I spoke. I looked washed out. Moving forward, I would take to caking on makeup like a beauty pageant contestant and grinning ear to ear for every interview.

"Well, I just meant that she's young and sort of like the kid sister," Jerica continued calmly. The suggestive remark struck a chord with me for a few reasons. First off, I was only 26 years old myself at the time. Given the relationship I was in, I didn't really feel like age should matter. We were adults and free to date whomever we chose. Let's be honest, our dramatic age difference wasn't an uncommon question, but Jerica asked it in a way that made me feel like there were ulterior motives at play—like she was using some sneaky back-door approach to get me to say something I didn't intend to.

"If I say that, it makes it seem like he's a pedophile, and that's just gross," I said, point-blank. No sense beating around the bush.

Second of all, I hadn't seen an episode pieced together yet and was still pretty untrusting of the process. Were they going to paint Hef as this villainous, predatory man? Part of me was still protective of him. Hindsight offers many luxuries, but in that moment my view was still clouded by the fantasy that Hef was my boyfriend.

"The idea that one of his girlfriends is still 'growing up' feels wrong," I explained, more politely than before—aware of all the eyes currently on me.

"Okay, fair enough," said Jerica. She continued to the next question, lobbing me a softball. "What do you see life like five years from now?" Mechanically, I jumped into my spiel.

"In five years, I would love for it to be just me and Hef," I said, smiling

and trailing off into my standard response. I was a part of Hugh Hefner's publicity machine and made sure that everything I said publicly was what I thought he would want me to say. Part of me wanted to please him, but mostly I was terrified of being reprimanded or losing favor by simply saying something he felt was off-color or didn't paint him in the godliest of lights. This was hardly my first dalliance with press interviews, so I had most of the answers down pat.

I think the "growing up" question struck a nerve even deeper than I cared to admit. Frankly speaking, I've always been pretty uncomfortable by Hef's fascination with extremely young women. He was obsessed with women looking as young as humanly possible. Everything—absolutely everything—about that skeeved me out. Jerica's needling pushed some button to cause all this subconscious crap to surface, but luckily I was still tucked safely into my corner of denial and quickly repressed the thoughts.

"How do you feel about the nine o'clock curfew?" Jerica asked, resting her chin in her hand. People were always fascinated by the curfew. As I've said, I was a homebody anyway—and little did outsiders know that the curfew was hardly the worst thing about mansion life. Like a robot, I happily went back to my Hef and Playboy-friendly responses, the hard questions dodged for the day.

Though *The Girls Next Door* marked a sudden change in Bridget's, Kendra's, and my lives, the series wasn't created overnight. Throughout 2004 and early 2005, different entities had expressed interest in developing a Playboy Mansion reality show. At first I paid no attention to the rumblings, thinking it would have nothing to do with me. The ideas that were being thrown around didn't center on the girlfriends. Ideas surfaced like, "Growing Up Hefner: What Life Is Like as Hugh Hefner's Son" or "Upstairs, Downstairs: The Butlers of the Playboy Mansion."

We were sat down for test interviews, along with the butlers. There is no doubt in my mind everyone on the other side of the cameras thought that Hugh Hefner's three girlfriends would be the most demanding, unreasonable bitches of all time, making the staff's life hell at any given

moment. None of these people, not even the executive producer (a close friend of Hef's), had ever gotten to know Bridget, Kendra, or me.

My test interview, for the most part, was relatively uneventful. I was asked all the usual questions about what life at the mansion was like: How is it having a nine o'clock curfew? What do you order from the kitchen? Where do you shop? Do you mind sharing your boyfriend? And I, like the drone I had become, answered all the questions with the same rote, dry answers I gave everyone else. The three repressive years I had spent at the mansion had drained all the personality out of me anyway, so I'm sure I sounded like a robot.

Then I was asked a question that threw me for a loop: "When did you first realize you were beautiful?" I started a bit, taken out of my hypnosis by an out-of-the-ordinary question.

"I never *did* discover I was beautiful," I snapped. "I *made* myself beautiful."

One of the head producers would later say to me that this answer led him to believe that they had something with the girls and maybe there was more of a story here than just "how do butlers deal with demanding, spoiled bitches while naked Playmates are running around them all the time?"

The answer I gave was the one honest, spontaneous thing I had said all day, and it alluded to so many things:

1. That I had been conditioned to believe that I was *not* beautiful.
2. That I was possibly entirely composed of plastic surgery (I wasn't; I stopped after the nose job).
3. That there was a little more going on in my head than most people would assume: that I was in on the joke.

It was finally Lisa Berger, then president of programming at E!, who suggested she would like to see what life at the mansion was like through the eyes of the girls: a Dorothy in Oz kind of take on the Playboy world.

I was torn on whether or not to be excited about this project.

I had come to L.A. wanting to be an actress. My newfound lack of self-esteem had made me crave fame for fame's sake. I had started taking hosting classes, hoping to make it in any way I could: acting, hosting, modeling, whatever. The one thing I hadn't considered was reality TV. Despite my hunger to be in the spotlight professionally, I have always been a very private person. Even before I moved into the mansion, I changed my last name, in part to protect my family's privacy should I become known. Even the small amount of notoriety I had already gained from being one of Hef's girlfriends made me extremely uncomfortable— being a part of a bimbo harem was *not* what I wanted to be famous for.

On the one hand, exposure on reality television could lead to many opportunities. Perhaps even something that could give me some pride, some financial security, and maybe even enough confidence to leave one day.

On the other hand, the drama demanded by a reality show could turn the mansion back into the snake pit it used to be during the Mean Girls days (on *and* off camera). The prospect made me anxious and depressed.

I was also scared of being lumped into a "blond bimbo" stereotype. After all, I remembered how I had felt recently when we had filmed an episode of *Entourage* at the mansion.

We were each given one simple line to say on camera, surrounded by the show's cast, crew, and hundreds of extras. The scene had to be shot over and over and over again to the point of lunacy . . . because Kendra couldn't get her one line right.

I was beyond mortified and prayed that the floor would just swallow me up. I was certain everyone on set was assuming that all three of us were equally ditsy. The thought of having to be compared like that, on a weekly basis, gave me crazy anxiety.

There were days I woke up, sat at the desk I had added to the vanity area, and just felt like falling to the floor because I felt so depressed. Though it is completely obvious to me now why I felt so dark, believe it or not, back then I was stumped.

Don't I have everything I want? I asked myself. The Mean Girls were

gone and life at the mansion was easier. I was slowly saving up a little money, and I was living in the lap of luxury.

Of course, to keep myself from really losing it, I was completely ignoring the fact that anyone who was part of an old man's harem and treated like a brainless idiot *would* be depressed.

Feeling like I was at a breaking point, I had told Hef that I needed to see a psychiatrist during one of my sob sessions, but my confession fell on deaf ears. He refused to let me see a therapist because, as he put it, a therapist would just tell me to leave the mansion. He told me to talk to Mary about my problems instead.

In spite of his objections, I did end up seeing a therapist in order to get some prescription medication. The therapist diagnosed me with depression brought on by my anxiety over filming the reality show and how it would affect my life. He prescribed me Effexor, a drug prescribed to those with serious depression (one I weaned myself off of a few years later). It made me feel a little better for the time being and helped buoy me through the mansion for a few more years.

THE FIRST EPISODE OF *The Girls Next Door* introduced the E! audience to Hugh Hefner's three blond girlfriends. Through interviews and "candid" moments, the series established the lay of the land at the Playboy mansion: the girls, the grounds, the pets, the curfew, the 24-hour kitchen, and other mansion oddities. The episode wrapped up with Hef, his girlfriends, and a handful of Playmates waiting for Kendra before heading to Hollywood for the AFI Awards red carpet honoring *Star Wars* creator George Lucas. The footage showed a jovial Hef hobnobbing with celebrities, goofing around with press, and routinely holding, hugging, or kissing one of his many dates.

"We get respect," Kendra said in a voice-over while the camera panned to showcase our backsides sauntering into the theater. I remember wondering, *Does she* really *think people respect us?* She seemed clueless

to the fact that most people probably *didn't* respect us for how we were living our lives and that the cheers and accolades she was witnessing were simply due to Hef's strange novelty as a pop culture oddity. I, on the other hand, was probably *too* aware of the negative ways in which we were perceived. And this awareness made me paranoid. In fact, I let it get to me so much that I became even quieter and more withdrawn than I had been before.

"We've decided on your characters for the show!" Hef told me one day when he ran across me in one of the secretaries' offices, going through Polaroids.

"Really?" I asked, curious as to what he meant.

"Kendra is the one who wants to have fun, Bridget is the one who wants a career, and you're the one who cares about me."

His delivery made it clear that the decision had been firmly made and that there was no room for argument. While caring about someone is certainly a positive thing, I was troubled by the limitations of our "characters." Couldn't we actually be who we are? Multidimensional people who have different interests, passions, and goals? Sure, Bridget wanted a career, but what about me? I couldn't want one, too? Apparently not.

I was too distracted to ask any more about it. I had been going through photos looking for potential Fun in the Sun guests while we were talking. Hef had long ago lost interest in trolling for new conquests, so much so that the pool party guest list had dwindled substantially.

Somehow I had found an old Polaroid from the year 2000 buried deep in the pile.

I blinked a few times to make sure I was seeing this properly: it was me! I was wearing a black Frederick's of Hollywood corset with a kimono robe and sporting strawberry-blond hair, but the real surprise was the "grade" I had received from Hef: A.

All these years at the mansion being made to feel ugly and less than— and he had marked me as an A all along!

Hef had already shuffled back down the hall.

"I can't believe I got an A!" I said to Jenny, Hef's social secretary, gen-uinely in shock. Hef always treated me like such a scrub, like I was barely lucky enough to be in residence at the mansion.

"Well, of course you did," Jenny said, matter-of-factly. "What did you think you would have gotten?"

While I knew that people were curious about the world inside the Playboy gates, I found it hard to imagine how we would fill an entire season. Relative to scripted shows, reality television is inexpensive to make (which is the reason so many of them litter the airwaves). I hate to burst anyone's bubble, but in order to get the most for their time and money, producers typically map out episodes in advance based on schedules and then determine what could make for potential plotlines. While our crew initially filmed us at all hours hoping for some of that legendary Playboy spontaneity, they eventually learned that mansion life didn't quite live up to the hype after countless hours (and probably thousands of wasted crew dollars) were spent filming the most mundane moments of our lives.

Finding interesting things for us to do proved more difficult than anticipated. Contrary to popular belief, I couldn't just tote a film crew with me around town. Producers had to get permission from every store, restaurant, beach, and salon in Los Angeles we wanted to film at. Every-thing requires some sort of preapproval.

And what the hell would this season even be about?

Soon I realized Hef had a plan.

The second episode focused on two prospective Playmates that were staying in the mansion's guesthouse. After having dinner out at Geisha House in Hollywood (where Hef had his own fried chicken meal brought in and prepared by the mansion staff, as usual), Hef called Brid-get, Kendra, and me into his room to "talk to us."

"I can't promise it, but you're going to shoot a cover and I'm going to put you in the magazine," Hef said. It was in many ways a defining

moment in my life. After four years living there, I was finally going to fulfill my long-held dream of being in *Playboy* magazine. And he just said it. The words fell off his tongue like the most ordinary of small talk while standing crunched into the corner of his bedroom entry surrounded by a handful of crew members.

It was so unceremonious a delivery that we needed a moment to process the news. We were utterly blown away. Kendra's mouth dropped to the floor and she appeared catatonic for a good 60 seconds. I screamed so loudly I was certain the dog I was holding had gone deaf, and Bridget looked as though she was going to burst into tears. This man—who had conditioned us to believe we were good enough for his bed but not his magazine—just made our dreams come true. It was well within his power all along, but he was finally saying we were worthy. It was validating and exciting all at the same time.

Still, we were extremely skeptical—particularly Bridget and me. We had been at the mansion for years and had been browbeaten to believe we just weren't *Playboy* material.

In the episode, Bridget revealed through a stream of tears that she had auditioned to be a centerfold years earlier but didn't make the cut. Hef had basically told her it was never going to happen.

"I'll believe it when I see it," Bridget said through a forced smile during her one-on-one interview. It was a small window into what was really going on inside Bridget's and my heads.

Earlier in that same episode, you heard me rattle off the same canned answer I'd given for years about whether I wanted to be in *Playboy*.

"People assume that I came here wanting to be a Playmate and that that's my goal," I said. "The choice is extremely clear to me. I would much rather be Hef's girlfriend. Hef and I are so much in love. That's not even a comparison to me."

But just because I valued being Hef's girlfriend didn't mean I still wasn't dying for a pictorial! In fact, the two things had become intertwined in my mind. Since the '50s, all of Hef's main girlfriends had ap-

peared inside or on the cover of *Playboy*—except for me. And by this point, it was humiliating. People would always ask me why I wasn't featured in the magazine and I felt the need to make excuses for it by convincing people that somehow I was special because I *wasn't*. Hef was keeping me for himself, I would explain. What else was I supposed to say? My boyfriend thinks I'm ugly?

My shock and joy was genuine when Hef revealed that we would be shooting for the magazine. None of us expected it, so the reactions the cameras caught were absolutely sincere.

I'll give the man this: he knew what made for good TV.

He also knew the importance of good timing. By allowing us to appear in the magazine, Hef would be cashing in the biggest insurance policy he had to keep us safely behind the mansion bars. But Hef knew something we hadn't yet figured out: the show was positioned to be a runaway hit for the network, so he no longer needed the magazine as a guarantee. He had better bait: fame.

The debut season's arc revolved around our feature and possible cover. It wasn't until about halfway through season one that shooting began for the pictorial.

Hef allowed us to choose between the two staff photographers for our pictorial: Arny Freytag and Stephen Wayda. For years, I had seen countless *Playboy* photo shoots come through Mary's office and I had absorbed every detail from conception to execution, from the first click of the camera to the ink on paper. I was so excited to finally be a part of that process myself. You would think that dating the magazine's editor in chief would have afforded me a sort of security and confidence before shooting the pictorial, but it was the total opposite. We couldn't have been any more anxious about the ordeal. We were *way* more nervous than just some random girl plucked from obscurity and thrown into a shoot. We had firsthand knowledge of just how fickle and critical Hef could be and we were petrified that we would somehow screw it up and he would just scrap the entire pictorial. After talking to a handful of Playmates,

I decided we should go with Arny. While Stephen is an extremely talented photographer, he worked best with more experienced models who knew how to move in front of the camera. Arny worked best with rookie models; those straight-off-the-farm girls who needed help posing every inch of their body. When you haven't done much of it, modeling can be quite a clumsy sport. Kendra, Bridget, and I needed help squeezing our three bodies into an 8.5" × 11" frame—while looking as amazing as possible.

The day of our first shoot I was absolutely ecstatic. We were told to arrive to the mansion's bathhouse in the morning for hair and makeup wearing nothing but a robe and slippers (tight clothes and shoes would leave lines on the body—and we couldn't have that!). I couldn't believe I was finally getting the full *Playboy* beauty treatment. For years I had watched girls transform into these glamorous creatures with the help of the expert editorial beauty team. Even with my weekly allowance, I would have never been able to afford the beauty team *Playboy* magazine used. In the early days of Hef's seven girlfriends, it was standard practice for the girls to call in the *Playboy* glam squad before evenings out and large parties. By the time I arrived on the scene, these were the kinds of lavish expenses that Hef had cut back on. Sure, we would occasionally head to the salon before a red carpet event, but we had never yet experienced the crème de la crème. The Playboy glam squad was legendary. It comprised some of the best artists in the industry—and they didn't come cheap.

The ultra-talented Kimberly Ex did my hair and makeup: full, barrel-curled platinum locks with a bronzed face, defined cheekbones, thick black eyeliner, and carefully drawn lips. From the neck down, we were expected to be in top physical shape. The only help we were given in that area was some baby oil mixed with bronzing lotion to give our skin a smooth sheen. I was over the moon with my reflection. I mean, I actually *looked* like the girls on the pages of *Playboy*! First, we shot a series of clothed setup shots, which included a shot of the three of us hula hooping on the great lawn in bathing suits. It was mostly intended to

warm us up before diving into the deep end (naked), but they ended up coming out great and one of the shots was published. The next setup had us in sexy cocktail attire standing in front of Hef's limo in the mansion's main driveway. After a few minutes of shooting, Hef appeared on set to join us for a few snaps.

How cute, I thought, *he wants some behind-the-scenes shots of our shoot for his scrapbook.*

Finally, it was time to begin shooting our nudes. By that point we'd each become considerably more relaxed in front of the camera. As Arny positioned each of us along the rocks in the mansion's infamous grotto, we were all laughing and goofing around. It was easily the best time the three of us had had together in what felt like months. When Hef came out to check on the photos, he was so happy with the results that he added a last-minute setup for the three of us in the bathhouse shower. It was already pretty late in the day—the shoot had gone longer than intended—but I couldn't get enough. The crew began setting up a final shot, but Bridget was scheduled for school. She had a final exam for one of her classes that she couldn't get out of. Apparently her professor didn't qualify shooting a *Playboy* pictorial as an acceptable reason to miss class. After a few minutes debating whether or not she should just skip (which would have resulted in a failing grade), Bridget dashed off to campus for her test.

Truthfully, it didn't feel odd shooting without her. I knew they wanted a lot of content to choose from and we still had the rest of the week to finish our pictorial. As far as any of us knew a "Bridget/Kendra" or a "Holly/Bridget" setup could have been on the books for the following day. Plus, shooting with just two girls was much easier than trying to arrange three. With wet hair and perfect makeup, Kendra and I playfully lathered each other up with sponges and bubbles in the tropical rock shower. Because it was one of the easiest sequences, it resulted in some of the sexiest shots of the entire pictorial.

The following day was hands down my favorite. The photographer and crew buzzed around the mansion's second floor preparing for our

individual photos. Set in each of our bedrooms, the shoots were designed to showcase our unique personalities, which was refreshing. To reflect Bridget's sweet and playful demeanor, her pictorial featured her swathed in a delicate see-through negligée surrounded by plush pillows in her pink-on-pink-striped room. Kendra looked absolutely amazing in a scrap piece of football jersey with knee-high athletic socks and straddling a bunny head chair in her messy room (which was tidied up substantially). My shoot was in Hef's bedroom and was intended to be reminiscent of old Hollywood. The beauty team styled me like a '40s movie star (minus the red lipstick) and the photographer draped me over an elegant wood staircase wearing nothing but a pair of vintage peach marabou bedroom mules. It was the most beautiful I had ever felt. Like giddy schoolgirls, we snuck into each other's rooms to get a peek of one another's shoot. Each setup was unique and tailored to our personalities, so there was no competition and we were genuinely excited for each other.

Stepping into the Playboy Studio in Santa Monica for our final shoot was surreal. It was the very same studio I had nervously visited with my old friend Heather years earlier. We had decided to try a *Playboy* Polaroid audition, praying that we would be selected. My life had come full circle, in a way. While the journey wasn't quite how I imagined it, I was arriving at the studio to shoot a cover for the magazine.

Surveying the massive studio space, I immediately noticed that the crew had constructed an exact replica of Hef's bedroom for our set.

"Why didn't we just shoot at the mansion?" I asked one of the crew members, totally bewildered. He couldn't produce an answer. No one could. I suppose Hef was more inclined to waste thousands of magazine dollars rebuilding his bedroom rather than being inconvenienced for a few hours.

Playboy photo editor Marilyn Grabowski used a page from a foreign issue of *Playboy* as inspiration for our first setup: three identical brunettes piled on top of each other in bed. Throughout the sequence, we couldn't keep a straight face. Since none of us were ever remotely attracted to one

another, it never even crossed our minds to "act sexy." Posing for such a risqué shot felt incredibly awkward, but it turned out that the laughter worked in our favor because the photos ended up looking quite erotic.

Finally it was time to shoot our cover. Marilyn positioned each of us on a slightly slanted bed covered in silk sheets (that she constantly kept smoothing, draping, and switching), while Arny positioned himself on scaffolding directly above us. Because we were nude and flat on our backs, our breasts had to be taped up to produce the amount of cleavage needed for the cover. Contrary to the quick sequence audiences saw, the cover shoot lasted several days. Our hyper-meticulous, *Devil Wears Prada*–esque photo editor kept analyzing every excruciating detail down to the placement of a single curl. She must have changed the silk sheets from black to white to black again a hundred times—sending the photographer into a tailspin. Despite all of it, I was having the time of my life. The white, skylight-lit studio pulsated with creativity energy and positivity. It was such a welcome change from the musty atmosphere of the mansion.

"I wish I could come here every day," I whispered to Bridget as we lay on the slanted bed.

"I know, me too," she said.

During our lunch break, Stephanie Morris—a junior photo editor at that time—called us down to her office to fill out "paperwork."

Hef hadn't spoken to us about how much we were to be paid for our pictorial, but we were about to find out. Rates for amateur models start at about $25,000 per pictorial. In 2005, reality-star types were earning roughly $40,000 to $50,000 for a pictorial. Hef's former girlfriends the Bentley twins each received $100,000 for their cover and pictorial years earlier. When it came to actual celebrities (like Denise Richards, Drew Barrymore, or Cindy Crawford, for example), paydays could be near a million dollars.

Truthfully, Hef had been so stingy with opportunities for the girlfriends to appear in the magazine that I wasn't expecting much. At that point, I was just grateful for the chance. For years the mansion was hell

because girls were fighting over this very opportunity—and here I was. Not them.

When we got to her office, I quickly scanned over the release she pushed under my nose. I didn't think much of it until I noticed the $25,000 fee we were each being paid for our pictorial. Since this was technically considered a "celebrity pictorial," part of me thought we deserved more than the stock fee. Even something like $30,000? Don't get me wrong, it wasn't the dollar figure that upset me, it was that we were viewed as no greater a commodity than any other girl who had walked these halls. We were simply a dime a dozen.

Still, $25,000 was the most money I'd ever had! I immediately started planning what I would do with it. I knew I wanted to put some in savings for the investment property I dreamed of buying—and maybe I could use a bit to buy that Louis Vuitton travel case that I'd been lusting over for years. It seemed like a fun way to commemorate this major goal I had just achieved.

This is exactly what I need to get back on my feet, I thought.

Bridget had tested to be a Playmate years earlier, so she knew what Playmates were paid and that with the growing popularity of the show, we deserved much more than what *Playboy* was offering. But she also knew there was zero point in arguing about it. She slowly put her pen to paper and signed away the photo rights. But worse than our bottom end of the scale pay for the pictorial was the fact that despite being the stars of the show, Hef and the producers decided that Bridget, Kendra, and I wouldn't receive a single dime for the first order of *The Girls Next Door.* Hef would later argue that he considered our pictorial fee our payment for season one. He clearly knew the value of a "buy one, get one free" deal. I recall someone connected to the show reminding us that we got "free room and board" at the mansion. This guy clearly didn't realize the heavy price of this "room and board": how restricted our freedoms were and all that was expected of us.

While the filming on the first batch of *GND* episodes was wrapping,

Kendra had finally gathered the courage to bring the issue up during a meeting the three of us had with the show's highest-ranking producers.

"Shouldn't we like . . . be getting, like . . . *paid* for doing the show?" she asked nervously. It really was a valid question and she broached the topic in a delicate way. We were working countless hours, opening up our private lives, and baring our bodies for public consumption, so in her mind that was worth something. She wasn't being accusatory; she was just being logical.

The response she received was not what any of us were expecting to hear.

One of the producers took a deep breath and suddenly became very firm before spitting out slowly and methodically (so that our tiny little brains had time to absorb this fact): "You. Are. Replaceable." (That would become the unofficial motto of *GND* for seasons to come.) "This is not a show about the girls who live at the Playboy Mansion. It's about Hugh Hefner and who *he* chooses to date. It is *not* about any of *you*." We were constantly reminded that the show was *Hef's* show—our contributions were irrelevant. We were the decorative icing, not the cake. According to our boyfriend, he could have splashed any three blondes on screen and found instant success. This producer's firm response quickly silenced Kendra into submission.

In the days and weeks following the photo shoot, I routinely stalked Mary O'Connor's office looking for the *Playboy* "brown book" (a mock-up of an upcoming issue for Hef's approval made from thick, brown, grocery-bag-like paper). I'm a self-proclaimed super snoop, so I spent hours lingering around her desk hoping to get a peek of our pictorial. Eventually, my persistence paid off.

As it appeared on the show, we were all oh so naturally sitting in a circle on the floor of Bridget's room when Hef came in to present the book to us. In actuality, Bridget and I spotted the book in Mary's office one afternoon and quickly flipped through it to get a first look at our feature. When we finally saw it, we weren't as thrilled as we could have been.

Physically, we looked great. The photography, lighting, and makeup that *Playboy* used at the time was so flattering, very little retouching (if any) was needed. Even back then, most people assumed that the women of *Playboy* were mainly a product of Photoshop, but that wasn't the case with most of the pictorials. Kendra would eventually request to have her labia Photoshopped out of one of the pictures where her legs were in the air, but that was about it. Years later, *Playboy* would auction off that brown book, complete with Kendra's crotch circled in Hef's red pen. So much for not having that out there! But it wasn't what we looked like that bothered us, it was which photos were selected.

The large opening shot just so happened to be the picture of Bridget, Kendra, and me in our sexy cocktail attire with Hef plastered right between us. Remember those brief few clicks he casually wandered into? Maybe it's just me, but I'm not so sure men picking up the magazine would be all that turned on by a septuagenarian man front and center. We quickly realized that none of our individual looks had been chosen—the one piece of the pictorial that could differentiate us from one another. The steamiest photo in the feature was a full-page photo of Kendra and me in the bathhouse shower. Like I said, at the time we didn't think anything of the extra shots, but looking at it in context was quite different. This was one of the largest photos in the pictorial, and it was very clearly missing one-third of our group. Needless to say, Bridget was upset. I'm certain Kendra or I would have felt slighted as well, but Bridget had dreamed of becoming a Playmate even longer than Kendra or I had, so she took this quite personally.

On the show, Bridget returned from class already worked up over the shower ordeal. On camera, she confided to her sister about how upset it made her to be excluded from the day's final setup and decided to speak with Hef about it. In the scene, viewers see Hef come to comfort Bridget, who was sitting on the floor playing with her cat.

This is the exchange audiences hear:

BRIDGET: *I know, but that's what I'm saying; everyone would feel the same way.*

HEF: *Okay, okay. Absolutely. Let me see what I can do. That isn't exactly the toughest one to do; it's a shower and hair.*

BRIDGET: *I know, but I just feel like saying something makes me seem ungrateful, and I'm not.*

HEF: *Listen, I know how important all of this is to you. I'll figure out some kind of solution, honey.*

In *real* reality, events didn't play out that way. Bridget didn't discuss the shower sequence with Hef until *after* we saw the brown book—and long after the pictorial shoot had wrapped (which was why Kendra appeared so agitated at having to shoot again). At the end of the episode that aired, people can clearly see the two-shot of Kendra and me in the brown book when Hef is showing it to us (the photo that went to press was the shot of the three of us in the shower).

Bridget was sensitive about how her reaction would be perceived, so she told producers she wished to speak to Hef off camera and asked that they respect her privacy. The crew preferred to film everything as it was happening, but they eventually agreed that Bridget could speak to Hef off camera. Reality producers love to find loopholes, though.

Both Bridget and Hef were still mic'd when the conversation took place, so the post-production crew dubbed their private dialogue over stock footage of Bridget and Hef playing with her cat, their backs towards the cameras. Oh, the magic of Hollywood!

IN THE BEGINNING, I have to admit that I didn't have a ton of faith in the process. I believed that everyone was pigeonholing us into their preconceived ideas of who we were and that audiences would see right through the facade—or, at very least, quickly become bored.

Perhaps there's a reason I wasn't a reality TV producer in 2005, because there was most definitely a method to their madness.

Nearly a million viewers tuned in to watch the premier episode of *The Girls Next Door.* A million! Overnight, the show became this pop culture sensation. The network immediately upped the order from 8 to 15 episodes for season one. Every Monday we'd receive ratings from the previous night's airing, and every week they were higher than the last. Not only were audiences fascinated at getting a glimpse inside the wondrous world of *Playboy,* but also at meeting Hef's three girlfriends. Kendra, Bridget, and I wouldn't really grasp the scope of how major this was for years to come.

For her part, Kendra was reality TV gold—especially in 2005. America was at the height of its obsession with dumb blondes. Paris Hilton and Jessica Simpson were among the most famous women of the time due to their airheaded antics on their shows *The Simple Life* and *Newlyweds: Nick and Jessica*. On camera, Kendra was spontaneous, carefree, and brimming with those bumbling mishaps ripe for television. And let's just say, when it came to Kendra, none of those dumb blonde moments ever had to be scripted.

On top of being the house cheerleader and the emotional anchor to our trio, Bridget was also the perfect attraction for more "conservative" viewers. With a serviceman brother, an adorable teenage sister, and deep-rooted family values (despite living at the Playboy Mansion), she connected with Middle America.

I added some levity to the show. Despite being delusional about my relationship with Hef, I recognized many of the absurdities of mansion life, and audiences seemed to gravitate towards that. I could roll my eyes along with those men and women sitting on their couch when Hef insisted on us all embracing in a cheesy group hug or laugh along with them at one of Kendra's dumb blonde moments—and actually be *in* on the joke, instead of its punch line. Sure, it could be construed as bitchy, but it seemed to strike the right counterbalance. Plus, there was only so

much I could handle. While I loved shooting, deep down, I still hated that *this* was how I had become famous.

Like a busty version of the Three Musketeers, we complemented each other's personalities well on camera. The initial appeal of *Playboy* was obvious, but what was unexpected was the audience fascination with the three of us. People came to the show for an inside look at Hugh Hefner's magical world, but they stayed because of Kendra, Bridget, and me. I honestly believe the show wouldn't have worked as well with any other cast of characters that had lived in the mansion. If cameras started rolling a year earlier when the Mean Girls still haunted the hallways, I don't think any production team could have made those women even the least bit likable.

Towards the end of season one, upwards of 1.5 million people were tuning in each Sunday night to see what was happening with the three quirky blondes on Charing Cross Road—major numbers for the network.

However, despite the show's immense popularity, we weren't able to celebrate many of the positive perks of our newfound celebrity. As usual, we remained locked behind the mansion gates, bound to our dictator's rules. We weren't well known enough yet to be recognized while simply running errands (usually in Juicy sweats and without makeup)—especially without one another or Hef. The club nights had slowed to a halt and we weren't permitted to do any of our own press, so any fandemonium we experienced still seemed to revolve around *Playboy* and Hef. I never knew we girls had fans of our own until later into the series.

But thanks to the Internet, we *were* able to absorb the full scope of the criticism that spewed from countless online haters.

In 2005, Myspace was still the most important social media site available, and was used primarily on personal computers (who had a smartphone back then?). These were the calm days before Facebook, Instagram, and Twitter became national obsessions. The term "cyber bullying" hadn't even yet been coined. While today most people are aware of the dangers of the anonymous taunting on social media (and many

have been victims themselves), reading truly cruel remarks about yourself online from complete strangers was a form of self-torture that I wasn't quite prepared to deal with.

My self-confidence was already fragile, so I took the vicious online attacks far more personally than I should have. Gold diggers, whores, sluts, stupid . . . we were called everything I had always feared I would be called for being a part of this group. When I would stumble upon a message board discussing *The Girls Next Door,* not only did I feel hated but also completely isolated. Even though Kendra and Bridget received equally as brutal commentary from these miserable trolls hiding behind their computers, there's something very lonely about being a battering ram for a group of hateful people. And absolutely nothing was sacred. Even those physical qualities I did feel secure with were subject to public ridicule (I love my big eyes, but ruthless haters labeled them "reptilian").

I was hyperaware of the public perception of Hef's harem of blondes, so part of me was convinced that Kendra, Bridget, and I were a total laughingstock. While promoting the show in New York, we were invited to be guests on the ABC daytime talk show *The View.* A producer placed Hef on a chair and strategically organized the three of us to perch around him. It was uncomfortable and awkward, but we were new to the game and wanted to be amenable. As soon as the cameras started rolling, Barbara Walters asked the three of us, "Do you always sit like this?" As if it had been our inane idea. In case I had somehow managed to drift off into blissful ignorance, Barbara Walters was there to remind us of how ridiculous we all appeared—and what a joke we were. Bridget and I wanted to crawl inside our own bodies and die. But Kendra . . . she just responded in an episode of *GND* that the hosts were all "haters" who needed boob jobs.

JUST A FEW MONTHS after the final episode of our first season aired, E! renewed *GND* for a second season. The premier of the second season would end up scoring a three-year ratings high for the network. In a way,

I got what I had wished for. The fame for fame's sake I had grown to desire was now mine. It didn't make me happy, though. It was the emptiest kind of fame, not gained by producing quality work, but by being a curiosity: one of Hugh Hefner's three girlfriends.

During the filming of season one, a Playmate named Kara Monaco had come to live across the street from the mansion at the Bunny House. Kara and I had become close friends over the year and she even made quite a few cameos throughout the first season of the show. When 2006 rolled in, Kara was bestowed the highest honor a Playmate can receive: "Playmate of the Year." She was on the cover of the June 2006 issue and featured in a gorgeous Cinderella-themed pictorial. Of course I was beyond happy for my friend, but I was also melancholy. Not only was a friend moving away, but her success reminded me of the dreams I had had when I moved in five years earlier. As Playmate of the Year, Kara would be graduating from the mansion and traveling the world for appearances and promotions. She was moving on with her life, in the same way I had once hoped to do.

At 27 years old, I felt positively ancient. It didn't help that with every batch of Playmate test shoots that trickled through Mary's office, I'd see memos on certain photos denoting a girl who was deemed "older." "She's 28" was always something the Chicago photo editor (a male contemporary of Hef's) had to point out as if a prospective candidate was at death's door. After 28, according to them, a girl might as well put herself out to pasture.

As production crews rolled back in to shoot season two, I reluctantly decided I would do my best to accept my lot in life and aspire to one day be the only girlfriend at the mansion. After all, that is ultimately what I wanted. Wasn't it?

CHAPTER 9

"It's rather curious, you know, this sort of life!
I do wonder what can have happened to me!"
—Lewis Carroll, *Alice's Adventures in Wonderland*

s *The Girls Next Door* continued on to season two, everything got . . . well, better. Filming occupied most of our days, so our evenings were pretty quiet. With all the attention Hef was receiving from the show, his ego was fully satisfied. He felt both famous and relevant again, and therefore didn't need to drag us out to nightclubs twice a week so the "adoring public" could ogle him. That was a huge relief for me. Not only was I sick of nightclubbing and drinking, but with the club nights now off the schedule, the post-club bedroom ritual also went out the window. It was definitely an unexpected bonus. It was the first time Hef's girlfriends could say "we don't sleep with him" and it would actually be true. Surprisingly, even though sex was out of the equation, Hef seemed happier than ever. I guess there is something Hugh Hefner loves more than sex, and that's fame.

Needless to say, for me, sex was never the highlight of the relationship. I was more than happy now that our evenings were spent eating

dinner in bed while watching *The Sopranos* or with Hef fretting over a Sudoku puzzle while I did a crossword. We were like a typical old married couple. The only difference was, only one of us was actually old.

For a time, the show's success really bolstered spirits at the mansion. The three of us girls were now getting paid for being on the reality TV hit and could finally start saving up some real money. *Playboy,* as a brand, was hotter than ever. We were on our way to achieving that long-desired harmony among the girlfriends. *GND* had become a project we bonded over. Many of the plotlines became memorable common experiences, and the times the episodes would spotlight our individualities made us feel special.

During season one, we visited Bridget's hometown, Lodi, California. It was so cool, getting to see her and her family in their "natural habitat," i.e., outside of the mansion. We visited Kendra's hometown of San Diego as well. She and her family went out of their way to make us feel at home. Kendra even coordinated a fun tour of her favorite spots and showed us her old home videos. Although, I have to admit, watching Hef fawn over her childhood videos and threatening to take one home made me really uncomfortable. When you're 80 years old and dating a trio of 20-somethings, you already look like a dirty old man. He didn't need to give viewers any more ammunition.

For me, the last episode of season one was really special. We visited the Palms casino in Las Vegas where they were readying the new Playboy Club, set to open the following year. Knowing what a fan I was of the Bunny costume and of Roberto Cavalli (who had designed the new Bunny ensembles for the club), Playboy PR tapped me to model one of the new prototypes in a fashion show (along with several Playmates). Not only was I able to wear this amazing costume, but I was able to do it without the other two girlfriends. It was one of those small instances where I could feel like I was my own person. I savored the moment and it became one of my all-time favorite episodes.

Less than a year after our first magazine appearance, Hef ordered

our second pictorial and cover for the September 2006 issue. The cover would be on stands as season two premiered—and I even got to develop the concept! I sketched the idea out on a cocktail napkin while at a Dodgers game. Taking the notion of "the girl next door" literally, the cover showed the three of us peeking through a white window with frilly drapes—and it became the first time the magazine photographed a corresponding back cover (which, naturally, was a view of our butts as we were peeking out the window). Both images were shot simultaneously to ensure continuity. And while this time we were finally able to star in individually themed shoots, it was mandated that the other two girls appear in the background of each. We still felt frustrated that Hef seemed to think we were only worthwhile as a threesome, but it turned out that casting us as a team wasn't making us jealous and turning us against each other; instead it was turning us into a team in real life.

Just like the first shoot, we had a blast modeling together. Being in the magazine was a dream come true for all of us, so being able to do it *again* was icing on the cake. But just like the first time around, Bridget's emotions started to get the better of her. She began to feel like the photo editor, Marilyn, was singling her out and nitpicking every detail. If there was a hair out of place, it was Bridget's. If someone needed to move, it was Bridget. It kept up like this for most of the shoot. Eventually Bridget reached a breaking point and needed to take a moment in the makeup room. Surprisingly, Kendra went in to comfort her and put her in a better mood. I couldn't have imagined that happening a year earlier, when things had been more strained between the three of us. We had made huge progress with our friendships.

Other changes were afoot as well. Prior to the show, we'd almost never traveled—Hef was a creature of habit who despised any sort of variation from his routine. Once he finds a comfortable one, he's bound to stick with it for at least the next few decades. So when we learned that the second season would see us not only on multiple trips to Las Vegas, but also on a two-week-long European getaway, we were flabbergasted.

Paris, London, Cannes, Barcelona, Munich, Rome . . . for us, it was un-
heard of!

It was on these trips that Bridget and I finally found something we
had in common with Kendra: we all loved sightseeing. The three of us
were very different, but we all came from working-class backgrounds. I
think at one point we each believed that moving into the mansion would
give us the opportunity to see the world, but the truth is, we rarely left our
neighborhood. After a while, we gave up hope that we would ever travel.
Now that Hef knew the world was watching, he had to be the "play-
boy" everyone believed he was. We were finally getting the experience we
thought we had signed up for!

It was the opportunity of a lifetime, to be able to travel around the
world in style, so we didn't waste a single minute. From Pompeii to the
Paris catacombs, Bridget and I were checking things off our bucket lists
left and right! Kendra said she felt like she was finally learning about
history for the first time, in a way that made it feel real. The three of us
were up at the crack of dawn, trying to pack in as many outings as we
could before Hef finally rolled out of bed and started his day (usually
after noon). He would join us for a few of the landmarks (mostly for film-
ing purposes), but he was more interested in doing press and attending
parties in his honor than in seeing the sights.

The second season rounded out by celebrating my and Hef's five-year
anniversary. Bridget set up a dinner party in the living room, transform-
ing it into a replica of one of my favorite restaurants, The Melting Pot,
complete with their signature fondue pots. I couldn't believe five years
had passed since I moved into the mansion—a half decade of my life had
been sucked into the Playboy vortex.

"I think a lot of people would look at being together for five years as
a turning point," I said to the interview camera, an empty smile on my
lips. "But I know it's not a turning point for us because I know nothing is
going to change in this relationship any time soon."

When we all gathered around the table for our anniversary dinner

(because it could never be just the two of us), I presented Hef with the sort of sap-filled greeting card he adored. I'd even scribbled the pet name "Puffin" across the top. As he read it aloud, I burst into tears. Hef put his arm around me and gave me a kiss on the head. He was positively glowing! Not only was he surrounded by a bevy of beauties, the cameras were also there to catch this public display of affection.

I tried to play off my outburst as having been touched by the romantic moment (and I think most people bought it!), but in reality I was crying because of what a farce this whole thing was and how stretched thin my nerves were at that moment. Hef reading off the flowing words of love from the card reminded me again what a joke this whole situation was and made me feel like I had missed out on my chance to ever have anything real with someone; to ever meet a man who really deserved a card like that. I had sold my soul to the devil and felt that there was no way out.

As the show continued to grow in popularity, we became more and more valuable to both the network and the brand. We even got to have a tiny bit more say in what kinds of things we filmed.

"Do you like it?" shouted a network exec, referring to the holiday-themed episode we had just seen a cut of called "There's Snow Place Like Home." The mansion was in utter chaos as E! executives, along with a few hundred other of our nearest and dearest, descended onto the grounds to celebrate E!'s upcoming season, which consisted of the season three premiere of *GND* and the premiere of Ryan Seacrest's first produced series, *Paradise City*.

"Yeah, I think it's really fun," I replied, with a big smile as the party buzzed on around us. "People are going to love it!" I had been angling for a Christmas episode since season one, but the producers had always refused. Holidays were a big part of mansion culture and one of the few breaks from the otherwise monotonous life there, so we looked forward to these large-scale events.

Historically, seasonal episodes hadn't performed well in reruns, which the network ran a lot of. During those years, you couldn't turn on E! for more than a few hours before bumping into the three of us, and the execs understandably didn't want to air a Christmas episode in July.

Just then, Hef appeared next to me. Seacrest had arrived and network execs and upper management were clamoring for his attention. Earlier that year, Seacrest agreed to a hyper-lucrative megadeal with the network and was quickly christened E!'s resident Golden Boy.

Hef grumbled under his breath, something about how E! would never have been able to afford Ryan if *GND* hadn't been so successful, before shuffling off towards a nearby table, expecting me to follow.

Hef had become obsessed with the show. When *GND* was first ordered, he wasn't particularly eager to make many appearances.

"This way, Daddy doesn't have to do the work!" he guffawed at the press when they would ask him why he decided to do a reality show that centered around his girlfriends. He also described reality shows as "dumb and a waste of time."

His tune changed as soon as he realized just how popular the show had become. Suddenly it became imperative that Hef have a substantial scene in every episode. If he saw a rough cut of an episode and wasn't happy with the amount of screen time he was getting, we were called back to re-film scenes in a manner that would include him more. Even when we shot entire episodes off the mansion grounds, we were obligated to call home on camera, so the show could cut back to what Hef was doing back at the mansion. Not surprisingly, it usually involved him spending time with other women. At the end of the day, the producers were right. It *was* Hef's show.

By the time we began filming on season three, my attitude changed when it came to our little reality program: I was finally fully embracing it. I had been skeptical of how the series would affect my life. But by the time the network ordered a third season, even I had to admit that we had a hit on our hands. I started to see the show as an opportunity. It was an

excuse to travel, to go outside the mansion gates and try new things. Also, I was starting to realize that being on a reality show brings a little magic with it. People are more willing to give you a chance when you are on TV, even if it's on the silliest of reality shows. I was beginning to sense that I might be able to get something bigger out of this, even if that something was confined to the world of *Playboy*.

That season, we were finally able to film in December and capture my birthday (Kendra's and Bridget's birthdays had both been covered twice over the previous two seasons). Birthday episodes were important to each of us, because it was another opportunity to feel special and to be portrayed as individuals. I think being able to feel like our own person from time to time made us all feel a little less insecure, which allowed us to come together as friends more and more. Even a silly activity like horseback riding helped us bond and, indirectly, ended up having a big influence on my life.

The show's producers found Sunset Ranch in the Hollywood Hills, offering horseback rides over the hills into Burbank and back to Hollywood. For the episode called "May the Horse Be with You" we drove up Beachwood Drive and passed through an old stone gateway into a quiet area populated with adorable storybook-style cottages. I had never seen houses so cute. They looked like one of the seven dwarves was going to pop out of one of the doors at any given moment.

What is this place? I thought.

I would later learn that the area was developed as a community called Hollywoodland (that's where the famous Hollywood sign comes from) and each house was built to look as if it came straight out of a fairy tale. I didn't know it then, but I would find myself returning to that neighborhood quite regularly five years later.

The episode that marked the most immediate change for me, however, was definitely the one called "My Bare Lady," which focused on me interning under Marilyn Grabowski at Playboy Studio West. Despite dating the boss, I didn't find the internship that easy for me to secure.

Prior to the start of each new season, the three of us girls would meet with producers to discuss the coming months and potential plotlines they could follow. The producers needed to know what we had going on in our lives so they could decide what they wanted to film. Even though reality shows capture "reality," there still needs to be a storyline to follow. Filming us watching TV or reading doesn't exactly make riveting television. So we would gather around the mansion's dining room table, pencils and day planners in hand, listing off our plans and goals for the next few months. The producers would throw around ideas with us and would eventually let us know what had been decided: what we would film, when it would be done, and sometimes even how the things we caught on camera would fit into upcoming plotlines. Every once in a while we would film an activity, not really knowing where it would end up. Those types of things often ended up in what they called "Frankenstein episodes." For example: me buying an exotic bird as a gift for Hef, Kendra consulting a "pet psychic," and Bridget taking her dog to get an agent were intercut to create a pet themed episode.

In several of the meetings, I'd campaigned for a *Playboy* internship under Marilyn Grabowski, the photo editor at Studio West. I knew this was never an opportunity Hef would give to me ordinarily, but I thought that if it was something chronicled for the show than he might actually let me give it a whirl.

At the time, we had already shot two pictorials for the magazine and I absolutely loved being at the studio. The idea of working on set with the models and being a part of the decision making really spoke to me—I was desperate for some sort of creative outlet. Marilyn was responsible for coming up with ideas and themes for shoots, doing the art direction, and choosing the best photos to send to *Playboy*'s Chicago offices for layout design. After spending years admiring all of the Playmate proofs routed through Mary's office, reading the memos back and forth between editors, and seeing the final selects for the magazine, I felt like I had developed an eye for the process. On the occasions the executive producer

pitched the idea to Hef he turned it down. (Hef was never in our plotline brainstorming sessions; he would be consulted afterwards.) No reason was ever relayed back to me—just that it didn't get approved. I was too timid to ask Hef about it myself, particularly with the knowledge that he had already shot it down.

I was so frustrated, always hearing "no, no, no!"

"It's the one idea I'm really excited about and he keeps turning it down!" I complained to Bridget one day while I was lounging in her room. Not only was I the quietest, least outgoing cast member, but my interests overlapped with Bridget's so much that I found it difficult to find plot ideas for myself. There were so few things that felt unique to me and were also within the boundaries of what Hef would let me do. I was starting to lose patience.

As she set about organizing a pile of craft supplies, she told me she had actually heard something about it. Sitting cross-legged on her poufy pink round bed, she and I had been discussing ideas for the upcoming season and I'd once again mentioned my favorite plot idea. Bridget went on to tell me that Hef didn't want to tell me no on camera if the work wasn't good enough. Hef said he wasn't going to approve something just because I worked on it.

"That's FINE!" I replied, exasperated. "I don't want him to publish my work if it isn't good enough! I *want* to learn! Plus, being able to tell me no on camera would make good drama for the show!"

Bridget started laughing her infectious laugh. "I know," she blurted out. "That's what I was thinking!"

Despite being addicted to drama in real life, Hef was adamant that no real drama or "negativity" play out on the show. We were to be depicted as a happy family, blissfully sharing our boyfriend at all times. I believe, because *Playboy* and his lifestyle were controversial enough, that he wanted to prove to everyone that things were always just peachy inside the mansion. The network and the producers would have liked a little drama (anyone does when making a reality show), but Hef wouldn't have

it, hence not wanting to tell me no on camera. The irony was, of course, that he had done so (and sometimes cruelly) many, many times in real life. He wanted to be portrayed as the best boyfriend ever, which meant he acted quite different on camera than off. In the world of *GND,* you ONLY saw his good side.

A season later, after the producers and I brought up the idea for the millionth time, Hef finally relented and let me give the internship a try. In order to secure the internship, I was charged with finding a potential Playmate candidate suitable for the magazine and bringing the photos to Hef for review. I instantly remembered meeting an adorable Puerto Rican girl that Playmate Colleen Shannon had introduced to me at an autograph signing—my first job was to track her down! When I finally found a photo of her to show Hef, he approved her as a candidate. Tamara Sky would soon become 2007's "Miss August," and her Playmate shoot would mark my first official gig as a *Playboy* photo intern.

Marilyn graciously welcomed me into the studio. She introduced me to Stephen Wayda, who would be shooting Tamara's pictorial, and walked me through proof editing for the Miss June shoot. With great patience and care, she pointed out all the elements that make a great centerfold—and exactly what it took in order to get Hef's approval.

I was still trying to figure that one out! I thought, laughing to myself.

It didn't take long before Studio West became my home away from home. In fact, I think I felt more like myself at the studio than I ever had at the mansion. Away from Hef's critical eye, I relaxed and grew into my new role. Having the internship gave me a sense of great pride. The photographers and staffers were an invaluable part of the experience, teaching me everything I needed to know. I couldn't believe I was actually getting centerfolds approved! I had been hearing for years that Hef was so picky, it sometimes took weeks to get a finished centerfold. Not only did I enjoy the job, as it turns out, I was actually good at it, too! Between my nine-to-five at the studio and all the editing homework I was bringing

back to the mansion with me, I ended up spending most of my time on the job, and I wouldn't have had it any other way!

When Marilyn retired, I was promoted from intern and given an actual job, with the title Junior Photo Editor. I was assigned to the up-coming Playmate shoots, and since I was the first editor to focus entirely on the Playmate of the Month feature, eventually I was given the title Playmate Editor.

I was finally starting to feel like I had a purpose, like I had some use in the *Playboy* world. I wasn't just one of Hef's numerous blond bimbos. My confidence grew for the first time since I had moved into the man-sion. This job did for me what starring in a reality television show and be-coming known worldwide didn't do: it made me feel good about myself. Having responsibilities, new skills to learn, and a creative outlet allowed me to slowly start coming alive again.

Over the course of *The Girls Next Door,* we would pose for two more covers (besides November 2005 and September 2006) and three *GND* cal-endars, which I took upon myself to direct and edit. *The Girls Next Door* projects weren't a part of my Studio West job in any way (on the clock, I handled only Playmate projects), but because I'm ambitious, love a good project, and wanted some kind of say in how I was portrayed, I took the helm of some of our shoots anyway and no one protested. The March 2008 "Sexiest Celebrities" cover was an outtake from a concept I devel-oped with the three of us perched inside a bunny-shaped constellation. Apparently fans of the show were enjoying my photo editor storyline, and production decided to spend more time with me in the studio. Some viewers probably thought my job was fake and only for the TV program. One E! executive even congratulated our executive producer for making me look "credible on that job," which I found insulting, to say the least. Most people only knew me as a reality TV bimbo, so I guess it's not sur-prising that many people assumed I couldn't handle a real job. But the only time I ever may have appeared involved in a shoot when I wasn't

was when a production team asked me to pop by the *Playboy* shoot Kim Kardashian was filming for *Keeping Up with the Kardashians*. I didn't have anything to do with her pictorial, since it was a celebrity shoot and not a Playmate feature.

Sneaking in a little creative say over our projects was a major outlet for me. Not everyone had that sort of outlet, though. As girlfriends, the three of us were to be seen and not heard. Never were we permitted to express any sort of discontent with Hef or mansion life. As Kendra's star began to rise, she became more confident, independent . . . and vocal. Bridget and I had been through so much by the time Kendra had arrived on the scene that we were already preconditioned to be afraid to ask for anything. But Kendra wasn't afraid, and as a result was granted a little more freedom. Her fearlessness certainly let Hef know that if she didn't get her way she would be out the door. Of course, granting one of the girlfriends some perks that the others didn't get played into his manipulative games as well. She was the only one of us allowed to have an outside agent, who booked her for a few club appearances. But like all things at the mansion, her added benefits came at a cost. She was no longer new and novel enough to be completely safe from Hef's belittling ways. Just like he'd done with me for years, he began chipping away at her confidence, slowly but surely.

"You have a little overbite," Hef pointed out to Kendra while shooting an episode for season three. Kendra had dressed up as Mae West for one of our calendar photos, an obvious bid to win Hef's affections by emulating an old Hollywood star.

"What . . . ?" Kendra laughed nervously, obviously embarrassed, looking straight into the camera for some kind of help as Hef went about his business.

It happened off camera, too. During a limo ride to an event, on a day when we weren't filming, the four of us sat quietly in the vehicle as it battled the L.A. traffic. Hef, for whatever reason, decided to have a go at her:

"You know, Kendra," he said out of the blue, "it looks like you are

putting on some weight." He then went on to talk about how she should watch what she eats at the buffets.

Oh my God! Did he really just say that? Kendra was athletic and never, ever did she need to lose weight. Bridget and I pretended not to hear his cruel remark, hoping that ignoring it would make it less satisfying an insult for Hef and less embarrassing for Kendra. In retrospect, I know I should have said something to stick up for her, but I was way too scared to stand up to Hef in any way. He frightened me.

Kendra and I might have had our differences, but the show had turned out to be a really positive thing for our relationship, and in that moment, my heart broke for her. I stared out the window, wishing I was anyplace but the back of that limo. To her credit, she didn't yell or cry; she took it on the chin. When we arrived at the party, Kendra was uncharacteristically reserved for the remainder of the evening, the wind quite visibly taken out of her sails.

In many ways, the playing field had been leveled since she joined the group three years earlier. The show gave us all a common ground and Kendra was now no stranger to the insults, tantrums, and guilt trips (complete with fake tears) that Bridget and I had been dealing with for a number of years. It was now the three of us girls against the world, instead of us against each other.

CHAPTER 10

"I can't help it," said Alice very meekly: "I'm growing."
"You have no right to grow here," said the Dormouse.
—Lewis Carroll, *Alice's Adventures in Wonderland*

I think a jewelry line would be really cute," I suggested to Darlene, one of the *Playboy* licensing department associates. The show's ratings were high and growing, so it dawned on *Playboy* to begin merchandising it—and the girlfriends—to increase profits and capitalize on its popularity before it was too late. They asked Darlene and some other licensing execs to come speak with the three of us.

"They should be specific to our lifestyle shown on TV," I continued. "Charm bracelets are really popular, so how about one with cute charms like a tiny dog, a champagne bottle, a jet . . ." I began doodling the design on one of the HMH (for Hugh Marston Hefner) monogrammed notepads placed around the dining room table.

"That's a really great idea," she exclaimed, watching me draw the little trinkets on a large link bracelet. "Wow, you can actually draw."

At the time, the licensing department was one of the star moneymaking divisions of Playboy Enterprises. Playboy clothing and accessories

had been popular ever since Sarah Jessica Parker wore a gold rabbit head necklace on an episode of *Sex and the City*.

And, for the first time ever, the show was single-handedly guiding *Playboy* into, dare I say, *almost* family-friendly, mainstream status. Our show was packaged in such a way that, believe it or not, many adults were watching it with their kids. The series, though loaded with sexual innuendo, was so colorful and cartoony that it almost felt more *Scooby-Doo* than sexy. *GND* merchandise was a natural integration. However, *Playboy* licensing was extremely cautious not to directly associate any one product with *The Girls Next Door* in order to avoid owing any sales percentages to the network (save for the *GND* book, calendar, and the bobblehead dolls, all of which were things I pushed to make happen).

Playboy accessories were already big sellers online, through the catalogue and in boutiques, so I figured jewelry was the smartest fit for our first collaboration. Together with *Playboy*'s jewelry manufacturer, I created my capsule collection consisting of earrings, necklaces, and bracelets.

When the show was at the height of its popularity, so was the Vegas renaissance—and it quickly became a popular destination for us on the series. If we were married to the mansion, then Las Vegas was our mistress. The Playboy Club inside the Palms Casino Resort opened in October 2006, and shortly after, *Playboy* licensing had the brilliant idea (no sarcasm, it actually was pretty good) to create *Girls Next Door* slot machines. We were made aware of the project and expected to be thrilled at the honor alone. No one mentioned any sort of compensation for use of our likeness or any percentage on the back end. We were really excited about the idea, nonetheless. Who wouldn't get a kick out of seeing their faces on a slot machine? We simply didn't realize that we should be getting a fee for such a thing.

By this time, Bridget, Kendra, and I had signed on with a management company. Hef had worked closely with this company in the past and had made friends with the owner, so I suppose he didn't feel too threatned by us "branching out" in this way.

Hef kept us aggressively sheltered and any press we were allowed to do was preapproved by *Playboy* public relations and only done if it promoted the brand, the show, or Hef specifically. Nothing spotlighting us as individuals was ever given the green light. For example, Hef refused to let me try to compete in the first season of *Celebrity Apprentice,* because he didn't want me to go to New York for a few weeks, but "coincidentally" a Playmate of the Year he was eager to promote landed the spot instead.

For the most part, we chose our battles and did as Hef requested when it came to our careers, but the slot machine idea struck a chord. "No way," an acquaintance of mine told me over the phone one afternoon. "I'm going to look into this. Slot machines are *big* money, Holly. They're planning on using your names and likenesses. They have to pay you for that."

Shortly after the licensing department was approached about compensating us, the slot machine plans came to a grinding halt. It seemed insane to abandon it altogether, but it was never brought up again. Either there were too many hands in the pot to make it profitable or no one wanted to concede that we should be paid for the use of our names and likenesses. God forbid they open up a can of worms by making us feel important or put enough money in our pockets to feel independent!

My last attempt at foraying into the world of *Playboy* licensing was a pitch for Bridget, Kendra, and me to create swimwear lines—an idea they were initially enthusiastic about. They immediately green-lit the project and I began designing my collection. It went far enough into development that samples of all of my designs were manufactured. But one day, without any explanation, the project was shut down. Bridget, Kendra, and I were so used to defeat by this point, we didn't even question the decision. It was never mentioned again until one day I noticed the *Playboy* catalog on Mary's desk. I spun it around to face me and gasped.

There she was: a sultry Sara Underwood lying across the cover in a sleek, sophisticated black monokini with a tiny gold Playboy logo beneath the belly button.

"What the fuck?" I whispered under my breath. That was my design! Did *Playboy* licensing actually go ahead and manufacture and sell my design without even letting me know? Sure, it could have been a mistake, since the same manufacturers that made the *Playboy* line made the *GND* samples, and maybe Playboy even had the legal right to use my ideas this way, but it still made me feel like dirt. It wasn't about the lack of compensation. It was about feeling owned, like I was Playboy's personal property and could be walked all over like a doormat. I didn't even bother confronting anyone about it, because I knew it would be a losing battle. It definitely made me question my loyalty to the brand, though.

As *GND* went into its fourth season, I finally had the opportunity to take Bridget and Kendra to my hometown. We visited Bridget's and Kendra's respective hometowns in the first two seasons and I had been lobbying to take the girls to Alaska for quite some time. Needless to say, it was a little more expensive to get to Alaska than to Lodi or San Diego, so it took a little time for production to come around. Hef even tried to throw a wrench in the plans when he made it clear that of all the places he had never wanted to go, Alaska topped the list.

We were finally able to make the trip, along with my mom and dad (Hef stayed home, of course). I loved taking the girls to Craig, the tiny town I grew up in, and to Ketchikan, the nearest city, where my family and I used to go when we needed to buy something that Craig couldn't offer (there were only a handful of stores in Craig). Bouncing back and forth between islands on the tiny Otter plane was an adventure in itself. Our plane broke down midair and the pilot had to make an emergency landing. This was one time Kendra was *really* afraid of flying. She had to have a few drinks before getting on our return flight.

Alaska is rugged and not for everyone, so I appreciated that the girls were enthusiastic about the trip and made the effort to have a good time. The episode turned out to be my favorite of the entire series. One shot in particular stands out in my mind. The three of us took a moment to quietly swing on a swing set while the camera shot us from the ground, three

dandelions of varying height echoing our three figures in the foreground. It seemed like such an innocent moment, and the whole episode captured us as ordinary, real people, not as the "Mansion Mistress" cartoon characters we usually played on TV.

Later that season, the cameras returned to Studio West with me for an episode titled "Go West Young Girl." In the process of finding a Playmate for the upcoming September issue, I invited four candidates out to test for the slot. There was a brunette named Melanie from San Diego, raven-haired Valerie Mason from Louisiana, platinum blond Kayla Collins from Pennsylvania, and a quirky 18-year-old from Las Vegas named Angel Porrino.

Not only was I thrilled to have an episode focus so much on the job I had grown to love, I made new friends and even found a few Playmates in the process. Valerie Mason, with her classically cute face, would end up being chosen as Miss September. Kayla, surprisingly, was turned down by Hef for "looking too much like too many other Playmates." Hey, at least he was starting to appreciate variety! Kayla ended up becoming Miss August 2008 after Hef's friends made a fuss over her when he screened the *GND* episode for them.

My favorite candidate was Angel Porrino. She had an electric personality and the most fun sense of humor. People couldn't stop laughing when they hung out with her, especially me. I'd never had a friend I'd laughed so hard with. Along with German Playmate Giuliana Marino, we became an inseparable trio, hanging out and goofing off whenever I had free time. Hef didn't end up selecting Angel as a Playmate and I was very sad to see her go when it was time for her to return home.

My sister's wedding made up two episodes of season four: "Jamaican Me Crazy" and "Wedding Belles." I was surprised when my sister said yes to the idea of *The Girls Next Door* covering her wedding, but since she had planned a very small destination wedding in Jamaica, it turned out that she thought it would be a great way to share the celebration with all of her friends that couldn't be there.

Bridget, Kendra, and I couldn't have had a better time. For whatever reason, Hef wasn't interested in attending, but I can't imagine his cranky, high-maintenance personality in laid-back Jamaica anyway. The three of us girls had an amazing few days at Sandals Negril, relaxing, zip-lining, and exploring with my family. There was no drama, just a truly memorable trip and a beautiful beach wedding. I was the maid of honor, my sister looked stunning, and my family and two closest girlfriends were as happy as could be. Who could ask for anything more?

Playboy could. Just before filming was set to begin on season five, there was a mad rush to get Bridget, Kendra, and me under contract. Prior to the first episode of the series, we had each signed the most basic of television releases—and nothing more.

Realizing that the stars of this hit show were theoretically free to walk away and pursue other television opportunities at any time, someone must have panicked. Unbeknownst to us, Hef arranged to have us contracted under Alta Loma (*Playboy*'s production company), which basically meant that we would have a talent agreement binding us to Hugh Hefner. Letting us negotiate directly with the network was never going to be an option, probably because it meant he would have had to relinquish too much control over his girlfriends. After all, what if E! offered us something greater than being one of Hugh Hefner's blond bimbos? As I understood it, the network was willing to work with us in this fashion as long as Alta Loma could show they had us under contract, and fast.

It all happened so quickly, I can't even remember how I initially heard about the contract. What I do recall is getting really worked up and marching down to the master bedroom to tell Hef I had no intention of signing.

"I think it's in bad taste to sign a contract to be your girlfriend," I maintained. Given that the show was about "Hef and who he is dating," as opposed to any of the three of us (as they liked to remind us regularly), I felt signing a contract with him was taking away my option of walking

away from the relationship at any time. It would be just another facet of this relationship that would make me feel like a hooker. "It's just weird."

"I understand the notion, but it's important to me that you sign it," he said, looking at me with sad puppy dog eyes. "If you care about me, you'll do it."

In the end, it was always about Hef. Quietly, I did my best to consider my options. I didn't want to be coerced into doing anything else for this man.

Sensing my hesitation, and realizing that my heartstrings might not convince me, Hef decided to appeal to my business sense, telling me that if we didn't all sign, the network might not order another season.

As further encouragement, Hef had told me Bridget already signed her contract, but I didn't learn until afterwards that she did so completely against her better judgment. As a reasonable person would, Bridget asked to have some time to have her lawyers look over the paperwork but was denied. I imagine she was given the trademark mansion attitude: "If you don't like it, you can leave." Begrudgingly, she signed the contract.

"Okay," I finally relented. "I'll look at it, but I want you to know, I don't like this."

"I understand," Hef said, unable to contain his smile. He didn't care what the hell I thought, as long as I walked my butt down to the office and signed those papers.

Still in my pajamas, I trudged down to Mary's office at the other end of the mansion. Without saying a word, I sat myself in the chair next to her desk and started playing with her white Maltese pup named Miss Kitty.

"So," Mary started, looking over the top of her small-framed eyeglasses. "Did Hef tell you about the contracts?"

"Yes," I grumbled, before pleading my case. "And I'm not thrilled about it. I think it's wrong."

Mary sat in silence with her arms folded, allowing me my few moments to vent.

"Because the show is about Hef's girlfriends, I feel like I'm signing a contract to be in a relationship," I whined. I was beyond frustrated. I had my back against the ropes. If I wanted to move forward with the show for a fifth season, I had to bind myself to Hef's production company. What if I wanted to move out? Or do another show? I felt like this contract might make that impossible.

"That's not really what it's about, Holly," Mary reassured me, her voice smooth and calm. "E! is just hesitant to move forward with the show if their talent isn't under any kind of contract. That's all."

"I know, but . . ." I allowed my voice to trail off. I'd already had the same argument with Hef and it wasn't going to result in any different outcome with Mary. I fell silent for a few moments before asking, "Do they have to be signed today?"

"Yes," Mary said very matter-of-factly. "They need them back today."

"Why did we get them so last minute, then?" I asked, my anxiety starting to escalate again. "We don't even have time to look them over!"

"The contracts are with Alta Loma, dear," Mary went on, sidestepping any explanation as to why we were just now receiving them. "You know if there's a problem, Hef will release you from it."

But would he? I know that in Mary's heart, she sincerely thought that Hef was a good man—just as I believed at the time. But a nagging voice in the back of my head kept warning me not to trust this situation.

If signing this contract was really so important to everyone, I decided to just get it over with. I knew that ultimately I had no choice. Hef would find a way to corner me into signing it, so I might as well just save myself any further aggravation.

"Fine, "I said, grabbing a pen on Mary's desk. "Where do I sign?"

I scribbled my name on the contract that Mary nonchalantly shoved under my nose and handed it back to her.

"Now . . . what to do about the Kendra problem," Mary continued. Kendra was in the Dominican Republic for a paid nightclub appear-

ance, so she could hardly sign the paperwork by E!'s alleged deadline. But Hef and his team must have found some kind of solution, if all three of our signed contracts were indeed delivered to E! that afternoon.

I can't say this with certainty since I never witnessed pen to paper, but the gossip around the mansion was that someone on Hef's staff must have had to forge Kendra's contract in order to meet the network's deadline. Of course it's also possible that E! never even gave Hef a deadline or that he used a false date to get us to sign without giving us the opportunity to really review the documents. Who knows? All I know is, the whole thing seemed highly unusual to me.

OUR FIFTH CYCLE WOULD end up being a season of growing pains. Looking back, I see that it makes sense that this was our last season as a trio. From an outsider's perspective, however, everything looked like it couldn't be going any better. The series had become such a phenomenon, there was even a movie being made about it. Well, sort of. *The House Bunny,* starring Anna Faris, was a comedy set at the Playboy Mansion, centering on a fictional Playmate who finds herself kicked out of the mansion (upon turning 27) and takes refuge in a sorority house. In the film, Anna plays a mansion resident named Shelley, a character clearly based on Bridget.

"You should have been the sporty one," Kendra teasingly pouted at Anna the first time we met her as she prepared to shoot a scene in the mansion's backyard. Anna was done up with curly blond hair, a frilly pink outfit, and her character had a grumpy pet cat, similar to Bridget's cat, Gizmo. Bridget's pink-striped bedroom was used as Shelley's room in the movie. Even the high-pitched voice and sunny, Pollyanna attitude Anna affected for her character were very much Bridget's style.

We had cameos in the film, playing ourselves for a few scenes. The movie would hit the number two spot at the box office on its opening weekend. Even I couldn't believe what a phenomenon this frilly, frothy,

girly (and in many ways make-believe) version of the Playboy world had become.

Not everything in our world was cotton candy and fluffy bunny tails, however. That year, Kendra started taking Accutane for an acne problem she had grown increasingly self-conscious of. To me, Kendra was a beautiful girl, with acne or without, so on one hand I couldn't understand her paranoia, but on the other hand I could. Every girl who ever lived at the mansion knew that her entire value, in Hef's eyes, depended on the way she looked. In fact, in an interview from the previous year for an *Elle* magazine article, Kendra confessed: "I'm very insecure right now about my face. I get scared with Hef looking at me at the mansion and maybe thinking I'm ugly." I certainly understood how she felt. In that same article, Hef went out of his way to tell the writer that I had only "become beautiful" and that I "didn't look the same" as when he first met me, going on to attribute my new acceptability to my nose job.

Gee, thanks, Hef!

Whether it was an excuse not to have to adhere to the filming schedules she hated keeping or if she really had grown debilitatingly insecure, Kendra often refused to come out of her room to film scenes. I would find out later that this was around the time she started secretly seeing her future husband, Hank Baskett, so maybe that factored into the equation as well. The producers were desperate to find someone to take Kendra's spot, should she decide to stop coming out completely.

No one was talking about adding a new girlfriend or anything, but I was asked to recruit some girls that I thought would be good for the show to stay at the Bunny House for a month or so while we filmed. I chose Laura Croft, a wild and crazy Playmate from Florida; Kayla Collins, the bouncy blonde from the "Go West Young Girl" episode; and Angel Porrino (also from the "Go West" episode), the funny girl with the high-pitched voice from Las Vegas.

Having the girls around proved helpful as Kendra refused to partici-

pate in quite a few of the episodes (sometimes she would salvage her spot at the last minute by agreeing to film something by herself; other times she was just missing in action).

When Bridget produced a campy B movie called *The Telling,* Kendra didn't take part, even though she was offered a role in the film. While Bridget and I traveled with Laura, Kayla, and Angel to Chicago, Dallas, and New York to scout Playmates, Kendra chose to stay home.

One evening Hef popped around the corner into my vanity area and announced that he was kicking Kayla out of the Bunny House.

"Why?" I asked. I couldn't imagine what Kayla had done to warrant such dislike and was eager to stick up for my new friend.

"Kendra doesn't like her," he said firmly. "She thinks Kayla is starting trouble between her and some of the other Playmates. She feels like she is trying to take her place on the show. She's toxic. She has to go!"

"Are you sure?" I asked. "I don't get it, maybe I should ask Kendra about it. Kayla likes Kendra, as far as I know. Who is she supposedly starting problems with?" I asked.

"Other Playmates," Hef reiterated, as if that made him any more clear than before. He went on to say how hysterical Kendra was about it.

I couldn't figure out what this was really about and pleaded for Hef to let Kayla stick around for the remaining weeks that she was scheduled to stay.

"I'll talk to Kendra about it and make sure everything is okay," I promised, trying to play the peacekeeper.

Hef agreed to let her stay, but threatened to have her leave if she made another misstep. He waved a finger at me and walked out of the room.

I wasn't too worried about the situation; I assumed Kendra felt threatened by another petite, energetic platinum blonde running around in front of the cameras.

She'll get over it when Kayla leaves, I thought.

Later, I would hear through the grapevine that Kendra's future hus-

band, Hank, was apparently after Kayla before he met Kendra. I have no idea if this is true or not, but it would explain the freak-out.

For the second half of season five, the girls in the Bunny House left and the three amigos gravitated back together. We invited all of our moms (and our house mother, Mary O'Connor) out for a group spa day, visited Barbi Benton's outrageous home in Aspen, and went on a road trip for Bridget's sister Anastasia's birthday. The three of us attended our friend Stacy Burke's wedding in Vegas. Stacy was always identified as "Hef's former girlfriend" when her name popped up on screen during an episode. As if there wasn't any other way to identify her! Hef truly loved to believe that the highlight of any of his ex's lives was the time they spent with him. He also loved to remind viewers of all the beautiful women he "dated."

Towards the end of the season, in the summer of 2008, we shot our fourth *Playboy* cover, slated for February 2009 (this one would end up being our last). After much lobbying, Hef agreed to a three-split run, which meant we each had our own cover. It felt like a *gigantic* milestone! Fans loved watching our shoots on the series (which is most likely why we ended up getting four covers) and since three *separate* shoots would mean more footage for the show, production kindly coughed up the budget: $10,000 per shoot. I was so grateful that production was doing this for us—I definitely felt like they went more out of the way for us, and enjoyed our triumphs more than Hef did. While Hef scoffed at the initial idea (to him, we still couldn't stand on our own), even he couldn't refuse a free $30,000.

Hef approved my idea for the cover: I posed each of us in front of the mansion in such a way that if you line up the covers it created one panoramic shot. Another first for the magazine! I loved being a part of these little "firsts."

To make our three pictorials look as varied as possible, I talked to the girls about each of us using a different photographer. Bridget worked with Arny on an elaborate circus design, I suggested Kendra pair with

Stephen to shoot her for a *Sports Illustrated*–inspired beach shoot, and I decided on up-and-coming photographer W. B. Fontenot for a glamorous (yet dark) old Hollywood shoot at the historic Los Angeles Theater. Unfortunately, I discovered at the last minute that the decadent old theater's fee to allow production to film there was out of our budget. Only the still shoot was affordable. Since I wanted my third of the pictorial to be done my way, I decided to cover the cost of the photo shoot out of my own pocket and provide a different scenario for *GND* to film. Additionally, this would give me rights to the photos and the ability to grant *Playboy* the license to print *only* the photos *I* approved.

In order to provide content for the TV show, I decided to do something a little experimental and "out of the box" for a *Playboy* shoot. Since the magazine would be using my theater photos, what I shot for the show could be done with television in mind and not the magazine. Back then, there wasn't much room to move when it came to *Playboy* photo shoots. Hef had very particular tastes, so if you didn't want to waste everyone's time and money, you didn't stray far from the formula.

One of the recent activities we had filmed for *GND* was scuba diving. I fell in love with it! We had filmed our training in the mansion pool—I was astounded by how beautiful all the natural rock looked underwater. Inspired by that day, Barry and I did my shoot in the mansion pool, setting up several surreal underwater scenes: a tea party, a chained escape artist, a mermaid, etc. It felt amazing to do something so different! The underwater photos were used as "bonus" photos in the Playboy Cyber Club, as most Playboy pictorials set aside a few bonus extras from each published pictorial for their membership site. Hef, never missing a chance to paint me as ugly, would later publicly announce that my underwater photos were never published because they "weren't flattering," when in fact they were never meant for the magazine in the first place.

* * *

THE RECENT DOMESTIC BLISS at the mansion was too good to last. While the television show had bolstered Hef's mood for quite some time, he was eventually brought back down to earth by the sad financial state of Playboy Enterprises. It's no secret that the company hadn't been profitable in years. I remember seeing a TV news magazine story on the subject even before I moved into the mansion, but what I didn't know was that things had gone from bad to worse. It was 2008 and the economy was teetering. Coincidentally or not, Hef was turning into a monster around this time. Bridget, Kendra, and I had each other's backs; it was next to impossible to create conflict between us. Without the drama and infighting he so craved, lashing out at me became his new way of letting off steam. Because I was the "main" girlfriend (and meekest one in the bunch), Hef always felt safest picking on me. Sure, he lashed out at the other girls from time to time, but he was more cautious about it with them. He recognized that any of the other girlfriends would be way more likely to pack up and leave if they'd had enough, so I was usually the one he took his frustrations out on.

In years past, when Hef and I had problems, I always blamed the other girlfriends for the drama. Without any Mean Girl scapegoats left, I was slowly beginning to realize that Hef being mean was just . . . Hef being mean.

"Count it *cumulatively*!" Hef yelled so loudly that someone clear across the street could have heard him. As Hef's two sons Marston and Cooper got older, "Game Night" with the girlfriends eventually replaced Tuesday's "Family Night." These Game Nights became a mind-numbing ritual—at best.

Bridget, Kendra, and I would gather around the dining room table with Hef (and whatever girls were visiting the mansion that week) and play games. I loved Monopoly and Clue, but he quickly lost interest in those games. Hef was introduced to a very simple domino game called Mexican Train and became instantly addicted. Ever the creature of habit, Hef had us up playing Mexican Train every Tuesday, for hours at a

time. I loved it the first few times we played, but the game was so mind-numbingly easy, I quickly became bored.

One night Hef was particularly uptight and kept anxiously checking the score pad over my shoulder. When he realized that I was keeping track of the scores per game (as I usually did) instead of cumulatively (we played many rounds of the game in a row), he blew a gasket.

"Do you even know what 'cumulative' means?!?!" he screamed in my face so ferociously that it made my blood boil. I wanted to give him my *cumulative* SAT scores and stomp out of the room, but I restrained myself. Clearly he was looking for a fight and I wouldn't give him the satisfaction.

I took a deep breath and looked him square in the eye.

"Yes," I said, firmly and evenly.

Everyone else was silent. Kendra and Bridget had been on the receiving end of such temper tantrums and unnecessary cruelty themselves, so I knew they were cringing for me as they looked down at their dominoes.

It wasn't just the verbal disrespect that was wearing on my nerves. The limitations of mansion life were starting to get old. After seven years living under Hef's strict rules, I thought I could have earned enough respect to be allowed to bend the rules every now and then. Even prisoners get points for good behavior!

But unless cameras were following me, I still wasn't permitted to spend a night away from the mansion. Looking back now, I get frustrated with myself for being so blind. I was complaining because my boyfriend wouldn't *allow* me to spend the night away from his home, because he wouldn't *allow* me to stay out without him past 9 P.M. As a 28-year-old woman I still had a curfew!

I had never even asked to spend an off-camera night away from the mansion until a worthy occasion presented itself. Playmate Tiffany Fallon invited us to her wedding in Mexico to Rascal Flatts guitarist Joe Don Rooney. A charming Southern girl, Tiffany was one of the most beautiful women ever to grace the pages of *Playboy* and truly a joy to be around.

Bridget and I were ecstatic when we received the invitation, which included gorgeous luggage tags with our name and addresses printed on them.

"I've never been to Cabo before," I exclaimed to Bridget, glowing with anticipation.

Bridget and I looked into flights from Los Angeles into Cabo San Lucas, Mexico, to see if we could fly in and out the same day. Despite being only a two-and-a-half-hour flight, none were direct, and international travel is always a bit more time consuming. A day-trip just didn't seem feasible (or like any fun). Since Hef thought the world of Tiffany, I figured we might actually have a shot at attending. But it all depended on what kind of mood I caught him in. After talking it over ad nauseam with Mary, I got up the courage to ask Hef if Bridget and I could have a night away (Kendra was invited as well, but since she didn't want to pay for her own travel, she opted out).

"He says we can go!" I exclaimed excitedly into the ancient, crusty, cream-colored phone in my dressing room. I heard Bridget squeal on the other end of the line. Much to my surprise, Hef had given me a favorable response and told me to work out the details and let him know how long we'd be gone. I felt like Cinderella finally getting to go the ball! I couldn't believe our good luck! I was so excited to have my first girls' night out in over six years!

"We'll have to make travel plans right away: flights, hotels, transportation," I rattled into the receiver. "If we leave in the morning, we'll get there with plenty of time to get ready for the wedding and the party."

"*Party?*" Like a record player screeching to a halt, I heard my plans instantly evaporate. Hef repeated himself, "You're going to a *party?*"

It was as if he appeared out of nowhere, having changed into his blue flannel pajamas, clearly oblivious to the fact that it was still daylight outside.

"Well, yeah," I began fumbling. "I meant the wedding reception. It's like I told you, we can't get a flight back late enough to be able to attend

the ceremony and reception. We'd be spending more time traveling *to* Mexico than actually *in* Mexico."

I prayed he would see this logic, but Hef let out a stifled, sarcastic chuckle, as if to mock me. He wasn't even actually listening to me.

"You're not going to any *parties,*" he said firmly before shuffling his feet across the hardwood back into the bedroom. "The trip to Mexico is off."

Without uttering a word to Bridget (who I was certain overheard the whole ordeal), I gently put down the receiver as tears welled up in my eyes. I realized in that moment that nothing was ever going to change. My years of dedication earned me nothing. All I had to show for it was an increasingly bitter boyfriend and no hope for a future.

"I'm so depressed, I don't know what to do. I'm not happy here anymore," I told Bridget as we commiserated over not being allowed to attend our friend's wedding.

Truth be told, I had never been happy at the mansion, but I had always been able to put on a facade leading others to believe that I was. After all, Hef couldn't be seen having unhappy girlfriends, could he? I had been fooling someone else all these years as well: myself. While I had come into the mansion looking for a temporary safe harbor and a possible stepping-stone to a Hollywood career, I had fallen down a rabbit hole of nasty girls, a degrading love life, eroded self-esteem, and total fear of judgment from the outside world. I felt like a failure on my mission to make something out of myself. I had tried to rationalize my choices by convincing myself that I had fallen in love with Hef and just wanted to settle down and have a family.

I know how absolutely insane it sounds to want to have kids with someone in their 70s. You are basically robbing a child of his or her father before it is even born. Now that I am a mom myself, the idea seems even *more* unpalatable. But I suppose I thought of it as a ticket out—in more ways than one. The last time the mansion had been multiple-girlfriend free was when Hef was married and had two children, so (considering

the mind-set I was in) that seemed like an ideal scenario for me. I had convinced myself that the multiple girlfriends were the problem, because I just couldn't admit to myself that I had made a terrible choice moving into the mansion in the first place. It was cognitive dissonance at its finest.

There was also the part of me that was grateful for the things Hef had afforded me: food and shelter when I needed it, the allowance put towards paying off the debts I had from college, and the opportunities to be on a television show. Though there was plenty to complain about in the way I was treated, I was grateful for the good things and couldn't stand to be just like so many of the girls who had come before me, taking and running with no shame. Attempting the marriage and kids game, knowing deep down that it was a dead end, was perhaps my subconscious attempt to end the relationship in the "nicest" way I could think of.

I then confessed something to Bridget that had up to that point been top-secret, known only to me, Hef, Mary, and a few doctors. A step towards settling down had been made.

Hef had submitted semen samples to a fertility doctor only to find what the doctor had predicted all along—that nothing from this 70-something-year-old man was viable. I'm sure Hef knew this, too, and that was the only reason he decided to humor me and submit anything. I had made it clear to him several times that I wasn't going to be happy settling down at the mansion without a family and this was his way of trying to "save the relationship," though I'm sure he was quite relieved to dodge having another child. This was concrete proof slapping me in the face that there was no future for me at the mansion and it was either sit there and rot or take the plunge and face the world. I couldn't even admit wanting to leave to Bridget—I just told her how heartbroken I was over the outcome of the tests and that I didn't know what to do with my life.

Bridget was a little surprised but not as shocked to hear the secret scoop as one might think. She knew I was miserable and that I had been for a while. She knew I wanted a family in my life someday and that that wasn't compatible with life at the mansion. She also knew of my other

fear: after being one of Hef's seven concubines, would anyone even want me now? Had I ruined myself forever by making this choice?

She was a consoling friend and a great listener, but she didn't really know what to say. She had her own set of frustrations with mansion life and didn't have the answers.

There was something else happening that was distancing me from Hef, and maybe he felt it—I was starting to realize that perhaps spending the rest of my (or, perhaps more accurately, the rest of Hef's) life at the mansion was not what I truly desired. It had been years since Hef had chased after any other girls. It was becoming increasingly clear that Bridget and Kendra were restless and thinking about leaving and that Hef was fine with that, too. When I wasn't burying my head in my work, I was starting to panic inside. Was this *really* what I wanted? As becoming Hef's one and only came closer and closer to becoming a reality, the truth was clear to me. I didn't want someone who wanted to settle down with me because he was getting too old and tired to continue his playboy lifestyle. I didn't *want* someone who wanted to settle down with me because I was convenient and docile, the "perfect" girlfriend. I had always wanted to find a soul mate who was creative, ambitious, adventurous . . . and yes, Hef might have been the epitome of all three of those things at some point in his life, but that point was long gone, probably before I was even born. What was left was an old man running like crazy on the treadmill that was "life at the mansion," desperate to live up to his image.

I felt horribly conflicted. I couldn't quite admit it to myself yet, but I needed to find a way out.

In the spring of 2008, *Playboy* searched for the 55th Anniversary Playmate to be featured in the January 2009 issue. Back in its heyday, when *Playboy* was still in the home of every red-blooded American male, the magazine would host a highly publicized nationwide search—à la the "Millennium Playmate"—to find the perfect girl for the anniversary issue, inspired by movie producer David O. Selznick's search for the actress to play Scarlett O'Hara in *Gone With the Wind*. When Ukrainian

model Dasha Astafieva happened across Mary's desk in the pages of the Eastern European country's edition of *Playboy,* I knew she was perfect! The black-haired beauty with ice blue eyes was the clear front-runner, but *GND* producers and I wanted to create a two-episode *America's Next Top Model*–esque storyline following five candidates as they competed for the title. In addition to Dasha, I chose four girls Hef would consider for the coveted spot: Hope Dworaczyk (a brunette standout from the Dallas casting call), Jessica Burciaga (a petite Jennifer Lopez look-alike whom I found on Myspace), Crystal McCahill (a curvy Chicago girl whose mother had been a Playmate in the '60s—a connection Hef loved!), and Karissa and Kristina Shannon (blond twins that I thought would make perfect TV drama).

After spotting the Shannon twins' photos in a stack of Playmate test shots, I decided to research them a bit further. It still amazes me what some people are willing to put up online. Both Karissa and Kristina's Myspace pages were riddled with the funniest posts imaginable. It's hard to explain without a visual aid, but just imagine two 18-year-old girls posting the most over-the-top, wild, impressively illiterate entries. It was like something off *The Maury Povich Show* or *Jerry Springer.* I couldn't tell if they were serious or not, but either way, they seemed like they might be the right kind of people to stir the pot.

"If they are anything like their posts," I said, laughing with Angel, who was standing over my shoulder as we were looking at their profile page, "they'll make for *great* TV."

The candidates were brought to Los Angeles that summer for their test shoots and invited to stay at the Bunny House. Our *Girls Next Door* production schedule was tight, so we had a quick turnaround and needed the girls nearby and available at a moment's notice.

The shoots were going along right on schedule, until I received word from Dasha that Jessica had left the Bunny House the night before her scheduled centerfold shoot at the studio.

If she were MIA, we'd lose an entire day of shooting and waste thou-

sands of dollars. No one had any idea where my runaway Playmate had gone.

"We really need you to finish your pictorial," I reasoned with Jessica when I finally got her on the phone. "We're on a tight schedule and every day costs money."

It turned out that the runaway bunny went hopping back to Orange County. According to some of the crew and other girls staying at the house, Jessica had been tormented for days by the twins, along with *Playboy*'s resident wild child Laura Croft. While Karissa and Kristina were surprisingly professional on set, they were apparently quite a handful after hours. Supposedly the three girls tormented Jessica: calling her names, smearing shaving cream on her bedroom door, and relentlessly accusing her of sleeping with a *GND* crew member. While these antics would have made for great TV, they were an example of the "negativity" Hef never wanted included in the final cut, so my efforts to include some spice in the mix, by inviting the Shannon twins, were wasted.

"If you come back, you can stay in the mansion guesthouse away from the other girls," I told her, hoping this would quiet her frayed nerves. They'd done quite a number on the poor girl! After some coaxing, I finally got Jessica to agree. I asked Hazel, the office administrator, to put Jessica on the guest schedule in one of the four rooms in the mansion's guesthouse. After sorting out that potential disaster, I gave myself a well-deserved pat on the back.

Crisis averted, I thought.

When I arrived later that day to the Sunday night buffet, Hef was waiting for me in the dining room with a rabid look in his eyes.

"What are you *doing* putting Jessica in the guesthouse?" he demanded, his voice quaking with anger.

"She was having trouble with the other girls, so she left," I calmly explained to him, hoping he would recognize the volume of my voice and aim to match it. The dining room was filled with guests and I didn't want to get lambasted in front of an audience. "I needed her here for work first

thing tomorrow, so I put her in the guesthouse. I guess the twins were picking on her, so I thought this was an easy fix."

"That is *not* your decision," Hef bellowed at me, with no intent to try to keep this argument private. "*Daddy's* in charge of who stays where! Not you!"

"But it's such a minor thing I didn't even think you would want to be bothered with it," I said truthfully. I'd invited girls to stay with us before and he never had a problem with it. I was completely caught off guard and could feel the tears start to burn my eyes. I took a deep breath and held them back with every ounce of dignity I had left. Trying desperately to keep my voice from shaking, I continued, "You have more important things to worry about."

"Well, this isn't *your* decision," he spat at me. By now everyone was staring at us. "*Daddy* makes the rules." When I didn't respond, he turned to one of the guests and began jovial conversation as if nothing had happened.

I looked down at my lap. I couldn't bear to make eye contact with anyone—I felt so humiliated. Despite his gentlemanly act, Hef had never been a progressive thinker when it came to women. I had always told myself that maybe I could change his attitude if he truly got to know me. It didn't look like that was ever going to happen.

As we were getting ready for bed, Hef shuffled into my dressing area to inform me that our *GND* shooting schedule for the next day had been postponed.

Shit, I thought. After hustling to get Jessica back up here and getting the fear of God instilled in me for it, everything was being rescheduled.

"Why?" I asked.

"Something's come up with Kendra that they want to shoot instead," Hef managed, barely making eye contact with me. At that point, we all knew Kendra had one foot out the mansion gate and was in talks with E! for her own spin-off series. The producers were starting to put scenes into place that would set up her eventual exit.

Recently, Kendra and I had been getting along really well, but as I had a full-time *real* job with actual responsibilities, I wasn't really thrilled about having to rearrange my work schedule for one of her last-minute whims.

"We always have to move stuff for Kendra," I said, half joking, half hoping he would change the schedule back, while applying face lotion in the vanity mirror and mentally preparing to reorganize my entire work-week.

Hef stopped in his tracks and looked right at me.

"Stop being such a fucking CUNT!" he screamed, his face bloated and red with his hands clenched into fists.

My mouth fell open in disbelief. In seven years, I never once heard that word cross his lips. And now he wasn't just saying it, he was calling me it . . . his girlfriend, the supposed "love of his life." I sat there staring at him in total shock—unable to move a muscle or even cry.

After what felt like 30 long seconds of him glaring at me with his jaw clenched so hard, I thought he might crack his teeth, he stomped his foot like a child and scuffled back into the bedroom.

Over the years, I'd dealt with a lot: the Mean Girls, the crazy rules, the irrational outbursts, and the repugnant bedroom routine. Because Hef so convincingly wore his "Gentleman Hef" act at all other times, I was able to make excuses for him. But this was it; after being screamed at for no good reason twice in one day, I was freaked the hell out. There was no way I could fool myself into thinking Hef was a nice guy anymore.

In that moment, I didn't care if I couldn't find someone to love me outside of the mansion, because it was crystal clear no one on the inside loved me, either.

I needed to find someone to talk to, someone who could understand all the pressures I was under but wasn't trapped in the same bubble as I was. Maybe I could get some advice and a fresh perspective. I eventually decided on one of Hef's friends, since he knew Hef well and certainly understood the degree to which I was bound to the show.

"I can't take it anymore," I confided to him two days later. I sat down with my chosen confidant to discuss what had been going on in my private life. I was already in the midst of filming season five, but I felt like I couldn't keep up the charade another minute.

Bridget had come in earlier and placed a box of Sprinkles cupcakes on the table. I cut myself a piece of one and passed the rest across the table.

"Just hang in there," he said, unwrapping the rest of the cupcake. "He cares about you. He didn't mean it."

He paused for another moment, sensing this wasn't giving me any comfort. Twisting up his face into a thoughtful expression, he said, "I'll try to find out what's bothering him."

"It doesn't matter if something's wrong," I said, trying to make sense of everything in my head. "This is just who he is and I am realizing it for the first time." I sighed helplessly and put my head in my hands. My rope was rapidly fraying.

He then went on to remind me that Bridget and Kendra were leaving soon and that *Girls Next Door* would then be all about Hef, me, my work, and the girls that came through the studio. He honestly thought this would lift my spirits. I loved working on the show, but this wasn't about the show . . . this was my life!

"Thanks for listening," I said dismally.

I believed what he had said about the show. Not only was Kendra on her way out of the mansion, but Bridget had recently been offered her dream job hosting a show for the Travel Channel, so her departure was inevitable as well. Audiences and E! loved the episodes that focused on my work at the studio—and so did I! It seemed like all my dreams were coming true . . . but I had to ask myself: were those *still* my dreams?

I was finally seeing Hef's true colors—and accepting that perhaps he had been that way all along. Now the promise of having Hef, the mansion, and the show all to myself just sounded frightening.

I didn't know what to do next. Despite the way he treated his girlfriends, I felt guilty even *thinking* about leaving Hef. I was constantly

being reminded of how blessed I was and how grateful I should be. I didn't want to disappoint or let anyone down. What would his friends think? They'd always been so supportive of me because they saw that I treated Hef well. Would I lose my job? I *loved* my job and couldn't bear the thought of losing it. Maybe I could find some way to stay on as an employee?

As all these questions were playing over and over in my head like a broken record, the time finally came to shoot the "good-bye" scene between me, Kendra, and Bridget. The scene was shot in Bridget's room, which was filled with suitcases and rolling racks full of clothes for the new travel show she was leaving to do. As I was the only part of the trio who was supposed to be staying at the mansion, I just plopped myself on Bridget's bed and waited for the others to talk. Most people who knew "Holly" from *The Girls Next Door* would have thought I'd be ecstatic to see Hef's two other girlfriends go, but in reality, I was on the verge of tears. The feeling hit me like a ton of bricks. *I don't want to be here without Bridget and Kendra.* At that moment I knew it for a fact, I just didn't know how I was going to handle it.

After more than four years together at the mansion, our little blond army was disbanding. We had each evolved so much in that time. Like the freckle-faced producer had suggested years before, Kendra really *did* grow up inside the mansion, but it seemed to be due largely in part to a man she had met *outside* the mansion. For eight months, Kendra had been secretly dating professional football player Hank Baskett and was madly in love. Gone was the insecure little girl who labeled Bridget and me the enemies and spent her days desperately jockeying for attention. In her place was a confident and gracious young woman.

Bridget was off to host her own show. I couldn't think of a more perfect job for my best friend, who was packing up to travel the world! When I first met her, all she had wanted was to be a Playmate, and she ended up achieving so much more.

The scene couldn't have been more genuinely emotional. I usually

kept my feelings locked up far, far away from the cameras, but this time my tears flowed freely. It was in that moment that I realized how much these two women meant to me and how only the three of us could ever know what this wild ride we had been on was truly like.

It wasn't just the prospect of losing my two costars that made me feel so empty. I knew that even when I was the only girlfriend, there would always be visiting Playmates and Bunny House residents to keep me company. It was seeing these other two women evolve, in just the ways they *should* be evolving, that made me realize that there was so much more out there for me, too. I didn't know what it was, but something had to feel more genuine and fulfilling than simply being the "first lady" Stepford Wife of the Playboy Mansion.

After our teary hugs good-bye, the cameras stopped rolling and I slowly walked down the hall to the master bedroom's back door. My mind was reeling, my heart was hurting, and my stomach was tied in knots. What was I going to do now? I knew I'd be heading to Vegas in a few weeks to finish the last shoot for Jessica's pictorial. Maybe having some time away from the mansion, without the cameras following me, I'd actually have a chance to think . . . and Las Vegas seemed like a good place to clear my head.

CHAPTER 11

"*Why, sometimes I've believed as many as six*
impossible things before breakfast."
—Lewis Carroll, *Through the Looking-Glass*

hank you," Hef screamed so loud that my cell phone shook, "for giving me the WORST night of my life."

Oh shit, I thought.

WE LANDED IN LAS Vegas early the previous morning for Jessica's Playmate shoot. I thought the Playboy Club at the Palms could be a playful backdrop consistent with the 55th Anniversary theme. Knowing that the shoot would pull me out of Los Angeles for a day didn't hurt, either. Jessica's shoot was scheduled over two days, and of course, per the curfew, I had planned on flying back and forth each day. Obviously, this would have been exhaustingly impractical, and given the state of mind I was in, I decided to just take a chance and try and stay over. I really needed the time to myself.

"I really should stay overnight," I told Hef. "It doesn't make sense for

me to fly all the way home, get only a few hours of sleep, then turn right back around and fly to Vegas the next morning."

Given that my last attempt at spending an unchaperoned night away from the mansion—for Tiffany Fallon's wedding—hadn't gone over so well, I thought I was in for an uphill battle.

"Okay, darlin'," Hef said casually—as casually as a normal boyfriend *should* respond to such an innocent request. "I'll miss you."

My shoulders melted away from my ears. Sweet relief.

"I'll miss you too!" I replied.

A night alone! I thought, realizing I hadn't had a night *truly* to myself since I moved into the mansion seven years earlier. After a full day on set, I was exhausted but still exhilarated at the idea of spending some time by myself in Las Vegas without the watchful mansion eye hovering over me. I was pleasantly surprised with how easy the conversation went—especially given the recent tensions between us—but Hef had an extremely selective memory. I guess the verbal beating he gave me was just another forgettable moment for him.

I desperately needed to get out that night and experience life as a normal 20-something before deciding if I was going to go back to Hef and settle down or break it off for good. I was like a bachelorette looking for her last hurrah or an Amish kid going out for Rumspringa. The only problem was, I didn't have anyone to hang out with. Jessica and the photo staff were wiped out from the day's shoot and all went to bed early. But more importantly, to make this night really matter, I needed to get away from Playboy people. The only friend I had in Las Vegas was Angel, but she was newly pregnant, so she was hardly up for a wild night on the town.

I guess I could text Criss, I thought. It was a dangerous option, but a tempting one.

Las Vegas magician Criss Angel had been jumping onto my radar for a while at that point. Bridget, Kendra, and I had been guest judges on a reality competition series he had been featured on. We met briefly backstage and he tossed some awkward pickup lines my way. Because I was

one of Hugh Hefner's girlfriends, guys didn't usually have the gall to hit on me that blatantly, so I found his fumbled attempts strangely endearing, like a teenage boy tripping over his own feet. I remember thinking he was attractive—his style was reminiscent of the hair rockers from the '80s that I thought were cute when I was a kid. He kind of looked like a poor man's Tommy Lee.

I didn't really think twice about his flirting until after the taping when Criss's people contacted the *Playboy* publicity office to invite Bridget, Kendra, and me out to a club in Los Angeles. He was a notorious publicity-fueled womanizer (an A-list actress, a former child star, a famous heiress, and a post-mental breakdown pop princess were among his many conquests).

"No way!" I laughed into the phone line when Sally from publicity called me. "Is he crazy? We're Hef's *girlfriends!*"

"I know," Sally giggled. "I just had to let you know."

I wasn't entirely sure which one of us he was after, but I couldn't help but be flattered. He knew our position at the mansion and wanted to take the chance anyway.

Not long after our initial meeting, we were invited to be guests on yet another Criss Angel television series, *Mindfreak*. Unlike the talent competition series, *Mindfreak* centered on Criss's day-to-day life as a street magician. Bridget and I accepted the offer and flew to Las Vegas for the day with a representative from Playboy PR (aka a chaperone). It was fun watching him on set. Unlike us, he had a say in what went on in front of cameras, as well as a producer role, which I found fascinating. Despite his mysterious on-camera persona, behind the scenes he was an easygoing jokester. In between setups, he invited us to join him and his usual entourage at his resident suite at the Luxor hotel (his friends referred to it as "the compound" behind his back).

I was charmed by the things that littered his suite: video games, a foosball table, and an intricate model train set. I wasn't so charmed by the cheap plastic dry-erase board stuck to the back of his front door with the

words "Britney was here! Spears" sprawled across the center in a drunken out-of-order scrawl.

We get it, I thought, laughing to myself. *You banged Britney Spears.*

It was all sort of obnoxious, but truth? It made me like him even more. I was so conditioned to the geriatric way of life at the mansion that Criss's boyish hobbies seemed so different and refreshing to me. Though I had more in common with Hef, I was so oversaturated with his life and style at that point that I probably would have found *any* hobby besides dominoes attractive.

We shot our final scene at LAX nightclub inside the Luxor. Bridget and I were escorted to a large booth, already populated with pretty girls. Producers sat me next to a petite sexy brunette with sparkly, high-gloss lips.

"This is Monica," Criss said as he introduced us. "She's the main boxing ring girl."

"Nice to meet you guys," she managed through a false smile. "I just love Kendra! She's the whole reason I like your show."

Wow, subtle, I thought.

It seemed to me that Monica was Criss's flavor of the night. With puppy dog eyes, she had followed his every movement as he performed— and as she watched him, he was clearly watching me.

"To true love," Criss toasted as he held up his shot glass filled with a sugary Washington Apple shot, somehow managing to split his gaze between Monica and me. It was a lame move to try to flirt with us both at the same time, but it just made me laugh. After all, I thought he was cute, but I wasn't going to date him, so I didn't waste my time feeling insulted. I could tell that Monica definitely thought something was up, though.

SINCE WE ALREADY HAD secured the Bachelorette Suite at the Palms—a 2,300-square-foot pink paradise (since rebranded as the "Hot Pink Suite")—for part of Jessica's shoot, I decided I should crash there for the

night. Criss responded almost immediately to my text, saying he'd love to grab dinner with me after his rehearsals. He suggested N9NE, the steakhouse at the Palms.

Yeah, right, I thought. Criss and I were just friends, but the last thing I needed was a picture popping up online of the two of us having a "romantic" dinner together—or however the press might spin it. The massive suite had a fully decked out dining room, so I suggested that he come over and we order room service.

In between shoveling pieces of steak and plain baked potato in his mouth, Criss rattled on about how he had to eat healthy because he was practically naked in his new show.

Again, his thinly veiled attempts at baiting me couldn't have been more transparent, but I was slowly becoming more and more charmed by him. I mean, I hadn't flirted with a guy my own age since I was 21 (actually, Criss was 11 years older than me, but compared to Hef he felt like a contemporary). After years of believing no guy would ever want Hugh Hefner's mistress, I was surprised that he actually seemed *really* into me. After all, he dropped whatever plans he might have had on a moment's notice to hang out.

"Well, I gotta see that," I joked, taking the obvious bait. Unlike the ultra-feminine, docile fembot I was required to be as one of Hef's girlfriends, with Criss I felt like I could be one of the guys. It was a refreshing change of pace.

Criss asked me what I wanted to do next, his thick Long Island accent coating every syllable as he examined his teeth in the reflection of his steak knife.

"Take me out!" I demanded playfully. I had one night away from the mansion and I didn't want to squander it sitting up in the hotel room, but we had to be careful. "I don't know the city at all outside the Palms. I just need to go somewhere low-key," I explained. "Hef has really strict rules when it comes to us, so I really can't be seen with a guy in public. It sucks, but . . ." I trailed off and shrugged my shoulders.

Criss didn't miss a beat.

He immediately suggested CatHouse, which he described as really low-key, jumping at the opportunity to spend more time with me.

"Great," I said, popping out of my chair. I had no idea what this place was, but I was eager to get out of the hotel room. If it was low-key, it worked for me. "Let me grab my purse." I bounded into the bedroom to snatch my bag and check my makeup. Looking at myself in the reflection, I couldn't help but notice the big smile involuntarily plastered on my face.

Maybe this is exactly what I needed, I thought, *just one night out. Maybe all of Hef's restrictions are just making me crazy and I'll feel better about him tomorrow.*

Of course, Hef would be irate if he knew I was headed out for a night on the town with another man, but what he didn't know wouldn't hurt him. *Nothing* was going to happen between Criss and me. Plus, paparazzi didn't really exist in Las Vegas—not like they did in L.A., at any rate. With all the strict gaming laws in Nevada, photographers couldn't be snapping away inside a casino. As long as we were discreet, I'd be fine.

The nightclub was small, dark, and intimate. Situated inside the Luxor, the boutique nightclub did feel surprisingly private, and I allowed myself to relax.

Criss asked if I would take a picture with the CatHouse girls, when a posse of uniformed women arrived at our table.

No harm in taking a photo with a couple of dancers, I thought. Cat-House was a restaurant as well as a nightclub, so I didn't think the photo could be that incriminating should it get out.

Criss and I sat in a corner booth, ordered two glasses of red wine, and talked over the loud music for hours. We spoke about my relationship with Hef and how stifling it was. He confided in me that he started dating an 18-year-old girl who moved into his hotel suite and "won't move out," as he put it. He told me he made a mistake getting together with her and was planning on breaking it off in the nicest way possible. The fact that he was dating someone 22 years younger than him, not to mention

barely legal, grossed me out since it reminded me so much of the Hefner situation. However, Criss seemed so sincere when he told me that he felt like he'd made a mistake and was looking for someone different that I was willing to overlook the impression his dating situation had made on me. We talked a lot about his new show and the pressures he was under. After we ran out of things to say, he started laying it on unbelievably thick.

"Ya know," Criss began, going into a bumbling speech about how he was looking for someone to have fun with . . . have fun with but to have a serious relationship with, he was quick to add after he noticed the look on my face.

I sat there quietly and let him continue as he stumbled all over his words while trying to share his feelings with me. I took his nervousness as a compliment—he seemed to be smitten with me.

He continued on about how he had worked for fifteen years to have his own live show and how it was finally becoming a reality. Between his TV show *Mindfreak* (which was in its fourth season at the time) and his over-the-top public performances (like being shackled underwater for 24 hours in Times Square) Criss was, at that time, one of the most well-known magicians in the world. He seemed so happy about the direction his life was going, telling me that things had been really crazy in the past, but now he could finally have a routine. He was locked into a major contract for the next 10 years, and he asked me if I knew how much he would be fined if he missed a single show. I shook my head as the new direction of the conversation reflected his more aggressive tone. He told me he would be fined $200,000. Criss was constantly peacocking around in diamonds and Rolls-Royces, bragging about his salary and never letting anyone forget how much he was "worth." To be honest, I found it a little tacky. But at the end of the day I didn't care. I have no idea if that number he threw out was real or just his way of trying to impress me. At the time, I was just flattered that anyone cared about impressing me, period!

He softened his voice again and went on to say that he had two days off a week and that he needed someone who could plan fun things for him to do on his days off, someone who he could do those things with. It wasn't the most romantic advance ever made, but I couldn't help but be intrigued. Here was this adventurous guy, so full of life, who was looking for someone to be young and wild with.

He blurted out that he'd marry me right now when I didn't take the bait. I nearly spat out my drink. Was this guy serious? While he was laying it on so thick, I found him playful and entertaining and he was clearly dead set on making something happen between us.

"For publicity?" I said, calling him out on what I presumed was bull-shit.

To be fair, I knew that Criss was used to women shamelessly throwing themselves at him, so I figured he didn't quite appreciate that I was simply interested in the novelty of hanging out with a guy who was closer to my own age for a night.

"No," he shot back, feigning shock at the suggestion. "What I mean is . . ."

He began his spiel (one that I would come to know by heart): how he was ready for a family and for marriage, how hard he worked for 15 years to obtain "success," how he had been "almost a train wreck" (referring to his slutty behavior, which he loved to remind me of, as if it were going to make me jealous or somehow grateful), and how he was locked into the routine of his new show, *BeLIEve*.

While I spent much of the evening at CatHouse rolling my eyes, I also had a hard time containing my smile. Sure, Criss was a well-known player and he was coming on strong, but something about his story made sense. Maybe he *was* at a point where he was ready for a committed relationship. He was 40 years old and making some huge changes in his life, so it was possible. On the other hand, we had only just met, so the whole conversation seemed absurd, but it was fun for me to get swept away in the idea that he was so into me. It was something I needed to feel after

years of Hef making me feel like a piece of dirt. And who cared if he was serious or not? I wasn't going to get with the guy anyway.

The most important part of the night, for me, was that in the span of one evening he had single-handedly crushed one of my biggest fears about leaving the mansion. Perhaps I wasn't damaged goods after all. In fact, in Criss's eyes, I was quite desirable. After a few glasses of wine, Criss gave me a tour of the Luxor Theater and then accompanied me back to the Palms and walked me back to my suite. He invited himself into my room, offering to "tuck me in."

"Okay," I giggled, knowing the cheesy line would get him through the door, but it wouldn't get him any further. After all, I wasn't *that* drunk.

I stumbled towards the large pink bed, jumped in fully clothed, and pulled the comforter up to my chin. As he stood over the bed and leaned in to kiss me, I erupted into a fit of laughter and turned my head away from him.

"I can't," I playfully reminded him. "Remember?"

He sighed, standing back up. He reached down and removed my earrings from each ear and set them by the bedside table.

He whispered sweet dreams softly into my ear. After walking across the room, he scrawled something on the back page of a room service menu (a note reading: "I miss you"), tearing out the sheet and sticking it next to my curling iron on the bathroom counter.

"Sweet dreams," I mumbled, immediately drifting off into a peaceful sleep as he exited the suite.

When I woke the next morning to my buzzing cell phone, the last thing I expected to hear was a ferociously angry Hef.

"Thank you," Hef screamed so loud that my cell phone shook, "for giving me the WORST night of my life."

"What are you talking about?" I asked Hef defensively. Honestly, I had endured so many verbal lashings lately that I had no idea what could have possibly been the catalyst for this outburst. After getting permission to stay over the night before, I had called him again shortly before his

10 P.M. bedtime to wish him good night. We traded "I love yous" and that was it. Sure, I hadn't offered up my dinner and clubbing plans for later that evening, because I knew he would never allow it.

"I didn't hear *anything* from you last night," he continued, screaming into the receiver. "I was up *all* night sick with worry!"

"But I called you right before you went to bed . . ." I tried rationalizing with him. "I don't understand what you're talking about. I had my cell phone with me all night . . ." I kept rattling on, before realizing he had to know something. "Why were you up?" I asked.

"Security told me," he spat. "You had a *guy* in your room last night!"

I paused for a moment, waiting for this information to sink in. *Holy shit,* I thought. *He actually had me followed.*

"Nothing happened," I said firmly and sternly. "I had a few drinks and a friend walked me in to make sure I got into bed okay. That's it."

And it was. Sure, there was some definite flirting and perhaps some blurred lines on his part, but I hadn't done a damn thing. I had never cheated on Hef. He had slept with an army of different women during our time together, but I remained faithful. Despite all my insecurities and regardless of how desperate I was to have one night out, in my mind I was *still* in a relationship. And I was nothing if not loyal. Whoever was trailing me around Vegas apparently didn't relay to Hef just how quickly Criss exited my suite.

"Oh yeah?" Hef asked, mockingly, "Well, we'll talk about it when you get home. *Thank you,*" he repeated in dramatic Hef fashion, "for giving me the worst night of my life."

I pulled the phone away from my ear and waited for the line to disconnect. I was equal parts stunned and seething.

How dare he have me followed, I thought. For seven ridiculous years, I remained entirely faithful to this man. Even if my evening did include some temptations, I had conducted myself like a good girlfriend. I wouldn't even kiss Criss when we were alone in a hotel room in a moment I thought would forever remain private.

I knew Hef well enough to know that in his head, I was already cat-egorized as a "cheater." I might as well slap a big scarlet A on my chest, because he would never let me live this down . . . even though there was nothing to actually live down. I was sure that for the rest of our relation-ship he would call upon this incident every time he didn't get his way and use it as leverage. I could kiss good-bye any chance of spending another night away from the mansion again.

One of Hef's favorite stories to call upon during press interviews is how, in his pre-*Playboy* days, his first wife, Mildred Williams, cheated on him during their engagement. When his then-fiancée confessed to being unfaithful, he was devastated, but chose to marry her anyway. Of course the marriage ended, but I always felt he used this incident as a way to justify his philandering behavior and to gain sympathy from the public. It was as if he was saying, "Sure, I'm a womanizer, but my ex-wife made me that way. *She* did this to me." In fact, he seemed to have a penchant for cheaters. After all, he did crave drama. His second wife was rumored to have been unfaithful (with a member of the mansion staff), and his third wife ran out of their first planned wedding to be with just one of the sev-eral men she had allegedly cheated on Hef with.

It would never change, I thought. *Hef would never change. If I stay, this would be my life.*

And in that moment I knew I couldn't stay. I wouldn't stay. I was *finally* done.

RETURNING HOME FROM LAS Vegas felt as awkward as you could pos-sibly imagine. I was determined to make my exit as quickly as possible, but Hef kept putting off having too much of a serious conversation about it. He pleaded with me to stay, "despite hurting" him, but I just gave him the cold shoulder. It seemed he felt that if he could somehow stall and put off my leaving as long as possible that I would just forget about wanting to leave and everything would go back to normal (save for the

giant imaginary albatross he had to hang over my head). He could sense something inside me had shifted and was waiting for it to shift back. I wouldn't allow him to manipulate me anymore. I had to make it clear to Hef that I was leaving.

Over the course of our relationship, I'd only ever initiated a "serious" conversation with Hef once, maybe twice. The morning after returning home from Las Vegas, I stopped by Mary's office before heading out for the day to tell her I needed to talk to Hef as soon as possible. I felt that if I could get Hef on the phone, I could say what I needed to say without him trying to throw me off course, pull at my heartstrings, or lay on the guilt, as I was sure he would be successful at doing if we tried to talk face-to-face.

"Hey, honey," Mary said, a bit cautiously when she called a few hours later. For months she'd seen the warning signs and knew what was coming. "Hef's on the line."

Before I could say a word, I heard Hef speak weakly into the receiver: "Mary says you have something you'd like to talk to me about."

"Yes," I said, feeling instantly small and incredibly nervous. I took a determined breath and continued, "I've decided I can't stay any longer. My feelings aren't there anymore and I don't want to fake it. I need to make a life for myself and have a family."

It felt like a full minute had passed before Hef spoke.

"Are you sure?" he finally asked, continuing to dangle the bait that E! had ordered a sixth season of the show.

If I wouldn't stay for *him,* he assumed that I would at least stay for the show. It seemed as if he thought all a woman could possibly want was fame and money.

I didn't say anything. My mind was made up.

He pleaded with me to stay, to not tell anyone we broke up, to try and work it out.

"I need my freedom," I tried to explain. "I want to be able to actually hang out with my girlfriends and have fun like a normal person."

"Ha!" he exclaimed, through a sarcastic cackle. "What makes you think any of those girls will want to hang out with you if you aren't my girlfriend?"

After years of being conditioned to believe that I wasn't anything without *Playboy* attached to my name, I had actually started to believe it. But I knew better now. His frantic attempts to keep me chained to the mansion seemed transparent, desperate, and just made me angry.

"I'm sorry," I said softly but firmly. I wouldn't be manipulated. Not this time.

And since I clearly wasn't responding to his spiteful attempts to cripple my self-confidence, he tried playing the guilt card, asking me if I wanted him to have another stroke and saying that if he died it would be my fault.

He wasn't above using his age and health as a tactic to get his way. Over the years, in a few of our more heated disagreements, he regularly made dramatic statements along these lines to get me to drop an argument. It was ridiculous considering that our disagreements, up to this point, had always been about things that should have been trivial to him.

But for him it was all about winning. He didn't care if I stayed out of fear or out of pity, as long as I stayed, but I wasn't going to budge.

I sat silently on the other end of the phone line, patiently waiting for this episode to pass. After gaining some self-confidence and a bit of perspective, I saw just how tired his routine had become. It's like I was seeing him with new eyes. He was no longer this infallible icon I created in my mind. He was just a spoiled child in an old man's body.

"I have to go," I said. "That's final."

Silence.

"Okay, darlin'," he managed, his voice choking up (sincerely, for a change). "But I hope you will reconsider."

Hef was in denial about our breakup for a long time. He chalked it up to some kind of phase I was going through. After giving him the "worst night of his life," he began pursuing me like never before. All of a sudden, I mattered. The entire concept for season six of *Girls Next Door* was to

follow Hef and me as we trotted off into forever land . . . just the two of us. To everyone on the outside it appeared as though my wish was finally being granted: Mr. Playboy all to myself.

But it was too late. The switch had been flipped. It wasn't one thing in particular, but more a cocktail of the last few months: his verbal lashings, my newfound confidence as a career woman, and the affirmations of another man all allowed me to see that the fears I'd been living under for seven years were just smoke and mirrors. Now the thought of living with the unfounded "cheater" moniker was just too much to take. I couldn't stay any longer.

After a meeting in Mary's office, Hef and I decided that I would move down the hall into Bedroom 5 while I finished shooting my final *GND* scenes. Most of season five was already in the can when I met up with Criss that night in Vegas, but there was still more to do. It came as a shock to most of the staff and show producers when I actually began the process of moving out of the master suite. (None of my packing was captured on the show. Hef and the producers were still hoping I would change my mind about moving out and that I would be back as Hef's girlfriend by the time cameras started rolling for season six.) I had done a good job of acting like a blissfully happy girlfriend—only the closest of confidants had known about my unhappiness. It was oddly nostalgic to be moving back into the same room I moved into as a mansion newbie seven years prior. Back then, I barely had a suitcase full of possessions; now I had substantially more to pack. I had a large storage closet—full of clothing, mementos, and Christmas decorations—in the mansion's basement, not to mention another one in the Bunny House across the street. Needless to say, *this* move was going to take a bit more time.

As I packed up the vanity in the master bedroom, I labeled each box with a Sharpie, listing the contents. One evening after work, I was making trips from Hef's bedroom to my old room down the hall. I noticed one box had been scribbled on in writing other than my own. In his

distinctive handwriting, it read: "Hef's Heart." In that instant, my own heart sank. Despite everything he'd done to me, I didn't enjoy hurting him. But that wasn't going to stop me. I knew Hef wasn't in love with me. He was in love with the *idea* of being in love. He was in love with the routine and convenience of our relationship. I wasn't interested in settling anymore, I was looking for *my* happily ever after.

During my final weeks in the mansion, Hef waffled between doting on me and punishing me. If I ever seemed to be in too good of spirits, he would do his best to smack me back down with snide comments or attempts at making me jealous by toting around the Shannon twins. I couldn't have cared less. In fact, I wanted him to move on! It would have taken some of the pressure off me. I was beginning to realize that he preferred miserable and uninspired Holly—maybe because she was easier to control. I buried myself in work. For the time being, I was allowed to keep my job at Studio West. While I had hoped it was because of my contribution and the experience I had gained over the last two years, I realized that Hef's team most likely advised him to keep me on staff to avoid any kind of lawsuit or wrongful termination accusations.

Still, while Hef had begun the process of "moving on," he hadn't lost hope that I would reconsider and move back into his master suite. Any time I would run into Hef in the mansion hallway, it was painfully awkward.

"I'll have the rest of my stuff out of your room by tomorrow," I told him during one such encounter.

He assured me I could take my time and there was no hurry, but I was anxious to get my stuff out ASAP.

The next day, while Hef was working in his office, I went into the master suite for my last round of packing. When I went to grab my things from a shelf near the bed, I noticed one of Hef's file folders sitting neatly in the middle of what was formerly "my side of the bed."

That's weird, I thought.

Hef *never* leaves important documents lying around. They're always locked up in his bedroom safe or his office, or being hand carried by him personally. He was a man of routine—and this was entirely out of character.

Curious, I picked up the stack of papers, which were obviously left for me to see. Inside was a copy of his last will and testament. I spent seven years living with the man, so I can tell you on good authority that he would have never have left something this important lying around by accident. It was clear to me that this was meant for me to see.

It carefully outlined the division of his estate. After death tax, his fortunes would be divvied up starting with roughly 50 percent to his charitable foundation and the bulk of the remainder divided evenly between his four children: Christie, David, Marston, and Cooper. No surprise there.

What came next was shocking to me. For the better part of a decade, Hef used money as a means to control each girlfriend. Anything he shared was temporary: a weekly allowance, monthly payments for leased cars, etc. At a moment's notice, he had the ability to pull the rug out from under us.

But it was there, in black and white. The will stated that $3,000,000 would be bestowed to Holly Madison at the time of his death (provided I still lived at the mansion). At the time, it was more money than I'd ever know what to do with.

We had never spoken about his will—and I never expected anything like that. In the past, he had casually mentioned leaving me the Bunny House, but I never took the bait. Disgusted by the gold-digger image the public had of me, I tried to stay away from those kinds of clichés as much as possible in my *real* life. I still held on to a shred of hope that I would one day be financially independent. I had saved enough of my *GND* salary to put a down payment on a Santa Monica condo I hoped to rent out. And once I had started making some money, I stopped accepting the "clothing allowance" that made me feel so cheap.

Eventually, I would go on to find my own success, but I didn't know

it back then. My future was a gamble. Despite spending seven years in one of the most expensive homes in Los Angeles, living a relatively lavish lifestyle, I had no wealth of my own—just the illusion of it. Three million dollars was *a lot* of money to me.

But I didn't want it. I actually pitied him for stooping to that level. I couldn't help being offended. Did he really think he could buy me?

I put the folder back on the bed just as I had found it and never breathed a word of it.

During one of our final encounters at the mansion, Hef spotted me as he shuffled down the hallway.

"You're not wearing your bunny necklace," he said, a sorrowful look plaguing his eyes. I didn't know what to say. I was only glad he didn't know that I had already started the process of removing my bunny tattoo as well.

"No one," he said, pausing for emphasis, "will ever love you as much as I do." He enunciated the sentence slowly, as if he were making a grand speech. I had no words. Instead, I gave him a friendly hug in order to avoid actually speaking to him. I know he was trying to sound romantic, as if he were pledging his undying love, but to me his comment sounded like a slight. I knew I deserved better—and there's no way his kind of love was the best the world had to offer.

Through his vain attempts to intimidate, guilt, persuade, and eventually bribe me, the only thing he succeeded in doing was to convince me that I was making the best decision I had made in a very long time.

During those final few months, I began spending more time in Las Vegas. It was a town brimming with opportunities! I met with the producers of the Crazy Horse Paris, a tasteful cabaret show at the MGM Grand. We had discussed me doing a guest run before, but now I was ready to pursue it. Bridget and I were hired to host a Halloween party in Vegas and were brought out early to shoot flyers for the event. And while my trips were primarily business focused, I was finally single and free to date whomever I wanted, so I found myself seeing Criss in my spare time.

Though I was cautious to take it slow at first, over time it was clear he really was looking for something serious and our relationship grew romantic.

When I announced to him that I was leaving Hef and the mansion, Criss opened up his world to me without even a moment's hesitation. He pleaded with me to move in with him by Halloween during one of my trips to Las Vegas.

"No!" I giggled. "That's too soon!"

I didn't want to rush into a relationship so fast. Honestly, I didn't see myself settling down with him quickly. I had big plans, none of which involved living with a man. I hoped to split my time between L.A. and Las Vegas in order to balance both my job at Studio West as well as performing regularly at the MGM. I had hopes of developing my own spin-off TV series chronicling my new life in Vegas as a single showgirl.

Unfortunately, my need to feel loved would win out over my need for independence.

DURING MY LAST FEW weeks at the mansion, Bridget was back on a break from filming her travel show. After we discussed the upcoming Halloween party, I had to fill her in on how awkward things continued to be for me under Hef's roof.

"Hef came into my room the other day and tried 'reasoning' with me," I told Bridget, sprawling myself out on her large round bed. "He was trying to talk me out of dating Criss and was like, 'The media calls him a douche bag!' I didn't know what to say!"

Despite everything, Hef hadn't quite given up yet. A few weeks after that fateful night in Las Vegas, photos emerged revealing what appeared to be an intimate evening I spent with Criss Angel in Las Vegas. I remained at the mansion for about two months total after Hef and I officially broke up, in order to fulfill my obligations to the TV series. During those eight weeks, as I waited around to see what sort of final scenes I

needed to film for season five, more details began to not so mysteriously emerge in the press about my relationship with Criss (for being an "illusionist," he sure was obvious).

The media was having a field day with the idea that all three of Hef's girlfriends were simultaneously leaving the mansion for other men. Though Bridget hadn't gotten involved with anyone yet, the media jumped on any sighting of her with another guy, hoping to round out the story of Kendra and Hank and me and Criss. One tabloid article in particular erroneously linked Bridget to a Las Vegas DJ. Since that same article went out of its way to mention that I was whisked away in Criss's black Rolls-Royce Phantom, I couldn't help but think he was behind that article, too.

"Yeah, he talked to me about it, too," Bridget said. "He thinks dating Criss will be bad for your career."

Was I seriously going to get career advice from a man who spent seven years treating me like a glorified pet?

"I told him a long time ago that I knew that you were really depressed," Bridget continued, "and that's why you didn't go to that Lakers game a while ago."

Months before our breakup and my fateful trip to Las Vegas, Hef, the girls, and I had plans to attend a Lakers game. Slowly, I attempted to get ready, but couldn't gather up the strength to finish my hair and makeup. Like a zombie, I walked back to our bed and tucked myself in for the night. Have you ever been so depressed that it's a struggle just to leave your room? By then I had weaned myself off the antidepressants I had been prescribed back when *GND* first started filming. Between the success of the series and my new career, I had established some much-needed self-confidence and even found some happiness in my day-to-day routine. But in moments of weakness, the depression kept creeping back in. It forced me to realize that it wasn't just in my head . . . it had to be this lifestyle that was draining me.

"I told him he should really talk to you about it," Bridget offered.

"Well, he never did," I said.

If I had any doubts about my decision to leave, what Bridget said had just squashed them. Hef knew how desperate, sad, and broken I was but didn't do a damn thing about it. I'd given seven years of my life to a man who couldn't even have a conversation with me.

Kendra's and my final scenes with Hef were a bit less authentic than the good-bye scene the three of us girls had filmed a few weeks earlier. Ever concerned with public perception, Hef had to ensure that the "breakups" painted him in the most positive light possible. He couldn't seem heartless, but he couldn't appear devastated by our departures, either. It was a delicate balance to strike—especially since it was a total farce. When Kendra walks into Hef's bedroom to reveal to him that she's decided to leave the mansion, viewers can clearly see framed photos of Karissa and Kristina Shannon (who moved in as girlfriends in October 2008) scattered around the bed—having already replaced the photos of the three of us.

Hef didn't start dating the Shannon twins until after Bridget, Kendra, and I had all announced our departures, so the framed photos posed a continuity flaw that the three of us girls noticed right away when we viewed the episode. The producers either didn't notice it or didn't care. In fact, it worked out for them quite nicely, because in order to make Hef look like the playboy he wanted to be portrayed as, it was important that him dating the Shannon twins be worked into *GND*'s fifth season *before* Bridget, Kendra, and I left. After all, how could the great Hugh Hefner *ever* be single? Even for one day?

The twins are shown moving into the mansion in the same episode we learn to scuba dive (and before we shot our final pictorials). It worked nicely for them because when Hef came to see us scuba dive in the ocean he brought a gaggle of Playmates with him, including the Shannon twins, who were shooting their Playmate pictorial. But the twins were never predatory, never trying to steal anyone's boyfriend. They didn't move in

until after the three of us had all broken it off with Hef, despite what he would like viewers to think.

When it was finally my turn to film a good-bye scene, producers asked me to film a short segment with Hef where I was to tell him I'd be heading to Las Vegas to work on a pictorial—it was intended to be my last scene. It felt so forced and inauthentic. The producers always knew how to leave a scene open-ended if need be—if I were to truly leave Hef forever, as I said I was going to, they had an exit scene for me. By asking me to refer to the "photo shoot in Vegas" I suppose they intended that to be where I met Criss. If I changed my mind and came back before the next season began filming (as they hoped I would) the scene could be played off as a temporary departure. In a moment of rebelliousness, I decided to wear a Criss Angel logo hoodie—a blatant flaw in the continuity of the series. The show was setting it up as if I were on my way to meet Criss for the first time, but in reality that wasn't the case. It was my way of alerting savvy viewers that it was all for show. If I met Criss during that "photo shoot in Vegas," why was I already wearing his hoodie? I thought someday someone might notice and realize that our relationship unraveled much differently than they portrayed it on television. Since the crew didn't notice the jacket, no one asked me to remove it.

The mansion's annual Halloween bash—the Saturday before the actual holiday—was my final hurrah before heading off to the Santa Monica condo I'd recently purchased (and eventually to Las Vegas and Criss). After years of being seated next to Hef at these soirees like a perfect little soldier, I was eager to *finally* let loose! As a nod to my new Vegas obsession, I decided to go as Elvis and immediately buddied up with John Stamos (who was also dressed as Elvis) and his then-girlfriend (as Priscilla, naturally)—and together we all braved the mansion's elaborate haunted house. The two were friendly and down to earth, a nice contrast to the overall feel of this particular party.

As I looked around, I realized that the mansion wasn't quite the same

magical place it had been when I first arrived. Like Dorothy, I peeked behind the curtain and saw the frail old man pretending to be someone he wasn't. The mystique had vanished.

But it wasn't just my perception that had changed. Just a few months earlier, the ailing financial state of Playboy Enterprises prompted them to begin selling tickets to the once-exclusive soirees. The guest list ballooned to accommodate the increasing demand—and the vibe became crowded and hectic. The new guest list was less exclusive in every way and a frantic touristy vibe took over the parties. It was easy to get separated from your friends, because it was so crowded and the overwhelming influx of newbies hungry to snap photos of every guest and every detail of the party totally changed the entire feel.

By 2008, everyone had a smartphone and the "no camera" rule that used to be what kept the parties a private and exclusive haven for celebrities was obliterated. Since by that time I had found a bit of TV fame, I spent much of the night taking photos with guests. The slow, sexy elegance of the first Playboy party I had attended back in 2000 had completely vanished.

So much for "what happens in the grotto stays in the grotto," I thought.

I decided then and there that the Halloween party was the last mansion party I ever needed to attend.

And it was.

Meanwhile, as I was contemplating how much things had changed, somewhere across the property that very night, history *was* repeating itself and someone else was seeing the mansion through new eyes. While Kristina and Karissa Shannon spent the evening stuck at Hef's side, itching for more freedom, someone else was standing outside Hef's roped-off area, looking in. I imagine the twins didn't want the responsibilities of being the "main" girlfriends, so they had their eyes open for a girl to fill that spot. And it was there that they spotted her, standing just a few feet away from their table, boiling over with nerves at the thought of meeting Gatsby himself.

Just as I had been, seven years earlier, Crystal Harris was 22, thin, blond, a bit plain, and somewhat shy. How could she ever outshine those gorgeous, vibrant Shannon twins? They had no idea that night that she would be their eventual undoing.

While someone else was thrilled at the prospect of getting into the inner circle of the Playboy world, I couldn't have been happier to be getting out. The Playboy Mansion certainly changed my life—for better *and* for worse. It had been both my safe haven—and my prison. Living inside those hulking walls hadn't been the path to fame and fortune that I had imagined—and it certainly hadn't been my path to love. I was grateful for all I had gained there, but still mourned all that was lost.

As I drove out of those daunting gates, I never once looked back.

Chapter 12

"She's my prisoner, you know!" the Red Knight said at last....
"I don't know," Alice said doubtfully. "I don't want to
be anyone's prisoner. I want to be a Queen."
—Lewis Carroll, *Through the Looking-Glass*

Criss was *desperate* to have me in Las Vegas for the premiere of his show *BeLIEve* on Halloween night. After fulfilling my final scheduled obligation to *Playboy* (in New York with Bridget and Kendra to promote a recently developed *Playboy* perfume—just don't call it *Girls Next Door*!) I jetted off to Sin City to walk the "black carpet" with my new boyfriend.

Seduced by this good-looking man who was seemingly frantic in his affections for me, I allowed myself to be lured in. After knowing each other only a few months, he *needed* me by his side for the world premiere of his new show. *I* was the one who calmed his nerves, he said. I had become so used to taking a backseat to Hef and sharing the remaining spotlight with other women, I was beyond flattered that this successful man was so enthralled with me—and *only* me.

BeLIEve had utterly bombed during press previews. Critics were

merciless in their dismembering of his performance. The *Las Vegas Sun* ruthlessly called Criss "a charmless mook" and "a rudimentary stage performer—he's barely believable playing himself." It didn't stop there. The writer went on to say, "The single most amazing thing about 'Believe' is that it is still so boring." Ouch! No wonder he was nervous! I felt sorry for the guy.

And, like a magician does when wanting to guide the audience's attention away from a trick, he needed to provide a distraction, or in magician's terms, "a misdirection," for the media the night of the show's opening. That night, unbeknownst to me, *I* was the misdirection.

On the night of his premiere, Criss introduced the world to his splashy new romance: the flashy blonde he had seemingly stolen from right under Hugh Hefner's nose. We paraded down the press line hand in hand, before pausing in front of photographers so Criss could plant a big wet kiss on me.

Wow, I thought, giddy with the excitement of my new romance. *He really wants to show me off!*

It wouldn't take long before the illusion started to dissolve.

TRUE TO HIS WORD, Criss spent his days off toting me around Las Vegas. Like a normal young couple, we'd spend afternoons four-wheeling out in the desert or going to pool parties and our evenings eating at the finest restaurants and catching some of the Strip's most acclaimed shows. The two of us didn't really have that much in common, but I was so thrilled to be able to go out and try new things that I didn't notice or care. We were quickly becoming the most buzzed about couple in Las Vegas. I have to admit, it was nice to be recognized as someone independent of Hef. Sure, people still thought of me as a "Playboy Bunny," but I had separated from Hef and was still not only relevant but thriving (things he told me that I wouldn't be without him). My name was topping search engine lists regularly and I was being written about in gossip blogs. I had never received

that kind of attention when I was with Hef! With all the excitement swirling around me, I found it easy to go along for the ride.

Not long into our courtship, Criss bought me a piece of jewelry—a small diamond cross necklace. Conveniently, a photo of us at the jewelry store popped up on a few gossip sites, most of which speculated that we must be engagement ring shopping.

With a 10-year Vegas residency on the horizon, Criss was in the market to purchase his first home—and insisted on me coming along to all the showings. He wanted me to love what he insisted would be *our* future home. As we'd stroll through these sprawling Vegas estates, he'd ask my opinions on this feature or that fixture—seeming interested in what I had to say.

On the days I would travel back to Los Angeles to work on my *Playboy* job that I had somehow managed to hang on to, I'd come home to a huge bouquet of red roses already waiting for me at my Santa Monica condo. Criss didn't waste a single opportunity to continue impressing me. He would text me often throughout the day wanting to know what I was up to, getting worked up when he couldn't get ahold of me.

After a few trips back to the coast, Criss began insisting that one of his security guards accompany me. As our public profile continued to rise, Criss said it was in order to keep me safe. The guard would stay in a hotel near my condo and was to accompany me *everywhere*. It was awkward and embarrassing to have to explain to my friends why a security guard joined us for every meal.

"Doesn't that seem a little unnecessary?" one friend suggested over our lunch. "Maybe a bit possessive?"

"No," I said, trying to hide my embarrassment. *Criss worshipped the ground I walked on and genuinely worried about me,* I thought. "He's just protective," I explained.

In my post-mansion life, Criss seemed to be exactly what I needed. It wasn't long before I reverted back into the Converse-wearing, jeans, ponytail, and black nail polish kind of girl that I used to be in high school. No

longer feeling the pressure to look and act like a human Barbie doll was a gigantic weight off my shoulders. In fact, Criss even encouraged me to go without makeup.

Wow. Somebody who likes me for who I really am! I thought.

Despite having made a complete break from my relationship with Hef, I still felt like I was awkwardly darting back and forth between two worlds. Not only was there my job at the Playboy Studio, but there were still *Girls Next Door* obligations to fill. I had been with Criss for only about six weeks or so when I received a call from the *GND* producers asking me to come into the studio for audio commentary for the season five DVD. Understandably, now that the season was wrapped and edited, the producers were eager to get this commentary in the can before the three of us girls scattered even farther in different directions.

Despite placing an impenetrable candy coating on what was often a miserable existence, I was always very grateful for *Girls Next Door* and the opportunities it provided me. Who knows where I would have ended up if it hadn't been for the series? Perhaps still locked behind that giant gate, depressed as ever . . . or worse.

Committed to fulfilling my obligations to the show, I agreed to come in that week. For the audio commentary, producers set Bridget, Kendra, and me in chairs around a monitor. They'd play each episode and we'd talk about what was going on in that moment or provide some behind-the-scenes details. Despite having been away from the girls for only a few weeks, it felt like I hadn't seen them in years—and it was so much fun laughing over the show with them.

My jovial mood, however, wouldn't last. During the final episode, producers had cut a video montage of Hef's and my most romantic-seeming moments over the course of the last five seasons. With our breakup (not to mention the way he had treated me) still so fresh in my mind, I couldn't begin to manufacture any sort of sentiment for the commentary. In fact, the entire montage made me sick to my stomach.

"Really?" I groaned into the microphone at our producer. "Do you *have* to do this?"

"Holly, Hef is a romantic," he said calmly. "He wants to hear from you."

"It's gross," I protested. "Do you have to put all this in? We're not together anymore. Nobody wants to see this."

He seemed disappointed that I wasn't making this easier, but I didn't care. The montage seemed wildly inappropriate. Plus, Criss was growing more and more sensitive about my affiliation with *Playboy*. About a month into our living together, he started getting really upset any time an article would surface linking me to anything *Playboy*-related. His rants frightened me, but since I had (foolishly) already moved in with Criss, I gave him chance after chance, hoping that this was a passing phase. In my head, I imagined Criss watching this episode and completely going off the deep end (which is exactly what would happen).

After we wrapped commentary, Bridget, Kendra, and I gathered around outside the studio with the producers and the crew chatting about the season, what we loved, what we hated, etc.

"You know, Hef *likes* all the drama," Kendra began. We'd all had our complaints in the past, but this was the first time Kendra was so vocal in front of production. I guess since it was all over, she had nothing to lose. "I remember one day we were all watching a movie and afterward Hef followed me back into my room. He goes, 'You know, I'm really disappointed that you didn't sit closer to me.' And it was so weird, so I just said, 'Well, that's, like, where Holly sits and I don't want to, you know, step on anyone's toes.' Then the dude stomps his feet and was like, 'I *like* the drama!'"

Kendra's story hit me like a punch in the gut. While I had long ago tired of Hef's double standards, ridiculous rules, and belittling comments, this was the first time I *really* realized what a manipulator he was. Suddenly, it all became clear to me. The biggest reason I never got along with

most of the girls in the house was Hef. He encouraged the infighting all along, despite his fake pleas for harmony. He was looking more and more pathetic in my eyes. I couldn't believe I had been manipulated for so long.

I kept in touch with the show's producers regularly. Since I openly blabbed to the press about my hopes to do a reality show of my own in Vegas, they called to find out what I had in mind. They also contacted me regularly to invite me to Kendra's bridal shower and to confirm me as a bridesmaid for her wedding. It was difficult for me to communicate with them, though, because Criss seemed to be getting more and more paranoid about any affiliation I had with *Playboy* or *Girls Next Door* and tried to talk me out of even attending Kendra's wedding. While his behavior troubled me, I could almost sympathize with it, in my own twisted way. After getting some space between me and the mansion, I was truly beginning to realize just how poorly I had been treated and what a grim situation that had been, and so in a way, I saw Criss's behavior as him protecting me from *Playboy*.

During one of Criss's performances, I waited for him backstage and found myself alone for the first time in weeks. Usually I watched his shows from the audience or waited backstage with other members of his entourage, but that evening everyone else must have been occupied because I was the only one in the room. I decided to take the rare opportunity to call one of my favorite producers and catch up.

The call didn't go quite how I had planned. Somewhere in the midst of our catching up, what was meant to be a friendly phone call turned into a berating session. I believe it stemmed from the fact that I didn't react the way they wanted to the "Holly and Hef love montage" during the audio commentary session. What I remember clearly is ending up in tears and trying to stick up for myself as he rattled off a list of complaints Hef had logged against me in a recent bad-mouthing session. I knew that when I made the choice to leave the mansion that I was leaving my spot on TV behind, but I certainly hadn't expected Hef to try and poison

everyone I had worked with against me. My producer friend told me that all of the things I'd said during the commentary made everyone uncomfortable: him, the crew, Bridget . . .

Apparently it had been okay for Kendra to rattle on and on about Hank throughout the commentary, despite having dated him behind Hef's back for the better part of a year. I guess because they had been planning a Kendra spin-off anyway, that was okay. True, they thought the spin-off was going to be about a wild, single Kendra out on her own, but the concept of the show was easily adaptable to the idea of Kendra having a boyfriend, once they found out about the secret months-long romance. I had thrown a huge wrench in their vision for *GND* season six, however, so my behavior and honesty during the commentary was deemed "wrong." It was incredibly hypocritical, but what else was there to expect from the same camp that thought we should all be faithful to Hef without him showing us the same respect?

Seized by an anger that was bubbling up inside me, I phoned the mansion to confront Hef about what he was saying about me behind my back. For years, Hef had maintained friendships, however superficial, with most all of his ex-girlfriends. I had expected to receive the same politically correct treatment and made sure that anything I said about Hef in the press was favorable and kind. For some reason, though, I seemed to be the first ex-girlfriend that he was going out of his way to poison.

"Hello?" Hef answered, not sounding particularly happy to hear from me.

"Hi," I said and jumped in before he could stop me. "I've been told about all the things you've been saying about me and it's not right. I did my best to be the best possible girlfriend for seven years and . . ."

"Ha!" he shouted into the receiver, going on to accuse me of having had an agenda all along and reprimand me for not showing up at mansion events post-breakup.

"I wanted to give you your space!" I near screamed into the phone. "I'm not going to show up and push whoever you're seeing out of the way.

I was never that kind of girlfriend. I'm not Tina. I'm not going to play that game."

I was fuming. For so long I tried to be—had been, in fact—a model girlfriend, and here was Hef, characterizing me as if I were no better than all the two-faced manipulators he dated before me. I was just trying to move on and live my life, but my 80-something ex wouldn't stop talking smack about me to anyone who would listen. So much for exiting with any grace!

He could only respond by ranting about how much I had supposedly changed and what a different person I was.

He was right. I had changed—and in my opinion, it was for the better. And for the first time in a long time, *my* opinion was the one that mattered to me.

After that call, I quit my job at Studio West. While I adored my position and the people I worked with, staying felt awkward. I needed to leave *Playboy* totally behind me. Plus, I was no longer feeling challenged. Hef had very cookie-cutter preferences when it came to Playmate shoots and layouts, so it wasn't long before I could do the job in my sleep. I felt like I wasn't learning anything anymore.

Over the next year, I would routinely pick up the latest issue of *Playboy* to see the published pictorials. I was surprised to see the take on the Shannon twins in their pictorial. While the sunny, fresh-faced tennis-themed photos that I directed (the same shoot that was seen on *The Girls Next Door*) were still included, the rest of the pictorial had a distinctly different flavor. The girls had been styled as "Mansion Mistresses" lying on top of each other on a floatie in the mansion pool, one of them donning Hef's signature captain's hat, seductively straddling each other on Bridget's former bed and climbing the grand staircase in nothing but cheap, stripper-store rhinestone jewelry.

So much for the girl next door, I thought. The title of our reality show was inspired by the way Hef described the ideal Playmate back in the '50s when he launched the magazine. Most women pictured in other publica-

tions of the era wore heavy makeup and very stylized hair. Hef wanted something different. He wanted his Playmates to look young and fresh-faced, not like "someone's older sister," which was how he described the look of most models at the time.

Criss seemed absolutely thrilled that I had quit my job. He'd been pestering me to leave and insisted I use his publicity and management teams. Since Playboy PR had long ago started giving me the cold shoulder, I accepted.

Over the few months that I was with Criss, my heart would sink any time I would see magazine articles featuring Bridget and Kendra together. It seemed as if Playboy PR was still working for them, and suddenly the two girls were pushed like never before. I was never contacted to be a part of the photo spreads and interviews, though, and it hurt to be the only one left out. Despite the other two girls moving on to new men, I was the only one Hef was determined to punish. In the media, Hef would always say what a great girlfriend I had been and that I was welcome back in his life at any time (which would always send Criss into a fury), but in reality he wasn't being friendly towards me.

Criss's explosive temper was becoming increasingly more alarming. I didn't want to go back to the mansion, Criss knew that, but it was as if he couldn't help his jealousy. For all his fame, fortune, and success, Criss, to me, seemed cripplingly insecure.

This was starting to feel all too familiar.

Before I met Criss, I had seen his television show and thought he was cute. Had I dug a little deeper and done some research on the guy, perhaps I would have been more hesitant to get into a relationship with him.

According to reports in the press, earlier that year Criss had threatened *Las Vegas Review-Journal* columnist Norm Clarke in public, screaming, "Don't ever write another word about me or you'll need an eye patch over your other eye." The confrontation was written about in the paper and online, but I wasn't aware of it until I had already started dating Criss. Many of his public rants, though, happened after I left him. Apparently,

he singled Perez Hilton out in his audience one night and called him "the world's biggest douchebag asshole"; and magician Joe Monti filed a police report that alleged Criss "flipped out" and assaulted him. Monti produced an audiotape with a voice that is allegedly Criss's saying, "Get out of my place before I knock you out." I wasn't surprised by any of it after what I had experienced.

In the beginning, any fame I had, Criss loved. That was what made our relationship such a publicity boon for him, after all. But as time went on, his jealousy seemed to get the best of him.

I remember him barking at me to cover up my hair as he yanked my hoodie over my head. He then went on to complain that my bright blond hair was attracting too much attention.

It was true. Even in his resident casino, people would often spot me before recognizing him.

After an amazing Elton John concert at Caesars Palace, we went backstage to say hello to the friendly pop legend. His dressing room walls were covered with shelves adorned with a massive bobblehead doll collection.

"You have my bobblehead!" I squealed, pointing at two of my dolls nestled in among the immense collection. I have to admit: it was a total fangirl moment. I mean, who doesn't love Elton John?! It was crazy, spotting my dolls in his dressing room.

Criss snapped that he had his own bobblehead coming out, shooting me a death glance.

Who gets jealous of their girlfriend like that? I thought. We were supposed to be on the same team, but it was starting to feel more like we were in a one-sided "who is more famous" pissing contest.

Before my last trip back to Los Angeles, I told Criss I planned to stay an extra day to take my car to the shop so that I could have some repairs done. He threw a fit, accused me of not caring about him, and told me I should put my car in his warehouse.

Already Criss had suggested I begin storing my valuables in his

safe—including my diamond watch and the two pieces of jewelry he'd already lavished on me. To me, my car was a reflection of my independence. It didn't feel right locking it away—and, honestly, Criss's apparent fascination with hoarding my valuables was beginning to make me uncomfortable. I canceled the car appointment and never mentioned it again—the last thing I wanted to do was put my car in his warehouse, and thankfully, I never did. Still, despite any trepidation that may have crept into my mind, I still wanted to believe we had a shot at making it together. It's easy to stand on the outside now and list the ways this relationship was clearly doomed, but I didn't have anything to compare it to. I had never been in a healthy, committed adult relationship before, so I didn't even know what was missing. With all my doubts, Criss seemed passionately in love with me and that was what mattered to me at that time.

The declarations of love from Criss flowed freely and he talked in front of his friends about wanting to settle down with me. He took me back home with him to Long Island to show me off to everyone he knew. As the holidays approached, I was treated like I was already a member of his family. Since we were both December babies, I began thinking ahead to our birthdays. Criss had already scheduled our joint birthday celebration to be held at his favorite night spot, LAX, but I also wanted to keep a tradition that I'd developed over the last several years: a trip to Disneyland with a group of friends. Near my birthday, Criss and I planned a day trip to the Magic Kingdom and invited my usual guest list, which included a few girls from the mansion.

As the day grew closer, my mansion "friends" suddenly became unavailable.

"You won't believe it," said one of the girls who lived at the Bunny House. "Hef heard you were going to Disneyland for your birthday and decided to take his new girlfriends the same day you're going."

Seriously? I thought. Hef abandoned making the trek down to Anaheim years earlier. He suffered from chronic back pain, so having to walk

more than a few steps at a time was incredibly uncomfortable for him. What are the chances that he all of sudden decided to go to Disneyland on the very same day I would be there celebrating my birthday? It was a pathetic attempt to get in my face and perhaps try to remind me of his earlier accusation: that the girls were my friends only as long as I was his girlfriend.

"I don't know what to do," she grumbled. "He invited me to go with him and I feel like I can't say no because I live in his house. This is really awkward."

Several of the girls called to explain that they wouldn't be going with either of us. It was obvious Hef was trying to force them to pick sides—and they didn't want to get involved.

If Hef wanted to go to Disneyland, that's fine, I told myself. He wouldn't deter *my* birthday celebration. Criss and I ended up spending the afternoon by ourselves. I asked our tour guide to help keep me from running into Hef's group, which was also on a guided tour, which I'm sure soured Hef's plans of ruining my day and flaunting the guests he had ripped away from my celebration.

Despite the fact that we avoided Hef, it still wasn't the most relaxed day at the park. Criss spent the whole day trying to orchestrate "candid" paparazzi shots without seeming obvious, which I found embarrassing. I never mind having my photo taken, but I hated his sneaking around. The way he tried to hide his oh-so-obvious agenda from our tour guide made him look, to me, like a complete idiot. This was the first time I felt embarrassed to be with him, and it wouldn't be the last.

Back in Vegas, Criss and I filmed a TV segment together for a local New Year's Eve special. The bubbly reporter who interviewed us was very interested in the diamond ring that sparkled on my finger. It wasn't an engagement ring, but the large diamond birthday gift Criss bought me piqued the press's interest nonetheless.

For Criss's birthday, I wanted to get him something special. But what do you get the man who has everything—or at least could afford to buy

himself anything he could ever want? I started reading interviews he had done online, hoping that it might offer me a clue or two.

Criss had told a reporter that he was a huge fan of Salvador Dalí. I'd never heard him mention art before, but why would he make something like that up? During one of my final trips to Los Angeles, I tracked down a rare Salvador Dalí print at a Beverly Hills gallery.

When I gave him the present, Criss tried to act impressed and thanked me vigorously, but didn't offer too much more. His manager, who was also in the room, seemed way more impressed than Criss.

Huh, I thought. *Maybe he doesn't really care about art after all.* This was just one example of how the public Criss and the private Criss seemed like two very different people to me.

For Christmas, I played it a bit safer. Criss had mentioned wanting to shoot a snowboarding episode of *Mindfreak,* so I commissioned Burton to create a custom snowboard and snowboarding gear. Believe it or not, he actually had the gall to ask me if Burton did that for me for free. So much for its being the thought that counts! All Criss seemed to care about counting was pennies.

In return, Criss showered me with an audacious diamond cross necklace—making the previous pendant he bought me pale in comparison. He also presented me with another necklace, this one with a large diamond-encrusted infinity symbol pendant. On the back, next to the clasp, was a little charm that read, in tiny diamonds, "XO CA."

Reading the huge smile on my face, Criss whispered that he had designed this especially for me and that he'd never designed jewelry for anyone before, not even his wife.

Criss had been married before, to his hometown sweetheart, but they filed for divorce after she learned that he had been spotted with an A-list movie actress. Criss never missed an opportunity to remind me of his high-profile conquests.

"Wow," I exclaimed, truly breathless at these elaborate gifts. "I don't know what to say. I love them!" He picked me up in a huge hug.

No one had ever lavished me with such elaborate romantic gestures before. Even though Hef had dropped a few pieces of jewelry on me, they were always pieces of mass-produced Playboy-branded merchandise, made even less personal by the fact that identical pieces were given to his other girlfriends at the same time.

To me, it was the care that mattered . . . not the carats.

Criss offered to fly my parents to Las Vegas to celebrate the holidays with us. I was impressed and flattered that he showed such an active interest in getting to know my family, something Hef had never done.

"I think Holly should have her own perfume," Criss told my parents one evening over dinner. "The slogan could be *Holly Madison: Bring Out the Bunny in You.*"

My dad couldn't help but stifle a laugh.

"Can you even use that?" he asked Criss. "Isn't that kind of a *Playboy* thing?"

Criss was beside himself. He'd spent his entire career surrounded by yes people, so he was completely at a loss for words and clearly uncomfortable that someone dared disagree with his idea. Ever the entertainer, Criss could charm the pants off anyone (in some cases . . . literally), but I was disappointed to learn that, just an inch below the surface, he didn't appear to be the sharpest tool in the shed.

Whenever he announced his next "great idea," I usually fell silent. I didn't have the heart, for instance, to tell him that I wasn't interested in cohosting a regularly scheduled "LoveSex" Pool Party (yes, that was the real name he actually came up with) at the Luxor with him. I felt sorry for him and didn't want to embarrass him.

Criss asked me what my parents thought of him as we rode the elevator back up to his suite. He was clearly in need of some affirmation.

"They liked you," I said with a big smile. After all, they hadn't told me they *didn't* like him. My parents confided in me that they found him a bit controlling, but they were seeing things I wasn't necessarily ready to accept. On the other hand, they saw that I appeared truly happy. Plus,

seeing me with a man closer to my own age had to be a lot easier to swallow.

He then asked me if I had told them I was "in love" with him.

"Um, I told them I really liked you," I offered honestly. I'd already moved in with him, adopted so much of his life, and gushed relentlessly about him to the press. I wasn't going to profess my undying love to my parents after just four months of dating, no matter how much of a whirlwind our time together had been or how often we said it to one another.

Criss pouted, crossing his arms, turning away from me, and, grumbling, asking why he was even wasting time on this relationship.

"Hey," I said defensively, "I don't introduce my parents to many people. This was a really big deal for me."

THE WARM MEXICAN SUN beat down on my shoulders as Criss and I sat at our beachside table eating sushi and drinking Coke Lights with our friends Barbara and Ron. Enjoying a few days off from the show, Criss swept me away to Cabo San Lucas for a late January getaway.

"We're going to miss you guys," I bemoaned to Barbara beneath a perfect cloudless Cabo sky after a boating excursion. The couple's trip overlapped with ours for only a few days. They were longtime friends of Criss's—and would soon become close friends of mine. The couple kept conversations lively and fun—they were the perfect antidote to the dark energy that I was starting to feel from Criss more and more lately.

"Let me give you my info," Barbara said. "Text me any time you're bored and want to go to lunch or something."

"Thanks!" I said, pocketing the business card with Barbara's information.

After we finished our leisurely lunch and said our good-byes, Criss and I went back to our suite.

Criss snapped at me as soon as the door had shut behind him. He demanded I give him the card and forbade me from texting her.

"Why?" I asked, confused. She seemed really sweet, but perhaps there was something about her I didn't know.

He put his hand out, motioning with his fingers for me to cough up the card. He gave me a lame excuse about Barbara being "over the top." It was clear that he presumed this was an acceptable explanation and he considered the conversation over.

Begrudgingly I handed the card over to Criss. Thankfully, I had already saved her number in my phone while we were still at lunch. After the holidays, I finally began recognizing Criss's behavior as unusually possessive. In addition to his unreasonable temper tantrums, hoarding my most valuable possessions, and encouraging me to quit my job, he was showing yet another troubling sign: isolating me from my friends. He didn't want me spending time with anyone else. He often found excuses to keep me away from my phone and recently began demanding to see it when he saw me texting. Needless to say, I was scared of where this relationship was going.

For the remainder of the trip, Cabo was hardly as relaxing. I soon learned that TMZ was reporting on our vacation. I never spotted the photographers; judging by the photos, they appeared to be shooting us from boats off the coast or from neighboring hotel balconies. I later learned that Criss tipped off the paparazzi—he never turned down an opportunity for more press to distract from his show, which was now seeing more horrendous reviews. A review in the *Los Angeles Times* had recently said: "If Criss Angel were blindfolded, straitjacketed, run over by a steamroller, locked in a steel box and dumped from a helicopter into the Pacific Ocean, he still might be easier to salvage from disaster than 'Criss Angel: Believe.'" Yikes.

That night Criss and I got into an awful fight—one of the first of many dramatic rows that would soon become a constant theme in the remaining weeks of our short-lived relationship. While the catalyst for the fights varied, the arguments themselves became somewhat formulaic. Here's how I would describe them:

1. Criss would become insanely jealous—usually a trigger associated with *Playboy*.
2. He'd accuse me of being a slut.
3. He'd say we should break up.
4. Criss would freak out if I didn't try to convince him otherwise or make attempts to "save the relationship." (I never did try to save the relationship during these tantrums. His outbursts scared me!)
5. He'd calm down and tell me what a wonderful person I was and how lucky he was to be with a sweet girl like me.
6. He would then take me in his arms and tell me he loved me.

I barely said anything during these rants, especially during the parts when I felt him getting hostile. His anger seemed irrational to me and was somewhat terrifying. By this time it had become clear to me that I had traded in one controlling megalomaniac for another. If there was one thing you could say about me at that time, it was that I definitely had a type! There were differences, though: Hef was a master of manipulation and knew how to cripple a girl's self-esteem. Criss, on the other hand, just scared me. His anger filled a room, and while he never threw a punch at me, I was scared that something of that nature might be lurking around a corner.

Once again I was sleeping with the enemy. Only this time instead of being trapped behind the mansion walls, I was Rapunzel locked high away in the penthouse of the Luxor hotel. Criss had become so controlling that security shadowed my every move—I wasn't even allowed to go downstairs to grab a Starbucks in the lobby without a security guard or assistant being ordered to follow me.

I started to wonder: *Was I really any better off than I had been at the mansion?*

AFTER OUR TRIP TO Cabo, Criss's performance schedule started to catch up with him physically. He no longer had the energy for any of the off-

day excursions we used to do—and during his on days, I had no choice but to adopt his routine. Criss wanted me to be with him 24/7 and he balked when I asked to go on simple errands by myself. We slept in most of the day, ate Mexican food in bed, and headed straight backstage two hours before the curtains went up so Criss could begin his preshow ritual: get an hour-long massage, eat a sandwich, and sit for hair and makeup.

And I thought mansion life got monotonous! Not only was I beyond bored, but my body ached from lack of exercise and activity.

Fueled by his failing show, recently called "a dog" by *Variety*, Criss's treacherous outbursts became more and more frequent. I spent most days walking on eggshells, hoping to avoid yet another land mine. My nerves were so frayed that I often felt faint and nauseous, causing female members of his staff to joke that perhaps I was pregnant.

As I was showering one day, Criss popped his head into the stall. With a false air of casualness, he said he saw that Bridget was hosting a Valentine's Day party in town that week and asked me if I was planning on going. I think he was itching for a fight.

I felt my body weaken and the light start to darken as my eyes rolled towards the back of my head. Criss swooped me up before my knees could buckle, pulled me out of the shower, and ran over to place me on his bed. He grabbed his terry cloth robe to lay over me and snatched a leftover chocolate cookie from Subway that was sitting on his dresser.

"Here, eat this," he said, tossing it to me from across the room. "What happened?"

"I don't know," I uttered breathlessly. "I just felt really faint all of a sudden."

I unwrapped the cookie and took a few bites as he stood over me and watched.

"I didn't plan on going to Bridget's party," I finally said. "I didn't think you'd want to."

I was scared to mention Bridget in front of Criss. He had become so controlling, always demanding to look at my phone and trying to keep

me from seeing or speaking to any of my friends. He seemed to have a major problem with Kendra ever since she announced her plans to marry Hank at the mansion (which I always thought was a strange choice, considering the Kendra I thought I knew would probably have preferred a beach wedding). Criss was wild with jealousy at the very thought that I might attend.

Apparently, that was the right answer, because his spirits immediately brightened.

"No, let's go to her party!" Criss said, in what had become a rare moment of happiness. I continued lying in bed for a moment, enjoying my cookie, my boyfriend's good mood, and the security in knowing he had just rushed to care for me. I was so relieved to have avoided another major blowout that I didn't even worry about what caused me to feel faint in the first place.

In the first few months of 2009, my primary occupation was being Criss's moral and emotional support. When he flew to Los Angeles to tape a segment on *Larry King Live*, I traveled with him.

"Do you want to go on with Criss?" one of his managers had asked me as Criss was being summoned onto set.

Huh? I thought. I didn't come here to be on the show. I thought I'd just be sitting in the greenroom with the rest of the entourage that made the trip to Los Angeles.

"No, I'm okay," I said, waving my hands at Criss as if to say "go ahead without me."

Criss pleaded with me to go with him, gesturing towards the sound guy, who was already holding a second mic pack.

I didn't feel like I had a choice in the matter.

"Uh, okay," I said, hesitantly, thanking God I wore makeup that day and wondering what I would talk about.

I didn't realize it at the time, but apparently I was the sideshow attraction that was to be trotted out to distract viewers from the disastrous show reviews that Larry would certainly be bringing up. I had become used to

being used for publicity at this point, but was still completely surprised by this particular ambush. Before I had been used for photo ops, planted articles, and local Las Vegas programs, but this was prime time, national television. It felt very uncomfortable.

"So . . . you've been on this show before," Larry said, giving me a pointed look. In 2005, I'd appeared on *Larry King Live* with Hef, Bridget, and Kendra to promote *The Girls Next Door*. It was obvious to me what he was thinking. To him, it seemed as if I was jumping from one rich boyfriend to the next with no purpose or pursuits of my own beyond being professional arm candy.

And in a way he was right. It hadn't been my intention, but the relationship with Criss proved so controlling and consuming that I hadn't been able to make any professional moves of my own. All of those dreams that I had been so enthusiastic about just a few months before had been shoved under the rug as my primary focus became being at Criss's side. Once again a lightbulb went on, and I resolved right then and there that I needed to make a change.

It had become increasingly clear to me that I had jumped headfirst into this relationship *way* too soon. Having striven hard for fame the first 35 years of his life, Criss was an expert at putting on a charming facade and being able to win people over. After I had spent several months with him, the facade faded and I started to see what was underneath, what the *real* Criss was like. I learned that our views on politics and most social issues were vastly different. He had a fifth-grader's sense of humor. (His entourage had to muster up convincing fake laughs every time he repeated the same joke we'd heard a million times.) I found him to be unintelligent and he seemed virtually illiterate. (He misused the word "misnomer" so much—even during interviews—that it made me cringe for him.)

It was disappointing to realize how incompatible we were, but I cared about him, so initially I just felt sorry for him. But as time went on, I saw a mean, bullying, and deceptive side of him, and I started to get dis-

gusted. I had been so enchanted by this man and by my overwhelming desire to feel loved and needed that I hadn't even taken the time to get to know him before committing myself to him. I realized I needed an exit strategy. And fast.

Criss insisted that I be present for every one of his performances. In the beginning, I would watch the show from a seat in the audience—and Criss would manage to work my name into the narrative and introduce me at the end, along with his family. Initially I thought it was sweet, but it soon became embarrassing. Eventually he would suggest that I wait backstage with his bodyguard, which meant I would be there to greet Criss during his quick between-scene changes. He told me that having me there helped the shows go by faster for him.

My mind was on my next step. Every time Criss went back on stage, I used those few minutes to pull out my BlackBerry and add to a list of what I needed to do. He was with me every other minute of the day, so this was my only chance. I quickly made the list: find an apartment in Las Vegas, contact *Crazy Horse Paris* (Criss had successfully talked me out of accepting their offer to guest star), get my valuables out of Criss's safe, etc. I wrote all of this in French so Criss wouldn't be able to read the notes the next time he snatched my phone away from me.

"Who are you texting?" the bodyguard sneered at me, throwing me a suspicious look.

"No one," I said as I pocketed my phone. "I'm just writing down some ideas."

I WAS DONE. I had gone to bed finally ready to leave Criss. He had started another one of his one-sided arguments over nothing and I had had enough. I didn't even try to engage him, and instead quietly sat through the rant until he calmed down and I was finally able to go to sleep.

The next morning, his fit clearly wasn't over. He stormed out of the master bathroom, tearing up a Valentine's Day card I had given him

featuring my pinup portrait by Olivia on the front. Criss was screaming about having just noticed that the rendering included a pair of curled-up pink bunny ears on top of my head, striking a deep nerve in him.

Criss finally said that he thought I should go back to my parents and that he would buy me a plane ticket.

"Okay," I said, barely louder than a whisper. I was afraid to argue with him. I silently congratulated myself on this easy out he had just provided me.

He stormed out of the room and yelled loudly to one of his assistants to book me on a flight to Portland that afternoon.

I crept out of bed and began gathering what I needed. Luckily, I still had a perpetually packed suitcase at the ready for my back-and-forth-to-L.A. trips that had come to an immediate halt a few months earlier.

Criss asked me if I wanted to wear my jewelry, slyly eyeing the vintage Gucci watch I had purchased for myself, my small cross necklace, and the ring he had given me.

"Yes," I replied without thinking. It never occurred to me that he would actually expect the gifts back. After all, I had bought him expensive things, too.

When I finally pulled my things—and myself—together, I walked out into the living room of the suite. Criss's bodyguard was standing by to drive me to the airport.

"Bye," I said, giving Criss a cold, distant hug.

"Take care," he said just as coolly, before planting a kiss on my head and asking me to let him know that I got in safe.

"I DON'T KNOW WHAT'S wrong with me," I cried through a stream of tears. "It's like, I know he's an asshole and I know he's not good for me, but I'm still so sad. I don't get it."

I was home in Oregon; the same place where I had decided to pack up my little red Celica nearly a decade earlier. In some ways, it was as if noth-

ing had changed and I was back where I started. I had no job, no man, and no prospects lined up. Luckily my close friend Sara Underwood lived in Portland and spent an afternoon listening to me as I poured my heart out. She was an absolute angel and held my hand through my frequent sobs. I was so grateful to have her there. She listened and offered me the best advice she could, but the real problem wasn't obvious to either of us at that point.

Yes, I had just embarked on a high-profile romance that went wrong, quickly and dramatically, but that wasn't really where my emotional crash was coming from. I was suddenly having to deal with my transition from the twisted world of *Playboy* into the real world. It was the unavoidable emotional fallout that had been postponed by my whirlwind romance with Criss.

What was I going to do now? I thought, feeling hopeless.

After a week in Oregon, my dad drove me to the airport and I boarded a flight to Los Angeles. I had no idea what was going to happen next, but I was determined to brave the storm, despite the heavy burden of sadness I carried onto the plane with me.

Criss's voice echoed in my mind, telling me I needed to go back to California. During a few of his tantrums, when he was mulling over a breakup out loud, he would always banish me to California, as if he owned Las Vegas.

Where I go and what I do isn't your prerogative, I thought, as if I now had a chance to respond to one of his treacherous rants.

I felt like Hef was trying to sabotage me in Los Angeles by bad-mouthing me and leaving me out of *Girls Next Door*–related press, and now Criss was trying to banish me from Las Vegas.

Sorry, boys, it's not going to be that easy, I thought, pulling my hoodie over my head. I felt the rumbling of the plane engines beneath my seat. *You haven't seen the last of me.*

For, you see, so many out-of-the-way things had
happened lately, that Alice had begun to think that
very few things indeed were really impossible.
—Lewis Carroll, *Alice's Adventures in Wonderland*

After my breakup with Criss, I returned to La-La Land absolutely lost. I knew that I wanted a successful career, but I didn't know how to go about achieving it. Since arriving back in Los Angeles, I was still reeling from the emotional fallout of my relationships with both Hef and Criss. For the first time in almost eight years, I was entirely on my own, but this time, I was carrying a whole load of emotional baggage behind me. *What am I going to do next?*

God bless Mary O'Connor. After I had spent all those years at the mansion, Mary became more than a friend to me . . . she became like family. When she and her partner, "Captain Bob," invited me to stay in their spare bedroom while I got my feet on the ground, I couldn't have been more grateful. While she remained Hef's loyal and loving secretary for more than 40 years, Mary was also a compassionate woman who knew I needed her (and knew damn well that Hef respected her too much to ever reprimand her for taking me in).

Of course I had my own apartment in Santa Monica, but I had become terrified of being by myself. I was desperately lonely and didn't feel at ease in my apartment. There was no security at my building and the neighborhood in Santa Monica where it was located didn't feel very safe after dark. Every night I noticed a truck parked across the street from my living room window with a man sitting in the driver's seat for hours. I have no idea why he was there, but I found it creepy. What I needed most was a comfortable, safe atmosphere surrounded by people I loved and who wanted the best for me. It was the only way I could be sure that my next decision would be a smart one. I was scared of making another bad choice because I was anxious, lonely, or desperate.

Despite Hef and the producers' incessant lobbying for my return to the mansion and the series (even though Crystal and the twins were already occupying our former spots), Mary encouraged me to make the best decision for me and to follow my heart.

"It's better for you to be on your own," she told me. Mary had a wonderfully maternal nature—and I often looked to her for guidance. "You need to live your life. There's not much you can really do at the mansion."

A few days after I arrived, I contacted Criss's assistant about shipping out everything I'd left behind in my hasty departure. When the boxes arrived on Mary's doorstep, I burst into tears. I knew I didn't want to be with Criss, but I was still broken. It's a humbling experience having a stack of cardboard boxes packed neatly with your belongings shipped back to you without even a single word.

I felt like I had been thrown out with the trash.

When news of Criss's and my breakup eventually leaked to TMZ, Criss began calling me and sending me nasty text messages accusing me of tipping off the press.

He angrily accused me of telling "them." When I asked him who he meant, he said, "Playboy," and went on to rant about how he knew this would happen and angrily said that I had better be saying he broke up with me.

There could have been no greater way of insulting Criss than if people assumed that I had been the one who actually wanted out of the relationship. I honestly didn't care what people thought—I was just happy to be a *safe* distance away from him.

We had barely spoken since I left him in Las Vegas that morning, so needless to say, we never really discussed how we were going to handle our very public breakup with the press. I didn't know who told TMZ about our dissolution (since I had only informed my family and a few friends), but it seemed Criss was irate because he had his own ideas about how he would announce our split. Since we still shared the same publicist, we both got an email from him asking what kind of "joint statement" we would like to make about the breakup.

Criss responded first, demanding that he tell them nothing.

Our publicist quickly replied:

We have to tell the press something. If you don't, no one will want to cover you the next time you date a celebrity.

Ouch, I thought, hit him where it hurts.

Eventually, we agreed to make a statement saying we broke up amicably due to scheduling differences—regardless of the fact that I had nothing to schedule. I don't know if anyone bought the excuse, but I didn't really care. The media and the public had become so used to seeing Criss run through starlets for publicity that I doubt many people ever believed our relationship was genuine . . . I was possibly the only one who had!

Now that my relationship with Criss was behind me, I could finally focus on my future. Though I was tempted to waste away in Mary's spare room, I knew I had to take action. At the insistence of Criss, I had turned down most of the opportunities that had come my way shortly after I left the mansion—most of which Criss's jealousy didn't allow for. Besides Mary, no one associated with *Playboy* or *Girls Next Door* would have anything to do with me, unless I abandoned my own dignity and returned to the mansion, which was the last thing I would do.

No, I thought. *I'm starting from scratch—and I'm doing it on my own.*

I made a list of the things I still hoped to accomplish in my life and career. Being able to see my goals spelled out in front of me was an important part of the process.

For my career, my list was pretty specific:

1. Develop a reality series that showcases the *real* Holly—apart from *Girls Next Door*, *Playboy,* and Hef.
2. Star in a Las Vegas show.
3. Appear on *Dancing with the Stars*.

The list went on, but those were my main goals. Prior to leaving the mansion, I had interviewed for *Dancing with the Stars* and even met the producers. I had fallen in love with the series when its second season aired in 2006. The contestants looked like they were having so much fun and I couldn't take my eyes off contestant Stacy Keibler's flashy costumes. Although I wasn't a dancer, I was dying to be on the show—it looked like the contestants were having the time of their lives! But despite how popular *The Girls Next Door* was at the time, rumor had it that one of the show's producers didn't think Middle America could relate to a young woman who lived with an old man like Hugh Hefner. Determined to one day appear on the series, I tried revisiting the idea two months earlier during a meeting with Criss's managers (this was during the period he insisted on "shaping" my career).

"So I called *Dancing with the Stars*," Criss's manager began, "since you told me you were interested in it, but they've already cast their upcoming season."

Criss remarked snidely that *Dancing with the Stars* was a show for "has-beens" and the only person to have ever done it right was Marie Osmond, because she did it right before she opened her show in Vegas.

None of my career ideas were up to Criss's standard, so this one—like many others—was shot down.

After making my list, I decided that tomorrow would be the be-

ginning of a fresh start. I knew what I *hoped* to achieve; now I charged myself with the task of going out there and making it happen. Deep down I knew that I would be okay. For the first time in weeks, I felt optimistic about my future. I knew I needed to gather my strength, so I decided to let myself sleep in before somehow starting a new life the next day.

When I crawled out of bed later the next morning, I noticed I had three missed calls and voice mails from the same number on my Black-Berry. Each was from a producer at *Dancing with the Stars* urgently looking to get ahold of me.

Holy shit, I thought! Was I dreaming this? I listened to the voice mails again just to make sure I hadn't completely taken a dive off the deep end. The producer had hoped she had the right number, since she was calling the phone number they had listed on my file from the first time I interviewed.

It was such an uncanny coincidence that I had to believe that someone above was answering my prayers. Since they had just announced the season eight roster a few weeks earlier (and the series was actually premiering the following week), I figured that casting directors must be beginning their search for the following season's hopefuls.

"Hi, this is Holly Madison returning your call," I said nervously into my cell phone to whichever bigwig I had just happened to call. (In all the excitement, I didn't even remember the name of the person who had called me.)

The producer confided (after swearing me to confidentiality) that singer/songwriter Jewel had seriously injured herself during rehearsals and they were desperately in need of a quick replacement.

"Would you be willing to do it?" she asked expectantly. "You would only have four days to learn your routine, while every other contestant has already had a month's worth of rehearsals."

"Are you kidding? Of course!" I gleefully shouted into the phone. I couldn't believe my luck. "Absolutely. Thank you so much. I'm beyond

grateful for this opportunity," I continued to stammer, positively beside myself. "I can't believe it!"

She seemed totally relieved and let out a big laugh. It was meant to be! After giving her all my current contact information, I called my publicist, telling him the good news and swearing him to secrecy. My addition to the *DWTS* cast was supposed to be kept quiet until they announced it live on the premier episode.

The next few days were an absolute Cinderella story. After signing the contract with *Dancing,* I was immediately whisked off to meet my new partner, Dmitry Chaplin (a new *DWTS* talent who graduated from TV's other juggernaut dance series, *So You Think You Can Dance*). Production provided me with my first set of dance shoes for our rehearsal. Eight hours of practice later, my feet had erupted in terrible blisters, but I didn't care. I lined the shoes with moleskin before returning the next morning. Not even the pain in my feet could dampen my spirits as I skipped my way back to the studio, eager to continue our routine.

Our first number was a cha-cha to Lady Gaga's anthem "Just Dance." I was overcome with excitement. Could they have chosen a more perfect song for this particular time of my life? After the second day of rehearsals, I was swept away to the office of Emmy-award-winning costume designer Randall Christensen on the CBS lot to begin fittings for my first outfit. (Side note: While the series *airs* on ABC, it's actually shot on the CBS lot in West Hollywood.)

Reminiscent of Hollywood's golden age, the costumes for each *DWTS* episode are crafted in-house each week. In what felt like no time, Christensen whipped up a short, vibrant orange dress drenched in beaded fringe and Swarovski crystals. It was absolutely to die for. Even though I was the new girl on set, the producers, cast, and crew couldn't have been more welcoming. Everyone was an absolute delight to work with—and seemingly grateful that I agreed to step in at the very last minute. Little did they know that this was the break I had been praying for—an opportunity when I truly needed it most.

Was I nervous to perform my newly learned dance in front of a live studio audience and 22 million viewers watching live at home? Duh! But not too nervous to forget to have fun and enjoy *my* moment in the spotlight (without any ominous boyfriend hovering over me). As long as I remembered the routine, I was going to be okay. My priority was to have a good time, work hard, and of course enjoy wearing the fabulous, sparkly costumes!

Over the course of my tenure on the show, my scores were mediocre, my dancing wasn't great, and the eight-hour rehearsals, five days a week were brutal, but I was having *the time of my life*. After practice, I'd make the drive back to Mary and Captain Bob's home in the Valley and collapse on my bed. For the next month, my life would be: eat, sleep, dance, repeat.

After my debut, Criss eventually reached out to me to offer his congratulations. With distance and a bit of time between us, it appeared we could be civil. Some of his messages were very flirty or risqué, but I didn't bite. I had heard through the grapevine that he had already moved on and was living with his current girlfriend. Plus, I knew Criss well enough to be certain that any sort of affirmation I was getting from him was most likely motivated by the new positive publicity I was receiving for being a part of the *DWTS* cast. For my part, I didn't resent him for how he had treated me, even though I could have. Instead of wallowing in the past, I chose to happily close that chapter of my life and be satisfied that we seemed to be on good terms.

"So you say, 'I'm Holly, I was one of Hugh Hefner's girlfriends at the Playboy Mansion,'" directed Freddie, a *DWTS* field producer, from behind the camera.

"Umm," I stalled. "I don't really want to say that. Can I say something else?"

"That's what they have here for you to say," Freddie said, looking down at his notes. "I mean, that's how people know you."

He didn't mean it as a jab; there's no way he could fully appreciate how negative that association was to me or that I was so eager to separate myself from Hef.

"Can I say, 'I'm Holly, I starred on the television show *The Girls Next Door*'?" I meekly and politely suggested, praying he would take the bait. I was so grateful for the opportunity and—despite the contract and grueling blisters—I was still slightly terrified the rug could be pulled out from under me, so I didn't want to go against even their smallest wish, but I just couldn't be labeled as Hef's ex. Not this time.

Silence.

Obviously this wasn't my first foray into reality television and I knew the executive producers had given Freddie the sound bites they wanted to hear. It was his job to make sure we stuck to the script.

He thought about it a minute longer.

"Why don't you say, 'Hi, I'm Holly, I was one of Hugh Hefner's girlfriends at the Playboy Mansion on the show *The Girls Next Door*,'" Freddie suggested, hoping this would satisfy my concerns.

"I'm not going to say the girlfriend part," I said through a sheepish smile. I knew I was pushing the envelope. I didn't want to be difficult, but I had to finally stand up for my own dignity and self-respect. "I'm sorry. I'm just tired of being branded that way. I mean, no one else would introduce themselves as somebody's ex-girlfriend or boyfriend, you know?"

"Okay. If you absolutely don't want to say it," Freddie conceded with a shrug.

In the end, I introduced myself as "I'm Holly Madison. I've been on the cover of *Playboy* four times and I starred in a reality series called *The Girls Next Door*."

Producers got their *Playboy* reference and I was able to stand Hef-free for the first time. One battle down, countless more to go . . .

Being branded as "Hef's ex" was a label that would continue to haunt

me for years, but one I would always fight against. I refused to let *that* be the most defining thing in my life.

Besides the one-time introduction and a legitimately funny *Playboy*-related joke (where fellow contestant Belinda Carlisle said, "I'm the former Miss August," then contestant Denise Richards said, "I was Miss December," and then they cut to me saying, "I've been Miss February, March, September, and November"), I was able to steer clear of any Hef/Playboy references throughout my run on the series.

When an entertainment news program came to film one of my rehearsals, the interviewer asked, "What do you have to say to Hef wishing you well on *Dancing with the Stars?*"

He must have read the perplexed look on my face, because I hadn't heard anything from Hef since landing on the show.

"We taped a message from him and we want to hear what you have to say in return," he explained through forced excitement.

"What's going on?" I asked my manager disappointedly, looking over my shoulder at him for help.

"Hey, guys, this is really inappropriate," he immediately jumped in. He then suggested the interviewer wrap up the segment.

Of course it would have been great for Hef to wish me well, but I wasn't really buying it. If he wanted to say "good luck," he could have easily gotten ahold of me. Instead, he used the opportunity to make a public statement and capitalize on the chance to look like the perfect gentleman. The whole thing felt insincere to me. A few months earlier, after Kendra announced her engagement, Hef publicly stated that she'd be getting married at the mansion and he'd be the one walking her down the aisle . . . before Kendra even fully agreed to it! (Kendra later insisted that her brother give her away. It was creepy enough that she had to get married at her ex-boyfriend's house.)

Did I really expect any different from Hef? He had been a public icon for more than half a century, but still, after all this time, he felt the

need to milk every possible publicity opportunity bone-dry. Wounded by the mass exodus of his "beloved" girlfriends, Hef was struggling to avoid looking like he wasn't in absolute control of the situation. It wasn't enough that he had already restocked the pantry with three younger, blonder girls, he needed to stay publicly involved in Kendra's and my new ventures as if he were still orchestrating our lives.

Who knows, maybe he meant well, but his behavior was suffocating and it motivated me to run even farther and farther away from my past.

I realized that *Dancing* could end any week for me, so I couldn't allow myself to become complacent. As much as I wanted to completely submerge myself in the show and enjoy every moment, I needed to quickly identify my next opportunity and strike while the iron was still hot. I suggested to my manager that we reach out to the *Crazy Horse Paris* again to see if they were interested in reopening our discussions.

"I have something else that I think you might be a good fit for," he countered. "There's a new show opening at Planet Hollywood called *Peepshow* and they're looking to replace the lead every three months."

From what I had read about *Peepshow* in Robin Leach's column in the *Las Vegas Sun,* I knew it was a Broadway-influenced revue with a sexy fairy-tale theme and a sultry "Bo Peep" as the lead character (hence the show's name). I'd seen some early marketing of the show around Las Vegas and didn't find the ads particularly appealing. In the posters, a shadowy, mysterious looking Bo Peep and a sinister looking Red Riding Hood lurked on a black background, the Bo Peep wearing a stock Trashy Lingerie corset. (Of course, when I finally saw the show, I realized how little those posters captured its essence and style.) While it didn't sound very enticing (especially considering that I was looking for something more long term), I agreed to take a look once I could get back to Las Vegas.

In the end, I lasted about a month on *Dancing with the Stars* and had simultaneously gotten myself into the best shape of my life. With all that dancing, I could eat anything I wanted (McDonald's French fries with barbecue sauce, anyone?) and I *still* had a six-pack. After my elimination,

I embarked on a whirlwind press tour: appearing on *Jimmy Kimmel Live* (where Jimmy introduced me as one of Hef's girlfriends. Oy vey!) before being flown to New York for a bunch of interviews and appearances.

I knew that I'd be returning to *DWTS* in another short month to perform on the finale along with the other eliminated contestants, so I was determined to have secured my next gig before then. If I could announce my future plans on the finale, in front of 22 million viewers, it would be perfect!

With a few weeks to collect my thoughts, I made a special trip to Las Vegas to catch a performance of *Peepshow*. During my short stint there, I fell in love with the newly renovated Planet Hollywood Resort and Casino. The *Peepshow* Theater held an impressive 1,500 patrons (most burlesque shows I had seen capped at around 300).

Wow, I thought. *They're really taking this show seriously.*

The theater itself was remodeled specifically for *Peepshow,* which told me that both the producers and the hotel intended for the show to stick around for a while. Large, exquisite props that looked like laced corsets beautifully covered the lobby's ceiling as mirrored walls glistened and glimmered around us like disco balls lined with plush white Hollywood Regency settees. Around the theater, the "peeping" keyhole motif was everywhere, and three large runways jetted out from the stage into the audience. As the lights dimmed and the show began, larger-than-life LED screens glowed behind the stage showcasing a magnificent black-and-white video of its current star, Kelly Monaco (a fellow *DWTS* alum, former Playmate, and soap actress). At the time, the show had two headliners: the other was former Spice Girl Mel B., who played the role of "Peep Diva." Kelly finally entered the stage wrapped in white acrobat's silk hanging 30 feet above the ground. The routines, dance numbers, and acrobatics were jaw dropping. Even though the best routines didn't even feature Bo Peep, it didn't matter. I was seriously impressed.

It felt somehow as if the part of Bo Peep had been written specifically for me. The character begins as a modern-day woman who can't find

love. After drifting off to sleep one night, she finds herself in dreamland being led through a series of vignettes—each teaching her how to be confident and sexy. In the end, she finds her man only after finding herself.

As the performers took their final bows at the show's end, I leaned over and shouted in my manager's ear (over the deafening applause): "I want in!"

"What do you know about this business?" the King said to Alice.
"Nothing," said Alice.
"Nothing whatever?" persisted the King.
"Nothing whatever," said Alice.
—Lewis Carroll, *Alice's Adventures in Wonderland*

It turned out that *Peepshow* wasn't just any small potatoes Vegas revue, this was serious business—and the creator and mastermind behind the production was none other than Tony-award-winning choreographer Jerry Mitchell. I knew that this could be just the opportunity I'd been hoping for. I officially threw my hat in the ring the next day. Auditions and interviews for the show were extensive and brought me back to Las Vegas regularly over the next few weeks.

"Do you guys mind waiting in the other room?" I asked my manager and my friends Angel and Alison. I was preparing for my final *Peepshow* audition in front of the show's director.

"Oh yeah, no problem," Alison said, motioning everybody into the next room.

The role required me to wear the skimpiest of costumes, which I

wore as part of the audition process, and I was still a little self-conscious (despite my new *DWTS* physique) and wanted some privacy. Contrary to popular belief, just because I had posed nude for a magazine doesn't mean I am the most confident, exhibitionistic person in the world. In fact, I was nervous that I wouldn't look good enough to be cast. What if I had cellulite? What if my body looked too "fake"? Seven years of being reminded that I never looked quite good enough was a hard burden to shake.

Plus, I felt sort of dumb performing the choreography while weaving around all the furniture in the cramped hotel suite. I know it seems counterintuitive that I was that nervous for the audition, since I was so eager to perform nightly for a large live audience, but there was something comforting about knowing that I'd be on a large stage, far removed from the crowd (with the appropriate distance between us . . . and, of course, flattering lighting!).

"What if I have tattoos?" I asked Jerry nervously. "And bruises? I bruise really easily—should I be wearing body makeup?"

"Not unless you want to." He shrugged, with his signature warm smile. "Tattoos and things don't really matter to me. It's more important that everyone in the cast is different, unique, and comfortable in their own skin."

While that should have sounded reassuring, I was far from comfortable in my own skin. I'd spent most of my adult life at the mansion, being required to clone the other women around me, so the idea of being "unique" was alien. I had a hard time believing that "unique" was really something anyone would want to see. I couldn't even wrap my head around what *was* unique about me. More and more I worried I wasn't right for the part.

After performing the choreography I had learned my audition was done. Though the producers would assure my manager that I had done great in the audition, I had no idea if they really thought that or if they were just giving him a polite answer. I wasn't particularly confi-

dent about my chances. As the month went by, more names were being floated into consideration and it was rumored that Lindsay Lohan was the front-runner.

I'm screwed, I thought, my confidence quickly deflating. *They'll definitely pick her! Imagine the publicity they could get!*

One of my *Peepshow* callbacks happened to land on Hef's birthday weekend, which he traditionally celebrated at the Palms in Las Vegas. Mary let me know that Bridget, Kendra, and I had been invited to attend. Naturally, part of me wanted to stay as far away from the man and his party as possible. But, at the same time, you have to understand that I'd been out of the mansion for only about six months at this point, and while I was increasingly coming to terms with the hell Hef had put me through, there was still a part of me that wanted to be able to walk away on "good terms," with a clean slate, like all his other ex-girlfriends. I didn't want anything from Hef . . . except perhaps for him to stop bad-mouthing me. Plus, I wanted to see Bridget and Kendra. Bridget was planning on singing "Happy Birthday" at Moon Nightclub for the second half of the festivities that night and I wanted to support her. Be that as it may, I agreed to attend the soiree only if I could have my own booth. It was proposed that I join Hef in his booth, but I needed to stand my ground as an individual. I was sick of the attempts to recruit me back into the harem.

I had heard through the grapevine that Crystal Harris had become Hef's new main girlfriend. I was thrilled that he had "fallen in love" again. I hoped her presence on his arm (and the fact that they had just started filming *GND* season six) would take some of the pressure off me. The friends of Hef's that had previously been so supportive of me had recently become less kind, believing I had somehow left him in the lurch. Now maybe things would be different. For my part, I was only interested in moving forward with positivity, despite anything that had happened in the past.

The wind was whipping wildly across the Palms Place pool. Since it

was considered a pool party, I chose to wear a black skull-print bikini and denim skirt, but I may have been better served with a windbreaker! It was awesome seeing the other girls again. Kendra complimented me on my new abs and it was great to meet Hank and to see Bridget's new beau, Nick Carpenter. When Hef finally arrived at the party, new girlfriends in tow, Bridget, Kendra, and I went to say hello and wish him a happy birthday. I greeted Karissa and Kristina, who were warm and friendly, and then said hello to Hef, who looked more pale than usual, but otherwise seemed to be in a relatively good mood. Next I introduced myself to his new "main girlfriend," who was occupying the seat to his left.

"Hi, I'm Holly," I said with a big smile, sticking out my hand. Remembering how people used to treat me, I made a conscious effort to go out of my way to be kind.

"Hiiiii," she said in a forced singsong voice, offering me a limp, weak handshake.

Was that a sneer on her face or is the midday sun causing her to squint? I wondered.

Immediately my gut told me that something was up with this girl, but I tried to give her the benefit of the doubt. She was young and new to all the commotion surrounding Hef. I chose to dismiss her shitty first impression as poor social skills and not the snobbishness that it felt like.

Hef's photographer, Elayne, lined us all up for a photo. As the former girlfriends, Bridget, Kendra, and I lined up next to the new girls, but were directed by Hef and the photographers to stand next to Hef instead. I felt bad that the new girlfriends were being shoved aside for the "famous" ex-girlfriends. I'd been shoved aside so many times myself in these situations and remembered how awful it felt. After the photos were snapped, Hef and the Shannon twins said good-bye as they were whisked away for press interviews. Crystal couldn't even be bothered to look in our direction.

* * *

"You got it!" my manager gleefully shouted.

"What?" I squealed into my cell phone, hardly able to believe what I was hearing.

Just a few days before my return for the *Dancing with the Stars* season finale, I received word that I had landed the part of Bo Peep for a three-month stint in Las Vegas. I was absolutely over the moon and determined to work hard, promote my butt off, and with luck find a way to become a more permanent part of the production.

The turnaround for production was quick and required me to get out to Las Vegas immediately following the *DWTS* finale. As I busied myself with packing the few things I had in my Santa Monica condo, I got a call from the Shannon twins. They wanted to see if I would meet them for lunch in Beverly Hills. Sure, the twins had a crazy reputation, but I liked them. They had always been nice to me and I assumed they wanted some advice on navigating the mansion—and Hef. Like I said earlier, you don't get a mansion operations manual when you move in, so I was happy to help them any way I could.

"We want you to come back," Kristina blurted out, not five minutes after we sat down at Il Pastaio.

"Yeah, come back," Karissa whined, their words almost overlapping. These two literally finished each other's sentences.

"I can't come back; I've already made a decision to move on," I said sympathetically, picking up a piece of bread out of the basket. "Why, what's wrong?"

I knew something must be askew for the twins to be asking my help.

The girls went on to say that they thought Crystal was mean, scowls appearing on their faces. Apparently, Hef's newest girlfriend wasn't too good at making friends. They even went on to say she was mean to Hef, though they didn't give specific examples.

"Really?" I asked. In the past, I've witnessed some of Hef's more vocal girlfriends fight back or disobey, but never were they outwardly *mean* to

him (not to his face, anyway). I wasn't sure what the twins meant when they said she was "mean"; it was just clear that they didn't like living with her.

One of the twins chimed in that Hef was really sick and not doing well before the other one took over, saying that he had fallen down in his bathroom the other day and wet himself.

Kristina reiterated that Crystal wasn't good for him, as if to imply his declining health was somehow Crystal's doing.

"Oh. That's awful," I said solemnly, bouncing my head back and forth from Tweedledee to Tweedledum, trying to keep up with the story. Friends inside the mansion had confided to me that Hef had become extremely frail and downtrodden. When the economy had crashed and burned in late 2008, I knew that *Playboy* must have taken a pretty severe hit. Hef already had financial pressures gnawing at him prior to Wall Street crashing, so this couldn't have helped matters.

Kristina tried to explain things to me, saying that Crystal felt really threatened by me and that any time she heard I had spoken to Mary she "freaked out" because she thought I was going to come back. Karissa cut in and said that when Hef had heard I was going to be at his birthday party, he took extra time in front of the mirror getting ready and that this had made Crystal jealous.

"Well, she doesn't have to worry," I said calmly and coolly. "I'm *definitely* not coming back. In fact, I'm really trying my best to give Hef space and—"

One of the blond beauties cut me off, telling me that Crystal took the panel off my old desk with the birds and the initials.

Well, that was fast, I thought. Years ago, when I had convinced Hef to let me have a desk installed in the vanity, I had a professional wood-worker from the mansion staff fashion a beautiful hand-carved panel for the desk drawer etched with the likenesses of my favorite mansion birds. In the center of the panel was a heart with my initials: HM. Considering Hef's monogram, HMH, littered everything at the mansion (notepads,

matchbooks, you name it) I figured he could always add an H at the end to make it his own initials on the off chance I didn't last.

I have to admit, I felt a little slighted. Pictures of Tina, Brande, and Kimberley littered Hef's room for years after I had moved in and Crystal was already throwing fits about any sign of me just a few months into dating Hef.

"It's a little early in the relationship for her to be that picky," I said with a small smile. I didn't want to give the twins any false hope that I was going to come back and I wasn't there to bad-mouth Crystal, so I stopped talking and wrapped up the conversation.

After lunch I hugged the twins good-bye, wished them luck, and let them know they could call me anytime. I didn't know what to make of what Karissa and Kristina had told me. I didn't feel like they were trying to sensationalize things; they just had their own way of communicating that didn't always make sense to me and no filter when it came to revealing others' personal details. (While living at the mansion, the girls even told the *Sun* that Hef was losing his hearing due to his use of Viagra.)

I have to say, I was a little curious about this Crystal character. Though I kept far away from Hef and Crystal (in part to avoid replicating how Tina had made me feel after her departure), it still seemed like Crystal had major jealousy issues. A few weeks earlier, I had run into a Los Angeles magazine editor I knew socially who told me a story about Hef begging him to retract a statement he had made about my being welcome back in his life anytime.

The editor threw up his hands and said he told Hef he couldn't retract it, that he had him on tape saying it and that he heard his new girlfriend threw a fit about it when it came out.

When it came to being dramatic, it appeared Hef had met his match.

AS PART OF MY contract with *Peepshow,* I was given a high-roller suite at Planet Hollywood. Not only did I have a steady job, I also had a reason

to return to Las Vegas—a place that felt more like home in a few short months than L.A. had felt in almost 10 years. With my Prius brimming with most of my belongings, I said my tearful good-byes to Mary and Captain Bob and headed straight for the desert.

Not long after arriving in town, I was finally able to meet up with Criss's bodyguard at the Luxor in order to grab my valuables that had been sitting in his penthouse safe for the last two and a half months. Criss had told me that mailing them wasn't the best idea.

"I can't *wait* to finally get my stuff back," I sighed to Angel, who had become my new best friend, as we drove down Las Vegas Boulevard. "It's like severing the last tie of that relationship. It feels good to finally move on."

"Amen!" exclaimed Angel as we drove into the Luxor's North Valet.

The bodyguard, whose expensive SUV had been idling as if he was on his way somewhere, jumped out of his car after spotting me.

"You drive a Prius?" he sneered.

"Yeah . . ." I replied, caught off guard by his making fun of me. He'd always been nice to me before, but was all of a sudden condescending and rude.

He let out a snarky laugh as he gave my car the once-over.

"Thanks for bringing this stuff down," I said, eager to get out of what was starting to feel like a really awkward situation.

"Yeah, no problem," he said shortly, handing me a bulging manila envelope. Without as much as a good-bye, he got back to his truck and took off.

I jumped back into my car and ripped open the envelope, anxious to see my things.

"What's wrong?" Angel asked, seeing the upset look on my face.

Some of my jewelry was missing, specifically, the items he had given me (the diamond-encrusted infinity necklace and the large cross). *Did he seriously take back those gifts?* I thought. It's not like I intended to wear

jewelry given to me by an ex-boyfriend, but I didn't think he'd actually take them back, either. It was as if he was telling me I was never worth it to begin with. It was also a petty, cheap move—after all, it wasn't like I was asking for the Dalí back (although perhaps I should have!). It wasn't about the jewelry (although I did wear the small necklace and ring he had given me to a few press events, knowing I'd be photographed and what a big "Fuck You" that would come across as). It was about him not having the decency to say something to me about it. Once again, I felt like I had been thrown out with the trash.

I decided to send him a text and give him the benefit of the doubt.

"Hey, the jewelry you gave me was missing from the packet I just picked up," I typed into my BlackBerry. I thought maybe he would have a few words explaining why he wanted to keep those things, and that would have made it all okay. But I never got a response.

I LOOKED AT MY new life in Las Vegas as an opportunity to reinvent myself. It had been an uphill battle, but I was finally where I wanted to be as a single, successful career woman making something of my life. To celebrate, I traded in my leased Prius and bought a convertible Porsche with some of the money I had earned on *Dancing with the Stars*. I wasted no time having it painted a custom sparkly pink. It didn't take long before I felt completely at home in my Planet Hollywood suite. I was even given an adjacent suite for my friend, Playmate Laura Croft. Laura was eager to make the move to Vegas—and I thought she would be a great character for the new reality series that I was hoping to develop. She was very pretty and had a wild personality that I hoped would translate on television.

Living at Planet Hollywood was absolutely surreal. It felt like all the perks of the mansion had been rolled up into one luxurious package and dropped squarely at my feet. Besides the gorgeous suite and 24-hour

butler service, my *Peepshow* contract covered all the room service and restaurant food I could eat (including the casino Starbucks!) and limitless salon and spa services. The best part was: I never felt lonely. At any given moment there was a 24-hour party right outside my door.

As the youngest headliner on the Strip, I took the city by storm. I knew that promoting myself was the key to having a successful run with *Peepshow,* so I attended every opening, every red carpet event, and every pool party, and landed myself on the cover of all the Vegas entertainment magazines before my debut. Despite the crumbling economy, it was a magical time in Las Vegas. Somehow it seemed that the city was extra determined to carry on just as fabulously as it had before.

When I wasn't busy running around taking in all Sin City had to offer, I was buried in *Peepshow* rehearsals. I couldn't have been more excited at the opportunity, but I was terrified that I wouldn't be able pull it off. Would people really pay to see me? I had only a few weeks of rehearsal and managed to pick up the choreography pretty quickly (thanks in large part to my time on *DWTS*), but all those insecurities were still running rampant. Sure, I had done pictorials for *Playboy,* but those photos were rigidly posed, heavily lit, and accessorized to perfectly complement my body. For *Peepshow,* I would be performing on stage for 90 minutes in front of a live audience wearing the tiniest costumes. My body had taken such a beating during the exhaustive rehearsals and I had bruises everywhere—not to mention scars and what remained of my Playboy Bunny tattoo.

"My boobs are going to look disgusting," I told Nick, the choreographer. I imagined them bouncing all over the place during the highly aerobic performance and it didn't necessarily strike me as sexy. He assured me that it was all in my head.

This was my big break. If I could manage to fill seats and earn favorable reviews over those three months, maybe they would decide to let me stay. I busted my ass day and night to make sure I gave this show everything.

The tremendously talented cast was warm and welcoming. I'm not sure they thought a reality TV star could add anything to their show, but they saw how hard I was working and that I took the production very seriously. It wasn't long before I joined their inner circle. Most of the cast were Broadway singers and dancers brought in from New York (Jerry wanted the best of everything!), so all these new transplants bonded quickly. And like me, they were taking the city by storm! After rehearsals, the cast would hang out at Striphouse, the restaurant next to our theater, and hit up clubs every couple of nights. I grew especially close to the lead singer, Josh Strickland, who became like a brother to me almost instantly. I don't think there was ever a group of people that had as much fun as we did. It was an amazing time to be a part of that show. As I prepped for my debut, I'd watch Kelly Monaco's nightly performances. She'd offer me a friendly wave from the rafters before taking her plunge down onto the stage each night.

For so long I dreamed of becoming a performer, and this was my chance to prove to everyone that I was capable of more than being a "trophy girlfriend."

It didn't faze me that the audience was never packed (maybe it should have). The show was averaging roughly 300 people a night, which was pretty dismal considering the size of the theater and the expense of the production, but in early 2009, people weren't flocking to Vegas to see shows. If they happened to come to the city, they most likely spent their time in the casinos hoping to earn back some of what they lost in the recession.

Either way, it was clear that something needed to change to help drive attendance, so right when I entered production, executives began an entire overhaul on *Peepshow*'s marketing campaign. You couldn't turn a corner in Las Vegas without seeing me smiling on a billboard, poster, or taxi. Suddenly the show had a face . . . and it was mine! But whether or not that face would sell tickets remained to be seen.

As (bad) luck would have it, when my opening night came around, I hit some rough waters.

Earlier that day, I had decided to text Criss. In retrospect it was a dumb move, but I was just so happy and in a place where personally I wanted to forgive and forget. I'd heard from mutual acquaintances that Criss was not pleased when I got the *Peepshow* gig and announced my return to Las Vegas. After all, it had been his agenda to banish me from Vegas as if I had never existed. It must have chafed him even more that my appearance on *Dancing with the Stars* ended just as I had landed *Peepshow*. And, whether I liked it or not, Criss was still a high-profile person in my new hometown, which could prove to be very small at times. Why not make an attempt to bury the hatchet? We'd almost certainly run into each other at some point.

"Hey, I just wanted to extend an invitation to my premier party tonight," I typed into my phone. "I wish you and your girlfriend the best!"

I assumed I wouldn't hear back from him, but wanted to extend the olive branch, so I at least knew I did what I could to end things on the best note possible.

A few hours later, I was backstage in my dressing room putting the finishing touches on my hair and makeup. I was taking a few deep breaths to calm my nerves when I heard my cell phone buzz. It was a text message from Criss. Instinctively, I looked at the clock.

He must be going on late, I thought. It was a few minutes after his second show should have started. I expected a generic "Good luck tonight" message. Instead, it went a little something like this:

"I told myself I wouldn't do this, but I am answering your text anyway. Criss is with me now. Stop texting him. You are disgusting. You are in a burlesque show because you can't do anything else. You used an old man to get to the B-list. Criss told me the real reason you guys broke up. It's not because of scheduling differences, it was because you were on antidepressants and he couldn't be with someone like that. If I had your reputation, I would be on antidepressants, too. You are the biggest running joke around here. You got used. Lose this number."

My face went white and I felt faint. I was completely beside myself.

Apparently, his new girlfriend had taken his phone during his performance. I sat still for what felt like 10 minutes reading and rereading the text. So many petty comebacks flashed through my mind. I wanted to tell her that soon *she* would be the biggest running joke (Criss routinely dumped his girlfriends whenever he had a famous fling, and many of them would come crawling back the moment it fizzled). I wanted to tell her no one would even *want* to look at her face, let alone pay to see it. But mostly I wanted to tell her that Criss lied to her about our breakup. I already knew he could be a piece of shit, but I couldn't believe he was sharing my private life with her! During one of our late-night talks, I had confided to Criss that I had taken antidepressants in the past. I was never ashamed of needing help, but the fact that he would use that information against me really pissed me off. It wasn't right.

After taking a moment, I simply replied: "Criss lied to you. I wasn't even on antidepressants when we were together." I didn't need to prove anything to her—and who knows if she would believe me anyway—but I wanted to say my piece. Not to mention, I wanted to take the opportunity to scroll through my BlackBerry and find one of the many flirty texts Criss sent me six weeks earlier when I was on *DWTS* (and after he had already moved her in). I selected a particularly salacious one, typed in my response to her rant, and hit Send.

"Oh my god, what happened?" Angel asked. She had come backstage to wish me luck and immediately registered the tears welling up in my eyes.

I read the text out loud to her and explained what happened.

"Do *not* let this get to you," she said, grabbing my shoulders and looking me in the eye. "Do *not* let this ruin *your* night. And don't think for a second she doesn't know what she's doing. She knows this is your big night. It's all over town!"

"Thanks," I said, sniffing back the tears, so grateful that Angel had been there at that exact moment to say precisely what I needed to hear. "You're right."

I took a deep breath, stood up from my chair, pulled my shoulders back, and left my dressing room to face the press.

(Being the "small town" that the Vegas entertainment community is, I eventually heard about the aftermath of my response to that mean text. After reading it—and Criss's earlier message—his girlfriend didn't let him escape unscathed. She apparently made an absolute scene in his dressing room during intermission and left him, only to come crawling back later, of course. I changed my number after that.)

Unfortunately, the night would not be without another hiccup as the show encountered some technical difficulties. The lift that was supposed to carry the male lead and me onto the stage for my big number wasn't working. As the stage went dark between scenes the stagehands swept the props (and us!) off into the wings. Quickly, I raced down the back-stage stairs for my change (which included being dried off and having my hair redone in roughly 60 seconds) before making a far less dramatic entrance from the side of the stage. After the show, the cast laughed off the glitch and encouraged me (still rather distressed over it) to do the same. It was somehow freeing to know that I could survive even the most inopportune malfunctions and still manage to go on.

Despite the mean text message and the broken lift, my official debut in *Peepshow* couldn't have been more perfect! After the performance, executives hosted a gala . . . for me! While fancy parties weren't anything new, I felt like the toast of the town drinking champagne and hanging out with industry bigwigs who were all there to toast my debut. Josh and Angel helped me laugh off the mean text from Criss's girlfriend. And despite the lift debacle, my reviews were glowing and advance ticket sales skyrocketed—making for some very happy producers. Planet Hollywood even blacked out the "Wood" on the hotel's giant neon sign so it read "Planet Holly" for the night. Was I dreaming? Or did this somehow really become my life?

* * *

Right around the time of my arrival, Planet Hollywood announced an upcoming auction of some of Marilyn Monroe's personal belongings, which would be put on display throughout the casino. When I was asked to model them for an upcoming magazine feature, I couldn't believe my luck.

Beyond honored, I modeled many of Marilyn's personal items, which I recognized from famous photos of the star: a white terry cloth bathrobe, an orange Pucci top, a curve-hugging fuchsia day dress, etc. I was fascinated with the quality of the pieces—things were constructed with so much more care back in Marilyn's time! Even her casual wear was of the highest quality.

A few items from Marilyn's movies were in the collection, too. Flushed with excitement, I tried on the *original* custom-tailored piece intended for her "Diamonds Are a Girl's Best Friend" number—a costume that was deemed too risqué and was eventually replaced in the film by the iconic pink gown. Much has been said about Marilyn's figure, and, like many women, her weight fluctuated over the years, but this circa-1953 costume fit me like a glove. The flesh-toned leotard was covered with a light fishnet, creating the illusion of being completely nude under the netting. The piece was so well built, the boning carved out my waist without feeling heavy or tight, like a typical corset. A handful of rhinestones glittered across the bust, creating a sparkly, "nude" look. It was hard to imagine that any other garment could make me feel sexier.

There was one more piece that made a lasting impression on me. After donning a strapless cream-colored cocktail dress and gorgeous amber necklace from Marilyn's personal collection, I was handed a kimono wrap to complete the look. There was no mistaking the frilly, violet and pink Edwardian-style confection. It was a piece Marilyn wore in *The Prince and the Showgirl*—the same kimono wrap depicted in my beloved Marilyn Monroe paper doll set all those years earlier.

Twirling around in front of the mirror like a little girl, I understood what Cinderella must have felt like when her Fairy Godmother waved

her magic wand and produced the most perfect ball gown. I was in absolute awe—it was surreal to imagine that she had worn these very same pieces, decades before me, and how, as a little girl, I shut my eyes and dreamed about what it would feel like to be her for just a moment.

And now I knew. Like me, Marilyn had suffered at the hands of some not very nice men. She was used, unappreciated, and struggled to find herself. She worked her way up in Hollywood with stars in her eyes and a kind heart, but found that Hollywood wasn't always as kind in return. She may have been publically adored, idolized, and lusted after, but she often felt alone and trapped. Those dark demons eventually got the best of Marilyn. Part of me knows that could have easily been my fate had I not chosen to take care of myself. I only wish poor Marilyn could have done the same.

CHAPTER 15

—

"If I had a world of my own, everything would be nonsense."
—Alice in Wonderland

Despite what one might think, creating a world for myself and by myself, independent of *Playboy,* wasn't all that easy.

"Why don't you go somewhere else—like Miami?" suggested Brenda, one of my favorite E! executives. A few weeks after I had returned to Los Angeles, after my breakup with Criss, I took a lunch meeting at the Four Seasons in Beverly Hills with a few people from E! to discuss ideas for a possible *Girls Next Door* spin-off.

"I don't want to go to Miami," I explained. "There's no reason to. I don't have anything to do in Florida. It just doesn't feel organic."

"What about . . ." Brenda began. She tapped her fork against her plate, trying to drum up some additional non-Vegas ideas. "Chicago!" she finally exclaimed. "You could try to take over *Playboy*!" she teased.

I smiled at her exuberance. As farfetched as it sounded, I knew Brenda believed we could make a good show out of something so preposterous. She was one of my biggest champions for my photo editor storyline on *GND* and really hoped to see season six follow the action at Studio West.

I needed to let her know that I was going to completely sever ties with the magazine, before the conversation went any further.

"I really want to separate myself from *Playboy* and do my own thing," I said, before revealing to them my grand plan. "I'm going to go to Las Vegas and do a live show."

They all stared at me with blank expressions, trying with great care to make sure their faces weren't betraying them. When we sat down for this lunch, I hadn't yet landed *Peepshow*. But it wasn't hard to read their minds: *Holly doesn't have any stage talent—what was she possibly going to do?*

Okay, so it's not like I had put my best foot forward for the meeting. Still in the midst of my *Dancing with the Stars* run, I didn't have time to shower before, let alone do laundry. I arrived at the swanky Four Seasons hotel dressed in old jeans, Converse high-tops, and a bulky Criss Angel logo emblazoned skull hoodie (not out of sentimentality, mind you; it's what was clean).

"Well, we'll see what happens," Brenda offered, after what felt like a 10-minute pause. "We just have a hard time with Vegas."

I gave her a puzzled look.

"Every season we get a Vegas pilot," she explained, her expression turning more earnest. "I'm serious, *every* season—and it *never* works."

E! had gambled on Vegas before and lost. I could tell the network wasn't quite ready to jump back in bed with Sin City, but I wasn't willing to alter my vision. After spending most of my adult life playing by someone else's rules, I was finally determined to follow my heart.

Shortly after my lunch meeting with the E! execs, I announced my three-month residency with *Peepshow*. Nonbelievers be damned! When *GND* producers reached out to schedule a date for me to do a cameo in the new season, I was hesitant. I knew they felt that if Bridget, Kendra, and I did these cameos, it would help loyal viewers make the transition and warm up to the new girls. I eventually agreed to have them bring Hef and his new girlfriends to see me in my new revue. I hated the idea of

associating *Playboy* with *Peepshow*—and so quickly into my tenure—but the free advertising for *Peepshow* was just too good to pass up.

The transition into the new season wouldn't be easy. To their credit, the producers wanted to populate the cast of season six with several Playmates in addition to the new girlfriends. They knew that fans of the show wouldn't necessarily warm up to three random girls being plopped into our places and thought it would be nice to have a few extra characters in the mix. Hef, however, insisted that Crystal, Karissa, and Kristina be the focus of the series, as the new *Girls Next Door,* despite objections that Hef's relationship with the twins "reeked of incest."

Hef was still convinced that the show would remain popular no matter whom he chose to date. In his mind, the girls' personalities didn't matter and certainly didn't contribute to the show's success. It was all about him, after all.

I didn't catch much of season six—not out of spite, mind you. With *Peepshow*'s six-nights-a-week schedule, I didn't have time for TV. However, I did make a point of watching the episode I ended up appearing in and noticed that Crystal didn't pass up any opportunities to take a few unnecessary jabs at me.

"I like Bridget and Kendra, but Holly . . . I don't know," one of Crystal's friends whined in a high-pitched, whimpery voice.

Crystal giggled and said, "Every time I try talking to her, she's like, woo hoo, out to space."

Keep in mind that at that point I had met Crystal only once (at Hef's Vegas birthday pool party). She made no attempt to actually speak with me, beyond her snotty response to my introduction, but I guess she thought making up lies was an okay thing to do on camera. After all, she was the mansion's head mistress and the star of *GND* now, so surely no one would question her.

Producers asked if I would be available to shoot a scene with the Shannon twins during the day and I agreed. Hef suggested the activity: taking the girls to see his wax figure at Madame Tussaud's at the Venetian.

Crystal and Hef arrived later at the Palms in Las Vegas to meet the twins, who were doing an autograph signing. Hef greeted them at the table where the signing was set up while Crystal hung back behind the velvet ropes. As the press cameras started flashing, Crystal bolted around the barricade to participate in the hug fest.

"They *kind of* look like them," Crystal sneered as she walked past the hotel's *Playboy* retail boutique and spied the Holly, Bridget, and Kendra bobbleheads in the window.

Before *Peepshow,* I was asked to join Hef, Crystal, and the twins in their suite for a family-style buffet dinner. Hef and I hadn't spoken much since our breakup, so seeing him for the first time on camera was a bit uncomfortable. As he went in for an embrace, I clearly opted for the ass-out "bro hug" and tried to avoid his kiss. When he offered to feed each girlfriend a bite of his ice cream sundae, he turned to offer me a spoonful, which I quickly refused, saying, "Oh, I ordered my own."

The Girls Next Door had planned on having us bring Hef up on the stage for our audience participation bit in *Peepshow,* and the crowd went wild. I played into it as much as I needed to, but was eager to go on with the show.

"It seemed like that night, Hef was definitely the main attraction," Crystal quipped, in a voice overlay.

I knew what it felt like, as Hef's girlfriend, to be compared to his former flames and feel undervalued or underappreciated, but there was no reason for Crystal to take that out on me with all her snide remarks.

When producers summoned Bridget, Kendra, and me to reunite for a *GND* episode featuring Kendra's baby shower, we all agreed without hesitation. Not only were we all grateful for the good things that came from the show and from Hef; we were, at that point, still very supportive of one another. While we had moved on to different places in our lives, we still kept in touch and deep down, there was an undeniable bond that we shared.

Mary O'Connor was gracious enough to host the bash in her back-

yard and Bridget did a wonderful job of putting the soiree together. It was a perfect little gathering on a beautiful summer's day—until Hef and his girlfriends showed up.

The ordeal that ensued was reported by gossip blogger Perez Hilton:

Sources tell PerezHilton.com exclusively that there was some major drama at Kendra Wilkinson's baby shower yesterday. We reported earlier that not only were Kendra's BFFs Holly Madison and Bridget Marquardt in attendance but also Hef and his newest girlfriends, Crystal Harris and the Shannon twins.

Apparently, the twins and Crystal put up a major stink about having to be at the party and refused to participate in any of the games by hiding in the house.

According to our source, the girls were exceedingly rude to everyone, especially Holly, Bridget, and Kendra, which just made the whole day awkward.

And because the episode was being filmed for *Girls Next Door* and not *Kendra,* Hef had to have his new ladies included in the footage, so he had them fake a scene "where it looked like Kendra was opening her last present when she hadn't even started opening presents, just so they could leave." Once they were gone, we're told the vibe mellowed out and everyone had a wonderful time.

Uh-Oh. The new gals aren't fans of the veterans, we see. Perhaps there's some jealousy that ~~Hef~~ America really likes Holly, Bridget, and Kendra more than these three infants?

Occasionally, when I was on my computer, I'd have the TV on in the background. Once I caught a commercial for the new season of *The Girls Next Door.*

"I'm not the new Holly . . . she's the old me," Crystal snapped sassily in the season's first promotional trailer.

Ouch, I thought when I first heard it. Honestly, I didn't even blame

Crystal for the snide remark. I'd been in that same interview chair for five long seasons before she even came along and I assume the producers fed her that line. Crystal just didn't come off as comfortable or clever enough to think up even a lame zinger like *that*. In fact, most of her dialogue on the show was painfully awkward at best.

I was terribly disappointed in the producers. For four years, I had (literally!) bared my life for that show, but as soon as I left, they were taking potshots at me. There is no doubt in my mind that, had the new cast succeeded and the show remained on the air, they would still be bagging on me to this day if it was good for ratings.

From the reports I read and the little I did see, season six felt like a stale rehash of old storylines mixed with some of the ideas we had tossed around but had not gotten around to using over the years (like "camping in the backyard"). And when promos began airing, I couldn't help but see my name popping up on websites and blogs because of some hurtful jab being made at my expense. It felt like they were *trying* to encourage a war between the old and new guard. Or perhaps they felt that by throwing our names around as often as possible they could distract viewers and keep them from realizing what a snore-fest the once energetic and bubbly series had become.

When asked in an interview what I thought of the new season, I was honest. Maybe I should have just said that I hadn't seen any of it, but the constant jabs had begun gnawing at me—after all, I'm only human.

"The girls need to focus on what makes them unique and not doing the same things Bridget, Kendra, and I have already done on the show," I said candidly. "I don't want to look behind, I want to look forward."

A week later I received a letter from Hef reprimanding me for my remarks. Hef *loved* to send letters. Prior to sending one, he'd usually make a copy and place it neatly in one of his countless scrapbooks. I don't think he writes the letters with the purpose of getting a response or closure (which is why I never bothered to respond), I think he does it so he

can have the last word in even the tiniest event in the story of his life. It's Hef's version of reality, all the time.

When I filmed a guest spot on Kendra's self-titled spin-off, my former housemate confessed to me (off camera) that she got disapproving letters from Hef fairly regularly as well. She told me she was forced to apologize for a quote she gave the media referring to the "whores up there" at the mansion, which Hef assumed referred to the Shannon twins.

I would end up receiving many "reprimand" letters from Hef— it seemed nothing I said in the press met his approval. The whole thing felt sort of creepy—as if he thought he was my dad or something and had some sort of jurisdiction over me. Eventually, when I would see letters from the mansion in my mail, I would throw them away without even opening them. They just creeped me out and brought forth negative feelings. I didn't want him to have that sort of power over me.

Meanwhile, I was taking Las Vegas by storm. *Peepshow* had quickly become the Vegas Strip's new smash hit. Ticket sales skyrocketed, prompting producers to sign me on through the end of the year! I couldn't believe it! I knew how hard I had worked trying to make the show and my performance as successful as possible—and it actually paid off!

Speaking of paying off, I was finally doing well financially. Actually . . . very well. I signed a multimillion-dollar contract with *Peepshow* (and even my breasts were insured with Lloyd's of London for a million dollars—not bad for a $7,000 investment!). People assumed I had been rich beyond my wildest dreams at the mansion and that I must be struggling to get by in my post-*Playboy* life . . . but, in reality, that couldn't have been further from the truth.

I was carving out a pretty unique niche for myself, and the quirkiness of my new showgirl life was becoming hard to ignore. I had been called "one of the most in-demand and beloved celebrities in Las Vegas" by the *Los Angeles Times*. Performing full time in a live show made me different from all the other talent on E! Most reality-show starlets on TV at that

time were L.A. girls with a passion for fashion, so being a new kind of Vegas showgirl at least set me apart from all the others. In the summer of 2009, I began seriously discussing a spin-off with E! I was determined to make Vegas work. Luckily, Brenda gave the idea another chance and we started exploring themes for a potential series.

Season six of *The Girls Next Door* was a total disaster. After viewers saw what they were getting on the season premiere, most never tuned back in. The new girlfriends pulled only about half the ratings we did in previous seasons. When the new season ended in August, E! pulled the plug on what had been, less than a year earlier, their number one series. In an effort to recapture some of the *GND* loyalists—who were tuning in by droves to *Kendra*—the network green-lit production for a pilot that would serve as an "E! special" that December called *Holly's World*.

My initial vision for the show was *Legally Blonde* meets a PG-rated version of *Showgirls*. *Peepshow* wasn't enough for me. I wanted my day job to be interning at the mayor's office, learning how to run the city. My pilot centered on a silly plot: me visiting the mayor's office with a complaint about roadwork, resulting in my friends and me going on several misadventures trying to collect signatures for a petition. It was a roundabout way of introducing the people in my life, what I wanted to do, and taking a tour of some unlikely spots and meeting some strange people in the city.

I didn't necessarily assume that my pilot would rate that well. I wasn't an energetic, ditsy, made-for-reality-TV blonde like Kendra. I was quiet and reserved and much preferred reading a book to shaking my ass. While I knew my lifestyle was unique, would anyone really care? When I received word that the special had not only done well, but that E! wanted to order an entire season, my jaw hit the floor! Of course that was what I had hoped for, but I certainly hadn't expected it!

It was official: *Holly's World* was a go. In my head, I thought it was going to be my version of *The Mary Tyler Moore Show*—girl moves to a new city post breakup in order to make it on her own. With shooting

to begin in early 2010, our first order of business was to lock down the cast. The three friends I had chosen to appear in my pilot were asked back for the full season: Angel Porrino (my bestie and new assistant), Josh Strickland (my charismatic *Peepshow* costar), and Laura Croft (my crazy roommate) rounded out the crew.

Anxious to begin this *Playboy*-free chapter of my life, I was eager to sort out contract negotiations as quickly as possible and begin filming. However, like a bad dream, my past continued to haunt me and the contracts we had to sign while at the mansion carried over onto my new spin-off with E!. It was a lot of baggage to move forward with, but I was in a hurry to get going. And, conditioned by all those years at the mansion, I still wasn't strong enough to hold my ground for long. I had grown a lot in the last year and a half, but I still had a long way to go.

At the start of 2010, cameras began following our wild lives in Sin City as sexy singles looking to balance our wild Vegas social calendars with performances six nights a week—and like all reality shows, it wasn't without its fair share of drama.

I was pressured heavily by production to put my dating life on camera and I stubbornly refused. I agreed to film a "blind date" episode, but anyone I dated in real life was strictly off-limits at this point. I was sick of being thought of as "Hugh Hefner's ex," and the way I felt like Criss used me for publicity had left a bad taste in my mouth, so I was determined to stand on my own and not publicize my love life. If I was even asked about a rumored romance on camera, I denied it. This resulted in more than one argument between production and me, but I refused to give in.

Over the course of the first season, I bought a house and Angel and her new son Roman moved in. We traveled to Mexico to shoot a calendar and went on a road trip with Bridget, and Kendra paid a visit for a baseball episode. The show followed Angel as she got breast implants and Josh as he went to New York to audition for a new Broadway show.

Overall, it was a fun, heartwarming season and the three of us had a blast. Viewers connected with Josh and Angel—they loved Angel's and my chemistry and Josh's endless energy. Laura was the weakest link of the cast—she was crazy and funny in real life, but on TV she was ordinary. In my time I've seen boring, snotty people come off as the life of the party on television, too, which just goes to show that "reality" TV isn't really reality.

Before the show's June 2010 debut, the cast and I were swept into a photo studio to shoot promotional photos for the series. Each sequence was more fun than the last: the cast strutting down a yellow-brick-road version of the Las Vegas Strip; me being shot from above, twirling in a pink dress atop a large cartoon graphic of the city; and me perched on a larger-than-life disco ball rising from the city's skyline. E! was rolling out the red carpet . . . for me! It felt like a dream come true.

Shortly before the show aired, E! flew me to Los Angeles to shoot video promos for the network. All the network stars were required to shoot: Ryan Seacrest and Giuliana Rancic, the Kardashian sisters, Kendra and Hank, and me.

"Everyone's really excited about your show, they're all talking about it," the makeup artist said, putting the finishing touches on my Marilyn-inspired look. "You are the only one who is getting to be in a shot by yourself. You're so lucky."

She was right. Everyone else was being shot with their costars or coanchors—and I would be the only E! personality featured solo, wearing a black version of the Marilyn Monroe *Seven Year Itch* windblown gown and elegant opera-length gloves.

"Oh my God! It's like, *so* nice to meet you," squealed a young, skinny brunette as she swept into my dressing room, seemingly taking stock of the hair, makeup, and wardrobe paraphernalia thrown everywhere.

"We loved *Girls Next Door*," her buxom companion gushed.

"Totally," the skinnier one jumped in. "Like, when I first got an agent, I told him I want to be on the *Girls Next Door*," she babbled, her

head bobbing from side to side as she spoke, "and then he was like, 'No, you need your *own* reality show!'"

"Oh, thanks! That's sweet!" I responded as an E! executive motioned to me from the doorway, ready to whisk me off to set. "Nice to meet you! I'm sure I will see you around!"

Certain we were a safe distance from my dressing room, I turned to him and whispered: "Who were those girls?"

"Oh, they're the Arlington sisters," he stated matter-of-factly as if I should have heard of them.

When I gave him a blank look, he continued.

"Did you hear about those robberies in the Hollywood Hills?" he asked, his voice taking on a very Hollywood sales-pitch tone. "All the celebrity houses, like Paris Hilton's? They are the ones that did those."

He said that as if that were a perfectly reasonable claim to fame.

Needless to say, some of the network talent wasn't necessarily thrilled to be sharing the spotlight with these young felons. Say what you will about how some of us became household names, none of us got there by breaking and entering. The world of "famous for being famous" was getting weirder and weirder.

HOLLY'S WORLD PREMIERED TO excellent ratings—nearly 2 million viewers!—and talk of a second season was practically immediate. Between filming the series, watching it unfold on air, and performing six nights a week, 2010 went by in a blur. My turn in *Peepshow* had garnered such fabulous reviews over my first 18 months that I moved from the three-month contracts the show had offered me initially to signing a full-year commitment and had even begun singing lessons so that I could take on an additional role in the production. On top of all that, I had a new gig as the Las Vegas correspondent for the entertainment news show *Extra*. I had little spare time, but was still managing to have a blast!

I was finally standing on my own. Ratings were so strong for *Holly's*

World, they were even surpassing those of Kendra's latest season. In fact, there was only one attempt to include a *Playboy*-related plotline in that first season. When producers suggested the cast and I stop by Hef's annual birthday party at the Palms, I wasn't particularly opposed to it. While I wasn't jumping out of my chair to go spend time with Hef and Crystal (particularly after I watched her spiteful *GND* character unfold), I knew that fans loved those sort of on-camera reunions.

The *Holly's World* cast arrived at the Hef suite at the Palms for the '80s-themed soiree (which I assumed was a not-so-subtle wink to Hef's age) in costume. Hef seemed genuinely delighted to see us, as did Mary and a few of the girls I had known from my mansion days. Crystal, however, barely made her presence known. New playmate Claire Sinclair (a Barbi Benton look-alike) acted as a go-between for a pouting Crystal, who spent much of the party tucked upstairs and away from cameras, despite being swathed in a stunning Baracci gown and dolled up to the nines. Hef's new number one girl seemed to resent having anything to do with my show—especially since "her show," *GND* season six, had been canceled.

The Shannon twins had since departed the mansion. According to the rumor mill, Karissa and Kristina were wild and never really good at adhering to the rules. I can't imagine Crystal was disappointed to see the magnetic twosome go. In their place was a new girlfriend, a gorgeous, baby-faced blonde named Anna Sophia Berglund.

Hef's birthday party eventually moved to Moon Nightclub. When Josh and I arrived back at the Palms—after doing two performances of *Peepshow*—we entered the club and situated ourselves in our designated booth, just a row over from Hef's table. Immediately, he spotted us and, with a big smile on his face, waved to us with both arms and the enthusiasm of a little kid.

"It's like he's signaling for help," Josh observed. "He looks bored."

He did look a little bored *and* eager for the cameras to make their

way over. Crystal was supposed to have sung "Happy Birthday" for Hef at midnight (something Bridget had done at his party the previous year), but she didn't end up performing. Knowing Hef, he clearly was waiting for his on-camera moment.

After downing a round of drinks, we made our way over to his booth. Suddenly, one of Hef's security stopped us.

"Sorry," the hulking guard said. "The boss wants to leave."

We couldn't have been there for more than 15 minutes. *What was this guy talking about?* I thought.

And just then bright security flashlights whizzed past us, leading Hef's entourage out of the club. Two Playmates—Jen and Kim—walked by us, looking truly embarrassed, and mouthed "sorry." Next came an angry-looking Crystal, who avoided any eye contact with us, dragging a dazed and confused-looking Hef, who shuffled along behind her.

"What happened?" I asked the guard.

"I don't know," he shrugged. "I just got the word they were leaving."

It was so unlike Hef to miss even a short chance to be in front of cameras that I was actually concerned. He *lived* for that sort of attention. He didn't *look* unwell, but I asked the *Playboy* publicists about it anyway. They assured me that Hef was perfectly fine and his sudden departure had nothing to do with his health.

It didn't take a rocket scientist to put the pieces together: Crystal's neurotic behavior and canceled performance combined with being forced to participate in my reality show and Hef's overzealousness to see us . . . You do the math.

Oh well, I thought. Hef loved any chance to be on TV and he loved *Girls Next Door* nostalgia. To me, though, it didn't matter whether we got the nightclub scene or not. If he didn't want to film it, it was his loss. Unlike Hef, I didn't enjoy living in the past. I was young and living for the present and future.

I couldn't help but think of Hef spending the better part of five

seasons pounding into Bridget's, Kendra's, and my heads that *we* were replaceable—that the show would be just as successful in our absence. With *Kendra* and *Holly's World* pulling in solid ratings and being renewed for additional seasons and *GND* fading quietly into the night, it appeared we weren't so "replaceable" after all.

Chapter 16

*"I do hope it's my dream and not the Red King's! I
don't like belonging to another person's dream!"*
—Lewis Carroll, *Through the Looking-Glass*

Even the most magical fairy tale isn't complete without a villain—
and one was about to arrive in *Holly's World*.

E! was thrilled with the performance of the first season of *Holly's
World* and promptly ordered a second season. To satiate the viewer
demand, the network scheduled production to begin in fall 2010 in order
to meet a January 2011 premiere date (in the television industry, fall and
winter premieres are reserved for the more established shows, while
summer premieres tend to be for untested programming). The shift for-
ward was a huge move for our little-reality-show-that-could!

Unfortunately, not every E! show saw such great success. Earlier
that year, Hef had delivered a pilot to E! titled *The Bunny House* that
he hoped would be the second coming of *The Girls Next Door* and keep
Playboy—and himself—on air.

The show followed the exploits of five Playboy Playmates as they lived

in a plush pad across the street from the mansion: Claire Sinclair, Hope Dworaczyk, Crystal McCahill, Jaime Edmondson, and Jayde Nicole.

Claire (the Barbi Benton doppelgänger) and I had become friends. Not only was she beautiful and sweet, she actually had a brain in her head. I had met Hope and Crystal during the Anniversary Playmate search a few years earlier, while Jaime was new to the mansion fold. She had an interesting history: she'd been everything from an NFL cheer-leader to a police officer to a contestant on CBS's *The Amazing Race*.

Then there was 2008's Playmate of the Year and the show's official mean girl, Jayde. The ex-girlfriend of reality star Brody Jenner, she had already spent some time in front of cameras during the final season of MTV's *The Hills*.

In the wake of her breakup, Jayde had been trying to shop around her own pilot with no luck, but the network loved the idea of a "girl you love to hate" character, so when producers got wind of that, they placed her in *The Bunny House* as the resident shit stirrer.

The pilot followed a re-creation of Claire's Playmate test shoot at Studio West—with Crystal seated purposefully in my former perch view-ing the instantly uploaded images on a computer monitor and shouting words of encouragement, as I used to do when I directed the shoots—and a group trip to Las Vegas for Hope's Playmate of the Year celebration. But between *Kendra* and *Holly's World,* there was just too much *Playboy*-produced content on E! and the pilot wasn't picked up to series.

However, there were those who remained obsessed with the idea of resurrecting *Girls Next Door,* so Claire and Jayde were planted on *Holly's World* in hopes that their characters would gain enough popularity among viewers that E! would be forced to revisit *The Bunny House* concept.

I had virtually no choice in the matter, but I wasn't particularly both-ered by it at first. Producers insisted that, per E!, the show needed more drama and Jayde had signed on to the show, knowing she was going to play the "bad girl." Honestly, that made my job much easier; I was happy to let her be the drama queen. Unlike *Girls Next Door* (where "negativity"

was forbidden), most reality shows require some dramatic elements . . . how can you have an interesting story without conflict? Oftentimes, producers will guide the storylines, encourage talent to make provocative statements, and edit things together to increase the overall tension on the series. If producers had a predetermined villain, then we wouldn't need to manufacture trouble between the existing cast—who at the time were my closest friends. Plus, I didn't feel threatened. I was sure E! would never order *The Bunny House.*

As for Claire, she was a natural fit for *Holly's World,* not because of her *Playboy* connection, but because she was a budding Vegas showgirl herself who had just signed on for a guest run at MGM's *Crazy Horse Paris* revue.

While we took a break from filming during the holidays, Hef and Crystal had become engaged. Right on cue, the media firestorm began citing that I was reportedly "devastated" upon hearing the news. Actually, I was probably one of the few people in the world not at all surprised that Hef was getting remarried. Hef's youngest son, Cooper, turned 18 that year, providing Hef the green light he felt he needed to divorce Kimberley (despite the fact they had already been separated for nearly 13 years), plus with *Girls Next Door* no longer on the air, Hef needed an incentive to once again reinvent himself and garner headlines.

I understand why people thought I would be upset. For five seasons it appeared as though I wanted nothing more than Hef to myself, a big white wedding, and the mansion hallways echoing with pitter-patter of tiny feet. In the media, our breakup played out as if I was unable to tame the ultimate bachelor only to have him propose to the next blonde that shoved her way into the mansion. The truth was: I couldn't have cared less. The happier Hef was without me, the more quickly I could disassociate myself. It could have easily been me walking down that aisle and I was grateful to have gotten the hell out of there!

Long after I left, a friend of Hef's confided to me that Hef kept saying that he had "no idea" why I chose to leave.

"All you had to do was stick around until Cooper turned 18," he said with a pointed look.

"But I don't care anymore! That's not what I want," I responded. So few people seemed to realize that I had woken up from the spell I had been under a long time ago.

The few years I had been out of the mansion had been the best of my life so far—if I had married Hef, I wouldn't have had any of that. My life would have been over.

"Don't you miss the maaaaaaansion?" a dreamy-eyed girl asked me during one of my *Peepshow* meet-and-greets. I would often get this question and it continued to amaze me how many women were cast under this *Playboy* spell. There I was headlining on the Vegas Strip, making millions of dollars a year all on my own and starring in my own television show . . . and they wondered if I missed living by an archaic set of rules with a spoiled man old enough to be my grandfather. Were they crazy?!

After hearing this over and over again, I began to realize that what viewers took away from *The Girls Next Door* was nothing like what life there was *really* like.

When it was suggested we film an episode of *Holly's World* at the mansion so I could congratulate Hef on his engagement, I actually jumped at the chance! This was my opportunity to show viewers that I wasn't at all "devastated" by Hef's engagement; in fact, I was happy that he was moving on and wished him well! Regardless of how I felt about Crystal, I never for a moment wanted to trade places with her. I thought it was important for people to know that.

It was an eerily quiet day at the mansion when I arrived to film my "congratulations" scene with Hef. An extra-large dollhouse occupied the great hall—a gift I had commissioned for Hef shortly before I left. The piece was an exact replica of the home he had grown up in in Chicago in the early part of the last century.

When Hef arrived to shoot the scene, he spent a lot of time fussing over the dollhouse. Eventually, Crystal made her way downstairs in a cozy-looking long-sleeved shirt. I congratulated her as well. She seemed different to me that day: calm and friendly, low-key, as if there wasn't a negative bone in her body.

Maybe she's finally growing into herself, I thought. It was nice to see that side of Crystal. *Perhaps I had judged her too harshly. Maybe they'll actually be good for each other, after all.*

I returned to Vegas that night and went back to finishing season two of *Holly's World*. The second season was even more memorable than the first. The producers found a couple of private investigators to track down Josh's birth mother (whom he had never met and knew nothing about). When Josh and Angel went to Charleston, Josh's hometown, everyone thought we were at the start of a long quest to find his real mother. No one actually expected her to turn up right away! The investigators came through and the episode turned out to be one of the most genuinely surprising and emotional ones of the series.

I let Angel go as my assistant and gave her the role of my understudy in *Peepshow*. She also landed a small role in another Strip production due to an audition that was planned and filmed for the show. Laura was mostly prompted by producers to hang out with Jayde so that our resident villain had an excuse to be intertwined into our storylines.

Though the show was better than ever, I found myself growing more and more distant from my closest friends. With my crazy work schedule, Josh was really the only person from the show that I regularly saw off camera—and that was only because we were in *Peepshow* together. It was clear that if there was a season three, Laura wasn't necessarily going to get invited back due to her failure to connect with the audience. I wondered if she would choose to stay in Vegas if that were the case.

Meanwhile, Angel, who was loved on the show, was growing more and more distant from me. I rarely saw her anymore and she seemed to make a point of hanging out with anyone *but* me, Josh, or Laura. She

spent most of her time at her mom's home, leaving her and Roman's things in each of their rooms at my house. I began to sense something was wrong. Her attitude changed, too. She'd come a long way professionally since joining the *Holly's World* cast and I thought I had helped her get so many things that she wanted, but maybe those were just things *I* would have wanted at her age. Obviously something was a bad fit, because she didn't seem happy anymore. The carefree, fun-loving Angel who used to light up my days was gone.

While my cast was handling their newfound places in the spotlight in different ways, I kept busy with work and foolishly pushed my concern about my friends aside. *We'll deal with that when next season's negotiations come up,* I thought. The future seemed so bright that I was sure everything would just repair itself eventually.

Claire was the front-runner for 2011's Playmate of the Year and it was suggested that since she and I had become so close, I resurrect my role as *Playboy's* photo editor for the pictorial as a special contributor. Despite how desperate I was to get away from *Playboy,* I actually liked this idea since it put the spotlight on my professional, not personal, involvement with the magazine.

Given her very era-specific look and curves, I began planning the shoot in my head: a vintage Bettie Page–inspired feature using the plush red *Crazy Horse* theater as a backdrop. We couldn't wait to get started!

As the shoot dates drew nearer, I was excitedly explaining the project to Josh when I got a call from one of the producers. With a heavy sigh, he dropped the bomb on me that we were no longer filming Claire's pictorial.

"Why?" I asked, hoping it was just a silly mix-up that could easily be fixed.

I heard him take a deep breath and exhale. He explained that Hef had just called him and said that Crystal and I had a Twitter fight and that she was really upset about it. He said she threw a fit about it and that Hef had no choice but to take me off the pictorial.

"Ugh," I groaned. I had heard through the grapevine that Crystal was still moping around the mansion because she had "her show taken away" and was upset that I was the one still on television. Any suggestion of my presence anywhere near *Playboy* sent Crystal into a frenzy. What happened to the laid-back Crystal I had seen the last time I visited the mansion?

"Are you serious? We didn't get into a fight," I snapped, exasperated by her immaturity. "Someone on Twitter pointed out that she copied my underwater photo shoot, and later I made a generic post about hating copycats. That's it. I didn't even mention her name or reply to the person who pointed it out!

"I'm sorry that she has a guilty conscience," I huffed, rolling my eyes. Over the past few years, I definitely began to feel that for whatever reason Crystal was trying to *Single White Female* me. "And I'm sorry that she can't deal with people's comments on the Internet."

Crystal had no clue what to do besides follow in my footsteps. Maybe she felt like emulating me was the only safe thing for her to do. In a way, I could empathize with her, since I knew how frightening Hef could be and how scary it could feel to try and step out of the realm of what he expected of you. I had been smacked down pretty hard for cutting my hair and wearing red lipstick and had been afraid to dress any differently than his previous girlfriends, after all. In my "off time" during the day, I had held on to being my own person in some ways, so when Crystal even started copying my private life, I was a little creeped out. She became an overnight Disney fanatic, made a point of tracking down and befriending my old buddy Britney (who had long ago ceased being a mansion regular), and started spending her days with her.

Crystal acquired the seemingly requisite boob and nose job shortly after moving into the mansion, and after her plastic makeover, Hef handed her a December 2010 centerfold. This was a stark contrast to how the centerfolds had been held far, far away from me and most of the girls I had cohabitated with, but I suppose Hef felt that giving Crystal a cen-

terfold to shoot on *GND* was safer than giving her a "celebrity pictorial"
like he had given me, Bridget, and Kendra. Or perhaps he was finally
playing fair for a change and putting her on the same level as the twins;
who knows?

The first photo in her spread looked a lot like the opener from my
final self-directed pictorial for February 2009 (standing back to camera
naked in between two theater doors). The rest of the pictorial was very
old Hollywood, complete with the same style of monogrammed pillows
I had requested for a *GND* calendar shoot two years earlier. Sure, the
fact that it was December (my birthday month and favorite time of year)
could have been purely coincidental, but I knew how painstakingly pro-
duced every last detail of these shoots were . . . including the hat that sat
next to Crystal in her centerfold: a fedora adorned with a single sprig of
holly. Even her Playmate video had been filmed at my favorite location,
the spot I fought so hard to secure for my final pictorial: the Los Angeles
Theatre. Knowing how expensive it was to shoot video there, they must
have spared no expense to get it done. It was weird.

Clearly I wasn't the only one recognizing these "coincidences." I con-
stantly saw fans on Twitter tagging Crystal and me, saying that Crystal
was copying me. Crystal must have seen them, too.

I was disgusted with both Crystal and Hef. He knew how much I
enjoyed producing these pictorials and he took the project away from me
as a form of punishment.

The producer sighed and said he was really looking forward to cov-
ering this shoot. I knew he was telling the truth. The crew and I had
known each other for years and we all seemed to especially enjoy doing
the photo shoot episodes.

"Me, too," I conceded.

He suggested, with a momentary flicker of hope in his voice, that all
I would have to do is call and apologize to Hef and Crystal.

"No way!" I exclaimed. "Why should I have to apologize when I

didn't do anything wrong? That's idiotic. If he wanted me to direct the pictorial and have it featured on the show, that decision should be separate from any drama Crystal and he are having. Forget it!"

Knowing Hef as I do, I'm sure part of him got off on the fact that Crystal was jealous and insecure. If I were to engage in this one-sided battle, I'd only give him the satisfaction of feeling fought over. No, thank you.

I can just see his scrapbook entry now: "Hef cancels Holly's shoot with Claire due to a fight Crystal and Holly had over Hef." (He always referred to himself in third person in the scrapbook captions. The whole thing is so bizarre.)

In your dreams, pal.

As season two of *Holly's World* wrapped, Lifetime TV was preparing a special on Hef and Crystal's upcoming June wedding, but it wasn't to go on as planned. Crystal ended up running out on Hef five days before the 300-guest ceremony was set to take place. The crew was left with nothing to film. I couldn't begin to imagine how mortified Hef must have felt. Hef's friends and many Playmates were in an uproar, denouncing Crystal, sometimes publicly on social media. Kendra and I were asked to film a scene with Hef to help fill time in the special, which was now titled *Hef's Runaway Bride*. I did it as a favor to production, the same people behind *Girls Next Door* and *Holly's World*, not Hef, though I do have to admit, despite all the negative things I had been through with the guy, I did feel bad for him after such a public humiliation. I wasn't interested in showing up to say "I told you so" regarding Crystal, I just wanted to try and be a friend.

I flew into L.A. the day of the shoot and arrived at the mansion early to wait for the production crew in the unusually silent great hall. Suddenly, a bleary-eyed blonde wearing a pair of Hef's oversize aqua silk

pajamas and a noticeable case of bed head appeared at the top of the staircase.

"Excuse me," asked Shera Bechard, a recent Playmate who had obviously just wandered out of Hef's bedroom, "how do I take the dog out?" She pointed down at a King Charles spaniel, the dog Crystal had left behind, who was sitting at her feet.

"Um, you just open up the door and take him outside," I said, trying my best not to sound condescending. It was a strange question with an obvious answer, but then again, the mansion was such a bizarre place it would have been easy to assume that there was probably a weird ritual involved with taking one of the mansion's dogs outside. Thankfully the crew showed up and ushered me down to Mary's office, saving me from that awkward exchange with Hef's latest concubine.

As Kendra and I sat in her mansion office, Mary explained that she had received a call from Crystal when Crystal was at the Jazz Festival. Crystal confided in her that she was really nervous. Mary said she had asked her if the problem was Anna (Anna was one of the two girls Hef was supposedly dating when he was "settling down" with Crystal), and Crystal had said no, that she loved Anna. Mary just shrugged and said she didn't know what happened between Crystal and Hef.

By then, we had all heard the gossip that Hef and Crystal couldn't come to terms on a prenup, leaving them at a stalemate just days before the wedding. So Crystal decided to up and leave—straight into the arms of her secret boyfriend, Jordan McGraw (the son of Dr. Phil . . . what would he have to say about this little love triangle?). One celebrity news site even revealed that she had moved in with him.

It was the giant elephant in the room, but neither Kendra nor I breathed a word of it. After all, we had a film crew surrounding us and we all implicitly knew that that topic was not something Hef would allow to be included in the special.

Kendra and I sat down with Hef in the mansion library, a room I had been in a zillion times before, but I had never been this uncomfortable.

Despite the years that had passed, there we were—Bridget, Kendra, and me—hanging on the wall. It was a photo from our first pictorial, the three of us piled naked on top of one another. Living at the mansion you start to get desensitized to those sorts of things. Nude photos, no matter how explicit, had all started to look the same to me. But after being away from *Playboy* for three years, the photo that had once seemed so silly and playful struck me for the first time as incredibly pornographic (which of course was the original intention behind the image in the first place). Who knows, I may have been the one that initially had the thing framed, but by that point I was embarrassed that that photo was still up there for all to see.

Hef confessed, while looking directly at me, that he proposed to Crystal to avoid making the same mistake he had with me. I remained as stoic as possible, just nodding solemnly like a robot. Giving him—or viewers—false hope was the last thing I wanted to do. We each gave him a hug, offered him our condolences and words of encouragement, and then let him get back to his paperwork.

The Lifetime special flopped. No one was invested in Crystal and Hef as a couple, and unlike the ferocious media storm, the special failed to mention the other man Crystal was involved with. Though the scandal made a splash in the press, most people who didn't know Hef brushed it off as a publicity stunt.

Trust me, Hef may be a publicity whore, but he would never risk his own bulletproof ladies' man reputation for the sake of a headline.

Crystal, on the other hand, didn't have as much reverence for his public image. According to a report in the *New York Post*'s gossip column Page Six:

Hugh Hefner's wedding to Crystal Harris was called off after she secretly planned to ditch the Playboy mogul at the altar in return for a $500,000 media deal, Page Six has exclusively learned. . . . A source told us, "Crystal wanted to ditch Hef at the altar. Her plan

was to walk up the aisle and say she couldn't go through with it. The wedding was to be filmed for a reality special, and her refusal to marry him would be a sensation. She was looking for a tie-in deal of around $500,000 for the exclusive 'I ditched Hef at the altar' interview. While there was interest, Crystal didn't get an offer anywhere near half a million."

Crystal continued to milk any ounce of publicity she could get for months: promoting her *Playboy* cover (the July 2011 cover had been designed to showcase Hef's newest wife, but at the last minute a sticker reading "Runaway Bride" had to be slapped over the top of it so the magazine wouldn't look dreadfully out of step and could simultaneously capitalize on the scandal) and *Girls Next Door* season six's DVD release (despite barely being in any of the episodes, Bridget, Kendra, and I were on the front of the box along with Crystal and the twins in an attempt to sell more copies). She appeared at a Heidi Montag–hosted pool party, publically pawned her engagement ring, hired an animal lawyer to get back the dog she left at the mansion months earlier, and made a well-publicized visit to Howard Stern.

In the graphic interview, she told Stern that sex with Hef lasted "like, two seconds. Then I was just over it . . . I'm not turned on by Hef. Sorry."

Even from Las Vegas, I'm pretty sure I could see the steam shooting out of Hef's ears. Nothing gets under his skin more than someone doubting his sexual prowess.

Unable to keep quiet and in a desperate attempt to salvage his lothario reputation, Hef fired back at Crystal via a series of tweets:

Crystal did a crazy interview with Howard Stern today that didn't have much to do with reality. Is she trying to impress a new boyfriend?

The sex with Crystal the first night was good enough so that I kept her over two more nights . . .

Sure, her turn on Stern was a low blow, but I was disappointed to see Hef stoop to her level. In the end, they both lost that war.

When the headlines disappeared, her new relationship ended and people stopped caring about Hugh Hefner's ex-fiancée, Crystal came back to the mansion with her tail between her legs and the pair wed in a low-key wedding ceremony on December 31, 2013. There certainly must have been a measure of satisfaction for Hef's ego. The woman who had so publicly embarrassed him ended up crawling back after all—just like he had tried to convince me to do after I met Criss.

My guest appearance on *Hef's Runaway Bride* was the last time I ever saw Hef or spoke to him. I continued to receive letters from him after that, but I just threw them away, because they were always only about him anyway. Three years after breaking off the relationship I could finally say he was out of my life for good.

DESPITE ANOTHER SEASON OF stellar ratings for *Holly's World* (seeing a series high of nearly 2.5 million viewers), the show was canceled.

E! welcomed a new president at the same time, who decided she no longer wanted the network to be in business with *Playboy*. "We want to get rid of the trashy *Playboy* element," she was quoted as saying. This hurt, since I had been trying so hard for the past few years to separate myself from that brand.

Kendra's show was canceled shortly after mine.

Sure, *Playboy* got me on television, but it was also because of *Playboy* that I was taken *off* television. Many people assume *Playboy* was my blessing, but most don't know it was also my curse.

Truth be told, I was devastated by the cancellation. The cast, production, and I continued to bring in the ratings for the network, but *Playboy* cast a shadow over my life and I couldn't escape it.

I felt terrible that I could no longer provide my castmates with the spots on the show that had brought them so much success. I felt like the Giving Tree after the tree was reduced to a stump and had nothing left to give anyone. I was worried that I would lose all my friends once they

learned *Holly's World* was to be no more. Of course, that didn't turn out to be the case. Josh and I, for example, remained and still are as close as ever. Angel and I suffered an estrangement for a few years, but sometimes that's what success can do to friendships.

I felt like I had just begun landing lucrative endorsements and turning my press coverage around. People had finally started saying "We love you on *Holly's World*" instead of "We loved you on *The Girls Next Door.*" I was scared that with the show's cancellation, my positive momentum could be stopped dead in its tracks.

"JUST DO IT," MY friend advised me. "They're going to make it whether you want them to or not. You may as well have your voice in there."

In 2011, E! executives asked me to film for their *True Hollywood Story* franchise. I'd been interviewed for the program before, but this time the entire episode was going to be about me! While the idea of having your own E! *True Hollywood Story* might be a sign to some that you've made it, I felt wildly underqualified and the prospect horrified me.

But I haven't even accomplished anything yet, I thought. My story wasn't ready to be told. I hadn't achieved enough on my own *outside* of the mansion—and I didn't want the hour-long program to be a tribute to my days at *Playboy.* But after talking it out, I realized I didn't really have a choice in the matter.

Eventually, I gave the network my cooperation. In retrospect, I feel so sorry for the poor producer forced to interview me. I did *not* make her job easy. I felt like I had nothing but a trail of mistakes and embarrassments to confess on camera (save for the previous two years), so I was perhaps the grumpiest, bitchiest, most emotional mess that had ever sat down for a *THS* about her life. The last subject she had interviewed for the series was Katy Perry, who was no doubt upbeat, but she's someone who's *really* accomplished things. I was so insecure—I worried that my life's story would be presented as that of just another famous-for-nothing *Playboy*

bimbo. Naturally Hef was interviewed for the special (you really think he would miss a chance to be on camera?) and his only real contribution was a chippy remark at my expense.

"What I thought I had found in Holly, I really found in Crystal," he had said to the interviewer . . . as if that was in any way relevant my story. He just couldn't resist an opportunity to belittle me and to make the story all about him.

But when the special finally aired, something interesting happened: people actually related to me.

To my surprise, viewers sympathized with my unhappiness and some even said they found the courage to reinvent themselves in their own lives. Inspired by my story, some women told me they were able to remove themselves from difficult situations, get over a breakup, or find the motivation to get healthy. I was and continue to be truly humbled.

Through these wonderful, honest people, I was able to reevaluate how I viewed my own past and maybe give myself a bit of a break.

Perhaps sharing my story wasn't such a bad idea, I thought.

Maybe I wasn't defined by the mistakes I had made after all . . . maybe those decisions were what allowed me to become the person I was always destined to be.

"It's no use going back to yesterday, because
I was a different person then."
—Lewis Carroll, *Alice's Adventures in Wonderland*

Kendra? Appear in *Peepshow*? You're kidding me, right?" I laughed, barely able to believe the suggestion.

Before now, I've never spoken publicly about my falling-out with Kendra. There were people looking to capitalize on the deterioration of our friendship, and I refused to allow them to benefit from it. Throwing away a relationship for cheap publicity isn't cute.

After E! canceled both *Kendra* and *Holly's World,* Kendra's series was picked up by a smaller cable network. When production started brainstorming ideas for Kendra's new show, they called me and asked me if I would like to participate. Always *The Girls Next Door*'s biggest fans, the producers wanted to keep the "team" together in any capacity they could.

"Of course!" I assured them. While there wasn't necessarily any upside for me to appear on her show, Bridget, Kendra, and I routinely made cameos on one another's programs. For us, it was a no-brainer. That's simply what friends do. Besides, it was fun.

When I was presented with plotlines to participate in, I was less than thrilled with the options. I wanted to make sure that my appearance on her series felt organic, but I was beginning to get the impression that there was a hidden agenda.

Early into our conversations, they latched onto one particular idea that they wouldn't shake. They insisted that the network wanted *sexy,* that they wanted *career.* And that they needed help with that because at that point Kendra wasn't either of those things.

One of them asked me to offer Kendra the role as my *Peepshow* understudy for a weeklong stint. Besides being a total rehash of a storyline we had done for *Holly's World* with Angel, there was a whole host of reasons I wasn't comfortable with that happening. I had worked hard to help make *Peepshow* a success and considered it a huge part of my post-*Playboy* identity. I felt that to show Kendra performing in *Peepshow,* on television, even if it were only for one night, would create the impression that it was just another *Playboy*-related venture that was handed to any *GND* alumnus. Couldn't I have anything of my own?

They continued to gripe, saying Kendra had no ambition, didn't do anything but sit on the couch, and had truly become famous for nothing.

Over the past three and a half years, *Peepshow* had become my baby. I busted my ass to create a successful post-mansion life for myself and I wasn't going to just hand over the reins for the chance to be on a show roughly 40 people would end up watching (okay, maybe a *little* more than 40). It felt like I was being used.

Despite sharing a friendship and a common experience at the mansion, Kendra and I were still *very* much different people. There were times when I was compared to her and encouraged to follow Kendra's method, but it just wasn't me. While she was quite a bit more mainstream than I was, her "career moves" consisted of things like releasing an old sex tape or coming out with a line of lubricants. While her tabloid coverage focused on positive things like her wedding and baby her first year out of the mansion, lately her headlines had devolved to negative things like:

"Why I Left Hank," "Kendra Loses Her Baby!," "Kendra's Secret Break-down," and "Sex Tape Scandal." Ummm, no thanks.

Since she moved into the mansion at 19 years old, Kendra had never had to work for a thing her entire adult life. She went directly from having cameras follow her as Hugh Hefner's girlfriend to cameras following her being a football wife. Luckily for her, whether it was Hef or Hank, there was always someone around to rescue her.

Were they seriously asking me to simply hand over the career I had built by myself so her life could look more interesting on TV? It appeared so.

"I worked my ass off to promote *Peepshow* and make it a success," I continued, firmly and unapologetically. "The work I put into this production actually means something to me. If I tossed in Kendra as my understudy, people would see that on TV and think *Peepshow* is just handed from one ex-Girl Next Door to the other. It would tear down everything I've built to make myself an individual."

I was told that it wouldn't and that Kendra wouldn't even be able to do the show. That she would think she could do it, but she wouldn't be able to pull it off.

"The answer is no," I maintained. "I'll support Kendra on her show, but I'm not handing my life over to her. No way."

They finally conceded, before offering one final plea: "But think about it. It would get you back on television!"

Did he really think I wanted back on TV that badly? I thought. I couldn't begin to imagine Kendra's *Peepshow* run. First off, there's no way Kendra had the self-discipline to perform in eight live shows a week. She didn't possess that kind of work ethic. And I could *never* unleash Hurricane Kendra on my cast and crew.

Sure, we'd been on excellent terms since we left the mansion, but I knew for myself what a nightmare she could be to work with. Her incessant tardiness, endless excuses, and toddler-like tantrums had become a thing of legend.

After continuing to turn down the *Peepshow* understudy idea again and again (they really were relentless), I finally agreed to shoot a simple scene with Kendra at her new home—Hank's NFL career had ended the year before and they had settled outside Los Angeles—for the debut episode of her series.

The plan seemed organic enough: she and I would simply talk and catch up. Producers encouraged me to tell her about my career and plans for the future—apparently this was intended to inspire Kendra to get off the couch and build her own career, a story arc they hoped to follow throughout the season.

When I arrived at her house in Calabasas, I was genuinely eager to catch up. We hadn't seen each other since filming Hef's *Runaway Bride* Lifetime special. She took me on a tour of her home, barking at Hank to stay out of the shot as we passed him in the hall. I talked at length about my life in Las Vegas, including my plans for *Peepshow,* other opportunities I was considering, and wanting to get out of the shadow of *Playboy* to continue to do things on my own.

As the conversation wore on, Kendra seemed to be getting more and more annoyed. It was becoming clear that she didn't like the idea that she wasn't the only *Girls Next Door* graduate to find success.

We wrapped our scene, hugged good-bye, and I jumped back into my Range Rover for the five-hour drive back to Las Vegas—after all, I had a show that night!

Before pulling out of the driveway, I shot her a quick text:

Thanks for having me over to your house! It was fun catching up!

She didn't respond, which was odd. Usually she was pretty quick in responding to my texts or tweets, but I didn't give it too much thought beyond that.

A few weeks later, a field producer for the series asked me to place a phone call to Kendra. They wanted to film her receiving the call from me to set up the idea that I was coming over for the visit we had filmed. After being rescheduled countless times because Kendra was "not answering

her phone," "not coming out of her room," or "not showing up to film," it became clear what was going on.

I spent five seasons on a reality show with Kendra—and her habits hadn't changed much. Instead of addressing the issue or having a mature conversation with producers, Kendra's go-to method was passive-aggressive avoidance.

Oh well, I thought. If she didn't want the scene on her show, that was her business.

Despite the fact that the producers couldn't coax Kendra into shooting a phone call with me, they continued pressing the *Peepshow* understudy idea. In the beginning, I was told "the network loves the idea for the premiere" . . . then it became "the network loves the idea for the season finale."

And each time I said no.

"Besides," I said the last time we discussed it, "I'm just uncomfortable with it. Something is wrong with Kendra. She doesn't answer my texts or tweets anymore—I think she's pissed at me or something."

My concerns were dismissed. "That's just Kendra. You know how she is—she never gets back to anybody."

"Not really," I said. "Actually, she used to always answer my texts right away. Anyway, the answer is no. It just doesn't feel right."

When they showed me the premier episode of the horribly titled *Kendra on Top,* it was clear what she was so irritated about.

As I rattled on to Kendra about my career, they cut to her interview:

"I'm pretty competitive . . ." she stated at the camera. "Ya know, I'm kind of already established, but I don't wanna lose that. I wanna gain."

I could tell Kendra was annoyed and trying to be careful how she worded what she wanted to say. She didn't like being set up to look less successful than me, even for one scene. While that wasn't the intent—producers simply wanted to inspire her to get her ass off the couch—the comparison couldn't be helped.

The next thing I heard from her was a headline she retweeted: *Kendra reveals why she is no longer friends with Holly and Bridget!*

I couldn't believe what I was seeing. Kendra had apparently given an interview to a tabloid explaining that she wasn't friends with either of us, as if she were somehow better than everyone else. "We've all found our own little roads to go and that's just the way it goes," she said, retweeting the article to her followers when it came out. For someone who was all of a sudden trying to act like she was better than Bridget and me, she sure wasn't above using us for publicity when she needed it. Anything for a tabloid-worthy topic!

Hurt and confused, I retweeted her post, saying: *Thanks for letting me know, Kendra!*

Of course I wasn't going to stoop to her level and address this only on social media, so I decided to text her how I truly felt: that she was a coward and that she tried to act like the "real" girl on TV, but she's the fakest person I've ever met—and that if she had a problem with me, she should have confronted me like an adult instead of just going silent.

This time Kendra responded and the exchange went something like this:

Girl, I don't have a problem with you. I just don't like it when people think we are friends, she texted.

Do you even have a clue how rude that sounds, what you just said? I replied.

WHO ARE YOU????? I DON'T EVEN KNOW YOU! WE WERE NEVER FRIENDS. IT WAS ALL JUST WORK! she responded in all caps.

Wow, I'm sorry I was stupid enough to think we were really friends. Have a nice life, I finally texted.

After that, I deleted her number from my phone. Kendra and I haven't spoken since, and I have to say, I don't miss her.

* * *

FOR ALL THE THINGS that were going right in my life over the past few years, there was still one area that I needed to get on track. The dating scene in Las Vegas was pretty grim. During my three years as a single lady, I had the worst luck in the dating department. I swear, I could write a book on the types of douchebags that lurk around these days (maybe I will!).

All of my life, I was an over-the-top romantic, but by 32 years old I had become pretty disillusioned. I'd often wonder what I did wrong. It seemed that spending my 20s at the mansion had caused me to miss out on meeting "the one."

I was alone because I wasn't going to settle for less in a man than what I wanted or deserved. For the first time in my life, I started to lay plans to become a crazy cat lady. What would my life be like without the marriage and children I had always envisioned in my future? It looked like spinsterhood was becoming a distinct possibility, so I decided to ready myself for it.

It all sounds a bit dramatic, I know, but I had pretty much given up when in 2011 I finally met the man I would marry: Pasquale Rotella. Isn't that how the universe always works?

Pasquale and I met when he brought his Electric Daisy Carnival festival to Las Vegas. He was around town a lot and we knew a few of the same people, so bumping into each other was inevitable. I thought he was good looking and he seemed like fun, but when we started talking (most of the time through Twitter—I used to be Twitter obsessed), I wasn't really expecting things to get serious. It wasn't that I didn't want them to, I had just come to a point in my life where I didn't expect anything romantic to work out anymore.

Boy, was I wrong! Not only did we completely hit it off immediately, we were instantly inseparable. He was perfect for me. He was smart, funny, and sexy, and I was always my happiest just hanging out with him. He was the total package *and* was also at a point in his life where he was

ready for a serious relationship. A little later down the road, he started talking about wanting a family . . . and he actually meant it! This is an important note: a man has to already know what he wants. Don't waste your time trying to change someone's mind. It never works.

And like they say: when you know, you just know. Our relationship got very serious very quickly and within a matter of months we were practically living together. Despite our whirlwind romance, our respective careers (he owns and operates his entertainment company, Insomniac, while I was still consumed by my *Peepshow* schedule) meant that making time to see each other required significant effort.

In early 2012, I decided not to renew my *Peepshow* contract for 2013, despite the lucrative offer presented to me. That year marked my fourth year with the show, and by then, I was not only playing Bo Peep but had also adopted the singing Goldie Locks role as part of my performance. As much as I loved it, there wasn't much further for me to go with the production. And while I wasn't eager to leave behind a cast and crew that had become like family to me, somehow staying didn't feel right. I wanted to leave the show while it was still on top . . . and was it ever! The schedule was so time-consuming that as long as I stayed with the production, I wouldn't have room to add anything new to my life professionally . . . or personally.

I wanted to explore new career options, spend more time with Pasquale, and travel the world. We even talked about starting a family as soon as my contract was over. In preparation for this new life, I purchased a home in L.A.—one of the fairy-tale-style dwellings I had been in awe over the first time I visited Beachwood Canyon in Hollywood, several years ago while filming an episode of *The Girls Next Door*. Something I couldn't even dare to dream about having for my own back then was now a reality, thanks to everything I had done after I left the series.

My move on to this "new life" would get an unexpected push forward in July 2012, when I got some surprising and amazing news: I was pregnant!

Pasquale and I had discussed having kids—we even planned to start trying as soon as my run with *Peepshow* was complete, but everything happens for a reason and we received the fabulous, life-changing news many months earlier than we had even planned to start trying. I started to suspect something was off—and a trip to the doctor confirmed the news. We couldn't have been more thrilled. We wanted to shout it from the rooftops, but the doctor suggested we stay mum on our big news until our second trimester (miscarriages are common during the first 12 weeks of pregnancy).

Keeping a lid on our new addition for the three months was brutal—but necessary. I knew the announcement would attract a lot of attention, so I didn't want anyone to know until I cleared my first trimester. Looking back, I'm surprised no one at *Peepshow* guessed when I suddenly stopped arriving backstage with my signature large Starbucks iced Americano clutched in my paw!

My biggest concern was how I was going to finish my commitment to *Peepshow*—it would be impossible for me to perform through the end of the year. I'd certainly be showing by then and I'm pretty sure producers didn't envision their sexy lead with a growing baby bump. When I finally was able to break the news to my employers, we decided how long I would stay in the show (through mid-October 2012, which marked the fifth month of my pregnancy), and they began their search for a new headliner who could start a few months earlier than anticipated.

(People sometimes ask me if I was worried that performing while pregnant might somehow harm the baby, and my answer is "of course not!" I was used to the physical demands of the show and my doctors approved every move I made. If anything, I think performing made me healthier than I would have been sitting on my butt doing nothing. I had an amazing pregnancy and stayed in great shape—though some of the costumes were altered to allow for a little more modesty, I didn't even have to loosen my corset throughout my run in the show. I believe that many sacrifices need to be made in order to do your best as a parent, but I also believe you don't have to abandon your whole life.)

I vowed not to cry on my last night, but that was impossible. The outpouring of love I received from the cast and crew was just too overwhelming—and I couldn't help the tears. These were tears of joy . . . the best kind. Over the four years I spent with *Peep,* I'd grown tremendously: from the insecure, unsure *Playboy* outcast to the confident, successful mommy-to-be.

But it didn't take long for the vultures to start circling.

In the wake of my departure, Angel, my understudy, was summoned back for six weeks while *Peepshow* found and trained my replacement. Before my dressing room door even fully shut behind me, I received word that a certain someone had already contacted *Peepshow*'s producers, begging them to hire Kendra for the lead instead of the rumored front-runner: Ice-T's wife, Coco Austin.

"How dare you!" I yelled into my cell phone. I was *irate,* digging my nails into the palm of my hand. After I had spent months explaining to him why this idea made me so uncomfortable, I couldn't believe he had the audacity to even attempt such a betrayal. I'd been foolish enough to think we had developed a friendship over the last seven years, but obviously, I was wrong.

"And I'm pregnant right now," I screeched, my blood boiling. "I don't need the stress of a public feud with Kendra."

He sat silent. What could he say? Finally he came back meekly with the confession that he thought if there was a feud between Kendra and me it would be good publicity for the two of us.

"That's the kind of publicity Kendra likes, not me," I said. "I don't want it!"

Despite his efforts, *Peepshow* chose Coco to debut as the new headliner. After a few months, the show officially closed. It was a shame to see such a wonderful show close, but as they say, all good things must come to an end.

* * *

"Rainbow," Mary smiled. "That's a wonderful name."

Mary O'Connor and I were sitting on her front porch waiting for one of her girlfriends to pull up so we could drive to lunch together. She was one of the few people I trusted enough to reveal my chosen baby name to.

Most people think the name is an outrageous choice, but Mary knew me well enough to appreciate my whimsy. I'd first heard the name in middle school (a girl in my sister's class had the name and I thought it was the prettiest, best name ever). I never had it on my list of my future baby names, though, until I became pregnant—and when it resurfaced in my mind, it felt like the perfect name for our child. And while many people think her middle name Aurora was simply after my favorite Disney prin- cess, it was also a name that is a little more common in Alaska, where I spent much of my childhood.

I'm so thankful I had that last visit with Mary, because it wasn't long after that I received a heartbreaking phone call.

"Mary's in the hospital," my old friend Britney told me. "She's not doing well. Bridget and I are going to go visit her. Do you want us to tell her something for you?"

As my due date was drawing nearer and nearer, I was on doctor's orders not to travel and was stuck in Las Vegas until after my delivery.

"Yes," I managed quietly. At age 84, Mary had recently undergone cancer treatments, but had appeared healthy and upbeat the last time I saw her. Hearing that she was now on her deathbed was a shock. "Please tell her I love and miss her and that I wish I could be there."

The message wouldn't be passed on, however. When Britney tried to visit Mary, supposedly Crystal turned her away, saying Mary didn't want to see anyone. Strange.

To the best of my knowledge, Hef never visited Mary at the hospital. Probably because he wasn't in the best health himself and rarely left the mansion anymore, not because he didn't care about her. In fact, Mary was the only person I ever saw Hef be truly candid in front of. Everyone else

in his life, including his relatives and significant others, seemed to be held at arm's distance, emotionally.

One of the few truly positive things that I took away from the mansion was my friendship with Mary. Everything else that came from that place was laced with darkness, a hefty price tag, or an eventual knife in the back. Mary was a no-nonsense, tell-it-like-it-is gem of a lady. The world needs more people like her.

ASIDE FROM THE SAD news of Mary's passing, I was in wonderful spirits during the final weeks of my pregnancy. I couldn't be more excited to meet my little girl. Everything was coming together and my dream of having a family was coming true!

Less than a week before my due date, I received a surprising call from E! The network wanted to order an hour-long special about our baby's birth! I jumped at the opportunity! Not only would it be such a cool thing for Rainbow to see when she got older and a wonderful family journey to document on camera, it was also a great way to celebrate as I eagerly awaited her arrival.

E! brought an in-house production crew to shoot the special, and they couldn't have been more fun, professional, and easy to work with. When I requested privacy for certain moments (no below-the-waist shots during birth, privacy during breastfeeding), the crew looked at me like I was crazy and one of the cameramen said, "We weren't planning on shooting that anyway." I was floored, but in a good way! I had been so used to the crew being ordered to capture every instance of nudity possible in my *Girls Next Door* days that I had been prepared for a battle.

Being surrounded by the crew, even in the delivery room, made me feel extra safe and supported during this new experience. They made me feel like they had my back and were the perfect complement to the love my family and friends were surrounding me with during that exciting time.

Little Rainbow Aurora was born on March 5, 2013. Anyone who's pushed out a baby will hate me for saying this, but I actually enjoyed giving birth. I chose to have an epidural and the entire delivery took only two hours. Rainbow is truly a blessing and without a doubt my greatest achievement to date.

The year 2013 turned into a time of rapidly checked-off milestones for me. Just three months after giving birth to Rainbow, I was officially an engaged woman. Most little girls fantasize about the day the man she loves asks to spend the rest of his life with her—and my special day was nothing short of magical. Pasquale proposed with a cushion-cut 40-carat yellow diamond ring surrounded by pink and yellow diamond flowers, which was amazing, but the best part of the ring was that he designed it himself with me in mind. He popped the question at the very top of a Ferris wheel at his Electric Daisy Carnival.

Despite the magical, colorful sea of craziness below and the elaborate fireworks spectacle above, it was strangely calm and quiet in our little booth atop the giant wheel. When Pasquale pulled out the ring box and asked me to marry him, I exclaimed an immediate "Yes!" The smile was plastered on my face like I was the happiest maniac alive.

How did I not see it coming? I thought. We had discussed marriage before, but with all the baby excitement, I was too preoccupied to focus on the when and the where of it. It was all too perfect—and even caught me by surprise.

I had never felt more loved than I did in that moment.

We married three months later on September 10, 2013, at Disneyland in Anaheim, California. Would you expect me to get married anywhere else? Our wedding was more beautiful and more perfect than I could have ever imagined. We had the entire park to ourselves—including our own private viewing of the *Fantasmic!* water show and fireworks that lit up the night sky just for us. The bridal party and I were given the exclusive Dream Suite inside the park to get ready in. The ceremony was held at the Blue Bayou restaurant inside the Pirates of the Caribbean and our

reception was in my favorite part of the park, New Orleans Square. At the end of the evening, we left the wedding in a horse-drawn pumpkin carriage. If that's not the makings of a fairy tale, I don't know what is.

This feels like an appropriate place to wrap up this book: Holly found her "happily ever after." And I did. I believe Pasquale and Rainbow were always the future intended for me—and without embarking on that remarkable, bizarre, twisted journey down the rabbit hole, who knows if I would have ever found them.

But let that not be the moral of my story. True happiness doesn't come from simply getting married. I don't believe a woman's worth should be measured by whether or not she is married (I'm still surprised how many people still think that way!). Marriage and family are certainly beautiful parts of life, but I believe those things can truly be appreciated only when we find, love, and respect ourselves first. Pasquale didn't come to me at a time in my life when I needed rescuing most—he came when I didn't actually need to be rescued at all. And because of that, we developed a true and meaningful partnership. He's my Prince Charming, but I didn't need saving. I saved myself.

I won't apologize for the choices I made, because all of them brought me to the wonderful place I am today. But rest assured, my journey is far from over.

Just like Alice, Wonderland opened up my eyes and prepared me for my real life's adventure . . . one that has only just begun.

And how she would gather about her other little children, and
make their eyes bright and eager with many a strange tale,
perhaps even with the dream of Wonderland of long ago.
—Lewis Carroll, *Alice's Adventures in Wonderland*

ACKNOWLEDGMENTS

"There ought to be a book written about me, that there
ought! And when I grow up, I'll write one."
—Lewis Carroll, *Alice's Adventures in Wonderland*

To my husband, Pasquale, and my daughter, Rainbow, for all your love, support, and inspiration.

To my collaborator, the amazing Leslie Bruce, who taught me so much and helped me put some painful memories on paper in the most fun way possible.

To Matthew Elblonk, who made this book happen in the right way, making a big dream of mine come true!

To everyone at HarperCollins, thank you for this amazing opportunity. To Denise Oswald, for being the perfect editor, asking all the right questions and leaving no stone unturned. To Trish Daly, Susan Amster, Joseph Papa, Kendra Newton, and Michael Barrs for all your hard work.

To Sue Madore for all your help getting this book out there.

To Jason Verona for keeping all my best interests in order.

To Max Stubblefield, who got this project rolling.

To everyone who was at E! in 2005–2011, without whom this story

wouldn't be possible. Ted Harbert, Lisa Berger, Jason Sarlanis, Brent, PJ, John, and so many more—thank you for turning that time in my life into such an amazing opportunity.

To Virgine for taking such great care of Rainbow while I worked on this book and to Gina for keeping my life together.

To my dear friends Bridget, Ashley, Josh, Claire, Angel, Vic, Becca, Tanya, Mike, and Alex for your support every day.

To Denise Truscello for the wonderful cover photo, so many of the photos in this book, and your invaluable friendship.

To my mom, dad, Stephanie, and Joe for all your support through the years.

ABOUT THE AUTHOR

Holly Madison spent five seasons on the top-rated E! hit reality show *The Girls Next Door* before landing the leading role in the Las Vegas Strip smash hit *Peepshow*. She also starred in two seasons of her own E! hit series *Holly's World*. With her husband and daughter, Holly divides her time between Las Vegas and Los Angeles.